CEN

The Journals
Josef Herman

Edited by Nini Herman
Introduction by Richard Morphet

Peter Halban London

In association with

European Jewish Publication Society

First published in Great Britain by Peter Halban Publi
22 Golden Square
London W1F 9LW
2003
www.halbanpublishers.com

In association with The European Jewish Publication Society
PO Box 19948
London N3 3ZJ
www.ejps.org.uk

ISBN 1870015 81 9

The European Jewish Publication Society gives grants to support the publication
of books relevant to Jewish literature, history, religion, philosophy, politics and culture.

The editor and publishers gratefully acknowledge Agi Katz and the Boundary Gallery, the
Glynn Vivian Gallery, the Roland Collection and Jorge Lewinski for permission to reproduce
illustrations and photographs. Every effort has been made to contact copyright holders and
the editor apologises for any omissions, which she will be pleased to rectify at the earliest
opportunity.

Designed by Katy Hepburn
Typeset by Computape Typesetting, Scarborough, North Yorkshire
Printed in Great Britain by The Bath Press, a member of The CPI Group

In memory of Josef.

My love to all who
keep that welcome in the hillside.

Acknowledgements

My gratitude to Martine and Peter Halban for that embrace of recognition; to Richard Morphet for his thoughtful and illuminating Introduction; to Judy Gough and Katy Hepburn for their generous devotion, and to the RA for once again acting as Josef's hosts.

Nini Herman

Contents

freely into the vans, helping each other, but
by lunch time, each few had to be dragg-
ined and there was a lot of shooting and
fires in some windows... The worst for me
was over... I was numbed, and slept the who
afternoon at Pearl's...

10 June.
The last few days I was ill... But I
feel better now... C. looked after me with
immense understanding. I must not think
any more. I must... I must... Pearl comes
to the hotel every dg. But we talk about
Paris.

12 June. The Louvre.
Caravaggio's "Mort de la Vierge". In
the afternoon the Jeu du Paume. The wall
with photographs impressed me most.
What beautiful heads, old Pissarro, old
Monet, old Degas nearly blind. I have
no heart for impressionist painting. In
the evening supper at Pearl. Met her
husband and a few friends, journalist
from Humanité, all members of the Fren
C.P. The conversation was disturbing.
All seemed to me living in a world of
political abstractions. The Social Dem

Introduction

Many readers of Josef Herman's Journals will use them as a rich and rewarding repository to dip into. This Introduction offers a complementary approach by giving an overview of the Journals' central themes. Necessarily selective, it brings together some of Josef's widely separated observations on certain key ideas. It also complements the special insights of his widow Nini, both in her earlier writings on Josef and in her moving and perceptive Preface to the present volume. As Josef records here, hers was a key role in his life, late in which he wrote: 'Each year, in forty years, she has become more and more special. In passion and in caring, she is equally special. My independence and her independence make our dependence on one another. Beautiful also in body and in mind are her spontaneous emotions.' [Jotters]; and 'When Nini dies, I will die too though I may go on breathing. Ours was the mysterious way from passion to caring.' [Ibid.]

These Journals will be an invaluable resource for biographers, though not in the same way as those of diarists whose chief concern was to record events and encounters as they occurred. In Josef's Journals names and facts abound, but not systematically; nor do they cover his life comprehensively even within the periods when writing was in progress. Moreover, if one omits the undated and even less time-specific Jotters, the period covered by the Journals totals only nineteen of Josef's eighty-nine years, and none were written before the age of thirty-seven.

It is thus all the more striking that despite the fortuitousness of what has survived, and the almost random timing of the entries, one has a powerful sense of encountering the whole man, at least of the years when he was an established British artist. One shares Josef's own regret that he destroyed many Journals. It would be wonderful if, however improbably, more volumes were to come to light, but even if they did it is unlikely that they would alter the portrait the present ones give of this important and distinctive artist in the last six decades of the twentieth century.

If the earliest of these Journals (1948–50) are compared with the latest (1992–2000), the main contrast is between the vigour of the younger man (constantly meeting other artists and writers and commenting continually on his wide range of reading, on past art and on the work and personalities of his peers) and the octogenarian, leaving his studio only reluctantly. The Journals of the last years include

many extended passages that are almost dreamlike in their at times free-floating blend of fragments of descriptive recollection with fresh formulations of his beliefs about the practice and purpose of art. Though this older Josef is markedly more introspective, he looks inward only the more fully to illuminate the nature of existence. In a tone at once broader and deeper, these later Journals continue the commentary on our humanity that marks the earlier writings and that his paintings and drawings articulate in their own language. Each of his modes of expression illuminates the others, and in each his clarity commands lasting attention. In view of the adversities both inner and outer that Josef suffered, his message is all the more telling. It is life-affirmative through and through.

The Jotters are a distinct genre within Josef's writing, yet their themes, too, are integral with everything he did. Their philosophical mode, no less than their date, links them specially to the Journals of 1992–2000. The succint statements in the Jotters are close in nature to those on the innumerable small sheets of drawings on archetypal motifs, in individual series, that poured freely from him chiefly in the very early hours, when he, alone of the household, was awake. On many of these drawings he inscribed short yet resonant thoughts. But at any hour writing and image-making served for him a common purpose: 'My way of working has not changed for years. I sit at something resembling a table. On one side, an open sketchbook for drawing. On the other side of my arm, a jotter. I draw and write things down at the same time. In each case I am not concerned with performance, only with expression.' [Jotters]

Several factors combine to suggest that Josef intended his hitherto private Journals to survive him and to constitute one aspect of his testament to the future. After the regret he records at his destruction of earlier volumes, it is difficult to believe he would have written at such length had he not now intended a different outcome.[1] While many passages pin down remarkable but fleetingly observed sights, as if to help his own later recall, even more have the character of statements distilled for maximum clarity in transmission. Like his paintings, many of these are re-formulations, as if a lasting truth is like a structure that can endlessly be apprehended freshly from new perspectives. For the reader, it is as though a friendly teacher is talking, with innate wisdom and authority and with a humility born of long experience. Though originally private, these writings have a universal quality.

The reader often has the sense of being with Josef specifically in the studio. The Journals offer a vivid insight of what it is like to draw and to paint. They function neither as an exhortation to others to paint in Josef's own way nor as a technical

[1] On 13 Oct. 88 he writes: 'None of my jottings are intended as a form of communication with others', but in Aug. 99: 'I am not writing this with the idea of having these things published but it will not worry me if some of these will be made public'.

manual,[2] but more as an existential testimony. They are likely to speak to many painters, and to be kept beside them for the encouragement and inspiration they offer.

Visiting Delacroix's studio museum [15 Jun. 48], Josef imagines the earlier artist's daily life and working processes. Like Delacroix's Journals, his own intersperse reflections on art and reports of personal encounters with beautiful passages of observation of nature.[3] Late in his Journals [20 Jul. 98 & Dec. 99] Josef praises the style of those of Delacroix and also of van Gogh's letters. In common with them, he records his travails as individual paintings take shape. In his accounts, however, there is less detail on specifics of imagery, but rather an emphasis on the nature of his vision. The character of his Journals is nevertheless related to that of both these classic (and contrasting) preceding texts. His entries lead one to agree that: 'When painters take the trouble to write they are better than the writers who attempt to write about them. No polish, direct force and often the charm of clumsiness.' [Aug. 99] On the other hand, one cannot agree when, after writing: 'With *each work I declare myself*', he adds: 'I no longer want other forms of declaration . . . whatever I have to say is of *no importance*.' [7 May 87] It is true that for the quiet, concentrated viewer all the things Josef writes about his paintings are eloquent in the works themselves.[4] But opportunities for such viewing are not always available, and one values insights into the content of Josef's art from the mind and spirit that created it.

The Journals for 1948–50 were written while Josef was based in Ystradgynlais, south Wales, though they record time spent elsewhere during that period, including in London and on an extended visit to Paris. The remaining Journals (the great majority) were written chiefly in London, but include some passages written in Suffolk (where the Hermans lived inland for ten years from 1963 and later spent holidays on the coast) and in places overseas. All the later Journals record the intensity of Josef's resistance to going away at all. For example, he writes on 5 May 87: 'The very thought of travel makes me restless . . . Once [back] in the studio [I] promise myself NEVER AGAIN.' This resistance seems at first paradoxical, since Josef's art draws richly and with evident empathy on motifs and atmospheres experienced when travelling.

[2] cf. 8 Apr. 84: 'As for technique: the main thing not to use materials as they *should* be used'; and 10 Apr. 84 'Working against the "nature" of a material can prove just as good as working with the "nature" of the material.'

[3] Josef 'paints' in words. As Robert Heller has observed, his verbal descriptions of scenes are just like his pictures. While the descriptions abound in references to specific things they, like the paintings, are highly selective in what they pick out. Texts and pictures alike present *his* world, rather than documenting the one he observed. A remarkable extended example, mixing observation with reverie, is his description of the Serpentine in Hyde Park, on 6 Jan. 76.

[4] cf. 26 Jul. 90: 'The *experience* through a work of art is also its meaning. The experience is wordless as is the meaning.'

Moreover, the Journals abound in fresh and affirmative descriptions of places and people and of his resulting feelings. However, the explanation is suggested by the words that immediately follow those just quoted: 'Continuity of feeling is even more important than continuity of thought.' Vital though the outward world was to him, Josef lived above all in an inward world. He always feared that travel would disrupt the contact with that world that he felt most keenly when alone in his studio.

This is one reason why his identification with place was overwhelmingly keener with the enclosed world of his studio than with the city in which it was located. In Aug. 99 he went so far as to declare: 'London is a monster. I feel no attachment to the city. I respond to the atmosphere of some small streets. I feel alive once I am near the steps leading to my red door. Behind this door my life begins . . . How can one speak of the ''atmosphere'' of a city with 12 million or so inhabitants?' Of the city where he was born and formed, he wrote in the Jotters: 'Oh, Warsaw, my Warsaw. I will never forget your green winter skies. Your white walls, your restless pavements. The men and women poorly clad, serene at dusk when taking air before sleep. The first star quietened your voices.' But the circumstances of Josef's life during his last years in Warsaw were difficult. Nini Herman has described him then[5] as 'constrained by the provinciality, driven by anti-Semitism and the pogroms' and, for a time, imprisoned with other leftists, concluding that 'he left Warsaw in 1938 with an over-riding sense of urgency and inevitability'.

Nevertheless, Josef would later write of his immediate milieu in Warsaw that 'though with the years I tore myself away, I have never really severed myself from this street. Today I feel it as a part of me still.'[6] Understandably, nostalgia would recur powerfully, but it would be joined by intense memories of one in particular of the places where he lived during the sixty-two years of his exile. As he wrote on 12 Mar. 76: 'In Wales my style of living was very near my style in art. It is not like this living in London. Mine was a hard working life with many pleasurable rewards. Very rarely was I bored. The great ecstasy was in my gift for seeing twilight's light and feel[ing] what it does to the world. The setting sun changed a grey street into an exotic land. Ecstasy, once awakened, lasted many hours. Sitting still, I travelled.' Consistent with numerous affirmations of the importance of his years at Ystradgynlais, he wrote on 21 Jul. 68, 'After so many years I still feel Wales is my natural home'. In turn, Wales continued to regard 'Joe Bach' (as he was known locally) with pride and affection, and as one of theirs.

These Journals begin only eight years after Josef arrived in Britain knowing no English. One is struck by the ease of his use of the language, no less than by the sophistication of the many books he was reading in it. Though he constantly stressed

[5] In notes written for the author, September 2002. [6] *Related Twilights* 1975, p. 14.

his lack of formal education, the very articulate Journals take their place beside his admirable writings already published, not least *Related Twilights* of 1975. Before the broad themes of the Journals are addressed it may be useful to give a short selection of some of the more particular topics he discusses there, to give some idea of their range.

Included in the Journals of 1948–50 is a poignant account of Josef's meeting again, at her Paris flat, a friend named Pearl, whom he had not seen for ten years. She had initially worked in the wartime Polish Resistance, before being rescued by its French counterpart. Josef records Pearl's detailed eye-witness account of the murder of his entire family by the Nazis, who herded them into gas vans. The brevity of this account and the substantial absence from the Journals of further discussion of this topic must surely be in inverse proportion to the impact of the knowledge on Josef's life and work. It was in Glasgow in 1942 that he had received from the Red Cross the dreaded news that his family had been killed, which led to a prolonged breakdown, through which crisis Jankel Adler nursed him devotedly. Soon after his stark account of the meeting with Pearl Josef gives, by contrast, a very rounded word-portrait of his father, closely followed by a vivid description of Warsaw and the Vistula, and of how it felt to be young. Nini Herman suspects[7] he wrote these perhaps surprisingly positive passages 'to spare himself from being overwhelmed, drawn back into those depths of pain over and over again'. She draws attention to his recording in the Journal how, having heard Pearl's account, 'he fell asleep on the table, surely the only respite available to him. On one later occasion had he not written: "I hate self-pity"?'

The same volume includes a painterly description of Ystradgynlais with tender details evocative of its people. Separately he gives an account of the excited effect on the village of the arrival of wild ponies, which had come down from the snowbound hills in search of eagerly offered sustenance. Josef explains why he admires ikons and how, in using colour, brightness is not everything. He reflects on Paris and on French art and compares Rubens with Rembrandt. He discusses Georges de la Tour, Delacroix and Courbet (three artists exempted from his view that much French art, though enjoyable, is weakened by good taste) and observes the characters of his fellow artist-refugees Jankel Adler and Martin Bloch.

The numerous and varied subjects in the Journals from 1968 onwards include an account of Josef's loss of religious faith, starting at the age of sixteen, but also of the importance to him of 'the dark, mystical sources of experience, [which have] remained . . . relevant and life enhancing.' In a related passage he discusses St Teresa of Ávila, mysticism and praying without words. Elsewhere he considers both the downsides and the satisfactions of the loneliness he feels. He reflects on experiences of London's East End and docklands (where he sketched from time to time) and on the life and work of

[7] In notes written for the author, September 2002.

those who lived there, but also on seeing the pyramids of Giza. He records the death in 1987 of his first wife, Catriona, and ponders her troubled life. Artists discussed include Brancusi, Braque and Rothko, as well as the views of Meidner, Adler and Bomberg on religion or philosophical belief. Two passages record his admiration for the poems of Walt Whitman. He writes about his later-destroyed picture 'Homage to the Women of Greenham Common'[8] and elsewhere contrasts a Hockney retrospective unfavourably with an exhibition of Tibetan tiger rugs.[9] In 1994 an extended passage of almost stream-of-consciousness musings on memories and things seen in the past mixed with current observations [21 March] is an indicator of the increased drift, in his last years, into a state of mind semi-independent of the contemporary world and of time itself.

The Jotters include Josef's adverse comments on D.H. Lawrence's paintings, seen in New Mexico, and, in one of many total contrasts, an explanation of the range of tragedies that underlie his own powerful late painting 'A Witness to the Terror of our Times'.[10]

It is clear from the Journals that the Josef Herman of later decades differed in significant respects from the widely held image of him derived in part from the subjects of his art and even – paradoxically – from peoples' rich experience of actually meeting him.[11] In the image, he was cheerful despite everything, enthusiastic about meeting visitors, keen to observe people in their everyday settings and implicitly working, as an artist, in some kind of class cause. The Journals show this image to be seriously misleading.

Two of the greatest surprises may be the degree to which Josef increasingly sought isolation; and the extent of his feelings of alienation from the late-twentieth-century art community in London. In addition, however, he was subject from time to time to deep and disabling terrors and depressions.[12] While the horrors of the murder of his Polish family, the breakdown of his first wife and the death of his four-year-old daughter all exacerbated his recurrent severe depression, he regarded the fundamental cause of these episodes as being his lifelong constitution. He emphasised this when he wrote on 28 May 88 of his painting of Shakespeare's tragic king, 'Lear Destroyed' 1964, that 'Lear on the heath is me and always has been since the earliest years that I

[8] Reproduced in colour in *Royal Academy Illustrated* 1991, p.46.

[9] 'Such closeness I feel towards any kind of folk art and any not too tutored artist. How near those remote tigers are – each single one, no matter how little of the tiger remains in the overall image! In front of these rugs, I feel so refreshed by humility!' [8 Nov. 88]

[10] Among this painting's earlier titles was 'Tribute to Goya's Black Pictures'.

[11] cf. Aug. 99: 'Being with others gives me no pleasure, though talkative as I am I may have given a different impression.'

[12] His Journal entry for 1 March 1976 gives one vivid description of these and of the process of recovery. Nini Herman's footnote on 2 Jul. 88 outlines the history of his depression and of the medication he needed for a time.

can remember.' Knowledge of Josef's psychological setbacks only strengthens admiration for his singlemindedness in continually reformulating his affirmative vision, in both art and words, and for his persistence and stoicism, however ill at ease he felt, either inwardly or with prevailing trends in art.

Josef felt keen solidarity with the working people who are the subject of so much of his art, but the promotion of social change was not his purpose in painting. Moreover, while his art was crucially dependent on what he had observed, its subject was at least as much an inward vision, imaginative, spiritual and latterly almost mystical in nature. Further, his imagery was much less pre-planned than its final appearance might suggest. A painting developed through a process of intuition and exploration that often started with no fixed goal in mind, albeit with a strong impulse towards archetypal form and motif. His search was always to express essential feelings that could not be articulated in a programmatic way. As he put it on 24 May 84: 'Oh how difficult it is to recognise the intelligence of the heart. So many side tricks.', and five days later: 'What makes of painting art is *unpredictable*. At this moment, the image is all intention and art stubbornly refuses to appear.'[13]

Josef's suspicion of clearly-defined intention on the part of the artist was in keeping with his aversion to the work of what he variously identified as thinkers, explainers, critics and curators. To write an introduction to his Journals requires temerity on the part of one of these! 'People with a university education use too many quotations', he writes on 21 May 88 (this introduction abounds in them). 'Authorities use too many ''rare'' words', he continues, 'Afraid of simplicity, they mistake academic language for ''culture''. They get dozy with too much reading and knowing. They also ''read'' images. How dreadful ''images'' sound when packed into words!' Earlier he stated, 'I

[13] This process of intuitive exploration towards something archetypal is one of the ways in which Josef is characteristic of his generation (that of the American Abstract Expressionist painters, among others). It also contributed towards the decision to display his work in the same room as that of Henry Moore (b.1898) and the painter Cecil Collins (b.1908) in the Tate Gallery's 1984 exhibition *The Hard-Won Image*, curated by the writer. The Journals include many indications of the extent to which Josef's paintings and even some of his works on paper evolved as a process of discovery conducted on the picture surface. 'Painting is first of all a way of feeling one's way about. True work consists of vague notions becoming a coherent mood. It is the blind man's hand searching in the dark for something tangible.' [28 Aug.48] 'With me now painting begins with the itch for handling pigment. The greater the sense for pigments the greater the painting.' [1 Oct. 48] He recorded how in painting his watercolours of heads of 'Children of North End Road': 'I have no control whatever, either of the colour or the form. I virtually don't know what I am doing. They are inventions which invent themselves. No one head is like another. Sometimes I wish that this would stop and I could get on with other works but I cannot. I have to work with a speed I have never worked with before . . . I spread out my morning's work on the floor. I was moved to tears. They have such unmistakable human identity. Perhaps they are autobiographic [Nini Herman confirms in a footnote that they are] . . . I hold nothing back. Nothing willed. Even when I chisel my way into form or light, I am following my feelings and not any deliberate notions.' [9 Mar. 84] 'The main thing is to let the image work out its own thinking. I do not even try to ''understand'' the thought-direction of the images in front of my eyes. At work I do not direct but follow.' [4 Aug. 88]

am weary of all interpretations of works of art . . . The pleasure of interpreting is a thing of its own. An intellectual exercise, little more, little else. It has no guiding lines into a work of art. There cannot be such guiding lines.' As recorded on 28 Jul. 87, he therefore resisted the idea of a Lund Humphries monograph on his work. 'I have . . . freed myself from the terror of the art industry with its connoisseurship and all in the service of this industry, in particular this so-called scholarship.', he wrote [17 Jun. 87] and later: 'Decided to sell (almost all) of the art books. Their very presence on the shelves irritates me'.

He wanted unencumbered contact with the source itself. Viewing works by Piero della Francesca and Vermeer in the National Gallery, 'at times I had to fight off distractions when I fell into the trap of seeing the image in terms of concepts and meanings but these did not last long once I got into the more beneficial state of directly experiencing the image free of any intellectual and historical props. Then the images and I become one in a state of radiant day dream.' [25 Aug. 87] In Aug. 99 he observed, however, that: 'After a visit to Altamira and the Lascaux caves, [even] the drawings in the Louvre seemed slick performances.' In the same paragraph as his denigration of 'people with a university education', he observed: 'I like illiterate people. They say things in an original way. Short of words, they make astonishing use of metaphors'. By contrast: 'Writer-explainers are bores and worse, misleading quacks and self-deluding opportunists. Almost stupid but not quite. Never trust the knowers. The best museum is the street.' [Aug. 99]; and 'Most of the things written, said or recorded about artists are seldom interesting. Only what artists say, no matter how poorly worded, is interesting.' [29 Jul. 88] The paradox is that Josef, though an artist-writer and not educated at a university, was himself a sophisticated reader, thinker and writer, and this gives his Journals lasting value.

The Journals include reflections on the undesirability of having exhibitions and on Josef's hatred of social occasions in the art world. In Dec. 98 he writes: 'It is the object of every painter to follow the needs of his talent and stay away from the art industry'. He also resisted the idea of art as contest: 'A runner, I did not run against the others. I ran against the clock. No ambition, no competition. Slightly scared. Carrying on.' [20 Jul. 98] Consistent with this position, he censured fashion as a motive force in art. 'When I go to galleries and see what painters are occupying their heads with, I cannot respect their premises. Even the best seem to have surrendered to the fashionable and the empty. Even the slightest is blown up with self-importance, with "personality". Nobody seems to have any faith in anything, no intimate belief in anything.' [8 Dec. 75]

Josef's reservations about other art also embraced some of the great names of the modern era. For example, 'The drawings of the Impressionists are feeble because they

tried to draw without outline. Only outline can define form . . . Degas understood this.' [14 Nov. 75]; Matisse was 'slight' [29 May 68] and Mondrian 'was no great shakes as a painter.' [25 May 68] But as with all significant artists, reservation or dismissal of the work of other artists and the grounds for these negative views have the value of making still clearer, cumulatively, what it is that motivates an artist's own work. The same is true of Josef's denunciations of fashion and of secondary workers in the 'art industry'. In each case, the limitation of view becomes a personal strength.

Also revealing of Josef's distinctive vision, especially when considered together, are the identities of the great artists of the past who were of special importance for him. On 24 Oct. 48 he states that he feels personally hurt when he reads harsh judgements of Masaccio (described on 26 May 68 as 'my favourite painter'), Michelangelo, Rembrandt, Turner, Millet, Monet, Ryder, van Gogh, Rouault or Permeke. On 20 Nov. 75 he observes that: 'Millet's draughtsmanship has a kind of serenity, typical only of him. How wonderfully his outlines frame the whole silhouette of a man, woman or thing!' Other earlier artists of great importance for him included Goya, Daumier, Kollwitz, Marsden Hartley, Derain, Sironi and Morandi.

Like all of these artists, Josef created any work – however intuitively – with care and deliberation, yet also like them he attached key importance, on several levels, to directness. Though time is needed for any of his works to reveal its full intensity, it was important to him that its essential character be communicated to the viewer on first sight, through the clear formation of its image. For him directness of route from his feelings to the image was in contrast to notions of good taste, over-civilised imagination or concern with the canon; he voiced suspicion of all these repeatedly in the Journals. Thus: 'Every painter should think as children do without any models in his mind. Whom did the cave painters follow or "rebel" against? No reading of books on art, except for relaxation as one would read thrillers or anything else. Definitely not with the object to emulate examples. Being what one is, doing what one *has* to do, guided solely by one's emotions. Most important, avoid discussions.' [16 Aug. 90]; 'I think with images and not with words.' [Jotters]; and 'The intelligence of the eye does all the thinking . . . When colour becomes articulate, words have nothing more to say.' [Ibid.]

Both in Josef's own life and in his pictures (through the ways of life he depicted) a key issue was work. The central purpose of his existence was not just realising his vision through finished works of art but also undertaking the labour of producing them.[14] His painting was physically direct, its sensuous textures attesting his closeness

[14] Cf. his statement in *Related Twilights*: 'A meeting with Morandi . . . made me more conscious of the need to live as an artist – of the need for an artist to shape his destiny *through his work and only through his work*. He was for me a shining example of a painter totally committed to his work.' (my italics).

to his materials integrally with that to his subjects. He had a keen sense that his pictures were the tangible product of labour of the hand. Thus however great the difference in terms of physical energy, his work paralleled that of the kinds of worker he chose to paint, while differing from that of white collar workers or intellectuals. The Journals abound in assertions of the connection between the making of art and life itself. 'Nothing could induce me to abandon the external world. Nothing could induce me to abandon my internal world. Living is one process. Living through one's labours is one process linking the two.' [18 Jul. 88] 'Workless days wear me out. Labour heals.' [Dec. 98] 'I am in my works. In life I am shadow. Alone but free! I find my freedom in work.' [Sep. 99] 'With me working is living.' [Jotters] 'The joy of labour makes us forget the process of ageing and dying. An inch of good painting makes me forget the impermanence of life.' [Ibid.]

Permanence was, indeed, the quality Josef sought to convey. It is embodied, in his art, in evocation of kinds of work that had continued for millennia (fishing, agriculture), of the labour of mining (historically more recent, yet still based on physical realities) and in the relationship between mother and child. While each painting focused on individuals, it evoked even more strongly the sense of a continuity that transcends personal experience. There is a relationship between the length of this perspective and the unhurried gestation of each of Josef's paintings. The slow pace of their creation is felt in their expressive effect.

In the Journals Josef reflected on the antithesis of this approach, as seen in much art of his period: 'There is no denying the inherent power in modern art. But why is it . . . that after the first excitement is over we are left with a terrifying emptiness? Perhaps all energies are concentrated on too little? Making marks is the beginning of drawing, but not its end. Spontaneity is the sure sign of inspiration, everyone now works madly fast. Invention, no matter how slight, came to mean everything. Originality is no longer a pointer to a destination, a quality of a mind, it is a texture, a twist in design.' [8 Dec. 48] and 'I think it is Romain Rolland who tells in his essay on Millet that the total output of thirty years of this painter's labours amounted to 80 pictures. Two months of a modern painter's work. But then what a coherent world Millet created! Today painters overproduce. We need a slower pace. We need calm.' [5 Jun. 49] Josef expresses his admiration for Crete's history of unhurried living [21 Feb. 76]. For him, 'Art is the slow rhythm of permanence.' [20 Nov. 48] 'My ideal is the painter who produces very little, very intensely and very deep.' [18 Jun. 68] His own habit is 'to look slowly. The eye is a slow thinker. It assimilates things from the strangest sources in its slow way but the emotional compensations are tremendous and often of puzzling intensity.' [19 Apr. 88]

Critical to the success of any work was to articulate its own particular mood. 'We

begin a picture with a general mood, a state of mind. Nothing is seen before it was painted. This is how we get to know reality. Mood is for the artist what enquiry is to the scientist (what goes into the making of a worthwhile work of art cannot be understood. It must be felt).' [7 Nov. 75] Near the beginning of these Journals Josef makes clear his affinity with C.D. Friedrich and Wordsworth. 'The romantics were the first to put mood before idea . . . They knew that the mood-idea is not a mere form-definition but a definition of our passions . . . Art at its deepest is always romantic'. [3 Oct. 48] He observes of the late work of Turner: 'There's a moment of hush and of dream and the unnatural light expanding into an aura around all the pictures. The light is the kind that the human heart responds to most willingly, soothing, warm and turning into a glow. It is art of the great human theme and this without involving the human figure . . . to an important degree.' [9 Apr. 50] Earlier in the same passage he writes of Turner that: 'with him we do not gain "more information about nature". That he was a good observer goes without saying but as with Rembrandt we enter a world of unique poetry.'

These passages reinforce one's awareness that central though the human subject was to Josef's art, so was intensity of mood, and this criterion transcended the need for fidelity to exact appearance. He wrote: 'I cannot do without a subject. What I paint in imagination has its source in memory of things and people.' [20 Feb. 50] and 'Whenever I am drawing a human form I am always conscious that I am drawing a social being. This affects the nature of the form itself.' [29 Jul. 68] Yet: 'Properties of things are not fixed, they will change according to the expression of form one is after', and 'Nature should only be approached when one has learned to feel without compromise, only when one has learned to organise one's quest. One should study nature in order to avoid "naturelike" art.' [both 27 Jul. 48]

Thus although Josef's pictures of the world are compellingly 'real', they are far indeed from being made from observation. As he wrote: 'I am more stimulated by my own drawings than by the reality from which they were made. In this way I can never fall into the trap of realistic painting. What a greater painting Millet's "Man with the Hoe" would have been if the image would have been free of realistic detail. What an immense outline of a figure! Like anything big of the Egyptians or the French Gothic! All this gets spoilt by the minutely painted fields!' [10 Feb. 76] 'Our visual experience matters. Oh yes, it matters a great deal but our emotions matter more. It is this that eventually makes the form what it is.' [28 Feb. 76] and 'This is how I work now – towards a gradual building up of a mood that owes something to reality but more to my own spiritual needs.' [16 Dec. 87] Moreover, 'It takes some time for a finished landscape to enter my mind. Usually weeks after I left the place and it is then that it comes to live in me. Only by that time I no longer know whether it is the spirit

of the place or a place formed by my own spirit. By then it may even be a dream.' [Jotters]

Such feelings demonstrate, too, how far Josef was from creating art in the service of class struggle. Two factors may nevertheless have fostered a belief that that was part of his aim. First, as successive biographical chronologies record, in 1935–6 he was part of a group of artists in Poland, 'The Phrygian Bonnet', for whom, as he states in the Journals, 'the element most admired in a work of art was the sense of urgency. We identified with the working-class struggle against the bourgeoisie. We thought, we felt, we lived this class war.' [20 Aug. 48] Secondly, in and from the late 1940s he became thought of, rightly, as an outstanding painter of the arduous life of Welsh miners, an association corroborated by statements such as this in the Journals: 'On the subject of places, only Ystradgynlais changed my life and my work. Not Paris, or Provence, not Italy nor the Middle East. Ystradgynlais mattered. When I left I took it with me. The telegraph poles were crucial, the road with the mother and child in a Welsh shawl but above all, the miners.' [Dec. 99] A drawing by Josef of a worker (perhaps on a farm, because holding a rake) was the cover illustration for the group exhibition *Looking Forward* at Whitechapel Art Gallery in 1952. Its curator, John Berger, wrote at the time in connection with the exhibition: 'The future power of this country is in the hands of the working class, and so obviously it is some form of living socialist faith that the art of the future will serve.'[15]

However, as early as 1948 Josef wrote of 'The Phrygian Bonnet': 'What I understand now and did not understand then is that artists are men of little choice, that the nature of their talents predestines their path and that artists with a social imagination are nothing better than artists with other kinds of imagination . . . Artists must be thought of as individuals and not as class phenomena.' [20 Aug. 48] Moreover, John Berger himself felt that Josef painted 'miners as if they were peasants, instead of one of the most lively and militant sections of the proletariat'.[16] In the Journals Josef wrote that 'one always has to keep one's mind on the basic problem of painting and ignore one's own times' [29 May 68]; 'the object of art is to remind reality of its poetic roots' [Jotters]; and 'art does not serve an end – it is an end.' [1 Oct. 91] During the Welsh years he stated: 'In the last few months too much documentation has found its way into my work and thus hampered my dreams. I am finding myself disliking so-called ''realism'' both in spirit and in method.' [30 Nov. 48]

Nevertheless, he continued to feel that 'in human labour I see the heroic aspect of our existence', [Sep. 99] and it was for one part of society, in particular, that he painted. At Ystradgynlais he wrote: 'The working class here, like anywhere else, thinks of painting as a sort of option for the rich. And who can blame them . . . Yet at heart it

[15] 'Dear Enemy . . .', *Tribune*, 26 September 1952. [16] John Berger, *Permanent Red* 1960, p. 92.

is for their kind that I work.' [26 Oct. 48] Recording how a poster by Käthe Kollwitz, 'Deutschlands Kinder Hungern', was 'the first image that moved me deeply and brought the first of many changes in the course of my life', he continued : 'Art and morality have close roots. Here was a beginning and [it] remained my objective.' [Jotters] Only two months before he died he wrote: 'I was asked the purpose of my work . . . I lowered my head and said: "First personal, then moral and social" . . . This was true' [Dec. 99]; and 'I never loved the poor, nor did I hate the rich – I wanted a society without either. I still want such a society.' [Ibid.]

At the core of Josef's art was a concern with what was essential to our humanity or, as he termed it, with the 'primitive'. This quality, he felt, was not found in bourgeois life. 'By temperament I am drawn to man. Not every man, but the man of *primitive* form and this the bourgeoisie as the intelligentsia has no longer got. Hence my searches (as a painter) midst miners, fishermen and peasants.' [28 Jun. 68] 'I draw workers because they are beautiful. Not on Sundays. On Sundays they become one with the middle class. The middle class is always ugly.' [Jotters] and 'I am deeply moved by poverty and the poor. I am indifferent to the elegant things of the rich. I see beauty in the working clothes of a worker but don't look twice at "well dressed" women and the tidy figures of middle-class men.' [Jotters] He recalled how: 'When in Wales I quite deliberately tried to give my images an atmosphere which would not fit comfortably on the walls of a middle-class drawing room', but continued: 'That they eventually land[ed] there made me laugh at my quixotic gesture. Still I was right.' [29 Apr. 88]

Art must affirm what matters in life. 'Tell me of an art centre and I will go the other way. Not art, [but] the moment of life matters. Life is the centre, not art' [Jul. 93]; and 'The object of art is to discover and hang on to something valid in human life. All other things, like art for pleasure, is so much drivel.' [31 Dec. 75] 'Japanese art', he wrote, 'reminds me of European rococo. Where is sadness and pain? No serious art can be without it' [Dec. 99]; nor was his own. However, he deliberately avoided depicting violence (as opposed to its tragic effects), believing that: 'Human culture asserts itself in the striving towards peace.' [16 Oct. 93]

Concentration and simplicity were vital means, for Josef, in communicating the content of his art. He sought: 'The simplest route from the heart to the canvas. The simplest means. Nothing else. Images without strain, without conflict, tension, torment, without disquiet, without agitation but not passive: a way of asserting the humane through positives', and deplored 'the sheer uselessness of things that bring disquiet and restlessness.' [15 Dec. 91] He believed that: 'an image should be quiet, strong and appeal to the heart at the first glance of the eye.' [24 May 84] Yet while affirming that 'economy of means is always a mark of a great hand' [24 Oct. 48], he stressed that 'primitivity does not come naturally to a man of our time. One has to

work for it. It is a matter of reaching natural simplicity' [20 May 68]; and 'simple feelings do not come naturally. One has to dig for them. They are there. Painting is a way of linking up with them.' [19 Aug. 84]

Late in life, he declared: 'I am after the simplicity of the pyramid and the intimacy of the lullaby' [Jotters], but conceded: 'Simplicity easier said than done. After the pyramids, nothing is simple. The pyramid mystifies and is the epitome of the best in all architecture. It is reductive in form, rich in abstract inferences.' [Sep. 99] Such remarks attest an affinity between his two-dimensional art and sculpture, of which Josef was well aware. He wrote: 'All matter is sculptural. Sculptural means also simple and primitive. Never floating and transient like all things of the senses. Movement is its basic enemy. In stillness is strength.' [Sep. 99] Already in 1948, when explaining his preference for Egyptian over Greek art, he observed that 'The fifth Dynasty has a stability that only the greatest works have. It is a masterpiece of expressionistic completeness. A completeness that we feel in the presence of a mountain.' [17 Jun. 48]

Josef's conviction of the necessity of simplicity of form is evident throughout his painting, much of which has a block-like structure, and in which light is not only immanent but helps define form. He very much associated this conviction with drawing, too. Again in 1948, he observed that: 'forms should stand out clearly and strongly. Like a trunk of a tree, a rock, or a mountain. As a rule sculptors know more about form than painters . . . I hope that my drawing will be strong in expression [and] still in form.' [27 Jul. 48] Also writing about drawing, he stated that: 'if one cannot embrace the whole with one glance, you may be sure something, somewhere, is wrong. If the silhouette is well drawn, space will arrange itself.' [26 Feb. 76] He added: 'Good drawing must have some hardness in it. Soft drawings are unbearable . . . The hardness in drawing is a guarantee that the scaffolding is trustworthy' [26 Nov. 48]; and that in drawing: 'The line becomes what it is through the search for form and expression . . . Line by itself does not make for drawing. Drawing is forming, finding an enclosed mass . . . No drawing is so complex as the simple one . . . Sometimes when I am lost in the search for the right colour, I consult black and white drawings. The suggestions of colour are there.' [9 & 11 Dec. 48]

There is a key connection between Josef's love of simplicity and the sculptural and his deep interest in tribal art, of which he made an important collection. He wrote that: 'African art has a special meaning for me. Those unknown artists are my old masters. By them I am reminded that simplicity is a way of enriching the content and subject.' [25 May 68] In their work: 'the art is secondary to the spiritual expression . . . With this their art differs from that of religious art which is objective in its conscious aims: illustration of the life of a saint, his martyrdom, etc. Instead of religious guidance, the tribal artist produces objects of magic.' [20 Jul. 90] 'My pieces of tribal art, besides

giving me great pleasure, are a source of learning about what the nature of primitivity is. The primitives of any culture are my teachers.' [Sep. 99] Josef's profound response to 'the primitive' and his quest to identify this quality in life and communicate it through his own art is a further marker of the degree of his participation in a key current of twentieth-century art, as already established in the work of such diverse artists and writers as Fry, Nolde, Brancusi, Josef's friend Epstein, Picasso and Moore.

There is also a connection between Josef's hunger for simplicity and the circumstances in which he felt most at ease. When these were simple enough they were also rich enough to feed his art. Thus about Dunwich, on the Suffolk coast, he asks: 'What do I like about this place that I like to come back here every summer [?] There is nothing here to explore: a good place to sit back and absorb the little there is. Little is always enough for me. Sea, space, fishermen, seagulls — enough for my primitive perceptions to come alive.' [28 Aug. 87] In Corfu he observes: 'I like the calm of this bay. Enclosed on both sides by leafy trees. From these hills come an infinite variety of scents mixed with the strong aromas of the deeps of the sea. Above all I like the air of a dreamy uneventfulness. When empty and indolent, solitude becomes loneliness with all its pains. True solitude generates its own content, its own stimulations, its own open-heartedness — to me at least more commanding than the purely emotional "zest" for life. Solitariness and birth are the same.' [4–18 Jun. 90] And he reflects: 'My life? Nothing wild. No adventures. Ordinariness suits my temperament. No passion for what is new.' [20 Jul. 98]

Above all other times of day, Josef found the hour of twilight the most propitious for engendering, within a condition of calm, the state of feeling from which new work might spring. Already in the Welsh years he noted: 'My favourite time of the day — twilight. My favourite season — autumn. I feel neutral in broad daylight and restless in the dark of the night. Eventide makes me feel tender towards life.' [27 Aug. 48] He wrote of preferring a very poor light to paint in: 'In the happy state of what is called inspiration the eyes could as well not be in the head at all. The hand finds its way without the guidance of the eyes. This is how I worked today.' [17 Sep. 48] He described 'the light of dusk, a fiery crimson that has nevertheless a tenderness along which the tide-waves of the wind float on as in dreams. The moonlight is all heart. That the light of a dead galaxy should awake such stirring of the soul which through the ages became the life of love songs in all places and all languages. Now it is the fierce midday light from which I want to escape. No ethereal afterglow in it whatever.' [4–18 Jun. 90][17]

[17] Consistent with his feeling for rich, tenebrous states of light, Josef attached great importance to tonal subtlety. The Journals include an informative entry on this on 9 Dec. 48. While colour values remained critical for Josef to the end, the hues in many of his later paintings are conspicuously more heightened.

It was as night began to fall that Josef felt most in touch with the sensations of permanence and timelessness that were so important in his art. He wrote of 'the . . . feeling of contentment I sometimes get whenever momentary emotion gives way to more lasting feeling.' [17 Aug. 84] But twilight was also a time of discovery, for 'distances which lead into the infinity of space awake in me the most mysterious feelings' [4–18 Jun. 90] and in turn 'the best things we do have the substance of a dream. We live most intensely when we walk in the dream.' [23 Jun. 68]

Josef would like to have worked on a public scale more than once.[18] Part of the appeal of tribal art for him was that those who made it were working for the whole community, and we have already seen how (even) on the scale of easel painting Josef was painting for a numerically large section of society. To attain wide recognition is, however, usually an uphill struggle for quiet, undemonstrative, idiomatically non-innovatory art that has in it something of the visionary, unless (as with Morandi) it repeats a signature motif to a greater degree than does Josef's.[19] Yet paradoxically, while the inward, spiritual element in such art may be a puzzling or subconscious barrier for many people, this same quality helps ensure the artist's long-term recognition. For any viewer who will stop and let them speak, the deeply introspective character of Josef's pictures, their affecting subtlety and tenderness and their expression of his feeling for humanity can all be accessed directly from the pictures themselves. As Josef writes in these pages, images speak without need of words. Nevertheless, the consistency of his Journals with the vision of his art ensures that each illuminates the other.

Josef wrote in the Journals of 'the inner light which alone makes me work in a creative way.' [21 Feb. 76] This light belonged to no religion.[20] 'The drawings I made in Crete last year have the glow of that inner light . . . As in all drawings I set out with something from the life around me but only when the inner light takes over is when I really draw . . . [Turner's late works] are spiritual landscapes with few physical

[18] 'I have no illusion about myself. I know that I would have fulfilled myself better on a greater scale if I could have been a mural painter and not an easel painter . . . The real point about mural painting is its public significance and its monumental scale. My pictures are but a poor substitute. I sometimes think of the tiniest canvas as a large wall. In this spirit, I work happiest . . . The only original picture, completely my own that I ever painted, was the mural for the Festival of Britain. All that preceded it found its culmination in this mural. All that followed it were not pictures but conceptions to monumental art.' [11 Jul. 68]

[19] Significantly, in this respect, it is for his paintings of miners that Josef is best known.

[20] 'I just reread some of Rouault's writings. Somehow his voice awakes in me an enchanting resonance. Not so much through what he says but somehow he opens the sources to the reality of feeling and also the state of mind when it reaches certainty. He is free from professional polish . . . He is not a religious man painting. He is a painter thinking religiously.' [4 Nov. 50] 'I don't know what "religious feeling" is . . . I think people still tend to call the experience "religious" which in reality is poetic and open to everyone: not to the artist alone. So powerful is this experience that early man could not do otherwise but ascribe to it a supernatural origin . . . I never had a need of religion, formalised or not formalised. This is why my humanism is restricted to man alone. Very much alone.' [28 Jun. 68]

semblances to things of nature. In watercolours he found himself much earlier. The difficulty seems to have been a technical one! How to make oil paint so pliable as to fit the glaze of his vision. All originality is a matter of spirit. The mechanics of technique will sooner or later adjust themselves to the demands of the spirit.' [21 & 23 Feb. 76] Later he wrote: 'If spirituality does not come through my work, then and only then, I failed.' [14 Jul. 93] At the end of his life he observed: 'I have not yet read of a single experience that a mystic might link to his creed, which I, as an artist, did not experience.' [Jotters]

The spiritual vitality of Josef's art is indivisible from the dedication to unceasing work that both made it possible and is part of its message for the viewer. He wrote in the Journals: 'I often say that in painting it is peace I am after. Taking the meaning of this for granted, I have never stressed that it is not a mindless peace, an idling peace, but a peace which activates both mind and feeling and this brings life back and work. Such peace gives direction to our dimmer intentions. Thus experiencing experience transforms experience into action. Without that action, we fall into darkness and despair. The peace that numbs everything is a sickness.' [7 Mar. 76] We should, he urges: 'Escape into our talents and die not in the battlefield but in our bed without any great goodbye. "I will weep no more, I will endure" (Lear). As much as I dislike quoting, I could not resist those words because they came to me as if they were my own.' [21 Sep. 90]

Consistent with the stoicism of these words, Josef did indeed die in his bed, peacefully and without any great goodbye. In his last years his life was, by his own wish, increasingly withdrawn, yet this was in no way a time of inactivity. Even when confined to a wheelchair he continued to write and draw. Right into the new millennium, he worked on the Journals and even painted. Decades earlier he had written: 'Complete art demands complete freedom and often even social *inactivity*' [23 Jul. 68] and 'Being alone is my way of being with others.' [19 Mar. 76] Now, 'travels are no longer on my mind. In my ante-room[21] I am everywhere, like the ancient philosopher in his garden.' [20 Jul. 98] 'There are no queues for my work; this does not worry me.[22] I like to work long on a painting and as long as it is with me, I go on. I don't know what it means to "finish" a work. When I sell a painting and no longer

[21] His cabin-like bedroom, from which a steep staircase led down into the large space of his studio.
[22] In 1992 he wrote: 'My recent images estrange me from others. A pity. They are meant to bring us closer. They do not. I can see this from the faces of those who come to the studio and look at them. I cannot do otherwise than follow my own ways.' [28 Dec. 1991] He also reflected late in life: 'maybe my works have become too elemental without any compromise to the sensual and "beautiful". As far as my feelings are concerned, they are not elemental enough.' [Jotters] Both observations confirm Josef's equanimity at the degree of his independence in these years.

have access to it then it can be said that it is finished. As long as it is with me, I can go on and on.' [4 Dec. 93][23]

The theme of continuity is at the centre of Josef's art and of his writing. He imbues the perception of an instant, in all its immediacy, with a sense of permanence. His pictures have the vividness of snapshots, yet they are also a type of emblem. As he put it: 'I always desired the timeless moment, when life stands still and is endless and this endlessness I tried to paint'.[24] Each of Josef's paintings and drawings is an affirmation. The same is true of the writing of his Journals. These were things he felt he *had* to do, yet each of his acts of creation has a quality of generosity. Like the viewer of any of his pictures, the reader of his Journals comes away with the feeling that life has been enhanced.

<div style="text-align: right;">Richard Morphet</div>

[23] Once when a painting sold many years before was sent to him for restoration by a foreign museum, he substantially repainted it, unasked.

[24] *Related Twilights* 1975, p. 51.

Preface

The Journals begin. It is 1948. Their third summer in the village, Josef and his wife Catriona, have just moved into an abandoned "Pop" Factory half way down that cul-de-sac on the right. The Roberts brothers, after unearthing a treasure trove of empty bottles, have converted those derelict legacies of industry into two studios: a home. They called it "Catria": address 38, Rhestr Fawr, Ystradgynlais, in the Swansea Valley.

Faced by a row of miners' cottages, two-up, two-down, renamed "The Studio", it stands alone in a tangle of dark trees left to dreams of long ago behind two tall wooden gates. The paint is peeling but suggests ultramarine blue.[1] Access to the inconspicuous front door is further concealed by a white hydrangea. It reaches taller than the door itself – as if to deny access should curious eyes seek to intrude on privacy of the past. Yet the legend of "Joe Bach" lives on in keeping of new generations while others still share their memories in an extraordinary number of pubs. If he was rooted anywhere, was it not, by his own admission, here in Wales?

Years pass. "At one time when I thought I was going to die I destroyed all my Journals. I did not die and regretted their loss. It left an emptiness." But when Josef did die, a few weeks after his eighty-ninth birthday, one by one, five volumes as well as a collection of "jotters"[2] came to light, survivors, buried under memorabilia hoarded over half a century. The Journals run from less than halfway through his eleven years in Wales to cover the subsequent fifty-two years until just under three weeks before his death.

The years in Wales, so crucial for the development of the artist who had arrived at a time of creative crisis were, against all expectations and intentions, to end. Following the stillbirth of their baby, the breakdown in Catriona's health and his own, adversely affected by the damp climate of the valley, he pulled up his roots yet again, travelling for some months in search of the sun and returned to rent a studio in Swiss Cottage, London. It was there that we met on a cold morning in February 1955.

Following the birth of our son in 1957, Josef bought the somewhat derelict

[1] His favourite colour since early childhood.

[2] In the last ten years of his life Josef kept "jotters" as a discipline in brevity, in separate notepads at his bedside. He was attracted to this form by his love of the Zen poets.

Victorian studio house in Edith Road, West Kensington. It was all he could afford and the studio, a lofty rear extension, was superb. Despite an interlude in rural Suffolk,[3] it remained Josef's sanctuary and our home. There he would die in the little room which overlooked the studio.

He saw the Journals as a journey of self-awareness, a record of work and ideas in progress: talent as the only, if unearned, privilege. Its nurture was his faith which he regarded as the singular responsibility to justify human existence, a relentless drive in the artist which left the man with a secondary aptitude for the role the era was laying down with much sound and fury. Yet with how much love he writes of "our little family", even more in his seventies when grandchildren came along – a miracle of survival against such odds.

Travels over forty-five years receive little attention. Dubrovnik, Crete, Portugal, Mexico, Egypt and New Mexico are almost unrecorded. Only the Villa Maria in the bay of San Stefano, Corfu, and the seaside of Tunisia secured a place in his imagination. Mere sentences cover Egypt where he sat for hours on our hotel balcony entranced by the changing light on the Pyramid of Giza, his long cherished objective for the journey while entries on a month's stay in New Mexico are mainly confined in word and image to the shape of the conical[4] Indian women in the square of Taos. Travels tended to be a source of conflict since they disrupted the essential continuity of work in the studio.

The chronology can prove confusing where, without a word of warning, the insertion of a distant past obliterates any here and now: Warsaw, a childhood hurt in time of hunger "when I cried and mother cried"; and later the tender evocation of a young man's love affair with Maria. By volume five the gaps widen further, continuity grows increasingly diffuse, the handwriting in various tints of blue, difficult to decipher. Here and there we encounter warnings. His legs are growing weaker. He can no longer stand for hours in front of the easel. He writes it down and accepts as life declines towards its end.

But if foreboding and thoughts of death creep in, the long day's work continues. There may be more intervals for rest in the famous, much photographed, leather armchair, his companion for fifty years, but there is no let-up in life's grounding: a fervent dedication to the artisan's mission and routine. "In the outlying district of long labour, I love the diligent worker who cherishes the material he fashions lovingly."[5]

An overview of the total labour emphasises a growing wish, an urgent need for solitude ever more to the fore with a passionate dislike of exhibitions and dealing until in the seventies, he would refer to "that slum – the art industry". While Roland Browse and Delbanco out of loyalty did not increase the gallery's takings from 30% to

[3] 1963–73. [4] The shape of their dress. [5] Georges Rouault (1871–1958).

50%, once they retired other London galleries[6] closed ranks on 50%. Once the taxman took a further 40% Josef's livelihood, like that of other successful artists, depended entirely on clients who bought from the studio. This "sideline" continued to the end of his life in a modest way but the fear of poverty, that dark cloud over his childhood, never left him.

Together with this anxiety, the extermination of his family marked his fundamentally joyful life-affirming nature with a deep undercurrent of despair and depression. He suffered from nightmares, panic attacks and a dread of pending madness and dissolution. This torment he kept heroically to himself and the extent of it came to me as a grievous shock as I typed the Journals. Josef was a profoundly private man and probing from journalists and friends was shrugged off with, "I hate self-pity."

Coming from a background in which feelings would not have been discussed or shared, the urgency for a route to express them, to be utterly scrupulously true to those "deeps",[7] to eliminate all that was facile, decorative, sensational and "modern", ruled over every brushstroke, every line, in the long disciplined hours of his daily work where everything, including paintings which failed to meet with his aspirations, was destroyed.

Work was a continuum of satisfactions and frustrations, self-doubt to the point of despair, with quiet interludes of belief in achievement, noted purely as a private milestone, all taking precedence over the relatively disposable life of the man.

If onlookers were not, the reader is aware of how Josef grew to live almost exclusively for a retreat into his inner world, the gateway to manifestations of mystical experience. In the Journals he is adamant that mysticism is not the prerogative of any religious order or underpinned by esoteric disciplines but an assertion of the deepest levels of the "unconscious"[8] shared by the artist, composer and poet in steadfast dedicated watchfulness. Feeling so profoundly at home among miners and fishermen, he surely sensed that men who labour in the bowels of the earth, as those who face the mighty sea, belong to that same fraternity.

The reader is left in no doubt how deeply Josef loved his children, drew courage from the gift of a family, if always in dread of further loss, and came to value marriage with an old man's declaration of enduring love.

It was not in his nature to record personal suffering. In December 1998 he fell in the street, near home, and broke his right shoulder. There were no complaints that easel painting was relegated to the past while drawing, Journal entries and notes in his

[6] With the exception of the New Grafton Gallery.
[7] This term is in no dictionary but was used by Blake in his poem "The Tyger".
[8] He did not use this in the Freudian sense.

bedside jotters continued regardless once the arm came out of a sling and the physiotherapist had done her job.

In June of 1999, a further fall in the kitchen resulted in a broken hip. A long anaesthetic, difficulties in resuscitation meant a week in intensive care, a long stay in hospital, none of which could be faulted! No word of complaint.

Late summer saw Josef back at home but reluctant to resume walking. Once life was restricted to a wheelchair, a sketchbook on his lap and jotters to hand, he assured us that he was working. If the output on paper was intermittent but real "Herman" for all that, who could doubt that his waking hours by day as by night were filled with projects even if they would no longer be realised.

Until the middle of January of the new millennium Josef remained alert and in good humour. Christmas and his 89th birthday on the 3rd of January were still joyful family celebrations in which he participated. Finally came a time when he was no longer among us but showed no signs of discomfort, nursed day and night by a team of devoted carers with our much loved GP[9] paying daily, sometimes twice-daily, visits.

Josef died at three a.m. on the 19th of February so quietly, in his sleep, that only when the nightnurse looked up from her reading could she see that he would not wake up to know another day.

The memorial service at St James Church in Piccadilly began and ended unforget-tably with Welsh singing. The Gynlais Choir, forty strong, had travelled up from Josef's home in Ystradgynlais in the Swansea Valley.

If the Journals can be seen to take their place in the lineage the academic inclination refers to as "the history of art", intuited in another dimension, they emerge as a timeless manifestation of the human spirit as it survives heroically among the misapprehensions and bombed sites of our era.

<div align="right">

Nini Herman
2002

</div>

[9] Dr Paula Fernandes.

Presentation and sequence

It was within a few weeks of Josef's death that I set about typing his Journals. It was very simply that I needed to share him with a wider world, to hear his voice: consolation and a labour of love. Not until work had reached proof stage, nearly three years on, did my publishers refer to me as editor. My own writing I had always gratefully handed over to a professional. This belated notion of a new role, the sense of responsibility, filled me with anxiety. Had I done this marathon – eight hundred and twenty typed pages – justice?

The Journals found in different parts of the studio, all hand-written in various shades of ink, came in all shapes from almost pocket-sized to large ring-binders whose loose contents were clearly notebooks taken out of their original soft covers. Between them they ran from 1948 to 1950, midway through his eleven years in Ystradgynlais, "his" beloved Welsh mining village in the Swansea valley, then on through half a century to mid-January 2000, a very few weeks before he died.

There were six Journals in all. But as the first two were a unit in place and time we regarded them as volume one.

The second touched on our ten-year sojourn in Suffolk,[1] while the third, fourth and fifth all belonged to London, long years in our terraced Victorian house in West Kensington with Josef's beloved studio, as a lofty rear extension.

Once I set out the respective dates that each covered, the extent of daunting gaps came as a revelation but no surprise as we read: "At one time when I thought that I was going to die I destroyed all my journals and later regretted their loss . . . it left an emptiness."

Whether this destruction already predated 1948 we cannot know. We also read that he did not see himself as writing for posterity but would not mind if this were to happen.

Josef was a prolific writer and in a second language he had only begun to master at the age of thirty.[2] Apart from the Journals he had been Art Editor for *The Jewish Quarterly* over many years of Sonntag's[3] lifetime and contributor to a variety of publications which included the *London Magazine*. In these his wide reading and interest in the world

[1] 1963–1973, while Edith Road remained our essential London base.
[2] He arrived in England in the summer of 1941 without a word of English.
[3] Jacob Sonntag, co-founder and editor of *The Jewish Quarterly*.

of ideas found erudite expression. An altogether third category, mainly pure medi-
tation, reflected his passion for the Zen poets. Often one- or two-line entries in his
"jotters", they had evolved over the last ten years or so of his life. There are, at a guess,
thirty or forty of these, a large number of which had always had to be moved to make
room on his bed.

One can almost envisage these three distrinct modes of writing as reflecting three
different expositions of himself to the world. For if we return to the Journals it could, I
think, be true to say that his entries there are of a special order, almost as if here he was
talking to himself, an essentially private meditation which pausing perhaps briefly,
almost accidentally, over outer events of the day flowed on as a soliloquy which
focused predominantly on work in progress or conceptions hovering, dreamlike in the
studio air.

Here, the companions of his inner world whom we meet again and again are a small
number of artists, kindred spirits of the past. When his great love of the late Turners
"brought tears to my eyes", using his name for "The Turner Prize", surely added to
his darker misgivings. But polemics were resolutely not what drew him to put pen to
paper where the Journals are concerned. If we return to the question of editing I can
see that I omitted repetition, incomprehensible and extraneous asides; that I did not
struggle with what was clearly illegible nor delve into sentences or paragraphs, on
occasion whole pages, that he had crossed out. There were also, inevitably, tracts that
seemed tedious and rambling. "Ninsky, not to worry,"[4] helped to keep me relatively
grounded over the years. In any event, the originals will meanwhile remain with the
family to facilitate access for any interested party until the archives are deposited in the
Tate.

It still has to be said that it would not have been my intention to omit any marital
contretemps. But it was never in his nature to dwell on such, even by the next day, let
alone to record them. It would simply have been another irrelevance, a distraction
from an essential fidelity to imaginative perambulations and heart-searching into work
in progress, be it drawings and ink washes, watercolours, gouache, mixed media or
oil. These drove the heartbeat of his life. All else was disposable.

This said we find recurring references, often deeply touching, to our children, the
survivor's anchor-sheet in a tragic century, as to our love for one another. Any reader
looking for "excitement" in today's promiscuous meaning of the word will be sorely
disappointed.

To travels he grew increasingly averse as to anything that took him away from the
studio as the years ran out. In the last years, once we despaired of airports, Josef dwells

[4] Most of my heart searching he always dismissed as "drivel".

at length and with deep pleasure on our annual summer weeks in Dunwich, on the Suffolk coast where we always rented Church Farm, a few steps from the sea.

Finally a look at the sequence:

Ystradgynlais – May 1948 to September 1950 together with October to December 1950.

Suffolk – May 1968 to January 1969.

London – October 1975 to April 1976.

London – December 1983 to December 1991.

The final volume follows on directly to an uncertain date in January 2000 a very few weeks before his death.

Seen in this sequence the intervals must appear daunting. But where we follow a journey increasingly dedicated to inner events, to revelations of the spirit and imagination guided purely by feeling, one is, unbelievably, not aware of them.

<div style="text-align: right">Nini Herman</div>

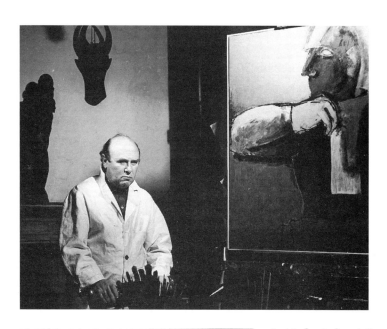

(top) **In front of a painting of a miner, 1958–60**
(left) **In the studio, 1958–60**

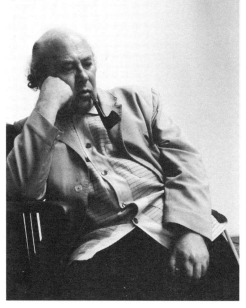

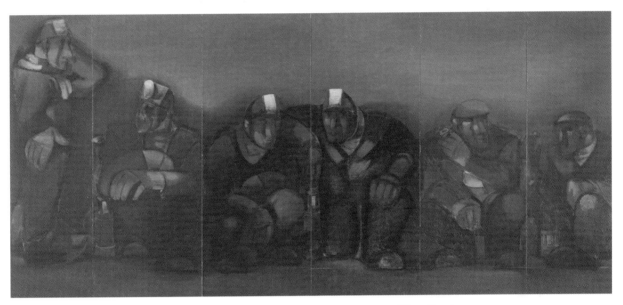

Miners Panels
Oil
each 282 x 103cm
Glynn Vivian Art Gallery
(overleaf) **My Father (The Cobbler)**
Tempera and gouache, 1943
93 x 70.5cm

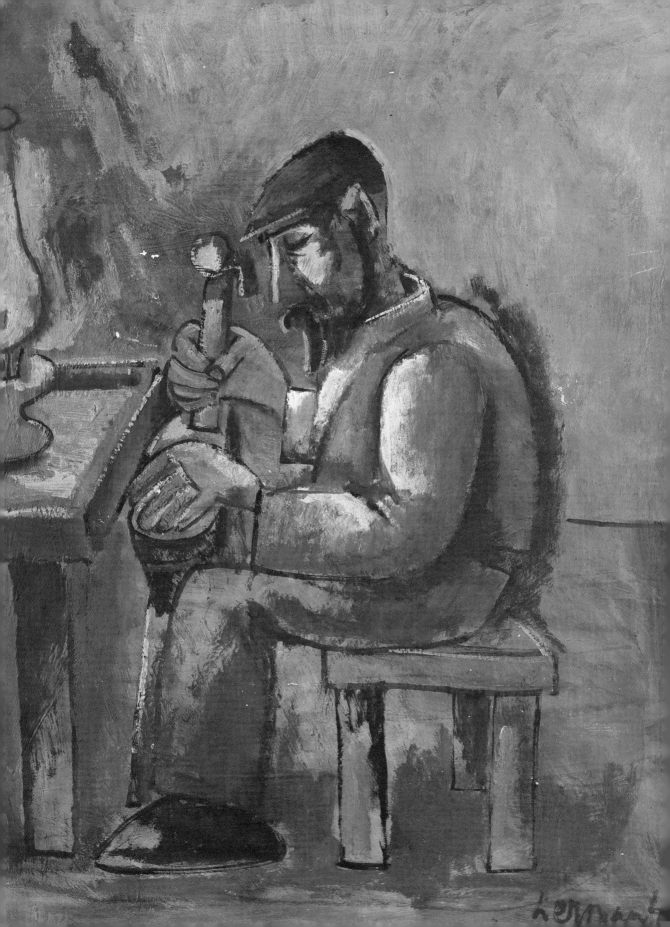

15 May 1948 – Ystradgynlais

While snooping around the bookstall at Neath market I came across a copy of Panait Istrati's[1] *The Bitter Orange Tree*. Wonders never cease! Only last week I talked to Manger[2] about Istrati. In England nobody knows of him. Manger knew him quite well. He said that Istrati died in loneliness, a tragic figure. It was a terrible rumour spread by Stalinists, that Istrati joined the Iron Guard. He also said something that astonished me: Istrati's book about Soviet Russia was a fake! Why should it have been a fake? Istrati at the time was in France and at liberty to disown it. Will we ever get to know the truth about the thirties? When I was young I loved Istrati's writings.

16 May – London

A party at Podro's. Robert Graves was to be there but at the last minute could not make it. Podro wanted him to be there "because this is a historic moment he of all non-Jews would appreciate". It was a birthday party to honour the new baby – the state of Israel.

Adler[3] got himself the voice of a prophet: "We have all learned to believe. For this miracle we have been waiting for two thousand years," etc, etc. Not bad for an anarchist! Koenig was half drunk. One eye of his was completely shut, the other with a heavy pale eyelid that made me think of a snail. He tried to be in his style, calm: "It is better to be a small nation living an earthly existence than to stand on one's toes, talk of heroics and mystical missions. Who in his right mind can envy the 'big nations'? We Jews are tired and need time to regain freshness and youth. We are the youngest old people." Podro was in tears. He came over and kissed me.

21 May

Went to the Zoo. The animals looked so bored that I lost all wish to draw them. I spent most of the time watching the people around the cages. They indeed were interesting to watch. Young women show extraordinary fascination in the pink penises of the baboons and their scenes of lovemaking. [They] hang on so tight to the arms of their men that I am certain something quite pleasant is going through their bodies. One

[1] Panait Istrati (1884–1935), Romanian writer loved by Josef. [2] Itzik Manger (1901–69), Yiddish poet.
[3] Jankel (also Yankel) Adler (1895–1949), artist and close friend from Poland and the Glasgow years.

woman pretended to be embarrassed when the baboons began fucking full steam ahead. She turned her head and pressed it to the chest of her male companion but after a second straightened up, head high, chest out, very bravely and with much courage, she looked on and on. Her face deserved to be recorded!

30 May – Ystradgynlais

Glad to leave London. Too many people! Went with C.[4] to too many doctors. Eventually, with effort, convinced C. that we must go home. One doctor told me that for reasons of her own, C. has now made up her mind to be an invalid. This is not the best of diagnoses but there is some truth in it. Anyway, it is a much better diagnosis than those of other doctors who prescribe rest!

31 May

Resumed today plans for the house.[5] I was very happy at the Pen-y-bont Inn and now am rather sorry to leave. However, leave we must for the Hodges[6] too will leave soon. Of everything about us the Hodges were most puzzled about my habit of getting up in the middle of the night and starting work at unearthly hours.

Ben once said, "If I was rich and had no work to do, nothing would get me out of the bed so early." To many people here, I am a rich man killing time.

1 June

Islwyn[7] is leaving Ystralyfera. Saw him yesterday. After tea we walked along the canal bank. The mountains were thin in this late light. Islwyn was not himself. He grumbled about the "lowering level of 'culture' in the valley".

"Why Josef look for yourself." He said with passion, "The valley now discusses Ascot and fashion! Our discussion groups had to pack up."

He got so worked up that he even threatened not to vote Labour in the next election. Not to vote at all! We stopped and looked into the water. We looked into the deep trees. After a longer silence, Islwyn translated for me the legend of the Lady of the Llyn-a-fan. I will miss him. He was likeable, very likeable and his stories gave pleasure.

2 June

Saturday C. and I are leaving for Paris. News from Roland.[8] The last picture the gallery

[4] Catriona, his wife who had suffered a stillborn baby in 1946. [5] The "Pop" factory they were converting.
[6] The owners of the Inn who rented Josef the ballroom for home and studio when he and Catriona arrived in Ystradgynlais.
[7] Local writer.
[8] One of three partners of Roland, Browse and Delbanco Gallery, Josef's dealers in Cork Street for 35 years.

had from my last exhibition has now been sold. Also from this exhibition, my first sale to a public art gallery – thanks to Hendy.[9]

6 June – Paris

Difficulty in getting a taxi: stuck with two suitcases on the kerb. A porter approached us and suggested he carry the suitcases to the hotel. He said, ''Paris is not yet its normal self. Taxis at the moment are a matter of luck. There are too few about.'' On the way he told us that on the day of the liberation he broke a bottle over a German's head.

''A soldier?'' I asked.

''No, no,'' he answered.

''How did you know it was a German?''

''Oh, I could not make a mistake. I can smell a German.''

The streets seemed sad. We paced too quickly to keep up with the porter for any real impression. In the evening we went out for a walk. The Seine was dark and still. The sky was unusually bright with one heavy red cloud. A storm was approaching. People passed the streets with hurried steps. On one of the bridges I saw the first of many plaques I had heard of. ''Here was so and so shot by the Germans. He was a soldier of Liberty.'' And the date. A few dried up roses on the pavement.

7 June

C. needed a change. I wanted to see Pearl – thus this journey to Paris. Now I am rather frightened to keep the appointment with Pearl. She rang last night and we agreed to meet this morning. Pearl was the last to see my parents. She herself, through underground channels and the Resistance, was brought in 1942 to Paris but before she left, she still witnessed the first gas vans and the destruction of the so-called ''smaller ghetto'' where my parents lived. Why did I want details? What do these matter now? Pearl, oh dear Pearl, I want to see you and I am afraid of you!

Pearl lives in the district of Père Lachaise, rue des Amandiers. This slum first looked to me like a drawing by a madman. Uptilted houses, broken shutters hanging on the wall from hinges. Wheelbarrows rattling on the cobblestones, bloodstained butchers stood in the doors of their shops yelling to someone in the distance and despairingly. Children with hungry faces with bread in their little hands. Beddings in the windows, pillows on the balconies. Gramophones blared. It was all terribly vivid and crazed.

The two rooms of Pearl's apartment are just as I expected from a luxurious heart such as hers. Here and there a cluster of postcard-sized reproductions. Van-Goghs above the books of Marx, Lenin, Bakunin, Balzac, Hugo, Gorky, Peretz and Mickiewicz.

[9] Philip Hendy (1900–80), later Sir Philip Hendy, Director of the National Gallery, 1946–67.

Picassos above the table which is one chaos of copy books, open books and newspaper cuttings. Above the bed, the only large reproduction: Daumier's "La Partie des Dames". What a contrast these rooms make to that dirty staircase which stinks of lavatory! Pearl did not change physically – I mean her face did not age. After nine years our greeting was almost Spartan, hugging each other, kissing and "good to see you alive!" While writing all this down, I am still bewildered by this instinctive self-control. I was afraid of tears – hers and my own. But no, we wanted just to look at each other and to make sure that our bodies are real, that our voices are real.

Pearl was in command of the situation. "Let's sit down." I sat down on the bed, and Pearl on the floor, and a bowl of cherries between us. It was just like our young days in Warsaw. Pearl was also in command of the conversation. I waited with my questions. And this is Pearl's story. This war had changed her plans. She gave up the studies of medicine but succeeded in taking a degree in modern history under an assumed, very French, name. She is now married and has a son of four. She met her husband in the Resistance where both were couriers.

It seems that the French Resistance was better organised than I thought. She was sent to several concentration camps to organise resistance groups and left the camps once her job was done. Men in service of Vichy got her out of Poland in 1942. One of her stories showed clearly the paradoxes of war. One day – she was in the early stages of pregnancy – while carrying a suitcase with newly made Molotov cocktails, pistols and home-made hand grenades, she fainted. It was early afternoon, the streets were busy. When she came to she found herself surrounded by a crowd and a Vichy gendarme. The gendarme helped her getting up and insisted on walking her home. He reached for

The Memory of a Pogrom
Watercolour
Glasgow 1942–3

the suitcase. Pearl's first reaction was to say that it was not hers, then it flashed through her mind that could be worse. She said nothing. The gendarme held her arm and carried the suitcase for her. He waited with her at the bus stop and asked her whether these are children's clothing for the baby to be born? and lifted high into the air the suitcase. She said "no" but she had done some shopping for herself. This ended his curiosity. When the bus arrived, he ordered all others to wait and he went in with her, made somebody give their seat up for her, told the conductor that Madame had fainted but feels better now, winked at the conductor, the conductor smiled and said that he understands, he will look after Madame. The gendarme kissed her hand, told her to do what the doctor says and went.

Then she asked me whether I feel strong enough to hear what concerned me. And she told me in detail what she and the Poles, with whom she had been living, saw from a neighbouring street of the "liquidation of the smaller ghetto". The "liquidation" began at 10 o'clock in the morning when the first gas vans arrived and lasted until 9 in the evening. There were only German soldiers and Gestapo men and a small number of Polish policemen to carry out the murder. The first few hours, Jewish families and my family[10] midst them, went freely into the vans helping each other, but by lunchtime, each Jew had to be dragged in and there was a lot of shooting and fires in some windows. The worst for me was over. I was numbed and slept the whole afternoon at Pearl's.

10 June

The last few days I was ill . . . but I feel better now. C. looked after me with immense understanding. I must not think any more . . . I must . . . I must . . . Pearl comes to the hotel every day. But we talk about Paris.

12 June – The Louvre

Caravaggio's "Mort de la Vierge". In the afternoon the Jeu de Paume. The wall with photographs impressed me most. What beautiful heads, old Pissaro, old Monet, old Degas, nearly blind. I have no heart for impressionist painting. In the evening – supper at Pearl's. Met her husband and a few friends, journalists from Humanité, all members of the French Communist Party. The conversation was disturbing. All seemed to be living in a world of political abstractions.

13 June – Charpentier[11]

A retrospective of Segonzac.[12] He is I dare say a good draughtsman but this elegance! Too many French painters are too close to the fashion magazine. To contrast this

[10] Parents, brother, sister and all neighbours. [11] A well-known commercial gallery in Paris.
[12] André Dunoyer de Segonzac (1884–1974).

whole exhibition with one nude by Degas or Rouault!

Did some drawings around the Seine. Paris is attractive but its heart is weak. I prefer London, sombre London but grand! Altogether I became attached to England and the English, to Scotland and the Scots. I cannot think of living anywhere else but in Wales, midst the Welsh people to whom, more than anybody else, I have lost my heart.

14 June

The Museum of Modern Art. I was never what one calls an admirer of the "French Genius" in art. I prefer the Italians, the Flemish and the Dutch. It is not a problem of France not having great painters. But have they really reached the immensity of the Italians? In every epoch French art seems to belittle itself by "good taste". They need a tight theoretical package. It is all very reasonable, clear, easy to translate into aesthetics. The nineteenth century is theirs and much of the twentieth but even with this France cannot claim the highest. My own feeling is that Paris has gone through an incredible change. It has no longer the air of the "centre" of Art. It is not a literary "centre" either. The cost of living is very high, the wages very low. Smaller businesses are closing down. Everywhere in the windows are placards with large red letters "à louer" or "à vendre". A worker, with whom I talked in a café, told me that all his family, three daughters and two sons, himself and his wife all go out to work just for food and a roof over their heads. What next?

15 June – "L'Atelier du Maître"

Everywhere I turned I felt the presence of Delacroix. Delacroix at home. Delacroix at work in the studio. Delacroix reading in his garden. Delacroix writing his journal late at night by candlelight. Delacroix and his intimate world. It was a world of solitude, thought, labour and books. Those of his world were with him at elbow's reach. Bonington, Constable, Lawrence, Shakespeare and Byron. I followed him in the morning when he walked down those stairs, slowly, carrying in his heart perhaps a feeling of apathy. His passions grew with the hours of work. I made myself invisible for him for I detected that he was now ready to forget the outside world, then to reinhabit it and even glorify in it. His creative fever found the necessary artistic eloquence. The brush now moved with uncontrolled rapidity from one colour to another. His well-organised palette became rich and confused. Then I noticed how fatigue set in and his hand became hesitant. It was getting dark, a day's labour came to an end. A new bitterness set into his mind. The emotions cooled off. Sour in himself and with himself he looked disappointed at his work. Now a tired man, he dragged himself up the same staircase. I followed him and saw him decorating himself in front of the circular mirror. Now he was ready to go out for dinner and conversation. There

are things in his work that are disturbing to me. Once again the French chase after ''charme''. Yet he draws and paints brilliantly.

16 June – The Gustave Moreau Museum

Because of Rouault I feel affectionately towards Moreau. We can learn from others what is already ours. In Rouault, certain of Moreau's strivings found the right scale and it is from Moreau that Rouault learned to cherish his own endeavours – more so than from his apprenticeship in the workshop of stained glass. Many of the great achievements of Roualt are in a small way present in the works of Moreau. The use of the palette knife, the Prussian blues and bleached green; even the restless effects of a scraped palette can be seen in Moreau. He has nothing of Roualt's primitive strength. His was a timid, over-civilised imagination – Rouault's of immediate inspiration. The concierge said that Rouault had not been there since he stopped administering the museum well over twenty years ''déjà''. As a point of fact, nobody comes to this museum for days on end except for an occasional tourist or a historian. The floor creaks. When I walked to the door the concierge shouted after me: ''Already? Have you seen everything? Il y a tant de choses. Have you seen the portrait of the 'Maître' by the painter Degas?''

It is a long time since I read Delacroix's journal. Bought today a new edition and am reading it with a new heart. Spent an hour or so at the Dôme where I had to meet Mané Katz[13] There too I met some [other] Jewish painters. Kremegne[14] seems to be made of the real stuff! With whomever I talked, all felt strongly about the few French painters who in one way or another worked with the Nazis. Particularly strong were their feelings against Vlamink, Derain and Segonzac. Those three painters were suspended for one year from exhibitions.

17 June – The Louvre again

Egyptian sculpture has a greater appeal to me than Greek. The fifth Dynasty has a stability that only the greatest works have. It is a masterpiece of expressionistic completeness. A completeness that we feel in the presence of a mountain. The Greeks introduced movement and with this halted the moment. The most ideal of their works is not as still as this extraordinary scribe. In many ways Egyptian sculpture worked too toward an ideal but from the stone they merely expected a sense of the ideal, not a representation.

Caravaggio's ''La Mort de la Vierge'' is an epic peasant scene. He never forgets the weight of the body. The outline is from a hand like in sculpture. No stress on physical

[13] Ohel Mané-Katz (1894–1962), Jewish Expressionist painter. [14] Pinchus Kremegne (1890–1981).

beauty but on more earnestness. An artist of my very heart! He worked with large masses.

18 June

Elegance and prettiness – French art is full of it. In drawing they are after caligraphic niceties. Form cannot do without boundaries. The outline is important. Cézanne could do a lot with an accent. Still, drawing is line.

The art of the past was less hurried than ours of today. At least it seems so. I wonder whether our art has a hard and endurable centre?! Who are the artists who synthesise our most serious ends? To walk around the commercial galleries one loses heart.

20 June

Paris and the whole of France in a one hour General Strike. How a city can change its complexion in one hour! This act of solidarity with the workers of Clermont.

22 June

In the afternoon I went to see an exhibition of Redon's paintings and graphic works. In the works of Redon and Klee one can recognise the abstract tremors of the spirit out of which all religions have been made. These strange regions of our longing cannot be discarded because we have a bone to pick with theologians and priests.

It is a long time since I have seen a funeral at which people cried loud. I sat on a bench brooding over some memories. I remembered how as a child I shouted at my ageing grandmother, "don't die, don't go away, not even to heaven." Then I remembered how I asked my mother whether heaven is very far away. How I was afraid of the coming of the night, for I was certain we do not die in the daytime, only at night. My grandmother died in broad daylight. I was terror stricken. Every funeral brings back to me that first terror.

23 June

The days are passing beautifully and I am very much at peace with myself.

24 June

Getting a cold. Stayed in bed for most of the morning. Read Gaugin's *Intimate Journals*. He can be irritating. Self-concerned, self-important and not free of cheap mannerisms. Some of the stories he sees fit to print would have been more suited to the gutter press. Nor do I care for his cynicism of a sympathetic kind. Then I read his praises of Degas and this grand phrase, "the tenderness of intelligent hearts is not easily seen". He had however, a good mind and a nose for what matters in art. He sang hosanna to sensual,

decorative and primitive living but in all honesty he knew that he stood alone, waiting to be bewildered by an awakening of his poetic sense. Sometimes he was not disappointed. After all that is said about him, I think he had a true feeling for what is noble in man.

25 June – Petit Palais
It is impossible not to feel the drastic change of moral atmosphere when entering the rooms of nineteenth-century paintings. How often we forget that it was the new subject matter that first sent Apollo packing. Poussin: I have a strange feeling that he knew more about landscape than about the human figure.

26 June
Leaves of Grass by Walt Whitman. It is indeed a great design. When reading, I thought of Turner and the echoes in Beethoven's 9th symphony.

28 June – London
C. went to Ystrad. I stayed on. Her health has improved on this holiday. It is already three years since the loss of the baby and the after-effects are still lingering on. I am afraid that the complications are of a psychological kind and not only physical. However, this morning on the phone she seemed very cheerful.

By chance met that fellow Potts.[15] I always meet him by chance and always find him in a state of agitation. He talked a lot about his love for Silone.[16] I dread to think what a meeting with the real Silone would be like.

29 June
With Koenig and Podro. They discussed the Jewish Cultural Congress to be held in Paris. Koenig will attend the Congress. Manger was his better self. No one can sing a Yiddish folk song as well as him and no one can equal him in telling a folk story. In the morning I met Stencl.[17] We went to the Tate. Going into the room "French Contemporaries" Stencl took off his hat, lowered his head and murmured, "Respect for the Masters." Then he caught my arm, "Let's stay here for a long time. Let's not hurry."

[15] Paul Potts. Writer and author of *Dante Called You Beatrice*. Josef painted a splendid portrait of him.
[16] Ignazio Silone (1900–78), Italian novelist and journalist.
[17] Abraham Nahum Stencl (1897–1983), an almost mythological Yiddish-speaking poet. German by birth, he lived in Whitechapel in the East End.

30 June

C. arrived on her way to Scotland. Both parents are ill. I felt miserable when the train left. She can hardly afford the extra emotional strain. I am afraid of the after-results.

4 July – Ystradgynlais

There is not a single painter in England at the moment from whom I would learn a thing. Turner had no precedents and left no successor. English romantic art is a pretty small affair. I always think of Turner as another Rembrandt.

5 July

For the past few years I have been living and working a very slow existence. To discover one's honest feelings and what is permanent to them is a slow business. One thing I have learned since my stay here[18] is when I must lean on my family tree[19] and not bother about others. My personal history of art contains a few, a very few names.

9 July

Since the return from Paris I am continuously haunted by my father's face. Never did I look at him through rose-coloured glasses. At times even thought him comic, with his bowler hat sitting on his ears. The Sabbath best did not suit him. But in his everyday, worn-out clothing, in his leather apron, I often thought him beautiful. The trouble with him was the way he held himself ready to be frightened as though the world had no place for him – only a tight corner. Life was hard on him and he understood little of it. If a soul could be visible, his would have been all bruises. He had no enjoyment in living and no thought as to what had hurt him. Like all men so deeply unhappy, he could be vicious. He had no kind word for anyone nor anything.

Grandmother on my mother's side (I never knew my father's parents), could size up a person with extraordinary accuracy, especially in the heat of a quarrel (and only in a quarrel was she truly inspired)! Once she shouted at him, "You are not of the living, you are not dead but let me say this, you are God's leftover bitterness."

My father shrank to the size of a worm. What went on in him? He did not answer and his eyes shone like a cats'. Sometimes I would awake in the middle of the night and see him lying on his bed with his eyes wide open and a tear running down his cheek. One day he shook his fist in the night and yelled at me that, "I will once again be rich. You will see . . ."[20]

I still wonder after so many years why he had to say this to me! Perhaps it was his way of making a resolution. Whether it was a resolution or not, he uttered those words

[18] In Ystradgynlais. [19] Earlier artists in whose tradition he felt himself to be.
[20] Illiterate, he had been cheated by his partner out of a little shoe business.

at a very unfortunate time. The Czech shoe combine, Bata, opened mechanised factories all over Poland and thousands of Jewish cobblers were thrown out of their existence. They were now to be seen on the streets, a new legion of shy beggars. New vendors of greengroceries or with a wooden little tool box offering their services on the spot. My father got himself such a little box. At bottom he was free of greed. He struggled on, the best way he knew, to survive. His was not a life that enriches life but to kill such a life is gruesome. Who were they, those killers of his, to pass judgement on him? I have also been thinking about my mother. But suddenly I feel as though I have lost my voice.

15 July
Restless days . . . unable to work. Walk, walks, without seeing things around me. It has all to do with sad memories which every so often darken my heart.

20 July
To be of one's own time! What a complicated business. All artists who are over their necks in "art" are certain that they obey the call of our time. Have we measured "our time" in decades, in years, in seasons? Movements which existed for a fortnight, surely these too were of our time. So what? During the war things were simpler. The war it was said had finished all nonsense. Was it all nonsense? I certainly did not think so but, as today so then, I thought of individual artists and cared nothing about "movements". A war situation is a disruption and a destroyer of normal fruition . . . The war finished, all more vital artists went back to where they left off. Artists have once again removed themselves into various aesthetic corners, working out their recipes but not their beliefs. This now means to be of our times.

21 July
Drawing the greater part of the morning. Later I walked in the hills which together with Varteg, gird the village. Some of these hills are steep and their surfaces are pleasantly soft. Cliffs that hang miraculously suspended against the sky. Underneath them are entries into mines or paths into a ravine. All this is deserted now. The rails are rusty and the mines derelict and nobody cares about either. High in a silvery mist the Varteg stands like a monument to endurance and to silence. The drizzle slowly changes into a heavy rain and I had to go back.

27 July
Feeling rather ill. A flu? Yet worked well the whole long day. Now in bed. Think of noting down a few points about drawing:

1. Drawing is not like writing. It is not a process. Nor does it end with the character of the line. Form, in whatever approach, is the aim of drawing. The line can be calm or energetic. It can be continuous or broken up but it works for the integration of all elements that go into the making of form.

2. Form is expression. Line follows active emotion. Form is the emotion.

3. In drawing, more than in painting, technique is indivisible from style. To argue that one can be a good technician and have nothing to say is to give licence to irrelevant activity.

4. Hesitation kills.

5. To make of enthusiasm a habit.

6. Continuance in work is the only path to stylistic coherence.

7. The study of outline. The outline is not the only boundary to form but a means of concentrating line problems like mass, gravity etc. which give meaning to form.

8. Simplicity is nothing else but a sense of concentration resting on essentials alone. Simplicity, in a psychological sense, is a different story.

9. Properties of things are not fixed – they will change according to the expression the form is after.

10. Nature. Should only be approached when one has learned to feel without compromise, only when one has learned to organise one's quest. One should study nature in order to avoid ''naturelike'' art. Just as learning in the museums not to be like others.

11. Our fundamental aims cannot differ from drawing to drawing. Variety in manner can still be repetition in feeling. To deepen one's sense of form does not depend on acquiring yet another trick. Forms should stand out clearly and strongly. Like a trunk of a tree, a rock or a mountain. As a rule, sculptors know more about form than painters, painters put form to their own use. Not only Michelangelo but also Rembrandt and Goya had sculptural elements. Ingres imitated sculptors.

12. At every start I hope that my drawing will be strong in expression – still in form.

28 July

The egoism in me – the person, is far greater than the egoism in me – the artist. My works are purer and more disinterested than my behaviour. What is it that in intercourse with others makes us often put an artificial halo around our heads, either to shock or show ourselves greater beasts than we actually are?

5 August

C. is still in Scotland. Already five weeks! Her mother died. Her father[21] is now dying. Spoke to her this morning on the phone. What I was afraid of I think has already happened. She is back in her depression . . . moods. Talked to her sisters. Like a stone!

8 August

This morning I received a pathetic letter from Paul Potts. I would have liked to ask him to come down but I am certain that it would have been hell! So off goes a cheque – what poor compensation. My God, how I suffer from the inability of handling a human situation.

17 August

I am often tired of living. I am also curious about dying. When my time comes, I wish to die fully conscious of every bit of life departing from me – fully conscious of what is approaching. Death in sleep or in a coma, no not this. I wish to die fully aware. Petrarch once said, "To those who enter, years seem infinite, to those who depart, nothing."

I do not think I will live to a "ripe old age". I think I belong to the children "kissed by death"- as Maeterlinck would have it.

18 August

Longing for Warsaw. For the Warsaw I knew, the streets and the people I knew. But above everything, for the Vistula. That I should have such strong feelings for a river?! At school we were told that the Vistula is more beautiful than all the other rivers. The Vistula became for me an abstract, like a fairy tale. Later, the bonds with the river became more intimate. It became a door to a young man's heart, a republic where I could feel completely free and equal to everything in nature. Working-class children are brought up with the feeling that the world is not theirs. From the banks of the Vistula I looked at the city and felt a rising hope. I loved cherries and sent laughs and greetings to the passing bargees. With a stone of the cherry in my mouth, to lie on the warm sand. A mist rising from the river. Above the mist, bridges – two in steel and one in stone. Above the bridges, silhouettes of trees and above the trees the city, bright and flat like a medieval woodcut. Or at night. To be with others. To sing. To tell stories. Or to swim naked in the moon's light. Our talents were our only possessions and we exchanged them between us freely. None of us ever thought of becoming great, we thought of being free. And of capturing, making it ours, this world!

[21] Catriona's father was anti-Semitic and had refused to meet Josef.

20 August

Still day-dreaming and memorising. My first meeting with Zyg[22] that winter night in 1934. We walked for many hours in the snow. We had met only a couple of hours earlier in a small café of the widow Yadwiga Zillenska in the Wolska suburb. It was a highly dramatic walk during which I diverted Zyg from the desire to commit suicide. With soaked feet we eventually reached his home where Maria, awakened from sleep, made tea. We talked until about 4 in the morning. Maria had to leave at 6.30 a.m. to work. The windows, I thought, would never brighten with daylight. I lay on the table and tried to sleep. In the morning after a big breakfast of bread, cheese and coffee we decided to organise a new group of artists of the left.[23] Our political formulations had to be the common denominator. With men I was closest to, politics had nothing of the hand-to-mouth professionalism. Politics was morality and ethics. The sermon of the soap box was the Sermon on the Mount! As regards artists of the left, their main preoccupation was to oppose the image of "success" and "fame" with our image of the "socially needed artist".

In circumstances unfavourable to living, a new stimulus to make contact with life was sought for. Thus the element most admired in a work of art was the sense of urgency. We felt as if in a permanent siege. We identified with the working-class struggle against the bourgeoisie. We thought, we felt, we lived this class war. In all honesty I hardly know of *any truly inspired painting out of these passions.*

By rare example some of us could demonstrate that an artist is not a man of a coterie but a social being, that art as an alternative to social feeling belittles its own integrity. However, what I understand now and did not understand then, is that artists are men of little choice, that the nature of their talent predestines their path and that artists with a social imagination are nothing better than artists with other kinds of imagination. Soviet art has failed because from all the cooks they expect the same borsch. Artists nust be thought of as individuals and not as class phenomena. True participation in life is marked out by the artist's work and not by his social gestures.

25 August

I can see more clearly now that of the three partners Roland is the man with whom I am most likely to form a closer relationship. Delbanco, although he introduced me to the firm, cannot get his teeth into my work. Perhaps his admiration for Rubens may have something to do with it. As for Miss Browse, I have this far not succeeded in establishing any contact whatsoever.[24] Maybe she is shy rather than unapproachable. At the moment I am very pleased with the way work is going. All my pictures are

[22] A friend in Warsaw. [23] Called "The Phrygian Bonnet" after bonnets worn in the French Revolution.
[24] Lillian Browse of RBD Gallery. This was to change into a warm friendship.

inventions. Did I assimilate the spirit of this mining village or am I giving it a spirit it never had? Either way it does not matter. I love this place and could not live anywhere else.

27 August

My favourite time of the day – twilight. My favourite season – autumn. I feel neutral in broad daylight and restless in the dark of the night. Eventide makes me feel tender towards life. I have no need for "believing" or for "hope". I am not mugged by the "whatever for?" I am greedy for living, merely taking time to *feel* life's big design. The thought of a God who gave us a purpose and an end to prepare for, or of a nature that meant us to be "happy", gets from me no reaction. What makes us splendid, this is what interests me. The mysterious feeling, the imagination and the serenity of the mind's still moments.

28 August

Worked the whole day until dusk. A long day's work. It was purposeful work, not just labouring away. Painting is first of all a way of feeling one's way about. True work consists of vague notions becoming a coherent mood. It is the blind man's hand searching in the dark for something tangible.

5 September

The sun improved the look of the village. Each house was radiant around the edges. The trees had pearl auras like Polish Madonnas. The telegraph poles stood bleak, the light passed them by. Human shadows lay flat and brought to mind a feminine resignation. By midday, the streets lost every shade. The textures were smooth and the sky was like a clean river – flat. At the Y colliery. Drawing on the surface and in the canteen.

6 September

Because I spoke highly of Meunier[25] some critics, P.D. Klingender for one, wrote about my work as though I was a follower of Meunier. I never had a master at whose feet I could sit. This I often regret. Those I call my masters are men to whose work I was drawn by the familiarity of their temperaments and also the quality of their minds. I never cared what they were as men. I admired Meunier and I think I can understand the quality of his genius. I admire Meunier for the same reasons as I admire Millet. They were in the right moral climate. However, I respond with greater fervour to Michelangelo's strength and Rembrandt's warmth.

[25] Constantin Meunier (1831–1905), Belgian painter and sculptor.

15 September

Lola[26] has sent me a fine reproduction of a late self-portrait by Cézanne. Here, there is a great kinship with Rembrandt. When Cézanne was not nervous about his geometrical butterflies, he painted with the most moving simplicity. He saw in the mirror the head of an old man with eyes saddened by age and strife. Even the beret on his head is not the perfect shape but of a soft material, faded, weather-beaten and old. It so much belongs to the old head. Tears came to my eyes. This self-portrait proves once again what the painter brings with him is more essential than what nature has to give him. All great art is a monument to this and to the nobility of human emotion.

16 September

It is already a few years since I have narrowed down my interests and concentrated on the single figure. It was clear to me that multiplying scenes from the miners' lives, or varied aspects of demographical landscapes will get me nowhere. This kind of variety counts for little; what I was out for was a deeper synthesis: to concentrate ideas, to distil all feeling into form. It still seems to me a sad day when painting departed from sculpture and linked up with music. Anyway, I discovered that a single figure can be an immense battlefield. And there I stand.

17 September

The moment I put my foot out of the bed, I knew that today the world is on my side. This in spite of the terrible weather! Darkness and rain and night the whole day. Another time I would have cursed the impossible light. Today I painted happily with little aid from my eyes. I read somewhere that Soutine, in his down-and-out days, painted at night by the glow of the stove. The choice for him was heat or light. He chose heat. One can get to know one's palette so well as to find blindfold each colour. One can get to know one's brushes so well as to feel the right amount of pigment for the admixture to another. After all, in the happy state of what is called inspiration, the eyes could as well not be in the head at all. The hand finds its way ahead without the guidance of the eyes. This is how I worked today.

26 September

Signs of an early winter. Misty mornings and dark skies. I stay with greater eagerness indoors and read. Stendhal: *Red and Black*, Balzac: *Seraphita* and Thomas Hardy. Have recently been steered by a new passion – a love for icon painters. Their styles, their inventions are characterised by an extraordinary vigour – a surprising grandeur in the smallest works, theirs is altogether a model of expressionistic art of all times. Their

[26] Lola Paulsen, a Jungian analyst.

colours are often a triumph of limited schemes. With but basic reference to the phenomenal world, they succeed pretty well in establishing pathos, drama and mortal anguish. The Fauves and the German Expressionists, although they adopted many of the icon painters' decorative contrasts, forgot one thing: what brings illumination to the mind is not necessarily bright colour on the canvas. They were right in following the Iconists' example to paint from inside out. When next in London I must try to get some decent examples.

1 October

I was not at all sorry to part with a lot of the works I did in Glasgow. Took out for burning some pictures and stacks of drawings: a curious delight.

I know exactly how I got on to this Chagallic trick but it has no longer any interest for me. Charm cannot be a substitute for good painting, and Chagall paints poorly and at no stage painted well. He has the right to be what he is. In his naivety there are sparks of greatness. Chagall is to be admired for his art, not for his painting. With me now, painting begins with the itch for handling pigment. The greater the sense for pigments the greater the painting.

3 October

The routine I set out for myself – since the day I moved into Pen-y-bont Inn is far too often at the mercies of my weak will. I let myself too often be interrupted, by every excuse, from work. Then I get restless, moody and sick with myself. I feel only complete and reasonably happy when I lose myself in work. Yesterday tried to drink myself (whisky) into a sort of sleep; all it did was turn my stomach inside out. Nor did the sleeping pills do any good. Today my heart beats like a drum and I can find no place for myself. I found some peace in Wordsworth's *Prelude*. He reminds me of the German Caspar David Friedrich. In our days the word "romantic" is almost a slander. Yet the romantics were the first artists to put before us *mood as an idea*, and, this is also significant, they knew that the mood-idea, is not a mere form-definition but a definition of our passions, of which the outward manifestation is more than one kind. It could be stormy as with Lear, Byron and Delacroix . . . but it can also be reflective and still in clear lines and slow flowing speech . . . as it was with Friedrich and with Wordsworth . . . the romantic temperament is distinguishable by the degree it is an emotional response which colours the intellect – which has too often been interpreted as absence of intellect. The romantic temperament is distinguishable by the degree the mood becomes an idea, reasonable though not reasoned, reflective though not discursive. Art at its deepest is always romantic.

15 October

Monet once said: "What interests me in a dying man is the light on his flesh." Léger said: "For me, the human figure, the human body, have no more importance than keys or bicycles." Objectivity and detachment cannot go further. We need not get hot under the collar because artists assume the pose of the scientist. The "scientific attitude" leaves the artist in no position to voice sympathy for man. Objectivity is not always on the side of man. Yet our choice is out of natural darkness into human light. Man can never, under no circumstances, be viewed as a thing, or as a plaything for light. The artist who is capable of dying with each death and being born with each birth states merely his fundamental humanity. He also states the difference between man and the world of things, between the form the artist brings to nature and forms of nature. I also find it very ambiguous when artists claim that they have eyes for things "behind reality".

16 October

Subjects of cruelty, agonising situations, are negations of man's fundamental serenity. We need serene forms and serene situations. I am driving myself hard to set my work free of all violence. I am departing farther and farther from the spirit of Goya. The landscape I am now working on presented me with a problem of how to express a mood without "spiritualising" nature. All technique is nothing but a clarity of mind. It is all a matter of "unreasoning" one's mind and following the pattern feeling dictates. This is not a way of denying the subject but a way of living with it and through it. Which brings me back to the Monet-Léger problem. They, like the artists of the Renaissance believed that for a sense of reality, investigation into things or nature was indispensable. In such an aim, art rules man and objects are indeed the same kind of springboard.

18 October

Myth is man's imaginative history before he reasoned what history is. Politics, religion, science and drama all went into the fabric of tales of war and social challenge, of cults and heroes. But better than history proper it succeeded in establishing a mood of elemental existence. The mood of myth is inevitably dark.

19 October

It took me a long time to face my own problem. I am a slow worker. So be it. I used to nag myself and be miserable whenever I looked through my year's output. Now I know that things I am after need maternal care and an unhurried state of mind. As the gardener who planted our trees said, "You can't hurry the seasons; the soil and the

roots.'' And puff, puff, puff smoked his pipe. Much too much is today expected from spontaneity.

22 October

My head is heavy with cold. How boring it is to feel slightly ill. To escape boredom I plunged into Gide's journals. I never realised that the economist Charles Gide was André's uncle. One entry intrigued me. He seemed to have told himself that his journals are exercises in fast writing. Yet not from his books neither from his journals, do I feel him writing out of the honesty of his heart.

23 October

The 'flu is worse. I am now in bed. Why do I force myself to reasoning! I am no good at it. My brain, though not empty, is as dim as the earth. It has no definite centre and no definite edges. My notions, my rapid insights, are better. I may have to live out my life with the little I have got and not aspire to do something beyond me or to be somebody I am not equipped to be.

24 October

If I could bring myself to think of art as a place for reliving pleasure, think of colour as a rich, teasing field with its own resources and ends, think of design as a means of entertaining virtuosity, I would have chosen Rubens as my master. As it is I prefer the clumsier Rembrandt. The profounder Rembrandt. The greater Rembrandt. With Rembrandt I feel myself coming out of the shell. Each district of his imagination is an inviting mystery to me and yet eternally familiar. God, how I love that man. Now I want to write something down about Rubens; and in praise of Rubens. He is a great, if not the greatest, oil painter. The radiance and inner luminosity of his oil sketches make by contrast many surfaces of a Monet, Sisley or Picasso seem opaque! How well he could vary the weights of paint! A thin wash of white over brown is grey but only one thick accent, a blob of white pigment, brings the whole grey passage into the family of white. How beautifully he handled each tonal order! Where other painters would have wasted themselves away in working out a pasty gradation, he could do with one accent. So simple and so rich. Rouault once praised Cézanne for doing with an accent what others could hardly achieve with a long line. Economy of means is always a mark of a great hand. If Rubens's pictures and drawings could only stand still! His paint makes my mouth water yet the total picture leaves me in a state of detached observer. I made many attempts to get closer to him. No use. I can only *admire* him. Masaccio, Michelangelo, Rembrandt, Turner, Ryder, Monet, Millet, van Gogh, Rouault, Permeke

– with them my feelings work differently, more intimately and whenever I read harsh judgements on them I feel personally hurt.

25 October

Back on my feet again. Out with my sketchbook but I have hardly opened it. Ponies came down from the hills. They roamed all over the village grazing where there was grass or standing still on the asphalt roads. People were kind to them. Children were around them with carrots. Suddenly one felt that the village was rich in children and carrots! Look out little pony don't go into a private garden! Stand still just as you are and look through the fence. Then an old man will come to the gate and caress your head. The old men talked to the children. All were gay. The ponies cause a sort of happy commotion. They bring life with them, an extra colour to the village. For the greater part of the day they were an event and in the evening in the Miner's Arms or in the Pen-y-bont Inn, people talked about little else than the "descent of the wild ponies".

Pit Pony Under a Tree
Ink and wash
19.8 x 25.1cm

26 October

People here worry little about my presence and my work. I see no reason why it should be different. The working class here, like anywhere else, thinks of painting as a sort of option for the rich. And who can blame them. Yet out of an inner loyalty many of them went to see my exhibition when it was on at Swansea's Glynn Vivian. Some made comments to me of the kind "it is beyond me, of course". Yet at heart it is for their kind that I work. I never consider any success as valuable as when I see in a poor home Millet's "Gleaners" or van Gogh's "Boots", no matter how bad the reproduction

is. People come to my workroom, sit, never as much as look at a canvas on the easel: "Just came in for a chat Joe". Some do not look out of shyness of course, others because all the noise about art has put terror into them, still others because they are genuinely not interested; all their lives they have had more urgent worries. But no one, no one brings with him pretence or that bit of indifferent "taste" which people with money pretend to have. Thus I can look everybody freely in their face. And their eyes are open to me. We talk about things which interest everybody; events, politics, local sports, singing.

9 November

Heavens, how I detest our frames! Because of the class habits of our picture buyers something of the golden calf is expected to be found, if not in the picture, at least round it. The frame of decent poverty and simplicity had to go if you were a struggling painter. Roland told me – without I am sure trying to hurt me – that it is often the frame that sells the picture! Salesmanship needs trickery. The frame, the glossy review, the sharp chit chat, all to glamorise an expression which otherwise could be repellent. And in this morning's letter Roland complains that my pictures are too dark! Apparently, not even a frame showing gold can lighten their darkness or relieve their mood. Have I any answer to this?

14 November

Drawing is the essence of all art. Drawing means to me the integration of form into precise ideas. Every drawing is to some degree hard, for it gives an edge to the image and stops it from swelling into a current. Permanence is always allied to form. Making marks or signs – without forms as the final object is not drawing, not in the European tradition, though the Chinese did very well with these. Rembrandt's terrible little marks, what do they mean? Uncertainty, impatience, nervousness perhaps? But how their significance changes once they become form. The impatience and nervousness is stabilised in a suggestion of peace radiant and absolute. The marks tell us something about the temperament of the person but little about the ideas and the directions of the artist. For this we need the more complete language of form. Delacroix is right, the first thought-scribble has a different quality from a complete drawing.

20 November

Goya and Courbet. During the last war many artists were troubled by such questions as what is the artist as artist to do? The answers were not very happy ones on the whole. War art, like all patriotism, is a gesture not all that sincere. Even after the war a painter like Rouault felt a deep-rooted scepticism when he said tearfully, "What's the use?

When one atom bomb can destroy all that man has ever achieved great and noble.'' (Or something to that effect, I do not recall his exact words.) It is all rooted in the time problem. All social situations nag with their immediacy. Art is the slow rhythm of permanence. Whenever a social situation asked for a savage answer, the shadow of Goya loomed large. But his negation of a historic here, a dreadful here to be sure, was no assertion of a new beginning. His is Hamlet's cry and Werther's despair. Courbet is a different kettle of fish. His is a different kind of social imagination. His art works on a vast theme of synthesising a new direction from the social centre. Courbet's ''Stonebreakers'' and Millet's ''Gleaners'' start off with the moral assertion of a class. Human labour and historical rhythm are the new social centre. It is not an accident that both these pictures have sculptural solidity and similar expansion. This kind of image may not call for so much ''personality'' as Goya's negations. It may not in fact, be related to any immediate issue but what it does is make us aware of a territory from which we can trace back each event to the general direction of the centre – like the sun rays can be traced back to the fiery centre of the sun. In certain conditions we may think that it is enough to go with Goya into the night. After a longer while of thinking we may find that in many ways we all stem from Courbet.

21 November

A letter from Adler. He gives me a lecture about the superiority of Oriental art over European and about the greater art in ''flat painting''. How Oriental we are gradually becoming! First, Japanese, then Chinoiserie, now Oriental. What puzzles me about the Oriental mind is its divided attitudes to painting and sculpture. Their painting is flat but their sculpture is massive. With the exception of racial and stylistic characteristics, their sculpture is very much European. They did admirably well with their flat planes, rhythmical lines and decorative ends in painting but I cannot see what can be deduced from this. Japanese art bores me to tears. I prefer the Chinese and of this their more archaic types of art. I must confess though that on the whole I like Chinese and Indian sculpture better than what is called ''Oriental painting''. The tendency, if my observation is not too hasty, is that European art is gradually going towards sign making, towards the mystery of brushstroke for its own sake. It all has to do with misconceptions about the element of spontaneity in art. We tend to forget the variety of Oriental methods and that some of their trends could be as stiff and cold, with a tendency towards elegance rather than expression, as anything in European art. Besides, is Oriental flat painting really superior to Gothic or Romanesque flat painting? The flight to the Orient has more to do with so called ''Romantic'' liking than with clear understanding. There is nothing wrong with it as long as it is not pushed down

our throats as a final truth, as this terrible painter Sérusier[27] tried to do with his "theories of symbols". Recently, Adler's letters tend to upset me. Yet his Yiddish is so beautiful that I wish he would have some more sense in his head and less of the rabbinistic way of nagging. For an anarchist he likes too much the closed-in circle.

22 November

I cannot hate for more than a bare few minutes. This makes me muddled. Others hold on to their hatreds longer and are therefore more consistent. I already regret the letter I posted to Jankel. I am more coherent in building up my more positive beliefs. This morning I recalled very vividly the few works I have seen in Paris by Georges de la Tour. This put me in a very sane and contemplative mood. I know nothing about him but from the few works I took away a family likeness. What is his subject? A lighted candle and a human figure. With this he attained the highest in art as only the greatest artists ever attained. Historians put him into the like of the Caravaggists but he is different. The Caravaggists integrated light into plasticity. With them, light is a dramatic happening. With him, it is mystery and silence. I think of his "Nativity" of the two women and the child and that magnificent hand above the candle which is also the frontier between the large shapes of light and the large spheres of dark. With this picture and the "Education of the Virgin" he stands alone. Though with one or two other pictures he falls into the line of Caravaggio.

26 November

Good drawing must have some hardness to it. Soft drawings are unbearable. This is also true for colour but with colour one has to avoid the metallic quality. In either case it is a matter of a sense for texture. The hardness in drawing is a guarantee that the scaffolding is trustworthy.

27 November

Whenever I read Yiddish, a letter from a friend or a book, the world suddenly goes dark. Even our wit is sombre. With Jews, a full burst of laughter is like a wail: it hangs over an inner sadness.

29 November

Delacroix wrote in his journal, "We will discover one day that Rembrandt is a greater painter than Raphael." This he wrote in 1851. Today there will be few who doubt it. By greater painter is meant greater man, man with a greater understanding of humanity. Raphael, like many a great offspring of the Renaissance, was fascinated by

[27] Paul Sérusier (1865–1927), French painter and theorist.

the human figure. Rembrandt, by the human being. Form and colour became subsidiary to insight. This is today all very clear as it is also very clear that it is this that added a new dimension to humanism. In Rembrandt's day, to be a humanist meant a respect for Italy. This Rembrandt had as well as an interest in Raphael. But as Hoogstraten[28] reports, in Rembrandt's workshop direct *experience* of reality was given a greater significance than the copying of antiques. With Rembrandt, one feels that painting man meant for him more than a single human existence. At the centre of his experience was his own moral nature. He seldom painted anything else.

30 November

Must compose more often from memory and set the imagination free. In the last few months too much documentation found its way into my work and thus hampered my dreams. I am finding myself disliking so-called "realism" both in spirit and in method. What is all this realism without Courbet's energy, Millet's tenderness or Caravaggio's sense of drama?

1 December

My life here has taken on a pattern all its own. I am usually up around five. At times even earlier. It takes quite a while until I hear the first sounds of hobnailed boots under my window. Still by electric light, I drink a cup of coffee and sit down to draw round ideas, vague notes for composition or drawing from yesterday's jottings. This for about two to three hours. Not until after breakfast do I begin painting. A break for lunch and back to work. And so on. I find this routine very helpful.

4 December

What interests me is what people do and why they do it, not what people are. "A nice fellow" means nothing to me. Character takes care of itself. The cult of personality has more facets than one and all of them spell some sort of danger.

5 December

In himself the worker is just another human being working and living the best he knows how. In art, since the nineteenth century, he was shaped into a symbol of the pathos that underlines our very destiny. With him, the social order replaced the divine order thus making us aware of what is permanent in the human condition. If Marx had contributed nothing else but the consciousness of the human potential of the working class, this alone would have sufficed to make of him a great thinker.

[28] Samuel van Hoogstraten (1627–78), pupil of Rembrandt and author of a treatise (1678) in which he analysed the theory and practice of Rembrandt's art.

6 December

I seldom these days think of Poland. I have no desire to go back there. When I do think of Poland it is with a bitter taste in my mouth. The Catholic centuries account for most of Poland's provinciality and cruelty. I never felt at home there. In this mining village I feel more at home. Received the other day a letter from Jankel. He tells me that freedom does not depend on social conditions, that even in prison a man can feel free! This is a typical Adlerian mix-up of the various facets of freedom. For him, political and economic oppression means nothing. He is too one sided, "Only intellectual freedom matters!" Well, well . . .

8 December

There is no denying the inherent power in modern art but why is it, as it so often is, that after the first excitement is over we are left with terrifying emptiness. Perhaps all energies are concentrated on too little. Making marks is the beginning of drawing but not its end. Spontaneity is the sure sign of inspiration; everybody now works madly fast. Invention, no matter how slight, came to mean everything. Originality is no longer a pointer to a destination, a quality of mind, it is a texture, a twist in design. Perhaps I am just tired of the things I have seen when up in London.

9 December

Tragedy implying certain defeat, collapse, terrible end. These are the basic anxieties in the Greek tragedies. Tragedy did not enter their sculpture. Catastrophe belongs to the dawn of our origin, but beauty belongs to the years of living. Apollo is an inspiration. He gave courage and eliminated fear. In the Laocoon group, the tragic is synonymous with struggle. He affirmed the goodness of living. He may have exaggerated. Today, he is a stranger. The heroic has assimilated the tragic. We are defeated in death, not in our labours. Hence the significance of the worker as a new symbol.

A good day's work. Feel very contented. A word about tonal painting. Colour by the tube is hard. By contrasting colours we merely enhance their decorative qualities. This does not matter in pictures in which mood is not a primary concern. In the past tonal painting was a device for modelling and a way of getting a smooth surface. Today, tonal painting can still be practised if the modern end is in view – that is to say if its aim is expression through gradation. Thus the main thing about tone is not how it merges with the neighbouring tones but its supporting power. Only in this way can tone painting be vital. Ah, the finished look! This truly is the devil of it all! But need we throw out the baby with the bathwater? Now a word about drawing. The "cognoscenti" mannerism wants it that analysis of drawing begins with putting a magnifying glass over the line. The incision, the pressure, is the character. Drawing is not like writing.

The line becomes what it is through a searching and laborious process, not through automatic don't know how. The line becomes what it is through the search for form and expression. The story we have been told a hundred times and more about the Greek who left a line on the door so that his absent friend would know who had been to visit, is a good story but torn out of the context of what must have been a very laborious life. Even with character, line by itself does not make for drawing. Drawing is forming, finding an enclosed mass. We must not use so easily the word simplicity. No drawing is so complex as the simple one. Is it so easy to get to know essentials and make a drawing based on essentials alone?

11 December – London

There is so much I have to explain to myself that I should be chained to this diary. To sort things out, one has to find the right tensions in the phrases set against each other. Differently said, one has to be a writer. Perhaps I could have become one if I would give it more time and would make an effort to master the language.

Sometimes when I am lost in the search for the right colour, I consult my black and white drawings. The suggestions of colour are there.

The recent few days in London exhausted me and this is the cause of my mental restlessness. At the Gallery they seemed to have liked my latest pictures. Roland was surprised when I told him that he can make up the titles for my pictures himself. I explained to him that as far as I am concerned pictures are not closed entities in themselves but fragments of a greater purpose. I immediately caught myself and knew that I was overstating my case and must have sounded a bit pompous. To hell! How difficult it is to explain the simplest attitude if one has not thought of it before. The truth is that when my pictures were more literary, like from 1940–43,[29] I had no difficulty with titles. Today, I find it difficult to give a title to a picture of three miners or a single figure. Roland gave me a lecture on the importance of the ''masterpiece'' and that a masterpiece is a single picture. To this I replied – still on uncertain ground – that the only true masterpiece is the nature of one's talent. I must give this some more thought.

18 January 1949

There is much talk now about freedom. It is cynical that it should be bound up with the Cold War. Broadcasters, journalists and of course professors, have become lyrical on the subject of freedom – they even quote from poetry! I don't know what the other side is saying. Are they also lyrical? Do they also quote from poetry or is it the old ''Imperialists''?

[29] The time in Glasgow.

In this social climate it is difficult to keep one's mind on one's work. I make an effort each morning to draw for a couple of hours and later to paint. Experience has taught me that labour, toil and creation are all one. One can never be sure when one creates, toils or just labours away. The clumsy Cézanne, the clumsy van Gogh, the clumsy Rembrandt.

Catria's father died. I never met him and I don't know what kind of a man he was. Apparently on his death bed, he expressed a wish to meet me. It was too late. He died before Catria managed to ring me. Poor C. Another blow on her bruised emotions.

19 January

I am working on the three peasants under an autumn sky gathering roots. I got the idea for this picture about a year ago but had to leave it after the first few attempts. The central figure kept on haunting me. Later the other two figures became real also.

A letter from Martin[30] asking me to share an exhibition with him at the Ben Uri. The Ben Uri, too, hold themselves stiff and unapproachable as far as Martin is concerned. Why Martin has difficulties in getting a proper exhibition he deserves is beyond me. Not one dealer to whom I took Martin's pictures responded favourably. Yet in spite of this, in his 65th year he is now producing better pictures than ever. He is an honest worker but this is a merit which in our time is easily overlooked.

25 January – Ystradgynlais

Back from London. Stayed with Martin. Fixed a date for the exhibition. On Sunday we went to Petticoat Lane and loved every moment of it. The animation brought back memories of Warsaw markets.

In the restaurant, a man with a grey face shared our table. He was poorly clad but very talkative. He said, "Just watch, I come to this place already three years but never yet got what I order. Just watch, I will order Braten[31] and get fish!" We were all served rather quickly and the man got his Braten. This had never happened before he tried to assure us.

Within one minute, from a humble fiddler who once played in his native Czechoslovakia, he suddenly called himself a professor of music! Then his lies got coloured with fantasy. He told us of an 18-year-old girl who loves him, "she has the most beautiful body in the world" and always walked naked in his room but he had no other feelings for her than fatherly. He took out a cheap necklace of imitation pearls and coloured glass. We each had to take it in our hands while he said, "This is for her. She is all alone in the world and I must take care of her. I do everything to make her happy." He took out a bundle of photographs but could not find one of her. Then all

[30] Martin Bloch, German-born painter, 1883–1954. [31] Roast meat.

27

went flat in his voice and his eyes got tearful. He took out from another pocket yet another necklace and asked whether we would not like to buy it from him as he had bought two or three too many. Martin looked at me. I looked at Martin and at a shilling a piece we bought two necklaces. Poor devil.

28 January

The picture of the three men gathering roots is much better than I thought. In fact it satisfies me more than anything I did of late.

David Raymond[32] has been here. He was to meet the men from the T. Colliery. To my mind he will have great difficulty in getting a clear idea of the situation. The miners think that the decision of the Coal Board to close the colliery is a disciplinary act. The Coal Board claims that the colliery no longer pays its way. A miners' agent told me that the local Board lies, for "the output is now higher than ever and is still going up and up". The conflict has also deeper undertones. The miners resent the payments of the millions each year to the former owners. They also resent the tone of the press always accusing them of not working hard enough. Not enough coal for export! Not enough coal for homes!

Miner
Ink, wash and watercolour,
1944–5

"What are we expected to do?" an old miner said to me. "At this stage of mechanisation we can, and mind you we do, produce enough for the nation and enough for export. What we cannot produce is enough for the nation, for export and for the mine lords!" This brings to the fore the basic resentment.

[32] Representative of the Coal Board.

29 January

Fine days. Weather as mild as in spring. The light is clear and good for work. At dusk we went for a walk. All the way along the canal I thought of the wonderful ways ideas for pictures come about. Each picture bears the seed for the next one. It is why continuance of work is so important.

30 January

Delacroix is immensely wise. How well his journals show off the things that passed through his mind and the things which went into his pictures. His objection to "thin washes" is not all gold but his passion for impact is the true passion of the oil painter.

10 February

Back from London. Catria's legs are still weak. She can hardly walk. When they give way she breaks into tears like a child, sits on the floor and repeats, "I am all right. I am all right. I don't need any help." Saw yet another doctor. He was reassuring but could not diagnose what it is. Staying with M. and L.[33] C. was in bed. Busy helping Martin select fifteen pictures and thirty drawings.

Chesterton's book on St Francis I found very beautiful but his book on Chaucer has not got the same ease and strength. All his best ideas went into St Francis, especially good is his detailed description of the Middle Ages.

11 February

"It is by their insignificance that the paintings of our time will be recognised," writes André Gide. This is a hard half truth but not a lie.

13 February

Definitely finished the three men gathering roots. Pictures, however, are never finished. They are put aside, sold but never finished.

23 February – London

I am exhausted to the marrow of my bones. My nerves are so strained in these last few days that I can hardly endure it. Martin and I worked like two mules on hanging his pictures in those dreadful rooms of the Ben Uri.[34] Two whole days on Martin's rooms! It was exhausting and nerve-racking only because Martin does not follow his eye but some preconceived dogma. Every warm picture has to be juxtaposed by a cool picture. The result he would be pleased with would form a kind of cold and warm chessboard. What about sizes, depth of frame? Ah, let's do it again. So it went on. Fortunately,

[33] Martin and Lotte Bloch. [34] It was located in Soho at the time.

there were not enough pictures of either kind to satisfy this formula of his. When he saw the result on one wall, he was almost in despair. After arguments, he let me, in the last couple of hours, rehang the whole exhibition. Up the ladder, down the ladder. It pained me to see Martin exhausted, dragging himself on his two old legs, handing me picture after picture.

At the end of my labours Martin looked round, he was as pale as an egg, tears came to his eyes. He said "How did you do it without my plan? I had worked out a whole plan." All in all a piece of rationalistic madness.

This done, Lotte arrived and both asked me who would be a good man to open the exhibition. I disliked the idea intensely and said so. The following day Martin told me that a Dr Barnet Stross, an MP, would open the exhibition. I said nothing. Bad habits die slowly. Thus came the day of the opening. What I feared happened. Martin sold nothing. There was quite a crowd, hot air and quite a bit of intellectual steam until at the end the crowd began thinning out. Eventually, Lotte, Martin and I remained with the secretary of the Ben Uri putting out the light.

The celebration was over. Martin said to me, "Perhaps it would have been better without this funeral oration, without this lot of people. Oh Josef! It is all so insulting."

In the evening went with Marek[35] and a few friends to see Griffith's *Intolerance*.

24 February
Letter from Roland. Phillip James bought my "Welsh Miner" for the Arts Council. Roland underlines in the letter that this is my first "official sale". What is heartening about the relationship that develops between Roland and myself is that he considers every sale a personal victory. In many ways it is. Pictures do not sell themselves – definitely not my so dark pictures.

Martin is ill. All this strain, this hard work, this anxiety. Already on the opening day he looked one hundred.

5 March – Ystradgynlais
C. recovers from a hard 'flu. Martin is also better.

A painter today has to grow a thick skin not to feel the pats of praise nor the pricks of criticism. It is the rarest thing to read a helpful word. Last week, when in London, Martin and Lotte were in a terrible state: "this lack of appreciative criticism".

I: "Martin, what can anybody tell you what you in your heart don't know already?"

Martin: "This is not the point. When you will be ignored for years as I am, you will

[35] Marek Zulawski, Polish painter and friend.

understand." Martin did after all sell a few pictures and thank goodness for that. I prayed for that in my atheistic way.

9 March

At the E. Tin works. The workers with white towels around their necks. Every few minutes they have to wet their heads and faces. Their movements at work are fascinating. They reminded me of acrobats. The colouring of the shop, silver-white with red furnaces.

22 March

Gustave is now back from the States. He says that an exhibition of mine there would be a waste of money and time. I am sure he is right.

7 April

Busying myself with the new house. Will soon be moving in. The studio part will be good.

14 April

Back from Glasgow. Stayed at the Central Hotel. Saw Benno and Milly.[36] Both as friendly as ever. It does me good to see Benno. He is complicated and has the make up of a true artisan. Attended the confirmation service at the Synagogue.[37] For C. it was a great thrill. For me a bit of a bore. Synagogues here are such dull places. Two days later there was a second party at Benno's. Hugh MacDiarmid[38] was in great form.

17 May

Already a fortnight in the new house. I named it "Catria". Slowly getting into a working mood.

29 May

Work is going well. The first picture in the new studio: a road, dark houses, heavy telegraph poles, a gold, almost a white sky. On the road, a dog, a man returning from work, another man minding a child, yet a third figure bending over the low wall and looking into the Tawe.[39]

[36] Benno (1891–1978) and Milly Schotz. Benno, from Estonia was an established sculptor based in Scotland and became a loving father-figure to Josef from the time he arrived, penniless, in Glasgow in 1941.
[37] The confirmation of Benno's son, Amil. In fact the Barmitzvah.
[38] (1892–1978), Scottish poet. [39] Local river.

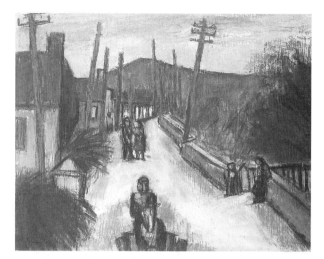

(left) **Autumn 1946**
Pastel
50 x 63cm
The Roland Collection
(bottom) **Ystradgynlais Bridge**
Mixed media 1954–5
18 x 23cm

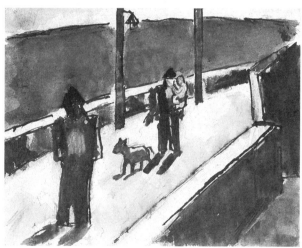

5 June

I think it is Romain Roland who tells in his essay on Millet that the total output of thirty years of this painter's labours amounted to 80 pictures. Two months of a modern painter's work. But then what a coherent world Millet created! Today painters overproduce. We need a slower pace. We need calm.

11 June

The only painting that matters is the painting that treats the canvas as though it was a wall. With the canvas something undersized came into art. The secret of a wall is that it commands monumental ideas. Why it should be so is a mystery to me.

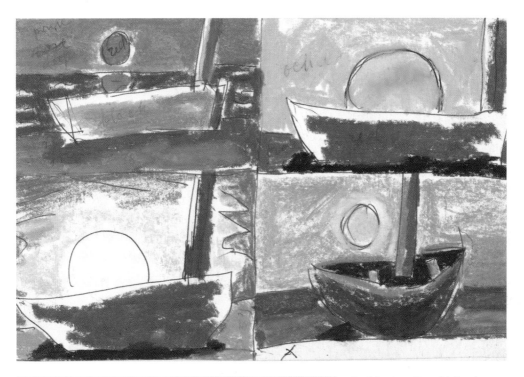

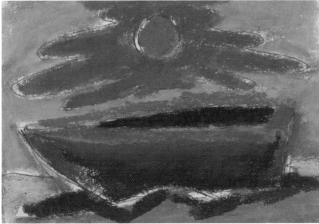

(top) **Boats on Dunwich Beach**
Mixed media
14.1 x 19.7cm
(left) **Boat on Dunwich Beach**
Mixed media
10.5 x 14.6cm

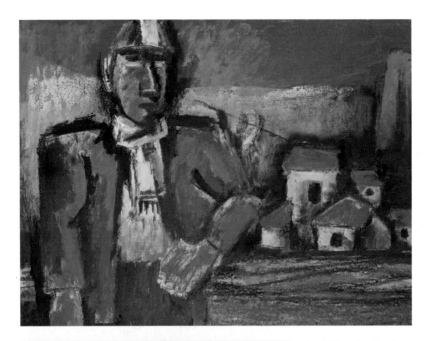

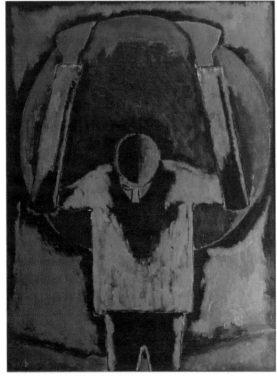

(top) **Miner in a Landscape**
Mixed media, 1952
56 x 74 cm
(left) **Fisherman with Pack of Nets**
Oil on canvas, c.1993/6
122 x 91.5 cm

12 June

What an immense source the single figure is. How I envy the sculptor. Perhaps I should have taken to carving.

17 June

My passion for Courbet is getting stronger with the passage of time. Looking at him gives me immense satisfaction. He was drawn to small things of everyday life. Already in his "Stonebreakers" he shows a great sense of synthesising the life of a class in two people. Realism without his strong emotions is nothing. Even a dead fish by him acquires universal grandeur. Because of his tendency for cool reasoning, one often forgets how much of the true poet he was. He disliked historical painting. The new subjects of the every day needed authority and Courbet felt himself the authority of this non-historical and non-idealistic approach. Curiously, he never painted topical subjects. Gericault and Delacroix were more topical than any of Courbet's pictures. It is true to say that Courbet's was a social imagination to a greater degree than either Gericault's or Delacroix's. Gericault's "Raft of the Medusa" and Delacroix's "Liberty on the Barricades" are in their very representation museum-like and far removed from life. They are what is called Museum compositions. Courbet could well afford to leave topicality aside. He had a strong sense for popular feeling like the primitives. In a way he was a primitive. And to be of his time he could well afford to ignore topical subjects.

25 June

All workers are alike. Find the type and you have found the class. The appearances only affect trivial details.

10 July

Art should be of the same seriousness as religions were in the past and as philosophy has been recently. There can be no humanistic art without the recognition of this fact. Yet our humanists and rationalists are frightened of dark images! They still think that a face, for example, lighted up by the sun is truer than a face radiant with human spirit. It is an age-old misunderstanding. Rembrandt was told that he paints figures as though they were in half-lit cellars. They look to nature for comforting signs, those humanists!

12 July

There is no co-ordination between art criticism and art. This is a pity. Much mental energy is wasted. Criticism is too much tied up with attitudes of the ruling class and at

this level it is good to no one. [Critics] became a sort of go-between, between the artist and the public. This justifies in their eyes the flatness of their styles. Perhaps if there would have been less reporting of a journalistic kind and more discussion that would stimulate artists to participate, things could have been a bit different. Criticism as literature is preferable to criticism as journalism. Like art, criticism needs a serious aim and roots within the coeval imagination. In the meantime we have to be satisfied with a lot of intellectual small talk. Art criticism as written by poets is interesting, interesting for what works of art do to the poet.

19 July

The less man fusses about his self the more likely he is to make something of himself. One should not worry about not being a masterpiece. To do what is in one's talents, without introspection, takes care of one's innermost personality. In small communities people are known for the function they perform and in this function lies their moral stature. On a walk the other day I suddenly found myself on the territory of Ystrad's sewers. The man who attends them spoke to me through a smile:

"Not the best place for a walk is it?"

I answered, "It won't kill me. What about you, you are here all the time."

He replied, "Somebody has to." These words I hear here very often.

7 October

The last few weeks I did not feel all that well. States of depression. Fear of death. Fear of madness. Spent days lying on the bed, restless, perspiring and afraid. Now I feel convalescent. Started normal routine and work. I am no longer worried about loneliness. Drawing goes well but I still have to force myself to paint. The great achievement of the nineteenth and the twentieth century is the Marxian blueprint for freeing labour from servitude. This is the meaning behind the growth of trade unionism.

25 October

In the thirties everybody was critical of bourgeois liberalism. Unfairly so.

26 October

What a poor worker in black and white Courbet was and yet in his paintings there is the form and power of a great draughtsman.

Cézanne, in his early years, resorted to a whirl of lines not unlike Daumier. Even then he saved the massiveness of his forms with accents as small as commas. The stress in the right place made the form. Rouault was right when he said that where others needed whole lines, for Cézanne an accent was enough (or words to that effect).

1 November

I have yet to come across an experience described by a mystic and unknown to the artist. Does this mean that the sources of art and mysticism are the same. Yes, it means this.

André Gide in an entry in his journal writes (29 December 1932), "We are just beginning to emerge from the mystical stage; but that the fine arts belong to it I am ready to believe and that they need that climate to prosper."

In many ways in modern times, art takes over where religions left off. We need not ascribe to mystical interpretations that they alone remain true to basic experiences.

15 December

Working on the sketches for Festival panels.[40] Things beginning to take shape. Reading Isaiah Berlin's *Karl Marx*. What a remarkable writer this Mr Berlin is.

18 December

Worked late into the night. Pleased with the idea of the three panels. Rain. I am very tired but pleased. Like a cat after a good feast I lay on the rug near the stove.

10 January 1950

The panel with the singing miner goes well. Also the panel with two miners squatting against a wall and two miners walking on a blue road. There is also a tip, a mother and child against a golden sky, this panel too gives me some satisfaction. And now I got another idea of a row of squatting miners and one standing figure. Will put it tomorrow on the panel and paint it as far as I can. I am eager to see what it amounts to.

5 February

Back from London. The studies were well received. The panel of the squatting miners was chosen for the mural. Hoped that all three would be given a chance. I would like to start immediately on the large scale but it will take quite a few weeks until the large panels will be ready. Saw the French landscape exhibition. Remarkable things. Poussin stands out. His trees, his mountains, his tracks all work to order but he knew that without sudden shots of light they would command little response. Claude is softer. The eighteenth century is unbearable in spite of Fragonard. Then comes another high flight with Courbet and Cézanne.

6 February

The inherent goodness in some young people is very moving. David is sixteen. I asked him what he intends to do after studies and university. He answered without

[40] Commission for a large mural for Festival of Britain. Now in the Glynn Vivian Museum in Swansea.

hesitation, "I would like to work with the blind. Perhaps teach them."

Everybody in the valley is sad and downhearted because of the news about the hydrogen bomb. Insecurity and the prospect of a third world war. Not yet, not soon but one day . . . and goodbye homo sapiens! In the meantime, one has to work as though all things were bright and beautiful. What for?

10 February

"A happy home makes for a silent woman." A curious proverb. I think it's German. Yet old Mr Thomas repeated it a few times to everybody's enjoyment. I asked him how he came to know it. He said he heard it from his father.

12 February

Some years ago E.M. Forster wrote, "the prolonged rule of the middle class in England became a menace to the life and culture of England". What would he say today? Everybody is busy polishing the statue they call the "middle class". The middle class, it appears, is the salt of the earth. It is England. "The English way of living." Let Labour not forget this! I am afraid the Labour government remembers this only too well!

20 February

I draw from nature and later I draw from the drawing done on the spot. I paint from drawings, sometimes from scribbles. I cannot do without a subject. What I paint from the imagination has its source in memory of things and people. Sometimes to activate the imagination, I let the arm go and paint fast not knowing exactly what I am doing.

21 February

My knowledge of music is nil. I can never read about it with heart and concentration, just as I cannot read about archaeology. But I do not think that I flatter myself if I say that I can listen. My ear is not very good but it is not at fault. I blame my childhood, my musicless youth and my intolerable laziness. Many people here know something about music, some a great deal. A piano in a home is not a status symbol, it is an instrument you grow up with. Good. Very good. I came to cherish music. I listen often for hours to records and to C.'s imperfect playing. But when I think what has been done to painting in the name of music, it angers me. No one should use one's eyes as though they were ears.

25 February

Art criticism is only vaguely related to art (i.e. painting). It has first of all to succeed as literature and then communicate the critical faculty. It may or may not be of interest to

the artist (painter). Artists are men who cannot be helped. If we are often irritated by criticism, it is because we do not read it in the right spirit. The right way to read criticism is to follow critical patterns: the way analysis turns into communication, the way perception turns into thought, the way accumulated knowledge – historical, sociological, philosophical etc., is used to support experience. Teaching the artist by the critic is of little interest. Why write about things that you damn? Modern journalism is much to blame. I often have the feeling when reading our "heavy journal critics" that at heart their own decency must be offended. Who on earth do they warn and of what? If artists cannot be helped, whom do they want to help? Was Chekhov right saying that the idiot won't understand the critics and that the intelligent does not need them? All this about certain types of criticism. But the criticism I have in mind is helpful in a roundabout way: it helps to mature the personality. The artist is stubborn and self-wise. The person is childlike and can be taught. Thus criticism should be read not as a judgement but as a way of thinking.

27 February

There are good reasons for fast painting, for letting the arm go, for not knowing what one is doing every now and a while. Good painting nevertheless means painting slowly and knowing exactly what one is doing. Of this I am convinced. Explained this yesterday to Will.[41] Facility is to be avoided. How? A work that came easily should be looked at over and over again to see whether, besides excitement typical for a picture done fast, it has the same serenity of spirit which characterises all serious works. Virtuoso painters like Tiepolo or Picasso are easy to admire, they have sensuality, they can "perform" a painterly act at a moment's notice. Admirable. Or not so admirable? I have been thinking that after all there may be some virtue in clumsiness. Perhaps one should not be worried that years of labour have *not* taught one how to paint easily.

My mind works round in circles. I do not know how to "think" out a thing and have done with it. Perhaps on these pages I even repeat myself. I certainly do repeat myself. I am constantly searching for the best way of saying what true painting tries to convey and that this is not at all a matter of means of "spiritualising" thoughts or methods, new techniques or believing that geometry is more precise than a hand. Inventions are merely inventions. In another frame of mind, I can say better things about methods, techniques and inventions . . . but the proof of good painting is whether it transplants one in mood, whether it takes our sight from everything around us and whether, as though after a dream, when we open our eyes to the world we see the world quite literally for the first time.

[41] Will Roberts (1907–2000), Welsh painter, who used to visit Josef once a week, on his afternoon off from watch-making. He came to learn.

I am surprised to have come to this conclusion – already a time ago – for these otherworldly inferences are only an arm's stretch away. Instinctively, I have always been drawn towards feelings out of which religions and myths have been made without having much interest in the religions themselves.

To be a painter means to be a man set in a mood. Not to be afraid of being static. And this is not a denial of living but the artist's way of affirming it. The discussions men have indulged in all through history are rather farcical. There is a "bogey" called "fallen man" and facing him is another called the "natural man". As though we really knew what we are talking about. So boundaries were set. Move out of one and you move into another.

Courbet refused to paint angels because he had never come across one. Perhaps he was right . . . Klee and Morandi also never painted angels. We shall never go back to painting angels, just as we shall never paint saints again. The "psychological man" has seen through the godly order. He has learned the order of his own moods and to disassociate morality and ethics from it. Also our "social imagination" will never be the same.

28 February

Courbet. In more ways than one he is my personal master. Looking at him closely, one can see all the dangers he was in. He almost missed greatness but did not. Because of his immense will! He was drawn to small things of everyday life and could have ended up another recorder, a storyteller of everyday living. But already in his "Stonebreakers" he showed a keen sense for synthesising the life of a class in two people. The result is a magnificent frieze!

So in Courbet are already most of the seeds of modern epic painting! Every now and then he is tempted to depict, to describe, but then like the big wave he likes to paint, he surges above the flatness and even a dead fish acquires universal grandeur. Because of his tendency to cold reasoning one often forgets how much of the true poet he was, an epic poet to be sure. Because of his obvious tendency to represent one often forgets the power he endowed all his forms with, whether suggested by an apple, a tree or a man. The new subject, the everyday, needed new authority and he felt himself the authority of the non-historical, non-idealistic approach. However, the Courbet image is as far removed from being a reflection of reality as angels are. His "enemies", the Romantics, painted more topical subjects (Delacroix's "Liberty on the Barricades") than Courbet ever did. Yet it is true to say that Courbet's vision was more linked to the social imagination than theirs. "The Barricade" pictures events – dramatic and terrible events – cosmic in attempt but museum-like in representation and in feelings. In representation as far removed from life as studio compositions, linked with the tradition of

historical painting at the time. Courbet could well afford to leave topicality aside. He wanted a form, big, noble and life-true. In a sense, he is a primitive. Courbet should be studied as an artist of form with a deep sense for popular feeling. In many of his landscapes the earth is the main thing. In the sky, the texture of clouds and concentrated air is the main thing. When he puts a figure into the landscape, the figure becomes the principal thing! He always knows where to put the accent. And so life-true had a definite meaning that is only vaguely related to the realism he professed. No, no, we must not let definition shrink the size of the artist. Baudelaire once said, "A man ends by resembling what he would like to be." This is probably the final victory one can hope for.

1 March

What is the basic difference between humanistic and non- or even anti-humanistic art? In our century the answer stands like this: the difference is between a heartfelt conviction rooted in mankind and between beliefs rooted in aesthetics. Even a devotion to the human figure is not a guarantee of a truly humanistic art. Art is of the same atmosphere as religions were in the past and as philosophy was until recently. Humanism, modern humanism is a recognition of this fact. The surface in a humanistic work is a by-product of a searching content and not an end in itself.

9 April

When years ago I saw for the first time a larger group of Turners, I stood in the middle of the hall with tears in my eyes. With him we do not gain "more information about nature". That he was a good observer goes without saying but as with Rembrandt, we enter a world of unique poetry. There's a great moment of hush and of dream and the unnatural light expanding into an aura around all the pictures. The light is the kind the human heart responds to most willingly, soothing, warm and turning into a glow. It is art of the great human theme and this without involving the human figure, anyway not to an important degree, as a great human achievement. Not then, or ever after, does a work by Turner make me think of a natural event or of an artistic illusion, or of the texture of painting without drawing or of colour and movement as the sole means of expression. From him it would be difficult to deduce a new beginning. Like Rembrandt, he interprets a personal longing but it is the power of that true longing that it takes and not trivial habits. As though civilisations have never been and only you, the universe, the first light and an awakening of the spirit. He is at his greatest in vast canvases like the "Snowstorm"; in canvases that are bare of presence and where Turner's marks alone make for a pattern, imposing their own disturbances, even violence and the significance of the painterly act. No one before him has ever done

this. Yet, Turner is often described as a landscape painter as though he would have been a mere Impressionist (some think they celebrate his name when making of him a forerunner of the Impressionists!). His ways are difficult to describe because he anticipates nothing and comes from nowhere, the essential Turner. He stands alone. In this is his moral example. The Rembrandtists lived on few technical devices. The Turnerists, should such ever come into being, would find themselves with still less to go by. It is characteristic of the "apostles" of schools and "movements" in art to be satisfied with less of the achievement and more of the intention. Perhaps it is good that Turner had no followers. I doubt whether Turner ever bothered his head with what colour is like in the shadow or how it is technically possible to make of it one with the colour that stands for light. His is, as the later Rembrandts were, what I would call a style of feeling.

15 April

Artists have only themselves to blame for the confusion. They were the first to give the impression that ideas and concepts are things that matter to them most. Form is bla. . . bla. . . bla. I do this or that because bla. . . bla. . . bla. There is a greater rationale and simplicity to our efforts to which cannot be given too much precision. Vagueness is a legitimate territory. Do we not begin with half guesses? Can we really call all points of arrival conclusions? This is the bad influence of metaphysics that a consistent pattern strikes a final truth.

That artists often find it necessary to explain themselves is understandable. What must be done away with is the absolute statement. To make clear the inner necessity (how vague can you get here?) is all we can authoritatively do. We must never forget our humanity. We must speak what we truly do.

When I look at a mere reproduction of a seascape by Ryder I have to say: now here is a painter, a true painter, not half as clever and ten times more great! Then I look at Goitia's[42] "Tata Jesuchristo" – two peasant women crying in the light of a candle – and have to say: now this is a masterpiece, not half as clever but complete in itself. Then I look at Permeke's "Étranger". Then I look at Rembrandt's "The Jewish Bride" and so on and so on. These are all works with the great power of dawn. This is the power of folk-art, of primitive art, of archaic art. This is the power that we have to recognise no matter what "problems" we superimpose. My idea of classic is peace.

19 August

In the afternoon I walked until dark. Still nothing stirred my emotions. No drawing. Am I losing my way here? Familiarity with things is a way of estrangement. Has this

[42] Francisco Goitia (1882–1960), Mexican painter.

sort of familiarity already caught up with me? Without the strongest emotions, how little can we hope to know of reality?! Whitman came to mind: ''What is humanity in its beliefs, in its loves, art, or even morals but emotion.''

12 October

Important guesses[43] as for example, the exact weight of the pigments in some parts, the precise amount in parts of glow coherent with the rest of the surface, the accurate closing of form so that the inner vitality should not overflow it, etc. It is so easy to fall into personal moodiness instead of expressing a life-true mood. However, my ''guessings'' of today were just right and the picture is progressing.[44]

Worked in the morning. About 12 o'clock David Bell[45] arrived. An interesting remark regarding the picture. He thought the right hand head of the two sitting miners satisfactory and complete. I still thought of working on it but he made me think twice. However, I'll see. His visit was indeed enjoyable. He recited from memory two beautiful Yeats poems. His voice low and sad accentuated a musical rhythm of the poems that I am certain was quite personal. After lunch we walked along the canal. The day was beautiful. Ystrad at its best.

14 October

''Willy Bach give us a song'' (Willy is 68). ''Tom, stop hammering that piano, Willy is going to sing'' (Tom is 70). Gwyn takes the stool at the piano (Gwyn is 60), ''A good tenor is Willy. A bit neglected . . . Not trained, man. This is what is wrong with all our tenors, they are not trained . . . Quiet! . . . There is no staccato here . . . This better . . . No mind left in him, Joe. You should have heard him forty years ago, the best tenor in the valley . . . Definitely the best . . . No one to beat him . . . What a bloody pianist . . . Well done, Will Bach, well done . . . And a fine song too! Definitely a fine song.'' I had a lovely evening in the Miner's Arms.

15 October

Worked a whole day. The picture is nearing the end.[46] I also started underpainting with watercolours the big Festival panels. There will be some technical difficulties in finding the right size brushes and preparing the large amounts of pigments. What at the moment worries me most is how the colour scheme will look on a larger scale. When proportions of planes change, colour values change also. However, I will try to work as little as possible from the sketch. Must stare for a longer time at the panels to get used properly to the size before commencing work.

[43] Work on the large panels for the Festival of Britain. [44] Not certain to what this refers.
[45] David Bell, Head of Contemporary Arts Society of Wales. [46] Not the panels.

17 October

Made a sketch this morning for a new picture. A darkish street, a road. A milk cart with a woman figure standing on it. Another woman standing nearby. Quiet. Peaceful. A gold morning sky. The curve of the road is very important.

19 October

In Cardiff with David. Saw another time the fraction of the Burrell collection now on view at the National Museum. The tiny Don Quixote by Daumier! Degas' dancers in the room with the staircase – what excellent painting.

22 October

Working on the big panels. Still must free my feelings from the uncertainties of "enlarging" and get used to the true proportions the panels suggest.

23 October

Got up very early and immediately began work. About nine o'clock was already fatigued. I'm full of cold. And with this I must go tomorrow to London. Something has gone wrong with "The Festival of Jewish Arts". I have to visit some people and galleries. I won't enjoy this.

26 October – London

Was in the Gallery. David Bell bought the "Mother and Child" for the Contemporary Arts Society. Everybody in the Gallery was very nice. What a tiring job to get pictures from people![47] Was in the National Gallery to see Rembrandt. There is no technical trick to the glow of his colours. He works out the colour 'til he gets the right glow. The eye and the mind are perfectly united. The process is often tedious. Catriona is coming tomorrow night.

28 October

All four of us, with Martin and Lotte, went to the Victoria and Albert to see the Raphael cartoons. They are very uneven, have a dramatic air but they have grandeur. An epic scale. Something important goes on and one is grateful for this feeling. Yet when we went to the room with the Gothic tapestries, I for one could not help comparing Raphael's cartoons with these and concluding that the Gothic tapestries are a greater kind of art. There is more reality and less of Renaissance make-believe.

[47] He was curating an exhibition.

29 October

Spent a few hours in the afternoon with quite charming people who are willing to lend a quite good Chagall picture.[48] They know of me "from your exhibitions of course". This made my request easier. Both are wrapped up in conformability.

1 November

Saw again the Rubenses at Wildenstein. His painting is brilliant, especially when he paints thin as in his sketches; probably the best way to use oil paint. Virtuosity I find disturbing. Also the noisiness of his compositions and the fuss about nothing! His energy is of an outward kind. Of course, nature is full of energy. Even quiet or rest is a form of it. Alive in art means imparted with energy. But gestures, flying and falling do not carry to the heart of it. Rubens opens form and lets energy overlap. The pictures then bedazzle, excite but do not compel serene feeling. At least it is how I feel in front of the Rubenses. His technique performs wonders. What this Master does with one accent blob of colour on a dirty wash!

His colour radiates like the sharp edges of a diamond and all through feather touches – a blob here, a blob there. Every painter yearns for a method. Rubens is the most ingenious and almost childlike in his simplicity. He is indeed, and most dangerously so, all method.[49]

2 November

Accidentally, while looking through some papers, I came across a longish note I thought of copying into the diary.

"My relationship with Jankel is strained but we are not estranged. I no longer feel any need of his company! He asked me today, 'Why don't you ring when you are in London?' I was frank, 'What for?' His face became red but he managed to decorate it with the most disarming smile, 'Josef, what are you saying?' I suddenly felt somehow guilty for the deterioration of our relationship. I made efforts to awake friendliness though and we talked for well over two hours and lunched."

4 November

I just reread some of Rouault's writings. Somehow his voice awakes in me an enchanting resonance. Not so much through what he says but somehow he opens the sources to the reality of feeling and also the state of mind when it reaches certainty. He is free from professional polish. His phrases are of an archaic and biblical kind but the ecstasy is of the poet: just as in his painting. He is not a religious man painting. He is a

[48] For the Festival of Jewish Arts. Josef had volunteered to find work to show.
[49] There follows: "lucky fellow", crossed out firmly.

painter thinking religiously. Poetry, plus morality, means to him religion but in his writing there is more poetry than religion. I wonder if he ever suspected that there is no such thing as religious feeling? That it is the poetic expressed in terms of religious doctrine?

10 November

What a misunderstanding! Gustave [Delbanco] hinted that I am repeating myself. As if I would not have been aware that I am on the ground of sameness. But, this is not the same as repetition. It is not his fault, for I do not think that he has given the matter serious thought. Weren't we all victims of the rationalistic identification of change with progress. As though an artist could never progress without changing. The inner stability of the true image works its way through many pictures. Here consistency is of greater significance than versatility. It has been said that the medieval and the primitive painter were incapable of progress (change) and this because of their adherence to one style. Isn't this because our "experts" on "beauty" are thinking of style as something personal? Style is the human group.

Art fussing about its own self can never achieve popular intimacy. There are many channels through which art connects with life but all demand that artistic concept forgets the experience of its own self. That it remains a language and not a thought. When art is thought in itself, it is also detached behind the doors of lesser importance. Only when it deals with a sense bigger than its own self is its gesture not an insult but a high praise. Only then does it reach the level beyond objective persuading. It becomes compelling. For the artistic quality realises itself when least thought of, when least precious to the artist, when least fussed about with tiresome "aesthetics". In order that art should lose its identity, the artist must have the humility to disclaim his identity and believe himself a realiser, a pointer to the concept of the collective. What I am dreaming of is one change and one stability. It is through our labours and not through our smiles that we are one with humanity. Too many people today have an authentic taste for falseness, even "cultured" vulgarity. It is through frequent visits into the same moods that one learns to distinguish poetic ideas from poetically disguised information. And only when reinforced with that knowledge can one see that the eventful world lies in the finality of the static image.

13 November – Ystradgynlais

Staying with the Farringtons, I somehow got a childish pleasure when Ben[50] showed me some of his books in Spanish, Czech, etc. – translations. He is one of the rare Marxists who can and do take the trouble to write carefully and beautifully. He is calm,

[50] Benjamin Farrington (1891–1974), Professor of Classics, Swansea University, and close friend.

clear, a bit over polite, at bottom really and truly shy. He always suspects that the person he is talking to may know more than himself. I think the incident with Professor Haldane, as Ben recounted it, is typical. "He asked me so many questions about Greece that I felt uncomfortable, for I was sure Haldane knew more about it than I." I noticed that this he feels often, even with people of lesser stature than Haldane. He was very attentive at my lecture and I read as though only for him

Trying to work. The days are cold but bright. The leaves and grass are only now turning brown. At twilight, strong scents from the trees. A soothing quiet with a few drops of melancholy. The hills throw sharp-edged shadows that make the village seem as if lying low in a basin. A faint nostalgia carried my memory back to the Karpathian Mountains. Away from the panels I find much peace in working on the landscape with the milk cart. The more one works out the quality of paint, the truer becomes the colour and the nearer it responds to the mood. One should never think of painting as a kind of shorthand. Fast work is dangerous. I am reading Da Vinci's *On Painting*. Most of it is curious as a historical document but of no help to a painter of our day.

14 November
Worked the whole day on the landscape with the milk cart. Also did some drawings.

15 November
Talked with some of the miners about Shaw's death. Bryn asked me what I thought of the obituary page in the *Daily Worker*. I told him that I thought it better than all the other dailies. Particularly so was T.A. Jackson's little essay. *The Times* and the *Observer* blew wrong notes on their apologetic trumpets. The other papers, including the *Daily Herald*, were just hollow noise. Shaw may have "entertained" a section of the bourgeoisie but on the imaginative left he had a definite influence. On this side he was taken seriously, not at his word value but at his thought value.

16 November
It is far more difficult to get used to the caprices of our temperament than to the shape of our face or the colour of our eyes. How I long for a quieter life. Though for the past six years I have lived pretty well in seclusion, the world's events hold me in their grip. Whatever happens stirs me deeply, yet it is not this that drives me to work.

18 November
Working on the Festival panels. Spent most of the day just walking around them, or sitting and looking at them. I wondered if the figures are not too big. Late evening I decided they are the right size.

19 November

For no apparent reason, on my walk alongside the canal bank, it came vividly back to me a memory of Adler, MacDiarmid, Douglas McCall and myself sitting in the "Taj Mahal" in Glasgow, that terrible year, early 1942,[51] discussing of all silliness the idea of Superman. Adler and MacDiarmid exalted the Superman. McCall and myself were doing our best to annihilate him. MacDiarmid and Adler thought large gestures and big enterprise qualities in themselves. We pressed the ethical motive and the socially relevant end. Jankel always thought it his duty as a "great man" to "defend" great men. He often laid on his shoulders other "duties". One day in his London studio, I think it was some time in 1945, the outcome of the war was already clear, I found him leaning over a map looking for a place where all surviving Jews could go. It must be, he explained to me, climatically a pleasant land and larger than Palestine. "The Jews have suffered so much. We are all sick. We need a rest."

He was quite serious. That day he was very serious on every subject we tackled. He was showing me a few of his latest pictures.

I looked at them and murmured as if to myself, "And I have my doubts about metaphysics being the right partner for our mother painting."

Adler quickly retorted, "Josef, painting today is metaphysics."

23 November

We have just come back from Pont-y-Cymmer where we went to see "Theatre Workshop".[52] The masque *Uranium 235* exceedingly well produced with a strong use of visual effects. But the text is childish, pompous, a third-class imitation of MacDiarmid's philosophisings but Miss Littlewood definitely has talent. The team spirit behind the stage was really impressive. It was very cold in the hall. Only about thirty people, mostly women, in the audience. Suggested to them a tour in the Swansea Valley. On the way home heavy snow fell. It was like driving into a lump of cotton wool.

26 November

The liberal mind hides behind a class-imposed cautiousness. It is wrapped in a class-agreed gentility, a philosophical mildness yet the bourgeois is always behind it, all quite visible. Not that the Liberal mind lacks spirit. What it lacks is directness, straightforwardness, simplicity.

[51] The year the Red Cross brought news of the extermination of his whole family.
[52] Joan Littlewood's Theatre Company which eventually settled in London, at the Theatre Royal, Stratford East in the late 1950s.

28 November

Wash in a drawing can only then be considered successful when it elevates the pattern to the feeling of space, light, colour, in other words, it must be evocative rather than follow what is prescribed for shading. The ink must be of a special kind and also the paper. Both must add an ease for the brush. Poussin, even Claude, usually use the method of tinting; Goya, Manet, drew with the brush which is also something different from a wash. Rembrandt alone washed a drawing in the sense that I understand it. Neither his charcoal drawings nor his etchings have this profound expressiveness as his wash drawings, which are always inspired.

11 December

Feel very uneasy. Cannot get the freshness of feeling so vital for work. The panels are giving me some trouble. Putting on paint one day and washing it off the next.[53] Cannot sleep. Brooding and brooding for hours. Reading alone gives me some rest. Hanging on to the wireless. I am certain that the American war in Korea is meant against China. Attlee went to see Truman and from the scraps one can gather from the press, this was a conversation between two salesmen.

13 December

There are people cursed with a dangerous logic. There is a terrible kind of coherence in whatever they say. Zhadanov[54] seems to have a logic of this kind. Heine once said, "Let him throw a stone unto me who would not betray his fatherland for a good joke." Zhadanov would have thrown the stone. He has also made a terrific discovery that Pasternak is an individualist! To call Akhmatova "half harlot, half nun"! True, her poetry has a narrow, lyrical range – is strictly personal and has an aristocratic scent but beside that there is also an all-human quality underlying. To classify her work is one thing, to insult it is another. The morbidity of it all lies in the shape Marxian criticism has taken. It is when people like Zhadanov are satisfied that it is time to think and think again. Yet his essay on philosophy has truly wide scope.

19 December

The photo Llew Morgan[55] took of the Festival panels (half way through) opened my eyes. The work is much better than I thought it. Took also up to London the landscape with the milk cart. Lilian Browse, as well as Roland, liked the picture.

[53] The Festival panels caused him much anxiety. He had not worked on that scale previously.
[54] A. A. Zhadanov (1896–1948), Stalin's cultural director.
[55] Important local photographer: see Carole Morgan Hopkin, *Full Circle: the Life of Llew Morgan*, Gomer Press (1997).

22 December

Everything with the Festival people goes satisfactorily. They seem to like the progress of the panels. Had lunch with Huw Wheldon. More and more people now see the American game correctly. A real feeling against American war intentions. But this does not stop the press from doing its damnedest to awake anti-Chinese feeling. Went again to see the Holbein exhibition. Slept at Martin's. The picture he now paints for the 60 artists' exhibition has very fine movement which spreads like music. This is due mainly to the design. The colour is rather limited and lacks force.

In the train on the way home, opposite me, were two couples. The younger couple near the door were kissing and hugging all the way. The old couple near the window. The old man smoking his pipe. His wife was sleeping and when she put her hand on his shoulder, he gently removed it. I wondered which of the two was the greater love.

(top) **Underground**
Ink and wash, c.1948
20 x 26cm
(bottom) **Two Miners**
Ink and wash, 1954
20 x 26cm
(overleaf) **Mother and Child**
Ink and wash
29.5 x 20.5cm

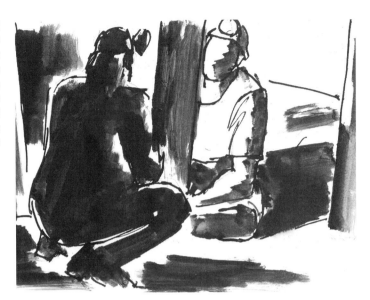

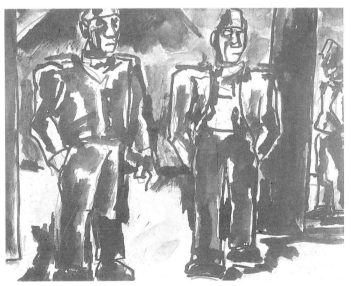

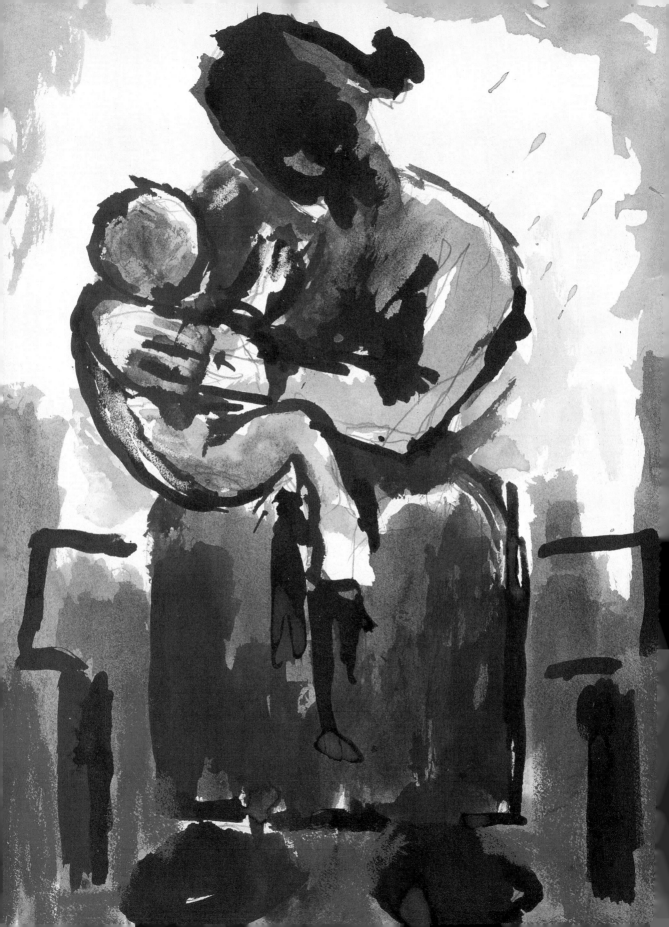

18 May 1968 – Suffolk

Jack[1] was here for lunch with his family. His work on the Cézanne book is progressing. I admire his capacity for work. He took only one year for the magnificent Turner book. Others would probably have taken five years on the research alone! Yet the result was not hurried. From Cézanne's early beginnings one could not predict the final result. This, I dare say, is true for most others. To find one's single way is with some artists a slow and tormenting struggle.

20 May

The mother breastfeeding her child, a picture 36 × 48 I began about three weeks ago, is much better than I thought. When I put it away it was with a feeling that I will have to scrape it off. One should never be in a hurry to decide the fate of a work. I see it now clearer and will continue to work on it. I am a slow developer and that is that. Experience has taught me that some pictures must be put aside and then one must wait for the ripe moment. That others ripen quicker is not to say that this is always the way. This mother and child had its ups and downs. It started as a grey, black picture. This stage I had to wash off. Now it is golden, but I felt that it is not primitive enough. Primitivity does not come to a man of our time naturally. One has to work for it. It is a matter of reaching natural simplicity. And for this end one has to work. I am still waiting for the moment when I could express myself with one line. But I am afraid this is a vain hope.

N. is off to London for the day. In an hour's time I will have to take David[2] to school. Mrs H[3] is coming to babysit for Rebekah. I am thinking of working the whole day on the mother and child.

21 May

Pulled together the mother and child picture. Am worried whether the unity achieved is not too much at the expense of colour. The sitting figure with the child sucking the breast is strong enough. Her class characteristics are all right. One can see, I think, not only from her clothes, but also from her face, that she is a working-class woman, or a

[1] Jack Lindsay (1900–90), Australian poet, novelist, historian and translator.
[2] Our son, born in 1957. [3] Mrs Haxel, our babysitter for many years.

peasant woman, the distinction does not matter. So far so good. But must leave it for a moment. Have I limited the picture to too few colours? Is the brushwork spontaneous enough? Is not the surface tired? And so on. Am working already on a new picture of a Mexican peasant playing a guitar.[4] Received yesterday Roditi's[5] new book of prose poems. The illustrations are by some surrealist draughtsman – clean, elegant and chichi! If it would not have been a friend's book I would have thrown it into the wastebasket so strong was my reaction against this chichiness. However, I will try to forget the illustrations and read the poems. His earlier poems he gave me some years back, I liked very much. Altogether, I think Roditi is a highly gifted man.

Roberto
Ink and wash
22.3 x 17.2cm

N. came back from London worn out. Little Rebekah is not herself without N. around. David has a cold. He is also feverish. After Sarah's[6] death, no matter how slight a thing happens to a child we get worried! The older I get the more I cling to children. A child is full of poetic puzzles which warm my emotions. For example, little Rebekah[7] has now a few personal tricks; when she likes a person at first sight she displays them. If she doesn't have a response she cries and cuddles into N.'s bosom. I could be with this child for hours without getting bored. Perhaps this is another sign of my old age catching up with me.[8]

[4] Came to be known as "Roberto". Josef spent 9 weeks in Mexico in 1966.
[5] Edouard Roditi born in Paris in 1910, linguist and poet. He first interviewed Josef for his book *Dialogues on Art* and became a lifelong friend. One of the few close friendships that endured until Roditi's death in the 1990s.
[6] Our daughter who died at the age of four in 1966. [7] We adopted Rebekah at six months of age in 1967.
[8] He was 57 years old at the time.

22 May

Read through Roditi's earlier prose poems which he calls "new hieroglyphic tales". From his Foreword it appears that he has written them thirty-nine years ago when he was eighteen. He has the right to be pleased with them and not to have rewritten any of them. They are lovely pieces! Vaguely surrealistic. No self-conscious extravagance. I already want to read them once more. Best are the images. Also good is the sustained low-key music. Each phrase self-contained in its logic but melodiously linked with the next one. Good. Very, very good. Yet of all his contemporaries, Auden, MacNeice, Spender, he alone remains unknown.

Ida[9] is coming tomorrow and her presence worries me already. I believe she is a very, very fine photographer. The hard times she is going through are of her own making. To give her a cheque could insult her. Better to let her do some work. It is terrible that truly gifted people should be punished with a lack of money for the difficulties inherent in their temperaments. Through Gernsheim[10] she managed to sell for a thousand pounds her collection of splendid photographs of writers and artists to some Mexican university. She squandered the money quickly and now she needs a few hundred pounds to print the copies that are missing to complete the collection. She bought herself she tells me, an umbrella for £10 and a Spanish fine laced mantilla for another £10 and so on before she noticed all the money had gone. And she laughed like a child who knows that it has done something naughty. We both laughed but her wrong became my worry. I am straining my brains in search of people she could photograph. It is in such situations that I am sorry to be so isolated from one and all.

23 May

Not a bad day's work. Tried out a few new colours Rowney have produced. Very useful, not only for glazes but also for subtle changes in tones. They have just enough body to mix well with earth colours. Reading Che's[11] reminiscences. Found them less interesting than I had hoped. Fidel Castro's Foreword I found very moving in spite of its repetitions. The fire is there. A sweep of great eulogy is there too.

Sometimes I get overcome by a nostalgia for Yiddish. I want to hear it spoken. I then do the best I can; I go to my bookshelves, find any anthology of Yiddish poetry and read them aloud. The poets I pick are: Moishe Leib Halpern,[12] Manger and Kulbak.[13] Only Manger is still alive and writing as beautifully as ever. By temperament

[9] Ida Kar (1907–74), Armenian by birth – wonderful photographer and friend of many years. She was given a retrospective exhibition at the Whitechapel Art Gallery.
[10] Helmut Gernsheim (1913–95).
[11] Ernesto (Che) Guevara (1928–67), Castro's right-hand man in the Cuban Revolution.
[12] Moishe Leib Halpern (1886–1932). [13] Moishe Kulbak (1896–1940).

he was a troubadour. I was told that even in the concentration camps his poems were set to music and made into songs. He is a truly great poet of the people and the "simplicity of a lullaby" which Pasternak was after came to Manger naturally and effortlessly. I still cannot make up my mind which of the two – Chagall or him – was the greater artist. I remember giving a talk, it must have been in 1943 at the then Peretz club, under the title "Manger and Chagall". This pleased Manger immensely, though he said I should have compared him with Rimbaud. In his mind he worked out a strange image of Rimbaud – "the child of European literature". I recall him best one night during an air-raid, sitting on the steps of an underground escalator with a small suitcase on his knees, working on translations of Shakespeare's sonnets into Yiddish. His English he explained was too poor "but it is the best way of learning English, don't you think so?" The underground, I think it was Edgware Road, was crowded with frightened people trying to get to sleep, children running about and their mothers were calling after them, small children crying. The stench was unbearable and here was Manger sitting as though in the best of all worlds working on words!

I miss his presence in London. I must look for the portrait I made of him in 1940 when we were both in the Norwood Refugee camp, frame it and put it on the wall in my bedroom.[14]

24 May

Ida arrived with one of her "apprentices". He carried on both shoulders cameras and other equipment. She is amazing, loveable and exposes herself in her innocence to all sorts of hurts. But exhausting! By God, she is exhausting! Only when she takes the camera into her hands does she radiate peace and concentration. She is a true artist. Another day I must write down the epic of the way she got her "apprentices". Sometimes, she calls them "students, my students".

When Ida told me that she is already sixty, I could not believe it, nor could N. She asked me whether I still have any of the nudes I did of her some fifteen years ago. I have about half a dozen left. She looked at them and told me that her figure is even better now than it was then. "Touch my breasts and see how hard they are." She asked me to give her a drawing and sign it to "Ida Kar, of Ida Kar, Josef Herman". I asked her why such formal words. Why not sign to "Ida, Josef". "Oh no, this must be for everybody to know that the drawing is not just of any Ida but of Ida Kar." N.'s fears were unfounded, I enjoyed the day with her.

From the latest news it seems that de Gaulle will get away with it once again. The

[14] The camp in Scotland where they were briefly interned as "enemy aliens" when they first arrived in Glasgow in 1941 without passports or papers.

Trade Unions and particularly the all-powerful CGT do not want insurrections and are ready to negotiate. The students, though they put on a "great fight" it is none the less in the style of anarchic rebellion. When they talk of the change of the whole structure of society, they still cannot say what structure has to take its place. So, de Gaulle makes a few changes in the Government and the administration of the universities. The middle class is on his side but also so are the better paid workers. The whole situation has a tragic aspect. There is a certain inevitability in the defeat of the heroes. In the meantime, battles go on in the streets of Paris and the great demonstration planned by the students for today will give the police another chance for displaying brutality. I am sure that but for the police, the demonstration would have ended in songs and calm.

25 May – London

Before yesterday R.[15] rang me. He said that he will be in London for only a few days until the situation in Paris calmed down and said he had something for me. He sounded very excited and I knew that it must be very good. What he had is indeed very good. A small Senufo figurine, about 8 inches high.[16] Of rare good quality and very beautiful. I told him of my gratitude for hunting all over Paris for small pieces for me. He is the only man I can rely on to find good quality pieces. He has an eye for greatness.

It was a good idea of mine to concentrate on small, excellent pieces, the Senufo figure is one of them. Many tribes are already in my possession but by no means all. African art has a special meaning for me. Those unknown artists are my old masters. By them I am reminded that simplicity is a way of enriching the content and subject. African art was the great discovery of modern artists. But to my way of thinking the Picasso generation instead of following an example, followed a recipe, and though some good work did come out of it they nevertheless have the flavour of "academism". Even the first of them all "Demoiselles d'Avignon". The thought that came to my mind is that the African things are more serene. What we should do is follow this serenity without trespassing on their formal devices. And I still think so. What matters is the intensity of feeling, or what I call the "mood" and not formal novelty.

Not one painter under forty knows how to paint. The fuss that is made now about such non-painters as Malevitch or Mondrian. When Malevitch emptied himself of all cleverness in "inventing" designs and wanted to paint and this actually happened around about 1934–5, it was pathetic and one could only pity the fellow! Mondrian

[15] Probably Roditi.
[16] An addition to Josef's large and growing collection of African miniatures of tribal art. His passion for his collection of African tribal art was second only to his painting.

was also no great shakes as a painter. And one could go on and on demonstrating "modern art" out of its existence. And this would be unfair for the twentieth century had some true painters with true feeling for pigment, only this decade pays no more attention to their example. Everybody now talks of "the death of painting" and the end of the painter as a man standing on his two legs in front of an easel.

Had lunch with Heinz.[17] He looked through my sketchbook and liked most of the drawings; but speaking as a dealer – he added – he finds it very difficult to sell any of my pages with two or more drawings on them. I know this to be true. When people come to my studio, they too prefer one page/one drawing. However, it is with me a habit to draw whatever comes to my head and often I have no patience and draw on the same pages as many ideas as I can. I do not think I will change. Later the two brothers Agnew,[18] very sympathetic men, came into the little Italian restaurant and sat down at our table and we talked football. Took an early train home.

26 May – Suffolk

Five o'clock in the morning, beautifully quiet and good light, cool with rose hues, like twilight. After the rain – a good deal of the night – the green smells fresh. Walked for a while in the garden and now intend to draw. For the past year made hardly any drawings except for nudes. But these I did to keep my hand loose like a piano player does his five finger exercises. What I mean is that I did no drawings of a compositional character. Must get back to the routine of drawing every day for a couple of hours.

Also must write to Edwin[19] and congratulate him on his article about Masaccio, my favourite painter.

27 May

At five Mena and Bryce[20] arrived. Now that they have a car perhaps we will see more of them. I do not think they are all that happy in the professional milieu of Cambridge. Mena wrote an article about the fate of being a professor's wife; how Cambridge treated women as second-class "partners", being admitted here and there and left mostly isolated from the men's rituals. Much gusto, real Mena stuff, published in the *Cambridge Review*. Apparently the whole issue sold out and many wives of professors said how much it spoke for them.

As I see it, the student rebellion in Paris is now on its last legs. Even the Communists are now trying to isolate the young workers from the student movement. Of course I

[17] Heinz Roland. [18] Of the Agnew Gallery.
[19] Edwin Mullins, author of *Josef Herman, Painting and Drawings* (1967), Evelyn, Adams & Mackay.
[20] Mena and Bryce Gallie, friends from Ystradgynlais war years. Mena, a novelist. Bryce, Fellow of Peterhouse, Cambridge.

am sympathetic to students' emotions, even to their rising. I can see that they know what they don't want but are not at all clear about what they do want. This is why it will be easy for the French Government to split them and defeat them. The positive side of their action is that it will definitely bring about some changes in the Government and some reforms in the universities. The French workers used well the situation for their own ends but behaved in a cowardly way towards the students. They, with their experience in organisation, could have given the student movement a longer term purpose.

28 May

Meant to make a note on [Graham] Sutherland's exhibition. I was very impressed with the high graphic perception – some of his best draughtsmanship. I cannot think of anyone working today who could produce such qualitatively high work of animals. Got a bit annoyed with the reviews he got. Anything minor is praised sky-high, anything major they raise doubts, or it is denigrated or bullied into disrespect. I do not think that the critics do it wilfully, only that they are so busy wanting to help the artists to be of "our times" that their minds work like sledge hammers destroying everything which is in their way, no matter how good. Respect for quality is the last thing they can afford. The American influence on their taste makes matters still worse. Sutherland's drawing of the lion's head compares very favourably with Delacroix. This should be good, but no . . . The best in Sutherland is really very, very good.

Found my gouache painting of Manger. Was surprised how bright the colours were and how crude the brushwork . . . still, will frame it.[21] It contains many memories. Some remind me of the inherent goodness of the man and his will to do good, no matter how difficult a situation.

At this moment stands out in my mind the visit to the camp of some women from the Red Cross. As matters of routine they asked everybody what he needs in the way of shirts, suits or shoes. Though I was practically in rags, I said to my interviewer that I have everything but could it be possible for them to get me a few tubes of gouache and some paper. The woman looked at me with eyes full of wonder and said, "This may be difficult for we can give you only what people give us. However, I will see what I can do." Time passed and I heard nothing and gave up thinking about it. One day the director of the camp asked me to his office and there was a parcel for me. There they were, a limited number of colours, about a hundred sheets of cartridge paper and two ridiculous brushes, one too thin but for the finest work and one so thick that it was impossible to handle except for the whole background. However, it

[21] He had ignored how he relied on the Red Cross for supplies of paints and brushes at the time. They were not to his taste.

would have been inhuman to grumble! Tears came to my eyes but also some greater assurance and even audacity. I asked the director of the camp whether it would be possible for me to get, no matter how small, a room for myself. He said that he had none but one tiny room which is reserved for people who broke the regulations. I said to consider me as a man who broke all regulations in the book. He smiled and once again I heard the words: "impossible, but I will see what I can do". Two days later I was asked by an orderly in a very brusque manner to take my things together and he led me to this tiny room, hardly bigger than the narrow bed. But it was heaven! I cut the larger brush to a manageable size[22] and now instead of walking about not knowing what to do with myself, I put myself into work! The director of the camp, whenever he saw me smiled.

29 May

The size of the canvas I have chosen is right for a monumental work. To compose one figure is much more difficult than to make a composition of many figures. I think I am using too many colours. After a day's work I washed the whole thing off. Today may be a day of trial and error. To cheer myself up I counted on a piece of paper how many pictures I have done since my illness.[23] Well over sixty. Not bad I thought for a man who is a slow worker and lazy who has to *make* himself work every day. One has to make one's own conditions for somehow feeling satisfied with oneself. For me, it is taking stock of the few inches of good painting I have achieved here and there. It used to be drawing. Now it is painting, by which I do not mean colour but the handling of pigment. When the pigment has a glowing richness, the colour is usually right. Colour matching leads to decoration and may excite the senses but seldom gratifies the spirit. This accounts for the reason why Matisse, being an original artist, is nevertheless slight and Rembrandt is deep. One always has to keep one's mind on the basic problem of painting and ignore one's own times. So I went to bed refreshed and full of hopes for the coming day.

30 May

White is the most difficult colour. Now, with the Mexican group of pictures I am forced to use it quite a great deal. More than any other colour it is dependent on its neighbouring colours. Now I am using white freely and with not bad results. For the first time I understand Soutine's addiction to white. Rouault, too, used white very well. Braque, though for decorative ends also used it very efficiently. But none were of real help to me except that they kept whispering to me, "it is possible". Martin used to tell me that "white does not exist". The true son of a post-Impressionist, he found no

[22] Josef also made brushes out of his own hair. [23] His major depressive breakdown of six months in 1966.

Fields in Suffolk
Ink and wash
20.2 x 25.2cm

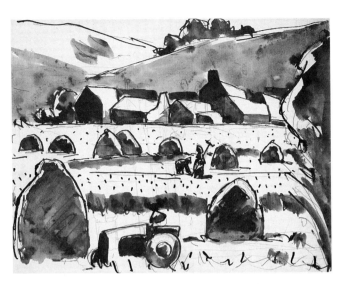

place for white in his colour scheme. We used to argue our heads off about the relative and absolute value of colour. I am sorry that he is not alive today. I miss such friendly enemies. I miss Bomberg, too, though we had little in common. Every conversation of ours ended in a quarrel.

Best[24] is really a teddy boy, though of immense talent. "United",[25] after eleven years of unsuccessful battles won the cup with a staggering victory 4 to 1. David's running commentary was as good as the commentators. Part of my enjoyment was watching this boy enjoying himself.[26]

1 June

Yesterday made real progress. The old peasant was so vivid in front of my eyes as though he really would have been in the studio and not miles and three years away in Mexico. This vividness of the real Roberto has its disadvantages. I could not get the right amount of freedom to exaggerate. The real Roberto had tiny hands and the theme of the picture demands heavier and bigger hands. Nature inhibits. A half an hour of good luck and the picture assumes its life! It is for this half hour that I am now waiting. In the meantime, I will carry on with other pictures. My mind is full of images. Thanks be for this. When I have to scrape the bottom of the barrel it is misery . . . I am alive only to the degree I am involved in my work. Life has no other precious things for me.

[24] The footballer, George Best. [25] Manchester United football team.
[26] Josef and our son David watched football together every Saturday.

2 June

What a waste of a day. Droppers-in until late afternoon. By the end of the day I felt truly exhausted. All I was capable of was to watch with David a very good Hitchcock thriller, "The Lady that Vanished" [The Lady Vanishes]. By ten we were all in bed. Had a restless night: nightmares.

3 June

A letter from the Scottish Arts Council asking me to open the Exhibition, "Painting in Glasgow 1940–1946". Without much ado I accepted the invitation. The pity of it is that J.D.[27] and Jankel are not alive, for both but especially J.D. would have enjoyed this event. In a small way I think we contributed something to the Scottish scene, if not to Scottish art, and it is good to know that our presence in Scotland is not altogether forgotten.

After a whole day's work on Roberto I have now reached the stage where I virtually hate the picture. Eagerness does not always pay. I have already put it away – face to the wall.

4 June

Last year I got so ravenous for drawing nudes that I got myself a professional model (though they are no use!). She was young and in the last few months of pregnancy. This made her interesting. Besides her, I could get no one in Suffolk to pose. I got an idea to buy some pornographic magazines and from these magazines I drew for quite some few months. In London, getting friends to pose presented no problem but in Suffolk . . . I miss the women who used to pose for me.

5 June

Selected Poems of Nazim Hikmet.[28] He is undoubtedly one of the great modern poets. In the longer poems he treads the common ground with Neruda and MacDiarmid. Once we got on to small talk, away from Party themes, how Hikmet laughed. How young he became once again. He forgot party jargon and became warm and loveable. But I could not forget the doctrinaire streak in him. To be a "people's" artist and to be a "party's artist" is not the same. This is an important distinction that faces every serious artist of our century. It is politics seen through the prism of morality and not as "committed" artists wanted, the other way round. It is not a matter of degree of talent but of the quality of talent.

[27] J. D. Fergusson (1874–1961), Scottish painter.
[28] Turkish poet of the Left. Nobel Prize Winner. Josef and Hikmet met in Helsinki in 1956 at the Peace Congress.

6 June

Robert Kennedy was yesterday assassinated.

9 June

We are here used to days and weeks when nothing happens. When the only great events are the goings on inside oneself and not outside. And when somebody unexpectedly turns up we are disturbed like silent waters into which a stone is dropped.

10 June

Although my days are much alike, my moods are not. They are my most important happenings.

Another letter from the Scottish Arts Council telling me of a mistake in the date of the opening of the exhibition in Glasgow. It is not the 4th of July but the 6th of September. I felt relieved! The 4th of July seemed too near to interrupt a lucky spell of work. Besides, by the 6th of September I may be ready for a couple of weeks' tour of the Scottish outer isles. Maybe N. will join me with the children. Maybe I will be ready to do some drawings. It is years since I have been to Scotland and I used to feel at home there.

At the moment I am not in the mood to move from this place. My inner eye is still fixed on Mexico. That it should be like this is a puzzle to me. When in Mexico I hated the place and wanted to get away from it quickly and cut the plan to stay there for six months down to nine weeks. Mexico, I felt was too exotic or perhaps too something else. The truth, as I discovered later, was that I suffered from a nervous breakdown. Back home, six weeks in a London hospital, three weeks in a nursing home and ECT. I will never forget the first day I felt a sudden urge to work again. For the first fortnight the urge was nothing more than to smear on paint! It was a purely mechanical urge. My imagination took no part in it. My nerves, yes, but not my feelings. Then all compositions were concrete subjects of Mexico! I must have unconsciously absorbed more than I could account for. Since then, and today, Mexico it is. Memory of a place I hardly looked at. Of people my eye could not see. I am fully aware that the Mexican Indians did not replace my love of painting the miners. The costume differs. That is all. It seems to be my thorny path to strive towards a consistency, an absolute consistency through little variety. The main change that the Mexican pictures have brought is a more fluid brushwork and the exploration of a few new colours I seldom touched before. Otherwise it is the same world. My world. My poor world. In which alone I can feel myself alive. Without it or outside it, I feel myself rather displaced.

13 June

Herbert Read died. A man of "meaningful quiet". A mystical atheist deeply concerned about the human lot. The small item on the 6 o'clock news, telling of his death, went like an electric shock through me.

16 June

Miska[29] arrived around 11 o'clock. He is attempting to make a film about my work which no one has commissioned him to do and no one will buy from him. He handles a movie camera as if it were a camera for stills. If he would not be going through a crisis, both in work and financially, I would have discouraged the whole undertaking but in this situation I have not the heart to say no. Since the *Observer* dismissed him things have not been going well for him. His main gifts have not dried out but because of his slowness in the darkroom, he is unemployable for the press. He is not elegant enough. Not flashy. Fortunately, our relationship is such that when he badly needs money he turns first to us. But he is no filmmaker I am afraid, of any sort. So he is wasting his time and mine. I wish I would have the strength to tell him this but I keep telling myself that this is not the time. Now he is in need of moral support above anything else, etc.

18 June

Val[30] arrived yesterday evening. Though I should feel grateful to the man who puts some order into my financial and tax affairs, I feel bothered. Today, and probably tomorrow, I will be hunting for bills, receipts and scraps in the corners of my memory. When he begins to ask me questions, for my benefit of course, I feel I would rather overpay than get into a state of panic. However, it only happens once a year!

In last month's *Encounter* I found an excellent article on Ezra Pound. So Pound lives now in his old age with the horrible (it must be horrible) feeling that the forty years' work on the *Cantos* resulted in "yop, I botched it!" One gets the feeling that he meant it but also that it is too late and nothing can be done about it. I never felt with him so much as when reading the four words "yop, I botched it!"

I am thinking of a painting I could work on happily for the rest of my life. The trouble is the nature of my imagination: too many subjects crowd in at one and the same time. A too fertile imagination coupled with a memory which does not let go, has its dangers. I see this quite clearly and yet am helpless to do anything about it. My ideal is the painter who produces very little, very intensely and very deep.

[29] Michael Peto, a photographer on the staff of the *Observer* for many years and a close friend until his death. He had been our matchmaker.
[30] Valentine Ellis, our accountant and friend.

Epstein[31] was a sculptor of genius, of this I am certain. Perhaps his lot is to be the same as Rodin's. After Rodin's death every Tom, Dick and Harry had something to say against him. Now he is back and how! Epstein's turn will come! The reaction against him is too violent to take his desecration seriously. In the meantime it hurts to see what is done to a man who was good and great.

22 June – London

Spent the day in London. Got three pieces of tribes I do not have in my collection and was truly delighted to have the additions. At the Gallery, Roland told me that the price of my drawings has now gone up to seventy-five guineas and ones with colour, eighty-five guineas. He finds no difficulty in selling them. Good! Lunch with Ida. The photographs she made at Holly Lodge are first class. Also showed me some of animals which are by far the most outstanding I have yet seen. How she gets such lovely colours I really don't know! If anybody deserves to be crowded with commissions and general acclaim, it is she. And yet she is neglected – burdened with penny problems. It can break one's heart. She knows her worth but is hungry to hear it from others. Like Cassius Clay, she tells everyone she is the greatest and *she is!*

23 June – Suffolk

The best things we do have the substance of a dream. We live most intensely when we walk in the dream. Most of our living depends on the utility of reason. Most of our living depends on it. The void is dark and frightening yet it must be faced. Reason is the cushion. The dreamer returns and lays his head on it. So human living is made possible. *Waiting for Godot* is a dreamer's record of how he got paralysed after reaching the void. All true thinking and all true feeling are the ways we choose for the return journey to humankind. I think that we are at the beginning of a new humanism which is no longer a song of the ideal, as it was with the Greeks, nor a song of nature as it was with the Renaissance, perhaps no longer a song at all but a poetic lift up of our humankind without a God and without a nice, nice nature.

28 June

By temperament I am drawn to man. Not every man, but the man of *primitive* form and this the bourgeoisie as the intelligentsia has no longer got. Hence my searches (as a painter) midst miners, fishermen and peasants. At the moment it is the Indo-Mexican. John Russell-Taylor[32] once shrewdly observed the miner's cap is for me what the halo was for the medieval artist: a symbol. I want the whole figure to have the same

[31] Sir Jacob Epstein (1880–1959), friend who encouraged Josef to collect African art.
[32] Art critic of *The Times* and author.

symbolic sense. Big, tragic and glowing with inner life. I don't know what "religious feeling" is. I trust Freud when he says there is no such feeling but I know what the impact of religion in mankind has made on its most serious art. It was heartening for me to know that Millet was an atheist. Yet he painted "The Angelus" because of the feelings it stirred up in him and not as a propaganda piece for the church. I think people still tend to call religious the experience which in reality is poetic and open to everyone, not to the artist alone. So powerful is this experience that early man could not otherwise but ascribe to it a supernatural origin. My reading of the mystics convinced me of this. Mysticism is nothing but artistic experience formulated in theological terms. There has never been a mystic per se, only a Christian mystic, a Judaistic mystic, a Moslem mystic, a Hindu mystic etc. Also I never read of a "mystical experience" which I could not verify with what I myself often experience while painting, or which I could not find in works of art. In my discussions with Meidner,[33] when he was living in London during the war, or with Adler and Bomberg, I have often noticed the difficulty that underlies all honest reasoning about experiences they know at first hand. The present fashion for Zen is another demonstration of this difficulty. Meidner talked himself into the most reactionary kind of Judaism. It was funny to watch him playing with his skull cap. Whenever he had to say the word "God", he paused, took his skull cap out of his pocket, covered his head and said "God". After this he took his skull cap off and put it into his pocket, and so dozens of times during the conversation. Adler, more fashionable, talked himself into a sort of Buberian anarchism and Bomberg went incoherent and almost mad. Meidner after some time refused to talk to me because I personified Lucifer. He never mentioned the word "Lucifer" without touching his fringed garment but one time the performance was a bit more complicated as he wore his fringed garment under his shirt. Adler was more tolerant; he simply said to me, "But Yo-seef, you too are religious without knowing it." Bomberg turned patronising and said "read Berkeley."[34] When I said I had he threw into my face, "So you did not understand him. Read him again." All three were true artists. I am glad I have a work by each. I never had a need of religion, formalised or not formalised. This is why my humanism is restricted to man alone. Very much alone.

[33] Ludwig Meidner (1884–1966), German painter .
[34] George Berkeley (1685–1753), Irish bishop and philosopher .

30 June

Yesterday, early in the morning, F.[35] rang again re. pictures. He definitely wants "Roberto" even if "I messed it up, keeping it so long in the studio". I told him that the picture is now as complete as it will ever be. This was not to encourage him to buy. Then he asked the price and I said, "Would it not be better if you come down first and have another look at it."

"I cannot do this," he replied, "I am frightfully busy but I take your word for it. What is the price?"

I told him. A sudden silence. "But for this money I can get a Picasso drawing, or two Moore drawings. I paid less than half the price you are asking for a Sutherland gouache."

I felt suddenly as though somebody had thrown a bucket of cold water over me. I know that F. has tact the weight of an elephant but this was really too much. I composed myself and said as calmly as I could, "On second thoughts, I will not sell you this or any other picture. In future, if you want anything of mine go to the Gallery, do not ring me. Goodbye."

As I put away the receiver I was shaking with rage. About 10.30 Vernon[36] rang. He was already in Colchester. I got into the car and popped down to fetch him. He was in low spirits. His wife had left him. Lunch over, he wanted immediately to go down to the studio. On the way he said, "When other men are in trouble they buy a car or other such thing." He wants another few of my pictures. "You don't know how much they have come to mean to me."

"You already have quite a few."

"Twenty. But this is not enough." He took one look at "Roberto" and said, "This is the one." In all he took three pictures and five drawings.

The F. affair is not finished yet. He rang again and apologised, "It must have hurt you, I did not mean to." Pause, "I am still willing to take the 'Roberto'."

I: "Sorry. The picture has gone already."

Pause. "When will you next be in London?"

I: "Tomorrow."

He: "Let's meet and have lunch. If you accept I will know that you have forgiven me."

I: "All right. Let's meet at one o'clock."

[35] An unknown client.
[36] Vernon Eagle, an American banker who lived in New York and was a good friend and avid collector of Josef's work over many years.

7 July

Benno and Milly coming down tomorrow for the day. I am very curious to see his new drawings he told me about. Friendship weakens the critical faculties. One tends to overrate a friend's efforts. I for one, cannot form myself into a cold fish. The two drawings he gave me wore rather thin on me and yet at the time I thought them beautiful. This is the common fault with all academicians who overnight turn "modern". Now over seventy and in fear of death, he sometimes weeps when he says, "I will suddenly disappear and this will be all to my life." Sholem Asch[37] told me that he often awakes in the middle of the night and rather welcomes insomnia. It assures him that he is still alive! Benno became oversensitive to any remark about his work except for praise. Probably he needs some assurance that his life has not been wasted. Why do we need this? Why has life such a grip on us that even expecting death we still want to know that we have been of some service to it? Even a Marxist like Ben Farrington turned in his eighties into some sort of Christian. In his latest book on Epicurus, he makes a poor effort at linking Christianity with Marxism as an eventual hope. He is not vulgar but seriously frightened.

Of all old men I knew, Martin Bloch alone showed that he needed no philosophical crutches to die. A few weeks before he was taken to hospital he said that death held no terror for him nor hope either. "It is all rather pointless and this cheers me. I agreed to live and am willing to die."

"Supposing," I asked, "that you don't want to?"

"Precisely," he answered and laughed. He laughed without any bitterness as though responding to a joke.

9 July

Since Mr Taylor took over the work in our garden, for the first time in all these six years the garden got a beauty all of it own. He approves of my idea to keep the field near my studio for poppies and sunflowers. The sunflowers are already two feet tall. The morning walk from the house to the studio through various shades of red and pink, roses on one side and shrubs on the other, is an adventure in itself.

10 July

Fetched Benno and Milly from Colchester station. We sat in the sun in the garden and had a nice irrelevant chat. How young he is for his seventy-seven years! I looked at him and thought how much I owed him. How good he was to me, how much trouble he took to help me when I was in need. Pale images passed through my mind in rapid succession. Then I heard Benno say, "He is not with us. He is far away." This he said to

[37] Scholem Asch (1880–1957), Yiddish novelist and dramatist.

N. and Milly. I shook myself as though out of a sleep and listened to Benno. He was a bit hurt that the catalogue of the "New Painting in Glasgow" did not mention that Jankel had his first exhibition in Glasgow in his – Benno's studio. I agreed with him that for the record alone this should have been mentioned. I said that it should also have been mentioned the care he took of me, that without him, neither Jankel or I *could* have stayed four years in Glasgow and there would have been no new Art Centre etc. This embarrassed him, the good man that he is and he changed the subject. But we did not go very far and once again got into the wilderness of memories . . .

Davidl[38] had chickenpox the whole week but it is over now.

Jack has finished his book on Cézanne. Once again a Lindsay marathon. The book could not have taken him more than ten months to write! As he did such an excellent job with the Turner on which he also worked for less than a year, I have confidence in this new work of his.

11 July

Today is exactly a year since I started on the Mexican group of paintings . . . I think they add something to the totality of my work. To "celebrate" the occasion I looked through all I have done this year. The progress in work was easy to follow but my final conclusion was not at all heartening. I have still far to go and am not at all sure that the years will not run out on me without fully achieving what I can only instinctively perceive. From work to work I am watching myself as if I was my own guinea pig. I am full of doubt and uncertainties with a tiny flicker of light. It could have been worse. I could have been in total darkness as I was during my breakdown. Now like a ball I am bouncing back in the direction in which I have been thrown by my fate, so far without great score.

I have no illusion about myself. I know that I would have fulfilled myself better on a greater scale if I could have been a mural painter and not an easel painter. But even here I am out of sympathy with modern architecture which uses materials unsympathetic for mural painting. This I could have overcome, given the possibility. The real point about mural painting is its public significance and its monumental scale. My pictures are but a poor substitute. I sometimes think of the tiniest canvas as a large wall. In this spirit, I work happiest. I hang on desperately to this illusion. The only original picture, completely my own, that I ever painted, was the mural for the Festival of Britain. All that preceded it found its culmination in this mural. All that followed it were not pictures but conceptions in monumental art.

[38] Yiddish version of David.

13 July

Taner [Baybars], his Cypriot-Turkish mother and Christine stopped off with us for a few minutes. The mother took a cup of coffee. What a gem of a woman! I could see her running a home, serving food and ready with common-sense advice. She speaks only Turkish and Taner was the translator. I congratulated him on the translation of Hikmet's poems and said that its greatest success is that we can hear Hikmet's voice. He said that he had never met Hikmet, that it was all instinct and that sometime after the translations had been done he heard a recording of Hikmet's voice and it was exactly as he had thought it would be! Poets often have that intuition for men and landscapes and their instinct proves true to the fact. I cannot quote at the moment but I do recall some renderings of places where the poet has never set his foot and yet had more than a mere evocative exactness. Taner was rather bitter that of all the magazines *The Statesman* alone did not review his translations. I was not surprised. *The Statesman* has the smell of a parish weekly and like their contributors to see nothing, hear nothing which is beyond the confines of the parish.

The visit was short but had on me an emotional impact. Particularly unforgettable was the mother; short, heavyish, silent and monumental. She could have been one of the many basic-women I am always attracted to.

15 July

My only desire is to be locked in the National Gallery and be left there for weeks. As I am looking through last week's work I am almost in a state of panic. All has to be washed off, forgotten and started again with new things. Writing this down gives me some feeling of relief. Years of work change nothing in the swing between failure and achievement. Perhaps one only learns to live on swings in the mid-air – imagination and memory, these are the sources of ideas. The trunk of a tree is the perfect example of how a human figure should stand, so that brushwork and the texture which follows from it should be *hidden* in between the basic lines. Simplicity plus intensity – these are the secrets of good work.

18 July

A very amusing morning at Sotheby's. The sale[39] was not an important one – then why the television lamps and cameras? Ah, there was one Lowry painting for which Sotheby hoped to get a record price. In the end this prima donna painting only got £3,000, much too little for the television people to get excited. No price, no fame – no fame, no television! I am sorry that this simple man, Lowry, became a victim instead of the *star!*

[39] One of many he attended.

I am often asked, even by sculptors, whether I do sculpture. Very often I exhaust my sculptural desires in a drawing and feel perfectly contented. The day I do not draw I feel as though a limb of mine is missing. The day I draw badly I get into a panic and take it out on everyone near to me. I am obsessed by a fear that one day I will awake and find that this is the end of me. With painting I have no such fear. Why?

Family on Suffolk Beach
Ink and wash
25.2 x 19.7cm

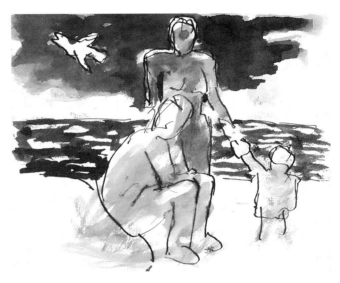

21 July

Bryce, Mena, her daughter, her baby, and Mena's mother came for tea. In Mena's presence I always feel nostalgia for Ystradgynlais. Bryce has a very good mind and like all true philosophers he is striving towards common sense but is still frightened to be *too* simple. His values on contemporary poets meet to a degree with my own: some reservations towards Eliot and Auden, a greater appreciation of MacDiarmid, Neruda and so on.

Mena's mother, short of sight at 82, is still the sweet old woman I remember from Wales and Welsh from the toes to the end of her hair. She still lives in her little bungalow in Craynon and told me a bit about her neighbours I knew, how they aged and how sadly fate has dealt with them. The colliery where I used to spend so much time underground drawing, is now shut. Onllyn is completely derelict. It has always been a dramatic, desolate place. Ystradgynlais has developed but for work people have to travel deeper into the valley.

It was all like listening to echoes. Mena's mother's voice, rich in Welsh intonations, seemed to come from all corners, all at once. I wanted to hug this old woman as though she was a young girl and we both would be alone in the mountains. All our desires, which sex and youth have monopolised, are in fact still present when we age.

Mena's body still seems as lovely as when she was the girl I knew in Ystrad and she used to pose for me. Time has done a certain amount of damage. The flesh on her arms hangs loose. The fingers of her once beautiful hands are bent with arthritis and of course her neck got red and wrinkled. Somehow I can no longer bring myself to ask her to pose in case other disappointments reveal themselves. Youth and old age are the two stages of women I can cope with. Could not take my eyes off her 24-year-old daughter – she is exactly as her mother was in her twenties. When they left I had tears in my eyes – was it Wales? Was it the young Mena far, far away? After so many years I still feel Wales is my natural home.

23 July

Today is speech day at Salter's Hall.[40] I know beforehand Davidl's results. He came first in all subjects but one: mathematics. In this he came third. He will also get the *history prize* and form prize – a silver cup. The boy is very excited and quite uncertain about his future. From the autumn onwards he will be going to the local grammar school. In some respects he is very like myself, frightened of change.

Last night he seemed a bit bothered. When I asked him what it was all about he said, "No more Salter's Hall, a pity." A long silence. Then, "I was very happy at old Salter's. I like Mr Miller.[41] It cannot be helped, can it?"

"No, it cannot," I said. To get himself out of the sad mood he turned on the television. I sat down in the rocking chair behind him.

I was asked to sign a letter to free Pound. In the end I could not bring myself to do it. Not that I don't see the difference between the positive values of genius and the negative "values" of fascism. The pity of it is that Pound did not see it or still worse, did not want to see it. No artist can claim immunity from his physical actions. But I would be against capital punishment, not because we are dealing here with men of obvious talent but because I am against capital punishment altogether. I am for morality free of thirst for blood. All this demands further probing into the problem. Even if a Céline would, in his books, defend what is humanly indefensible, to take the example in its extremity, fascist atrocities would still claim for him the freedom to do so. He could be answered by other men of genius and be proved wrong-headed. But once he leaves his field of art and allies himself in the class battle with forces of evildoing, he can no longer claim artistic immunity. Complete art demands complete freedom and often even social *inactivity*. It is social activity that is subject to battlefield morality.

[40] The school in Sudbury which David attended until 11 years of age.
[41] The headmaster – a lovely, inspired man with a genius for the job.

25 July

I never knew that one can mourn a pipe. Yet I got very sad indeed, yesterday, when my Dutch clay pipe broke into irreparable pieces. It was very beautifully shaped for a cheap pipe and gave the coolest smoke. For the whole year, at all waking hours, it was in my mouth. I got as used to it as my own lips. Besides it was beautifully glazed and looked well.

Heinz and Lil are coming down on the 25th of August. He is a bit worried that the large van Gogh exhibition is at the same time as my own and knowing the habits of the English critics I may not get enough attention. This exhibition of mine worries me the least. Exhibitions have become a sort of arena in which the artist, like Mr World, displays his own self . . . am I not beautiful?! False vanity! What are a few years in relation to a lifetime's quest. Personally, I am rather cynical about commercial exhibitions. No artist should have more than one exhibition of *all* his works – failures as well as achievements after *his death*. "I have been here and this is what I have done and *now goodbye!*" I would settle for this. But the economics of an artist's life are such that picture-dealing, hence exhibitions, are the fabric of his daily existence and all the fanfare nonsense that accompanies it! When one has gone through as many of them as I, one should be able to take it easy and with a smile. But it is *not* so. The performer in each of us comes to the fore for a short time and how *silly we look!* If anyone wants the spectacle of a lost soul he should only look at an artist in the crowd on the opening day of his show! I once had the following conversation with Morandi.

Morandi: "J'ai peur des expositions, et vous?"

I: "Je les déteste."

Then he went on to tell me that at one opening of his exhibitions he had to run the whole evening to urinate every few minutes. Because of the sell-out of my recent exhibitions, two young artists even wrote to the *Tribune* to the effect that I have sold myself out to the bourgeoisie! Well, well. Most of my sales are due to the energies of Heinz. I wish I could do away with one-man shows for the rest of my life, yet I do not see how this blissful existence could be achieved.

29 July

Whenever I am drawing a human form I am always conscious that I am drawing a social being. This affects the nature of the form itself. In drawing nudes the interest varies. But these I treat as a pianist does his five-finger exercises, though sometimes they are more than this. For fuller expression I have sometimes to use gouache or colour or both.

4 August

So far I have kept away from the Matisse exhibition at the Hayward and Moore's exhibition at the Tate. No particular reason except that I am not in the right – call it receptive – frame of mind to look at the work of others. Perfunctory visits to exhibitions are a waste of time. At the moment I am terribly impatient of works by others except the ones helpful to my own direction.

11 August

N.'s trip to Scotland with the children is definitely off. I cannot say that I regret it. Both Rebekah and Davidl are a great joy to me. The older Rebekah gets, the more of a charmer she becomes. After a day's work it feels good to be with this little family of mine. Yesterday I had my first day of working well. It felt like being reborn.

25 August

The last few days I have felt anxiety about the outcome in Czechoslovakia.[42] In many ways it was a deeper anxiety about the future of socialism. My mind was not at all appeased when the communist parties of Italy, France, Great Britain etc. condemned (half-heartedly I must say) the Soviet action.

Deutscher's[43] book on Stalin became my sole nightly reading. I cannot imagine any thriller being more breathtaking. Knowing his hatred of Stalin, the degree of historic objectivity he achieved is really astonishing. In the meantime I gave Kierkegaard's journals to N. to read.

Reading the second part of N.'s novel. The more I read of the novel, the more certain she has got something there. Like with all first undertakings she is full of fears and uncertainties. Fortunately, it does not reflect in the style. I am glad for her.

29 August

Yesterday delivered all pictures to the gallery. Heinz is still very enthusiastic about them. The partners showed little interest. Heinz also said with a sad tone in his voice, "Should I die before you, it would be wise to leave the gallery." I said that without him I would not have stayed with the gallery for twenty-four hours. I would positively *dislike* working with Lillian and Gustave. We worked ourselves into a better mood and parted in the best of spirits. Never has the coming of an exhibition worried me less. My imagination simply swarms with ideas and images and there is a drive in me for continuous work.

Got a lovely Maori brooch for N. On the way home I showed it to her and she was in seventh heaven! Every few minutes she commented how happy it made her. Each time a day in London makes me realise how much my solitude is good for me.

[42] Russia's invasion in 1968. [43] Isaac Deutscher (1907–67).

31 August

Preparing notes for the opening speech at Glasgow. Will try not to talk for longer than fifteen minutes.

The news from Czechoslovakia is very sad. Russians are using all Stalin's means from clumsy lies to extreme brutality. The Prime Minister appeals to all intelligent people to leave while there is time, that he can guarantee no safety; his own safety, he said, is not certain. It brought tears to my eyes. The theoretical implications are clear. The Russians are fighting for the centralised idea of communism. What Moscow says goes! No experiments with individual freedom, national freedom etc. Moscow knows best! Soviet Russia must be written off as a socialist state. With all this on my mind, I find it difficult to concentrate on work at hand. Yet it is in my studio that I find some sort of peace.

3 September

Writing this journal is like so much else in my life, very much subject to routine. If I write every day I have something every day to write about. Should I miss a day or two my day seems empty and I have nothing to write about. My interest in the political world does not come from any will for active participating. It belongs to the number of passions which make for my belief in the social nature of art. But it never makes me want to paint an image related to the ''hot'' moment. Mine is a slow movement to link up with all those artists who had the people in their mind when they decided to become painters. Thus my only significant time is the time I spend in the studio; in daily living I just drag along.

4 September

Received a letter asking me to add my signature to a broadcast by the BBC to the Russian people, a copy of which will also go to the Soviet Embassy. Though the letter drafted by Jack [Lindsay] is very mild indeed, I agreed. The Russians, I am certain, are confused and a strongly worded letter may not get through their thick heads but they might listen to a mild voice. Others who have so far agreed to sign are Priestley and Iris Murdoch I was told.

8 September

Back from my sentimental tour to Glasgow. With the exception of the two hours at the Kelvin Grove art gallery,[44] spent most of the time walking the streets, revisiting old places I knew so well. Glasgow has changed, but not enough. There are still too many slums reminiscent of stark poverty. I hardly used buses. I preferred to lose my way and

[44] The Glasgow Art Gallery.

find it again. No, I have not lost my ties with this city. I remembered, I remembered. Grove Park Street[45] was still there, all new faces but with a great family likeness to the tenants of twenty-five years ago. Besides this, Glasgow is getting the "international look". I am not so sure that I am "with it". The white concrete does not stand out well against the northern light. Looking at the sky, the little that remains of it, I got more nostalgic than looking at the walls. Northern light is my light! Then, heavens, who is this middle-aged woman dressed in such "with it" clothes. It cannot be . . . yes it was. The young girl who worked at Maples[46] and used to give me an extra egg to my rations so that I could make tempera. She recognised me and said in her warm Glasgow accent, "Yosef! I would recognise you anywhere . . . you have put on weight." I hugged her and kissed both her cheeks. I remembered, I remembered. We went into a Wimpy's for a cup of coffee and we exchanged small talk.

To harden a bit I made my way to the Art Gallery. I went from room to room over and over again until I got physically exhausted. Out in Kelvin Grove Park, not a soul around. I spread myself out on a bench and though I did not sleep, was only half awake, I dreamed away for a few hours. Then I walked in the park and thought out what and in what order of things I will be speaking in the evening. It went through quite well but not as well as when I talked to myself in the park.

I am still deeply moved by this sentimental journey into the world of memories and my old love for the city of Glasgow, the few people that are still alive and still there. My opening words, that in this gathering I missed the two faces of the late J.D. [Fergusson] and Jankel, came from the heart like everything else I said that evening of this I am sure. Even at this moment when I am writing I can find no exact words to express my nostalgia. And how did Jankel's work of the time look to me now, or J.D.'s? It did not matter. My critical faculties did not function. Their personalities mattered to me more than their works. And still do. Until this trip I did not know how attached I was to them. One postscript: the industrial landscape seen through a window of the train just before the station of Motherwell seemed to me grand and beautiful.

9 September
Tomorrow is David's first day at the Grammar school. I am nervous.

20 September
Yesterday I spent the whole day in London. Heinz told me that Douglas Hall[47] was at the gallery and he suggested to Heinz that his museum would be ready to show

[45] Josef's old original studio. [46] Presumably his local grocer at the time.
[47] Douglas Hall, Director of the Scottish National Gallery for Modern Art and a good and loyal friend for many years.

Heinz's collection of my drawings together with my collection of African things. It would have made things easier with the trustees if Fagg[48] of the British Museum would OK my African things. Now Fagg does not know of my existence or of my collection and I doubt whether I could get him to come to Suffolk. It will be best to leave the whole thing to Douglas and Fagg.

Lunch with Cliff and Dorothy. She is now the vice president of the London Group. I committed myself not to resign from the London Group though I see no function for it. The Group's exhibitions are no longer representative of anything or anyone. The truth is that they get very few worthwhile things. We also talked about a man who through Sotheby's sold four pictures by Cliff as Bombergs! To make matters more comic, the man got authentications that these are genuine Bombergs.

A letter from the Israel Painters and Sculptors Association asking me to be an honorary guest at their National Conference on the 8th of October. Not a word about expenses. Some honours which come my way are rather expensive! Their funds most probably are very meagre but I cannot see how my honorary presence there could justify the expense, effort and time.

What goes under the name of Fine Art belongs to philosophy, sociology and morality. A picture is never a picture unless it is also something else – an atmosphere, a mood, a monologue turned into a dialogue in the sense that it is more than for one pair of eyes and one human spirit. Its place is on the wall but its reality is in the spiritual *why*. Why it has been created at all. A chair can only have one element of a work of art: taste. I can go with Bauhaus only half of the way and even this with a great strain on my poor intellect. In itself the mixture of Rudolf Steiner, Mme Blavatski and Nietzsche did not add to a health-giving medicine.

18 October

The most important event since my last entry was William Fagg's[49] visit to assess the collection of Negro Art. The quiet man worked indeed very seriously for well over three hours looking carefully at each piece. I think he liked quite a few pieces. In fact he said so. After Fagg's visit I felt a bit more assured. He agreed that all my favourites are worthwhile things.

In the meantime on the 15th was the opening of the exhibition. Heinz had put in too many pictures and too many drawings. The walls are heavy and crowded. As for the results I am astonished. In the first two days practically all works have been sold! But the most touching thing was that the staff of three, at RBD, each bought for him or

[48] William Fagg (1914–92), Keeper of Museum of Mankind.
[49] This visit to Suffolk was the beginning of a close and loving friendship until Bill's death. Josef often sought his expert advice before buying a piece.

herself a drawing! Naturally we made for them special prices, none the less it was something that these young people should each want to have a drawing of mine.

Another moving thing happened yesterday. Richard Gainsborough came yesterday to the exhibition and made the following suggestion to Heinz: that he would commission me to paint a self-portrait which after our deaths his son would donate to the National Portrait Gallery. I have not painted a self-portrait for years and years. I am really not my own type. However, I will try my best. No matter what I will equip my studio with a mirror and have a good look at myself.

19 October

Heinz rang yesterday to tell me that the trustees of the Scottish National Gallery for Modern Art have agreed to the exhibition. Hope I have not offended Douglas Hall. If I did it was through sheer clumsiness of the way I express myself when I am in a hurry! Why did he not write to me?

The van Gogh exhibition starts next Thursday. It will be good to see an old friend. Awaiting the exhibition with great impatience.

26 October

If sales are anything to go by, the first eleven days of the exhibition are a "success". (How I dislike this word!) All due to Heinz's work. He did not spare himself and out of eighty-one only ten are now left and the show has still to go on to the 16th of November.

21 November

N. has indeed been very ill. As always in such emotional upsets we recognised it late but in time. She worked in an inhuman way on her novel and got herself into a complete state of exhaustion. I got an idea to take her to a sunny place and give her a complete rest for as long as it is needed. We went to Malta. In the meantime I recognised that I too needed a rest. We stayed in a secluded bay, the Paradise Bay, at the Paradise Hotel. We slept for forty-eight hours with the only interruptions being meals. It was sunny and quiet and indeed very restful. Later we explored a bit of the island and indeed Malta turns out, to our amazement, more beautiful than we were made to believe. Within four days N. was a different person. What a difference one week made to her. I knew that she was better when she began missing the children and our life at Holly Lodge.

Jack gave me the proofs to read of his Cézanne. The portrait of Cézanne that emerges is probably the truest I have yet read but the first chapter is unduly heavy. I hope I have not lost Jack's friendship. I fear I have written a few hundred words: "A

Postscript to my Mexican Painting". I did not want Sonntag[50] to ask of some critic or other to write yet another review. They have really nothing more to say about my work and flattery depresses me. Critics when they are asked to write about an artist feel that they have to be "kind". This goes under the heading of "appreciative criticism". I am really out of sympathy with the "new generation criticism". The very way they look at pictures gives me the creeps. One of them praised my drawings for "their sparkling surfaces".

22 November

The Welsh Arts Council is organising an exhibition under the title of "War". They have asked me for my "Aldermaston" picture I painted in 1963.[51] Today I took it out and am more pleased with it than I thought I would be, but I don't know what to do with it. To give movement to the three banners may take away from the stillness of the picture. However, I will continue to look at it, maybe I will find some solution. It is the red that is too hard in outline, I think. This is I think what bothers me most.

26 November

I was rather hasty in my judgement of the Mexican mural painters, Rivera, Orsoco, Siquieros, Tamayo etc. The very fact that they attempted what no one else was doing on such a scale is already in their favour. They seem now to me to have been the first painters with whom politics found its own iconography. Curiously, their iconography stems from similar roots as religious murals formerly: teaching a people its history, its heroes; awakening in people pride in themselves, pride in being free, in being man. They modelled themselves on religious murals of the past, but not for long. Each man found his own single way. All of them composed well and designed well, it was their colour sense which disturbed me. But this single blemish should not have blinded me to their own accomplishment, particularly their draughtsmanship which is quite considerable.

10 December

What I feel is the matter with most journalism is its closeness to fact and its false sense of urgency. I wish I would know at least one language! Received a letter from Fagg. I came to like this man very much after two meetings only. He asked me to become a member of the British Museum Society. I wish the British Museum could get itself a building like the Anthropological Museum in Mexico City! With its collection properly displayed, it could be one of the finest museums in the world.

[50] Jacob Sonntag, then editor of the Jewish Quarterly.
[51] We had stood in Kensington High Street to cheer the great event marching in.

13 December

This morning the fog had a great deal of rose in it. The silhouettes of the trees were of pale blue. Suffolk looked rather lovely in the fog. Two tractors with beams of hard light were already roaming the field of sugar beet. I walked about the lane for a few minutes then went back into the studio.

24 December

Charles Spencer is at the moment organising for the Camden Arts Centre an exhibition of English landscapes. Heinz asked him whether he will include a Herman. Charles answered: "No, he is not in the English tradition." This would be fair enough if this would really have been the reason. Most "anthologists" have recently taken to exclude my work from their shows. The real reason I think, is that at the moment there is an undercurrent against me. Critics, the Arts Council, the British Council, the whole pack. I know their human and intellectual qualities and I know I can expect still greater meanness.

25 December

Christmas Day and I am in the studio, but to please N. I will have to have lunch with the whole little family of ours. I don't know why I dislike so much not only Christmas but all holidays. N. has arranged a programme of visitors which, commencing tomorrow, will keep us busy well into next week! But as long as I have my morning's work I mind it little.

27 December

More or less finished the article on the Mexican contribution for *Art and Artists*.

4 January 1969

At long last received Edwin's[52] book on Braque. I was impatient for I wanted to read it. Braque belongs to the group of painters whose work affects me very little; at whom I look as a child licking a lollipop! With basic enjoyment and greed. He is the most painter-like of all his generation of painters. That he should have liked so much the humble Corot! There are some paintings of his that go deeper than the sense; some of the seascapes and landscapes. With Braque order is part of the silence. The deep quiet which has its own way of playing on one's feelings. There are other things I like about Braque: that he learned a little bit from house painters things which gave his most lofty pictures enough everydayness to keep the dangers of "good taste" at some distance. Jack told me that after having finished his book on meetings with poets he suddenly

[52] Edwin Mullins.

remembered how neglected MacDiarmid is and decided to dedicate this book to him. This was a really good thing to do.

Apparently he is dedicating his Cézanne book to me, unless I misunderstood him. He told me this in a hasty mumble, obviously embarrassed. If I understood him rightly, and it is as I heard, it would give me great pleasure though I don't know why I deserve it.

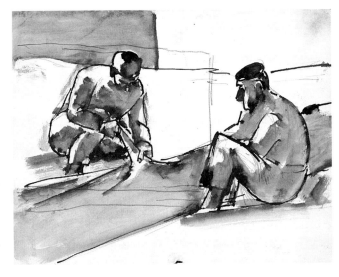

Fishermen with Nets
Ink and wash
17.2 x 22.3cm
(overleaf) **Nude**
Ink, wash and watercolour
25.2 x 19.8cm

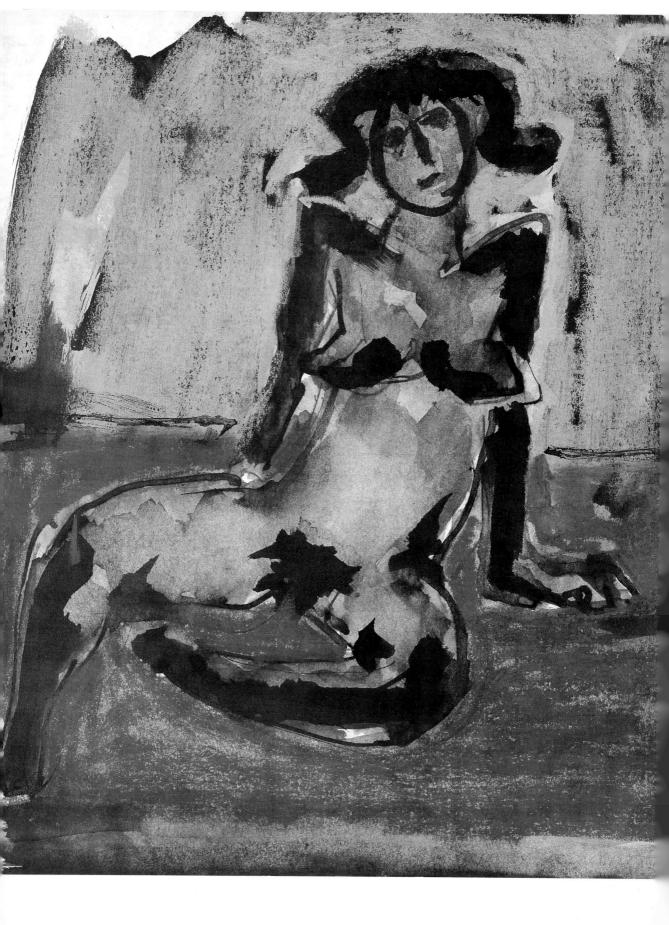

26 October 1975 – London

"The Great Image". I keep thinking of the "Great Image" as mystics used to think of "The Big Word". But I don't know what it is. Will the world ever be free of misery? The moment of absolute peace – this is all one works for, though it is not all one lives for. Thomas Mann called artists "moralists of achievement".

29 October

I listen to a lot of music but nothing moves me as deeply as anything by Beethoven or Wagner, sometimes Bach. It is more profitable to read and reread one's few favourite books than to read something because it is in fashion. This is also true for music and painting.

I have recently been painting a lot in watercolours. Am very satisfied with most of what I did. I have shown a selection of them to Roland and we agreed on an exhibition of them in April '76.

Rebekah wrote a poem and she came to the studio and showed it to me: "It rains and I cry".

I took her in my arms and kissed her little head. I wanted to hear more about this poem. To provoke her I said, "Darling, but it is a sunny day . . ."

She tore away from my embrace and said, "Daddy, you understand nothing. It is all imagination!" Where did she get this word?

30 October

Yesterday a celebration dinner. The occasion sixty years of the existence of Ben Uri.[1] The most moving part was the chairman's – Alex Margulies's – account of the origins of the Ben Uri. A few tailors, cobblers and carpenters got together in a café in the East End and spoke of the need of an Art Society for the Jewish community. None of the speeches which followed meant anything to me. It was a rather pleasant evening.

Strange. The watercolours lead me into a sphere of brighter colours. But the stillness has not changed. In many ways some of the watercolours have a deeper stillness than anything I have done before.

[1] Ben Uri Gallery, London.

31 October

Sibelius's Symphony No 2. Must listen to it more often. Only work gives me tranquillity. Tranquillity is what a man needs most. Yesterday we had lunch with Ellen.[2] She is ageing. For the first time in years I felt tenderness towards this old woman.

Oxford looked lovely in the warm light of autumn. All the way back to London I felt like singing. It was a splendid day.

5 November

Artists are workers and not intellectuals. This should never be forgotten.

7 November

We begin a picture with a general mood, a state of mind. Nothing is seen before it was painted. This is how we get to know reality. Mood is for the artist what enquiry is to the scientist. (What goes into the making of a worthwhile work of art cannot be understood. It must be felt.) I thought of Goethe from his *Jahrsbücher*: "I could have been a beggar, a highwayman or a king. But it so happened that I am a poet." To paint one needs a mood not a philosophy.

10 November

It appears that N. has a record of Sibelius's Symphony No 2. I listened to it with still greater intensity than the first time I heard it on the radio. To me it ranks now together with Beethoven's Ninth as my favourite. The opening is quiet enough, lyrical, descriptive of a reflective mood. As it goes on it gathers in strength and invention until at the end it has a power that I cannot find in any other musical work.

N. bought me a dressing gown which not only fits me but also suits me to perfection. I feel it is so comfortable as I seldom feel in a new garment.

12 November

Listened another time to Sibelius's Symphony No 2. Music is the most concrete language of the emotions. When we are looking for the thought we cannot find it without making it slight. Yet there is in all great music a thought content but about this we should better attempt to use a poetic language. Even then I am not certain we will get far. With true painting it is the same, almost the same.

13 November

Each material changes its nature by the way it is used – this apropos my recent

[2] Nini's mother, Ellen Ettlinger, in Oxford.

preoccupation with watercolour. At dusk even the familiar becomes like a foreign land.

Virtuosity can impress. A sustained naivety is truer to the nature of painting, to all art.

14 November

A small bother but it upset me. Apparently Reece Pemberton told Roland that I over-varnished his "Rower" that he lent for the Glasgow retrospective. A pity that Pemberton did not tell me this for I could have told him to bring the picture to me and I would remove the varnish. I suggested this to R. and I also said that if he does not trust me let me give the picture to my restorer and I will pay for the removal of the varnish.

Studying nature we'd better leave to the scientists. When I am alone with twilight all around me, this is when great things happen.

The drawings of the Impressionists are feeble because they tried to draw without outline. Only outline can define form. No outline, no form. Degas understood this.

Painting should not arouse in us the same feeling as things of nature. The Impressionists thought it should. Another of their mistakes. Pigments are matter capable of expressing the whole range of human experience. They can even express nothingness if this should be the artist's desire. The visual process must be treated as an inward tunnel towards feeling and not as a way of gathering data.

16 November

For the past few day I have left the studio only for meals. I have hardly stepped outside the house. The watercolours absorb me completely. The temptation is to work for the accident and not with the accident. Some washes are so lovely that one often feels inclined to leave them and not to struggle on for deeper expression.

"Imagination is the queen of the faculties. Originality is no longer enough.
We need an image popular enough to appeal to our collective unconscious."[3]

Most twentieth-century art is too theoretical for its own good. There are by far too many techniques – what is one to do with so many techniques?

17 November

With many of my watercolours I took the sun as my subject – not a motive; a subject more of the imagination than of nature. The big silence of light! Not the physical contrast – this does not interest me, of this I am certain, but the encouraging YES it says to our lives. In some watercolours people just stand and look at it, ordinary men and

[3] Charles Baudelelaire (1821–67), French poet and critic.

women awakened to wonder. In science, the sun is a fiery star set in orbit. This is only one side of the coin. For the human heart it is a source of prodigious variety, dreams, even hopes beyond words. Small wonder that the sun has ascribed to it godly powers in the earliest myths.

18 November

When Apollinaire wrote a quite conventional lyric but put an aeroplane in the sky, he was greeted with acclaim: how modern, how new! I say that Rouault is just as modern without an aeroplane in the sky. It is not a matter of producing an encyclopaedia of modern gadgetry nor going on inventing "new" techniques. It is a matter of conquering the anxiety which bedevils the existence of man in our society. Not to deepen man's alienation but doing away with it altogether. The set themes of the so-called "modern" artist bore me to tears. We need now other attitudes to triumph. More basic, more human. (I speak here for myself. On the whole I do not care much for "general principles". They sound too much like "schools" or "movements": manifestos!)

R. the other day – when I suggested an exhibition of my watercolours said: "What we need for your next exhibition is a few major pictures." He meant a few larger canvases – large oil paintings. Many people regard drawings and watercolours as mere "preparatory" things for the "greater" oil paintings. What nonsense! As though size and material could be indicative of achievement! The "sketch" and the "finished work" really belong to the past. To have done away with this artificial division is really a modern achievement. This is one point on which all modern artists agree. Our so-called "connoisseurs" have not yet caught up with it. In a more arbitrary way "first thought" and "final design" do exist. I myself often begin with scribbling on paper no matter what, when gradually the labour acquires a more decisive purpose and an image takes shape. However, this is one of the countless ways of the process of work. The final work may not at all have a "finish" in the Renaissance sense, nor does it inevitably lead to a large canvas!

"Science is almost always fatal to the Artist."[4]

19 November

I got so exhausted this morning working on a watercolour of a man sitting on the sand facing a yellow sun, that I had to give up the idea of working on something else. I seldom worked with such intensity and such concentration. I think the watercolour

[4] Eugène Delacroix (1799–1863).

shows this. One question kept on nagging me: do I leave too much out? For one minute's certainty I pay with a day of doubts.

20 November

How I dislike polemical writings! Let each have his say without abusing the spiritual territory of the other. Why argue, why quarrel? We all have only one right! To speak one's honest mind. Yet the most difficult thing in our life is to respect the rights of others which we ask for ourselves. Nobody can help being what he is. Least of all the artist. Art critics use a dreadful language about artists they do not care for. I read today . . . oh why go into it.

Yesterday, at the RDB gallery I talked with D.[5] He told me that the large exhibition of Millet, now in Paris, is coming to London. I got excited. I doubt if anything new can emerge – I think I know Millet as much as can be known – still it does the heart good to see things one has loved all one's life. With so much dead wood, it is wonderful that one truly great artist is brought near our eyes. I doubt whether in the whole nineteenth century there was a greater draughtsman: Delacroix, Daumier, Degas. The essence of Delacroix's draughtsmanship is *movement*, of Daumier's *vitality*, of Degas' *precision*. But Millet's draughtsmanship has a kind of *serenity*, typical only of him. How wonderfully his outlines frame the whole silhouette of a man, woman or thing! I can hardly wait for this exhibition!

21 November

No painter can change his basic nature. He can change his manner, even his style but what is basic to his nature will always come through. In this sense I believe in destiny, we are its prisoner and cannot escape it.

When I hear a painter say he has just finished a half dozen or so pictures I envy him, for I have not in all those years of labour finished even one picture. I do not know what it is to finish a picture. I could quite happily spend all my life on half a dozen pictures.

> My love for the colour of dead flowers.
> The deep light of dusk,
> To work with all the intensity of living impulses.
> The rest is labour,
> Falling,
> And rising again.

[5] Possibly Delbanco whom Josef called "G".

22 November

What I see, everybody sees. What I feel, I alone feel. No one can challenge your nostalgia, your joy, your anxiety. All this is your breast, or heart or wherever. All this is our mute "yes" to life.

Today I remembered situations I thought long forgotten. The great adventures while walking along the canal bank of Ystradgynlais. Tears came to my eyes so strong was the nostalgia for those days. I saw against the peach colour light the silhouette of a man standing and looking into the water. This is enough for an image of human grandeur. I was dreaming with open eyes. Compositions with silhouettes and a rose background signifying neither space nor emptiness nor light. A rose colour just to warm up the black of the silhouettes.

"The artist belongs to his work, and not the work to the artist."[6]

"I walk near the wall not to be in anybody's way," – a vagabond I talked with at Tottenham Court Road.

"I need a pipe to hide behind the smoke," – a man I met at a cocktail party.

23 November

Non-existence is the most difficult thing to imagine. This is why we can endure so much and do everything to delay the inevitable death. I am like everybody else. I cannot bring to my mind what non-living is. I am absolutely free of the *fear* of death. And so I do not mind whether I die now or in a month or in a year.

Today for the first time in days I went with N. for a walk in Holland Park. Rebekah came too with her little friend. It did me good to breathe the fresh air after being cooped up in the studio. The park was at its autumnal loveliest. I was also enchanted by the unexpected sight of pink flamingos but Becci said that these birds have always been here.

Davidl is still working hard for his scholarship exam. N. regrets that though she has the will to write, she has nothing to write about.

We were both in a mood of half-contentment and half-melancholy.

24 November

"Without ideals, life is but a ticking epoch."[7]

Perhaps it is better to have a conscience than to have ideals. Every tyrant has ideals, none had a conscience. A weary day, little work. I feel old, tired and empty.

25 November

A personal morality is no substitute for a collective morality.

[6] Novalis (Friedrich von Hardenberg) (1772–1801). [7] Honoré de Balzac (1799–1850).

28 November

Most of the day spent brooding over the idea of leaving the gallery. The so called "art world" fills me with disgust. I would like to get out of it, sit in a quiet corner, continue my work in peace and quiet, not to exhibit – particularly not to exhibit, not to hear, not to know what anybody thinks of me or my work. After leaving RBD I would not work with any gallery . . . I would . . . I wish. When will I do something about it? This is not the first time I have thought this way and while thinking this way I feel good, elated and free. It is time I did something. First I must discuss it with N.

1 December

There is a gladness in living . . . otherwise who could endure it?

4 December

One must write from a position more enduring than a passing mood.

5 December

A small party at David Wolfers.[8] The High Mistress of St Paul's Girls School gave me a lift home. We talked about the good St Paul's did for David. I think she was pleased to hear me praise St Paul's teaching staff.

At last it appeared in print. The review of *Related Twilights*[9] in the *Anglo-Welsh Review*. A review by Peter Abbs. Beautifully written and with unusual insight, with sensitivity to the pattern of the book. I felt immense gratitude to this man whom I don't know.

6 December

Read this morning Rimbaud's *Illuminations*. He nearly inspired me but didn't. Perhaps he stakes too much on words! True illumination escapes him because he chases words. There is a greater sincerity in Whitman.

7 December

Great men are not very companionable. Even in the company of others, they are alone. Their lives are neither exemplary – though their labours are – nor should one aim at imitating them. Greatness is something only the great can live with, greatness is unrepeatable. It stands by itself like a lighthouse in the ocean. They are of life and for life. As for their place in time, this is a matter of fashion.

[8] Of the New Grafton Gallery in Barnes, London.
[9] Josef's autobiography *Related Twilights. Notes from an Artist's Diary*. Robson Books 1975. New edition, Seren, Wales (2002).

8 December

Awoke this morning with the most painful pessimism in my head . . . not a thing seemed worth doing . . . I felt strongly that I am neglected by one and all, what's the use? No painter has any influence on life. Let alone myself. Perhaps I am exaggerating but I feel this strongly. When I go to galleries and see what painters are occupying their heads with, I cannot respect their premises. Even the best seem to have surrendered to the fashionable and the empty. Even the slightest is blown up with self-importance, with "personality". Nobody seems to have any faith in anything, no intimate belief in anything. I keep telling myself – ignore all this around you. To ignore all this is already remarkable. Yet the thought keeps presenting and nagging: what is the use?

9 December

One's work, one's character is founded on the culture of one's times, but it is one's vision of life and human history as a whole, which makes me so critical of the present times. I feel so helpless, so inadequate to do anything to change its course. I feel as though I was surrounded by barbarians. I keep telling myself that only achievements will eventually have any significance. But I feel drained of strength. How to carry on?

10 December

Received this morning a letter from Gabriel.[10] He also enclosed an arts journal called *Orbit* in which there is an interview with him. What is so remarkable about that interview is the absolute clarity of his aims as a writer. His direction is clear to him and so he can carry on. This is not surprising. Can from his premise grow a significant work? Perhaps. After all one's premises come *after* the writing is done. A better day.

11 December

I have no talent for friendship nor for personal relationships. All my personal relationships no sooner established begin to crumble.[11] I am sadly conscious of this but it seems I can do nothing about it. Some people find that personal relationships enrich their life. I don't. Something in my behaviour causes misunderstandings and even my affection gets blamed and is not noticed. I am easily discouraged. This lack of a gift for friendship has been with me for as long as I can remember. Yet I am not an emotional taker, if anything I share all my emotions. This may be a bit too demanding or exhausting or whatever. I feel more assertive, or my inner life has a greater tension, when I am alone. I somehow give the impression of such self-sufficiency that no one feels the need to stand by me and protect me, not even N.

[10] Gabriel Josipovici. [11] This was not true.

88

With her, perhaps, I am too absorbed in my work. A woman can forgive love for other women but not for work.

When my imagination fails me, all my zest for living fails me. On such days I feel the need for a sympathetic arm to turn to, but there is none. I am full of sorrow that it should be so.

12 December

Am now quite occupied with thinking out the shape for an essay on Tribal Art. There has been too little work done on the *history* of particular tribes. The devastating role of Christian missionaries has also to be looked into. I am not an amateur anthropologist. Wherein lies the magnificent accomplishment, the superb artistry etc?

13 December

Began writing . . . still not certain about the design of the piece. Back from a dinner with the Münsterbergers. Dominic was there too. A pleasant evening. All in good mood. Small talk, serious talk but all very leisurely. N. got restless when the conversation turned to Negro primitives. She later told me: "It was darned rude."

A lunch party at D. Talked with Jeremy.[12] He seems quite happy with *Related Twilights*. It sells slowly but it sells. Public libraries etc. Jeremy even said as much that he would be willing to publish my next book. If I ever produce one.

15 December

G. told me that Roland can hardly keep his eyes open. It was so bad that he could not come to the Gallery today. It must have been pretty bad for Roland to take such a step.

17 December

I have become so attached to the studio that whenever I have to go out I feel myself hurrying to get back to it. This is also why I prefer to receive people than go out visiting them in their places.

18 December

After he succeeded in getting a place in Cambridge's Trinity College, David now got a scholarship. He wanted this scholarship because with it goes a "private bathroom". N. was excited. I was excited to the degree that I could not work. To top this came his school report the like of which I have never read. His main quality is his love of work, this is why I believe that he is truly gifted.

All in all what joy. I would do anything for him yet he puts so few demands on me.

[12] Jeremy Robson, the publisher

From time to time I ask whether he needs something. His reply is always the same: "No, I have everything."

I told him once that he should not work so hard and take things a bit easy. He said, "Look who's talking." It will be hard to live without him around when he goes to Cambridge.[13]

23 December

Today, what happened the whole long day? Nothing. That is to say nothing much. Sally came at ten in the morning. Undressed. Posed. I made drawings. Naked she made lunch. The soup was good. Then we had salad, two slices of salami each and a pound of cherries between us. Then Sally dressed and said, "I am going now." I said, "Must you?" She threw me an endearing smile. She went. It is like this twice a week with Sally. I always say, "Must you go?" She always throws me a smile and goes.

24 December

Moelwyn's[14] book of poetry arrived. A good title, *Breaking the Code*. A pleasant to handle publication. As for the poems, I have not yet found a few lines which have really moved me. What will I write to him?

27 December

I still work *too much* with *things* real. The operative words are "too much". I feel this so strongly – strongly because I also feel that something new is trying to take shape within me. Perhaps a new beginning . . . I will stand back, I will be passive and watch, not interfere. In the watercolours, I discovered a kind of naivety that pleases me. Now I must go further.

29 December

I paint too much with my eyes and not enough with my guts! Also I feel a bit dry of painting ideas. For instance, the composition of three miners: the figures are good but the background I have already repainted four times is still not good. The peach colour gets on my nerves. I will leave it for the time being and go back to it when the poetry will guide me. Strange how dry one can get at times. I want it (the background) to be more of a background with a slight hint of sky; all I get is all sky! The truth is that I am getting confused. I don't know what I want. I know what I get is not good. Instead of poeticising, I need the feel of true poetry.

[13] Three years later he went on to Columbia University, New York on a Harkness scholarship. Another wrench.

[14] Moelwyn Merchant, Josef's friend. He commissioned "Lear Destroyed" for the Arts Council.

30 December

Another day of agony. Now I know what it was all about. It was all this bloody Christmas spirit. I hate holidays, any holidays, and here I was trapped. Because of N., because of the children. I wanted to escape. I couldn't and it is not yet over. I walk as though in a trance. Hear nothing, see nothing. And if there would be a precipice before me I would step over the edge and fall into it. Perhaps I am already there. No, for in the studio I find life again. I must learn to work by artificial light. The winter's day is too short.

31 December

"Is this the place where man has to live?"[15]
The object of art is to discover and hang on to something valid in human life. All other things, like art for pleasure, is so much drivel.

A telephone call from Alexander Margulies. Stella is now better and next Friday they are both coming to look at pictures. I will be relieved when all my business with them will be settled. I will be the loser but this does not matter. This morning M. arrived as arranged. He was very excited about my watercolours and about one or two oils. He regretted that I had no drawings in "your style" to show him. I told him that this business about style no longer has any interest for me. I work now free of any other preoccupation than the image at hand. He took two watercolours, had coffee, told me of his worries – very personal – and went. For more than an hour I could not get back to work thinking how I could help him.

At last finished the few sheets "On the Defence of Primitivity". Not bad. Made my point without a single superfluous word. This is good. As soon as I finish a thing I long to know how others will react to it. Most probably will give it to Bill to read and see.

1 January 1976

A peaceful New Year's Day.

I do not want to write like any of the great writers or even the greatest but I would like to be able to write like Delacroix and van Gogh. Delacroix may be too subtle and van Gogh may be too rough. A combination of the two would make the right kind of magic carpet and off I would fly.

2 January

A sad morning. A big afternoon. Alex and Stella arrived at eleven. When we began talking prices I got nervous, jittery and upset. Still, somehow things got to an end by

[15] Rainer Maria Rilke (1875–1926).

them choosing two pictures which covers exactly what I owed them. I lost £150 on this deal. It is worth it. It is the end of the story.

After they left I fell asleep in the armchair. When I opened my eyes I looked at my watch. I slept two hours! Now I felt fresh and had a splendid afternoon's work. I could not stop even when the light faded.

3 January

London is a grand and beautiful city. It gets too uniform at present. Still, there are many districts with a special flavour to each of them. Each bringing out in you a different reaction. Each making you feel young, alive. Some streets remind you of other days, other moods, other people, other forms of transport. There are streets where a house is still the right shape and the trot of hooves gives those streets the right sound. The bus in such streets looks horrific. I am sorry for Oxford Street. It looks nastier every day and more like some terrible street in New York. Dreadful signs, bright letters in nasty yellow on a background of blood red. In the rain, Oxford Street looks pathetic and in the sun, disgusting. Regent Street is better. Much of Piccadilly Circus has been fouled up. Piccadilly is still good. It is not privacy as found in some small, silent streets. I do not mind its noise, its pace, its crowded pavements, its crazy excitement but I do mind whether the totality which is before the eye awakes in me a desire to stay on it or off it. I have known myself to run from some streets. Oxford Street for one.

London can be as grey as the fur of a mouse. This grey suits the city. It is not a city like Florence for "cognoscenti" – how I loathe this word! London is a city for poets who can answer to the spell of the great totality. It is a city of strength and passion.

Of Westminster, I like the side streets, but of all I like best to stand on the bridge and let the eye explore the dark green of the Thames, the sheen of the surface, the pattern of the changing waves and the passing of cargo boats. The admirable white of the buildings and the way they are curved into the flat sky – this I find also moving. They remind me of piles of white stones. The autumn, with a rose sun, suits this part of London best.

Smithfield has a hustle all of its own. I don't mind the smell of rotting carcasses. The meat porters are grand in white capes and bloody aprons and a half cow or whole pig on their shoulders. They go about their tasks like actors and absorb much of the bleakness of the street. A sombre act, a feast which dissolves into drama. In the summer, in the heat, the flies buzz. They threaten, they attack all things, distracting and menacing each and all. They remind one of madness, in which we all have to live – to survive somehow. Smithfield is the most philosophic section of London.

In the East End, I feel as an envoy from another world. Everybody talks. Each has memories worth telling. In the small cafés, a glass of lemon tea, perhaps two or three glasses of lemon tea on a small square of a table with two or three men around them. And talk. Some are Jews, some are Negroes, all men animated with passions. Gentle faces but not relaxed, rather intense. Some talk with their hands, with their eyes, when the lips have nothing more to say. Already the streets give a feeling of high excitement. "I knew Morris Wintchervski." "I knew Rudolf Rocker." "I knew him, I knew her." All marvel at the marvellous people they knew once . . . it is all like a dream. It is like the songs one cannot forget. It is all so near to my heart. The texture of the walls, endless smashed fragments of mortar, graffiti, a subdued reminder of poverty and passions. The eye can explore no more. It has taken everything in but the tensions which must be experienced, to be felt. On the coldest day, I feel warm here. Poor but generous people live here in an aura of their own courtesy.

4 January

Nobody comes. Nobody rings. Very few letters and I am happy. Painting, reading – I do not care what. What peace! What a lovely day this was. Marvellous, marvellous.

5 January

There are days when I do nothing but read. N. asks me whether I feel all right. "When I see you at the easel I know that you are all right." Yet I never felt better not being at the easel.

6 January

The most dignified part of the East End is the area of the docks. Monumental blocks. Raw in its effect but dark and strong. And the dockers! Giants. Lovely oblong heads, broad bodies and strong arms. They move swiftly with huge packs, yet they are calm. They still have energy to smile when they see me with my sketchbook. I talk with them freely. Nothing can inhibit me when I am with such people. We talk in a cheerful vein. What about? Does it matter? Our talk is another way of shaking hands. Then I want to be alone and get on with my work. I speak now less and less and let them go their way. This wonderful dockland! Unloading boats. Loading boats. Only the Thames seems still and the sky too. The atmosphere, the colour of it all is grey and brown, the boats are white. A touch of blue, a touch of red, a touch of rose. All those touches of colour change rapidly. My eye takes everything in and will give those touches a static permanence. Brother-poets, brother-artists remember this. This must never be for-gotten! Somewhere else are other worlds. Other men doing other things. But for the

moment this world of the East End dockland is all that matters. The group of clean sailors are also part of it. The children running for no better reason than to run. Everything fits. The letters, black and red stencilled on the packs, the boxes almost yellow in the air before landing on the boat. The images keep changing but the meaning is one. The endlessness of it all. Fixed forever, this lively movement of the dockland. One boat sails away, another passes it in another direction. Seagulls everywhere like white ornaments over the dark water. It is still again. And the dockers work on. Always swift, always precise. A rhythm beyond change, like symbols shifting around, they remain what they are.

I like Hyde Park in all seasons, at all times. Here I look at trees as though I had seen trees for the first time. Here I walk on the grass, sit on the grass, or lie on the grass and the scent around me. Lying on the grass, holding one thin blade of it between my teeth. I gaze at the sky; it is different here than in other parts of the city and that it can be so is a revelation to me. Hyde Park is something else each time I go there. It is different independent of time of day, of season and of weather. The leaves can be sharp as crystals and luminous too. The sap of the green can be aggressive or neutral. The park is new each time. It is in this newness, whatever it is, which welcomes you. You stand surprised in silence, hit in your emotions.

Take the Serpentine. Ducks on the water, narrow boats, two young people. A young he and a young she, each working the oars to each boat. It is idyllic. Silence but for the flap, flap of the water and the occasional screech of a duck. A feeling of delicacy all around. Of tenderness. It is idyllic. No enemies, no venom. You feel pure, freed of all conflict. Each noise is subdued and what happens happens quietly: a late sun, cool and rose and an early moon the colour of a peach. Both at one and the same time in the sky smooth, thin, flat and transparent. Faintly blue as tissue paper and the water strangely bright. What would you not give to stop this moment. Let it always be like this! It is good for the senses, for the mind, for the whole of the startled you. You know that you will never be the same again. Something has entered you and added a new dimension to your range of feeling. Wait, it is now half dark and it is the time the mysterious acquires a new depth. You feel extra light. Instead of a great fear you feel drawn upwards as though to fly and feeling drawn in this way feels marvellous. For the first time you were all alone in the park. If there were others did they feel the same? I am furious that such a sober thing should come to me after this marvel happened. When I was all feeling. Now I know that I wasn't alone. Only in a special way I was alone, lighter than air. Now I hear laughter and voices which must have been there all along. I see cars following their own lights; I see shadows and human substances. What I see and what I hear is neither reality nor mystery. It does not matter in any true way. What matters has gone. The park used to be open all night long.

In a Café
Ink and wash, 1952

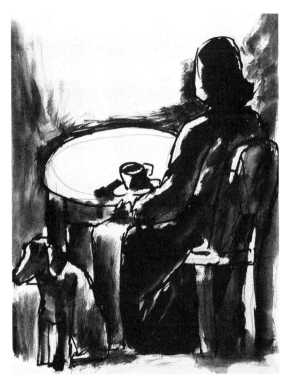

8 January

I like districts with an unchangeable element which words cannot describe. I still like Chelsea. But the streets of Chelsea which bowed to the fashion of the fifties and sixties I avoid. The Kings Road became really ugly and the boys and girls walking up and down are ugly too. The boutiques that opened, the little art galleries and cafés are ugly. Streets take on the character of people. Their so-called gaiety frightens me because I feel the purposeless violence it hides. The violence which people do to themselves and are ready to do to others. There is no life in them, no real life. It is not even make-believe. These people have wax faces and live their unreality. You need a street to be free – this I understand – but here all look as though they had stepped out of an advertising photograph.

With so much colour around there is little colour, a starvation of colour like in a coloured photograph. They need this unreality, this life without colour, for in reality they would find their faces unbearable, but in the unreality of their taste they can still raise their faces high. This is true for two or three streets. On the whole, Chelsea resisted change and remained a beautiful district with slim buildings, cul-de-sacs and narrow streets.

It is not because Whistler and Carlyle lived there but Cheyne Walk has a loveliness all of its own, enough to uphold the spell of the past, to make it interesting in the present. Admittedly, the best streets in Chelsea are so quiet that they do not give the feeling of everyday life, rather of holiday. If a human being walks, it is usually because the dog needs exercise. Very few people, very few. Perhaps the aura is of glamour. Too much glamour. More glamour than in the King's Road. These streets resisted fashion so that their glamour is different and because they resisted, a glamour more acceptable. Middle-class resilience is what it is but it worries me less than the shallow decadence of the King's Road. It is called rebellion. Some "rebellion"!

10 January

It was a terrible thing that happened last night. Rebekah made a nuisance of herself to one and all as children sometimes do. David lost his temper and smacked her back. Rebekah began to cry, no to yell and got into a real state of hysterics. She cried out: "I hate you all! I wish you would all die! I hate you because you hate us blacks."

My God, it was really terrible what this child suffers from the colour of her skin. No words could soothe her. "You don't love me. I am ugly, I am black . . ." She went on like this for an eternity. I did not know what to do. N. did not know what to do. David suffered, I could see it. Suddenly our little family was divided. We three and her. It was good that we were quiet and did not assure her of our love. All that deep down pain had to come out. What suffering there is stored up for her. If our love could not get through to her and in a moment of crisis her insecurity showed itself because of her colour, what will happen when she really meets hatred of her colour? This brought back to me another terrible memory of when I found her in the bathroom rubbing her skin with soap, then showing me the palms of her hands which with coloured people are nearly white: "You see Daddy, I'm nearly white. All I have to do is wash myself with soap and I'll be as white as you." Tears choked me. She was only three years old then and did not yet know that she was adopted.

What is one to do? What?

11 January

Today I had a chat with Rebekah. She does not remember anything of yesterday. I asked her why she said that I don't like black people.

"I did not say this."

"You said it, you know – you said that neither Mummy nor David nor I love you because we don't like black people."

"I don't like being black. I would like to be white like you and Mummy."

I tried to explain to her the different colour of people that inhabit this earth and

explain that as long as you are a good person, it does not matter what colour you are and so on.

She listened and then said, "I don't know what I am saying sometimes. Yes, I know I get angry. Forgive me Daddy."

I took her in my arms and hugged her strongly.

14 January

Reading Pissarro's[16] letters. Another excellent writer. He has a very clear mind and a style which matches to perfection. He never says anything for the effect of saying something "profound". A certain amount of naivety and a genuine simplicity. Of all the Impressionists he was probably the one with the superior intelligence. I was astonished how often he advises that we should work like the primitives.

The more I look at Rodin, the more I become aware of certain falsities in the outline: there is just too much Baroque-like movement, lumps instead of masses, not enough simplicity. Yet in the drawings I find a conscious drive towards synthesis and this is enough to give the drawings a greater meaning. I dare say even men of genius cannot have everything.

Roland's eyes are getting worse. Today he could hardly keep them open. Business is non existent. RBD's clients are mainly of the middle class and they have been hit by the present crisis. Even when they have money to spare they are not in the mood for spending it. I am afraid these are the people on whom my livelihood depends. Not very bright prospects. My sales through the gallery have been nil for quite a few months now. Douglas Cooper calls my work "heavy handed". It most certainly is not light-spirited! Writing this diary before going to bed is a great strain on my tired out emotions.

16 January

Roland told me the following: he was approached by Leslie Waddington who told that all art dealers came to an agreement that the 33% commission they have so far been getting from artists is no longer economical, they must now get 50%. I listened and did not say a word. I know where I stand. If RBD would ask 50% from me, I would leave the gallery. It is very difficult with the 33% to manage. Supposing I sell a watercolour through the gallery for £200 (this is the price of my watercolours) what do I really get to live on:[17]

[16] Camille Pissarro (1830–1903), French painter.

[17] After RDB gallery closed, Josef had to pay other galleries 50% (the New Grafton in Barnes 40%). It is not recognised that today a gallery (plus income tax) leaves the artist with nothing.

£200 minus 1/3 for the dealer remains £134
 ,, 1/10 for framing ,, £114
 ,, 1/8 VAT ,, £100
 ,, 1/3 Tax ,, £67

This has also to cover the times when nothing sells. This is therefore the best one can expect! To make £67 one has to hand over £134. One can do this only by producing greater quantities of work and hope that there will be clients for them. Those who are slow by the nature of their temperament are not to be envied.

Why wonder that even the most successful are not without anxiety? It has always been and remains a precarious profession. However, unlike other professions we have no choice but must put the nature of our gifts first, no matter what.

It took man a few hundred years to assert his solitariness that weakened his sense of togetherness. It will take perhaps a bit less for his instincts to regain their natural strength. This period of transition is the crux of the matter. Soviet Russia in particular went about it the wrong way. This is why I believe in the slower ways of democracy.

20 January

I have done nothing. I have achieved nothing. Yet, I am not a failure in my own eyes. I was devoted to my labour and to the nature of my talent. I did the utmost, but my talent did not prove itself rare enough.

My dear friend, I believe your sincerity but I don't trust your judgement of yourself. Nobody can be as cruel to artists as artists are to themselves. When I look at your work, I see not only sincerity but originality and achievement. And this of the highest human and artistic scale. How is it that you yourself cannot see it?

It is because of my painting that I know what living means. This is why I do not think myself a failure. As for achievement, no, I achieved nothing in the art of painting but outside painting, life was never real to me.

23 January

How lost I get on days when I cannot work! I get trapped in a deep gloom. A few hours' intense work and living is worthwhile. I am no longer curious about other people's reactions to my work. What matters is my own sense of direction.

25 January

Although for many years I have lived from the sale of my paintings,[18] I am still surprised when Roland rings me and tells me that he has sold a painting or a drawing. I get excited and feel rich! But it is not the money. Merely the fact that I was paid for the

[18] This means sales from the studio: Josef had to have private clients or he would have starved.

picture I painted and would have painted anyway. You feel needed, that is what matters. I would have preferred to be needed in a different way, like the tribal artist is needed. But, living in a society which needs no artist, every illusion of being needed is better for one's ego than not selling and feeling that you are not needed.

I remember when Bomberg[19] at the time of the National Assistance said to me, "You don't know how humiliating it is not to be able to sell a picture and not to be asked to send something to an exhibition. It is all so soul-destroying."

"It all depends on who it is who is not inviting you."

"No," shouted Bomberg, "you get to a stage when you don't care who invites you as long as you are invited."

I understood the way he felt and it broke my heart, I know of no other artist who suffered so much by being an artist today.

26 January

Millet's exhibition. This is the third exhibition in London in the last twenty years. It is the first complete one. Reviewers could hardly find enough adjectives of praise. And why not? But few see the essentials about Millet. Of course he was a great draughtsman. But he was also a great painter. He achieves more with a limited number of colours than others with an extensive one. In fact "The Man with the Hoe" would have been a greater work if there would have been fewer colours and fewer naturalistic effects, particularly in the painting of the fields and in the sky. His "Washerwoman" is a greater synthesis and thus a greater picture.

In the Renaissance, woman whether dressed or undressed, is part of man's possessions. In seventeenth-century Holland, she is homebound, in eighteenth-century France, she is all sex and intrigue. With Millet, she is a human being. I love Millet's vision of woman. Perhaps with any other class of people, Millet could not make this point but with peasants he could and did.

The Impressionists painted cityscapes as though these were landscapes. Pissarro, Monet, Manet and Seurat. This is not surprising for they were not interested in the city as such. Both in landscapes and in cityscapes they were only interested in the effect of things on the eye. The street replaced the field with no difference whatever. The true city painters of modern times were Meidner and Sironi. In the graphic arts: Masereel and Kollwitz though in a journalistic sense Grosz, Beckmann and Kirchner also have some excellent city scenes and so have some Americans, especially Hopper.

I like new places but I do not like the journey to get there. N. has arranged another trip to Crete. Not that I feel a need to go anywhere but N. is worn out and she needs a

[19] David Bomberg (1890–1939), British painter.

change. That in our case is what a holiday really is. I am sure that once there I will be glad.

Crete has for me a special fascination. The landscape is old, older than anywhere else – at least so it seemed the last time I was there. Also the people I like. I like the way they look, their archaic heads with curly black hair and though they are not big they give the feeling of bigness, especially the men. When all is said, I think I am looking forward to being there.

My decision not to read newspapers pays off. I am much more at peace with myself and the world. One may lose one's sense of reality but what on earth is this reality one loses a sense of? Do I really need to know that Jeremy Thorpe may or may not have had a homosexual affair with some pathetic wretch who has nothing better to do than tell one and all that the leader of the Liberal Party had an affair with him? Now I have also given up the Sunday papers though N. still buys *The Sunday Times*. I don't look at it. In the quiet my mind works best but I will never give up my books.

3 February

Little Becci came into the studio while I was painting and said, "Why do people die? Why do dogs die and cats die too?"

I said, "I know nothing more about it than you. Everybody and everything is born and dies and nobody knows anything about it."

She said, "You know but you don't want to tell me. You know . . . you are old."

I said, "I am old, this is true, but I don't know. Do you know?"

Becci said, "I am a child so I don't know, but you are old. This is silly." She said and went.

Awoke this morning with a great desire to read Whitman. So I took his *Leaves of Grass* and read great slices of it. The pieces I read today gave me huge pleasure. Few English people like Whitman. They only hear the rolling noise of his phrasing but they do not see the strong images and the wonderful immensity the lines suggest frighten them. Most of the time it is like an epic with Walt Whitman the central hero. Most of the time it is the good thing great poetry is.

6 February

I asked Dominic whether he has seen the Millet exhibition. He said yes he had seen it and did not like it. Dominic teaches at the Royal College and I wonder how many students he has poisoned. I cannot remember who said to me that Millet was all right for the nineteenth century but not for "our times".

7 February

One of those black moods. Slept badly. Nightmares most of the night. Terribly, terribly tired.

8 February

Have just finished the best book on Stalin's trials. Arthur London's *On Trial*. Stalin governed by means of *perpetual* terror. This is the bizarre *contribution* of Stalin to the story of governments who used terror. *No one* has to be exempt from it. This was Stalin's vision of communist government. Terror, trials, confessions were to be its *permanent* future.

9 February

Began early morning to paint. The light was still grey but it did not matter. I was in a state of extraordinary eagerness. Nothing went wrong. Ideas produce ideas and so it went on but it lasted for only four hours. When I was younger, such states could go on for fourteen, even sixteen hours. Still, in the four hours I accomplished quite a lot. Later, did a few watercolours. A heavenly day: felt intensely, thought intensely and the paint accordingly had all that intensity of mine. What a terrible let-down this will be if in a few days time I look at these three pictures I worked on and see that I missed and the intensity of my feelings will not be there. No, I refuse to think it possible.

10 February

I am more stimulated by my own drawings than by the reality from which they were made. In this way I can never fall into the trap of realistic painting. What a greater painting Millet's "Man with the Hoe" would have been if the image would have been free of realistic detail. What an immense outline of a figure! Like anything big of the Egyptians or the French Gothic! All this gets spoilt by the minutely painted fields!

18 February

G. claims that since the fifties my style did not undergo any change. Why should it? With it I try for as much variety as possible. To call this stationary is both unfair and untrue. If my dealers have such blinkers on their eyes that they cannot see this, what can I expect of others!

21 February

Talked with N. about going to Crete. We set a date for the 15th of April. David will by then be in France and N. can take time off from St Bernard's.[20] Why Crete? Since last

[20] A London psychiatric hospital – no longer in existence.

year when I for the first time set foot on Crete's soil, I felt drawn to get back there. It is not its nature nor its natural light that draws me. Of this I am sure. It is the inner balance I get from some places more than others. Its history of unhurried living. The inner light which alone makes me work in a creative way.

The drawings I made in Crete last year have the glow of that inner light. In fact very few were throw-aways. As in all drawings I set out with something from the life around me but only when the inner light takes over is it when I really draw.

23 February

How long it took Turner to find himself! In his long life he produced many excellent pictures and some masterpieces but only about ten years before his death did he find his own expression, the image we identify with his name – the almost Zen kind of blobs, tree crowns in a luminous space. He only produced a sparse number of this kind of great works. But how great these are! These are spiritual landscapes with few physical semblances to things of nature. In watercolours he found himself much earlier. The difficulty seems to have been a technical one! How to make oil paint so pliable as to fit the glaze of his vision. All originality is a matter of the spirit. The mechanics of technique will sooner or later adjust themselves to the demands of the spirit.

24 February

Brancusi's work is often little more art than craft – the trap into which so much modern sculpture has fallen. But Brancusi has lyricism, dream and depth. Above all depth. He was never a cubist and this says much of the strength of his personality.

He is sometimes accused of having produced too little. Also of having varied too little his style. Rubbish! The trouble with the greatest number of artists today is that they produce too much, have no single track. Thus they chop and change as though they were working like some fashion house. I admire his spirit of independence, his way of standing and doing it alone.

25 February

I am sixty-five now and at the height of my beginning. Not until one is cold and dead should one consider a painter's working years finished. Nor his achievement final.

26 February

In drawing, even more than in painting, we progress from the impersonal to the personal. Preconceptions about one's working habits have to go. We should be free to accept the unexpected whenever it manifests itself. To see form for what it means to you; for form if it means anything comes from our feeling toward the totality of mass

and outline. Mass and outline and your feeling. The feeling gives everything we draw and paint a uniqueness and the rare stature of the symbol: the silhouette. If one cannot embrace the whole with one glance, you may be sure something, somewhere, is wrong. If the silhouette is well drawn, space will arrange itself. Anyway, space can only be evoked; the pedantic devices of perspective or of Cubism are of little relevance. Cycladic sculpture is the greatest example of a good understanding of silhouette, of a well-felt expression through the silhouette. Their outline of absolute silence may be unnerving to some temperaments but what I am driving at is an example of absolute achievement in the region of an outline.

27 February

No artist should proclaim his work as the expression of truth. Life is full of truths! In fact there are too many of them about! An active imagination uses all means to make itself articulate and all means are valued, even truth. But it is a vain hope to put everything on the scales of truth. The human sources of art are too varied to make truth a single denominator.

28 February

Our visual experience matters. Oh yes, it matters a good deal but our emotions matter more. It is this that eventually makes the form what it is. This is also true for whole cultures; that images are not only what they saw in life but what they felt about life. The images may tell us something about their convictions but their forms tell us about their feelings.

I find conversations more and more tiresome. What I want to say no longer fits into a dialogue. Meeting others in silence.

1 March

Everything comes to me after a crisis. First, the crisis: a sick insecurity, a bewildering feeling of not knowing what to do – a disbelief in the value of anything I have ever done. Frustration. Lost in an abyss. Not what next but what now? These are my worst days and they recur every so often. Confusion. Sterility. Fear that this will go on for ever. Books are no use. No thoughts. No deeds. So for days and nights. Such a time I call crisis.

The best days in my life follow immediately after such crisis. As though someone would have shaken me out of all morbidity, all impotence. I am back in the world of my own reality which is different from the reality of the world. Images follow images. I am in a world of plenty. Exalted but still restless. Difficult to tell how this new will to work begins but it comes as suddenly as a good fairy in a fairy tale. I can now leave it at

that, for from then begins my normality, my day-to-day living. All I wish for is this normality to continue, but deep down I know that this won't last. Another crisis is sure to darken my existence. In the meantime I am free from disaster.[21]

A theme builds itself in my imagination and out of the theme one picture, then another, then still another. I know of no greater fear than the fear of a void mind and a void heart (an emptiness of all feeling). Being free of that fear means the beginning of a period of work.

7 March

I often say that in painting it is peace I am after. Taking the meaning of this for granted, I have never stressed that it is not a mindless peace, an idling peace but a peace which activates both mind and feeling and this brings back life and work. Such peace gives direction to our dimmer intentions. Thus experiencing experience transforms experience into action. Without that action, we fall into darkness and despair. The peace that numbs everything is a sickness.

10 March

N. is becoming a remarkable woman since she took on the job at St Bernard's but above all it is the Kleinian analysis which has made such a difference. I am no longer sorry that we are again living together.[22] She read to me a letter she wrote to the BMJ [British Medical Journal] which is extraordinary stylistically. If she could sustain such a stylistic level in the fiction she attempts to write then she would have produced a masterpiece. Thus far her fiction is too self-conscious "literature" with a capital L at that.

11 March

Sometimes I find my loneliness saddening. But most of the time I find myself contented in its frame. It suits my nature, my temperament. To be alone. There is something naive and primitive in me struggling to find its own form and its own colour but so far there is also something which holds it back.

12 March

In Wales my style of living was very near my style in art. It is not like this living in London. Mine was a hard working life with many pleasurable rewards. Very rarely was I bored. The great ecstasy was in my gift for seeing twilight's light and feel what it does to the world. The setting sun changed a grey street into an exotic land. Ecstasy, once

[21] At these times, no one could have guessed what he was going through.
[22] In 1974 we lived apart for some months but still within a close relationship.

awakened lasted many hours. Sitting still, I travelled. Nostalgia, like a faithful puppy was never so far from me. Ecstasy and nostalgia were the two sustaining moods in my existence. Living wherever my fate wanted me to live never changed this. Each land is my home and it isn't. No land is an alternative for another, not really. The real world begins where one finds an awareness of it. All my work is of these moments of awareness.

17 March

Painting is a need. I cannot visualise the circumstances under which this need disappears. I cannot imagine a way of living without it. What way of living would free me from it? Would living be better without it? Perhaps it belongs to the more permanent of the human needs?

19 March

People have often tried to get close to me but failed. Was it my fault? Perhaps it was. Not out of mistrust of others have I built a wall around myself. Not even to avoid pain nor to avoid being hurt. Being alone is my way of being with others. The distance helps. When I die I want to be completely forgotten. Probably I will. I do not want to belong to the history of publicity. Will I manage to do enough to belong to the history of art? This kind of thinking is too oppressive to go on.

20 March

The sales of my work in the gallery could not be worse. Nothing – not even a drawing. Yet at no time have I worked better. It is not only the general situation,[23] which admittedly is pretty bad but it is the attitude of the public to my kind of work – particularly my subject matter. Heinz has already hinted that I "should find another subject". This I cannot and will not do. With me, the subject is an integral part of my thinking, my feeling, my being. The pressures on me are great. I still have some money in the bank[24] but this I must guard for back years of income tax. All this puts me in a mood of instability, worry and restlessness. I make superhuman efforts to be calm and work as though nothing has happened.

21 March

What would I not give for the peace and quiet I so badly need for work. My mind is still full of good ideas. I still get some good notices for my Related Twilights but the

[23] There was an economic depression at the time.
[24] A recurring anxiety not based on reality. Perhaps an identification with his father who was always in a state of poverty.

fashionable élite says nothing. Neither the *TLS* nor the *Statesman*, nor *The Sunday Times*, nor the *Listener*. However, this I view without bitterness. *Related Twilights* is full of faults but I have learned a lot and I intend to rewrite the whole book.[25] Also the sales of the book are negligible. Jeremy is an angel the way he takes it all.

24 March

It pains me but I will have to give up smoking my pipe. Smoking blocks my nose and I have difficulty breathing. The days I don't smoke I feel much better. I will probably still use my pipe when in company with others. Pipe smokers are somehow more tolerated than non-smokers when they sit quietly and don't say a word.

30 March

We derive spiritual profit only from looking at pictures of kindred artists. They excite, they stimulate, they alone revitalise our senses, our spirit, our mind. No artist is ever alone, like our blood group we belong to a group. We can only hope that we will mean something to future kindred spirits, like kindred spirits of the past and present mean something to us. It all works like a "ritual".

31 March

Because of the isolation each artist is forced to live in, do we today feel more than any artist before, "homesick". Today, I feel a strong desire to belong to a people, to be needed, to be commissioned and work for them. I remembered the fervour with which I worked for the Festival of Britain in 1951.

Every painter I talked with at the time expressed a deep satisfaction from working for this project.[26] I think that deep down each artist likes to feel himself needed by a human community.

2 April

Mahler's Sixth Symphony. Not a single passage is empty of feeling. What an achievement.

7 April

Death surprises us all. It always comes too soon. Though at times I am even looking forward to it, I am only afraid of the hours or days of dying. More than this, I am terrified of an early senility. In the meantime I still have too much to do.

[25] He never did but *Seren*, a Welsh publisher republished it in October 2002.
[26] The artists shared the space at this time.

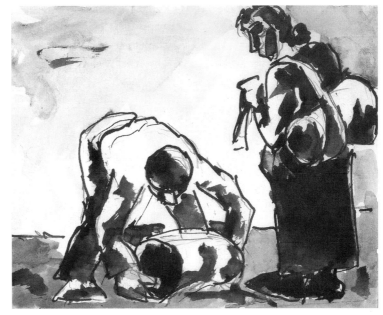

(right)
Couple in the Fields
Ink, wash and
watercolour
17.2 x 22.2cm
(overleaf)
Seagull in Flight
Ink, wash and
watercolour
28.5 x 19.2cm

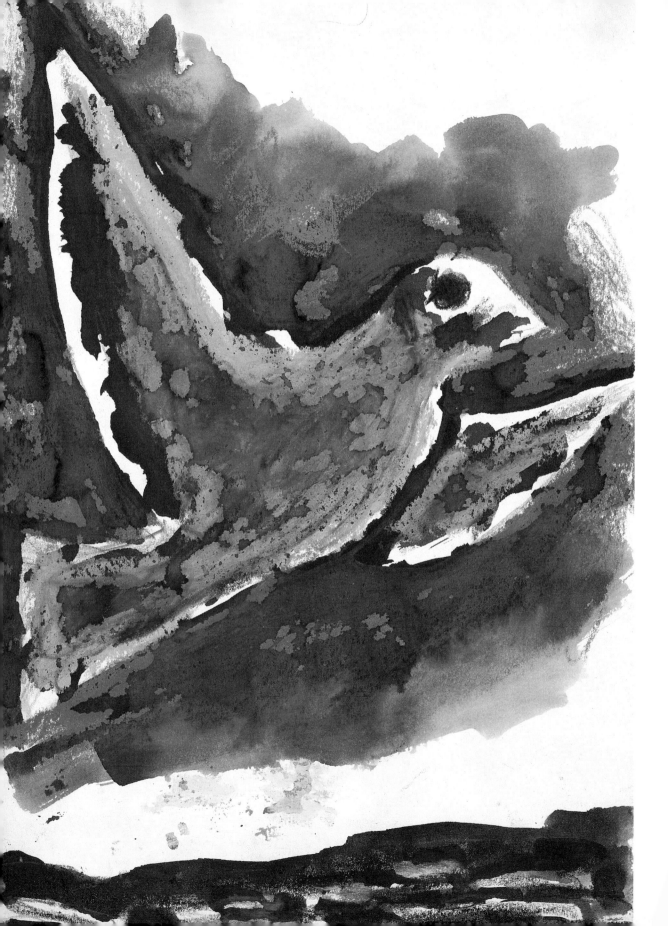

December 1983 – December 1991

21 December 1983

When a painter changes his "style", his habits of thinking and feeling etc, he must also change his friends. They will expect him to remain what he was. Denis[1] was here the other day. He looked at my recent watercolours that hang on the walls and asked: "Do you like your new work?" An offensive question I thought.

I answered impatiently, "Yes, yes." Then not to return to the subject I got into a manic kind of state and talked a lot of drivel.

A few months ago I thought I was going to die. I tore up all my diaries. Only two copy books remained, which I found later. Now I am sorry I did this. I am still alive and without them.[2] I feel I created a sort of emptiness around myself. There exists no past and only a kind of continuous present. This morning I went out and bought this copybook and here I am again.

22 December

This morning I awoke in some sort of panic.[3] I could not account for it. Once in the studio, the panic has gone. Yesterday I made an unsatisfactory image in watercolour of a man and a woman or vice versa. I took a new page and began working small changes in the design and things at once began to flow. On the radio was good music. I feel that I had a satisfactory morning's work. I now must go out to Reeves to buy some watercolours and a few long-haired brushes. I became very fond of these long-haired brushes; with them I can get the rugged texture I am after.

24 December

I am no longer worried by the anxieties and depressive feelings I awake with each morning. I know that they disappear the moment I get down to work. The unpredictability of the process of painting fascinates me. I do not know what I am after but what comes out seems to be exactly what I want – strange, absorbing, fascinating. Totally different from my past ways. The other day I said to Tim[4] that the images I am now preoccupied with are strictly autobiographical. He asked me what I meant. I failed to

[1] Denis Matthews, painter and friend.
[2] After Josef's death, six books were found in the studio as well as the jotters.
[3] These occurred frequently. [4] Tim Hyman, friend, artist and curator.

give a satisfactory answer. I still don't know what I meant. I do feel that they present more of me than anything I did before.

Enough of this. On Radio 3, splendid music. On television, all channels seasonal drivel. At this moment, after a few hours intensive work I am now sitting in my armchair listening . . . just listening . . . perfectly content.

25 December

Though I slept very well, found it very difficult to get out of bed. Had to force myself to go down to the studio. Yesterday was an unsatisfactory day as far as work was concerned. Too much premeditation. David came to stay over Christmas. He is still unsettled. Still undecided. Doesn't know whether to go on with his PhD or not.

For the first time in the past year he said that he wants to come down to the studio and look at my recent work. I was glad. He has wonderful gut reactions. But going by the posters on his wall, I was not certain that the watercolours will be his territory. To my surprise he was greatly enthusiastic. When he said: "They are so beautifully quiet," I knew that his response was real. He also wanted to look at the sketchbooks. His enthusiasm grew stronger. I had the feeling that his "father problem" is not as difficult for him to bear as it used to be. He is leaving today and it truly breaks my heart. He is in the grip of a superman battle to find his own way. After dinner we sat in the adjoining room and talked until about 11 p.m. I felt tired and fell asleep as soon as I laid my head on the cushion.

26 December

After a few minutes break . . . I was wrong. The last of the works I did yesterday are good. All I did this morning was to change the colour of the bird in the window from white to pale blue and the whole image came to life. I looked through last week's work. No matter how "abstract" my figures have become, their class adherence is unmistakable. This pleases me immensely.

N. is the best arranger of flowers. With an unmistakable sense of rightness, she puts colours where they are at their most expressive best. This goes also for her sense of shapes. Whenever I look at one of her arrangements, I feel a need to paint it. All my flower pieces owe much to her inspiring force, though they become something different in the process of painting but I could never have thought of painting a flower piece if not for her. David is now preparing for his journey back to his flat. I feel driven by some inexplicable force to stay with him until he closes the door behind him. I watch him putting his bits and pieces into his rucksack. I am a possessive father, although my reason tells me "you have to let him go!" So back to work with a sinking heart.

Nini Arranging Flowers
Ink and wash
25.4×20.2cm

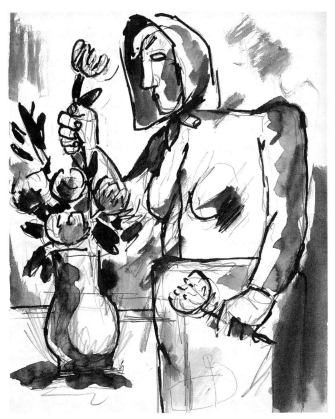

2.30 p.m. Could not work. Sat in the armchair. Switched on the radio. Just in time for the announcement of Brahms Symphony No 2. I did not hear it before. A sad work! It said everything I felt. When it finished, I felt a new energy wanting to surface. Went to the table and painted a small flower piece on grey paper – one of N.'s arrangements – from memory. Yellow against grey, green against grey and black for contrast. I feel much relieved now. Immediately hung it on the wall.

27 December
There is no virtue in spontaneity per se. Spontaneity is its own justification when it comes about guided by the force of our feelings. Today did four watercolours. One of a tree I saw yesterday on our walk in Holland Park.

28 December
This morning I looked again at the watercolours I did yesterday. I find that I was unduly harsh with myself. True, drawing from nature inhibits me but it really does not

matter what one starts with. Certain things happen in the process of painting that have little to do with the memory of reality and with these four watercolours such unpredictable things did happen, which is quite gratifying. I find that to use tubes of watercolours is better than to use the little blocks. It gives me an opportunity to use thick blobs when needed. I find it a bit infuriating that to the liquidity one often ascribes the "specificity" of watercolours.

Preconceived notions of materials make the hand move with "professionalism". Last night I read stories of Borges "Alef". Like many stories of his, these too must have come to him after reading writings by religious mystics. As often with him I soon found myself in a kind of mysticism that is at the root of all human creation. It is not an argument. It is a short record of a wandering mind on the track towards revelation, at once personal and all human. The words are almost in the way. Splendid. Absolutely splendid.

29 December
Ah, the simplicity of the pyramids.

31 December
Sometimes strong emotions bar one from reaching the deep recesses of our feelings. Strong emotions are often the reaction of shattered nerves. Deep feelings have a quality of stillness and serenity. Last night I noticed from the corner of my eye a dark violet, amethyst flower in one of our wine glasses against the beige of the table. When I went back to my ante-room and lay on the bed I made a quick note of what my memory retained. The design corresponded with my feelings. This morning I got up at 5.30 and though I had only four hours of sleep I felt fresh and eager to start work at once. The first watercolour I did was after this note I made hurriedly last night. Then I got obsessed with the shape of the wine glass. In the first version there was not enough blue in the flower. My feelings grow stronger the longer I work on one theme.

1 January 1984
Any New Year resolution? Yes, to continue as though time did not exist. When my imagination gets active on its own volition in the middle of the night, night becomes day. When in broad daylight my creative energies leave me and I lie on the bed in terror of not knowing what to do with myself, day becomes night. The objective specificity of time does not concern me. The natural nature of time I leave to scientists and philosophers. Let them worry about it. The fact that in two days' time I will be seventy-three I look at with total indifference. My imagination is more active now than at any time I can remember. My urges to work are as strong as ever. My old age has

only so much bearing in that I get physically tired more often. I used to be able to stand in front of the easel for fourteen hours without any need for food, or as much as to sit down. Today, after three or four hours of work, my knees give way and I have to relax in my old armchair. I look at the armchair with some fear that one day I may be more dependent on it than I would care to be. This far I am lucky and I will probably make the healthiest corpse ever. No, I do not think much about death and when I do think of it, it is in a strange, detached way. Darwin told evolution how long each species can live and I am powerless against such a formidable combination as Darwin and evolution. Nor do I kid myself that I will have some ''floating'' existence in the ''universe'' after death. Come death, I will cease to exist as though I had never been born. Whether I will exist and for how long in the memory of my nearest and dearest, or a few strangers, is of absolute indifference to me. Life and death drivel! Only the years of living and what we make of them as long as we are alive, this alone can be meaningful, even worthwhile. Yet in this we are all beginners. I tried, I did try. Another year has gone. So what? Only yesterday it was still 1983. Today, I feel as I felt yesterday, eager to start a day's work. Usually I write these jottings after the day's work. Today I had to do it now. Why? It is 5.30, neither morning nor night. It is the long lasting day. This is how I feel and I am glad.

3 January
This morning I went to the paper shop to buy tobacco. I was struck by the loveliness of the boys and girls who deliver the papers. There is an otherness in their heads, which made me think of Romanesque heads and of some of the heads of tribal carvings. Even the anxious looks in the big eyes did not awake pity in me. With a strong feeling of compassion I stared at them. When I noticed that one girl blushed and turned her back to me, I left the shop. Back in the studio, I painted three heads: two of boys and one of a girl (the one girl with the red dress I may have to do again).[5]

5 January
More children's heads. I dream of those lovely children of North End Road. Today I worked on more heads and one group of three children. These children carry me into a territory of feelings I have never known before.

[5] For the next six months Josef did almost nothing but these children's heads. Evocative of his Warsaw childhood, they belong to his most important works. There are 200 of them!

12 January

Yesterday I had a visit from a Mr Shapiro of the Jewish Museum in New York. He bought an old charcoal drawing: the head of an old miner, one of the early studies I did when I worked in Ystradgynlais. I must have done it in 1944 or '45. I sold it for £375. This morning I received from him a personal cheque. I got in touch with Consolidated Cargo. It would cost me shipping the drawing £275! Of course I cannot do it. The economics of selling paintings do not cease to amaze me.

15 January

Quiet, with strong feeling. The thirty or so children's heads now that I look at them, are a bit too emotional. I am always satisfied when I start with emotion but eventually link with the deeps of quieter feelings. Still, one has to be thankful for small gifts. I feel that I will soon have to start working in oils. Feel a strong need for a heavier medium.

28 January

A very unproductive week. I did little work. Could not get my concentration going. I feel socialising a burden now. Basically socialising is quite antisocial. This too worries me. I am more involved in life when alone doing my work. Being with people brings out the worst in me. Enough. I can blame no one but myself. Why I let myself into this trap of socialising I don't know. It is so difficult to regain concentration and the vital connections with our true feelings.

4 o'clock. What a relief. Only yesterday I could not get to my feelings. This morning everything went right. The first morning of the whole damned week. Not certain of myself, I took a few older pen and ink drawings and painted on them with thick watercolours. These set me on a more familiar track.

22 February

I cannot go on with the Prometheus image. The moment I put the canvas on the easel, the rages simply paralyse me. I don't care for the state of utter confusion this image puts me in. Decided to leave it . . . to forget it. It makes me feel ill. I cherish my more peaceful feelings. These are not transient moods.

9 March

The children's heads have become an obsession. From the moment I wake, wherever I turn my eyes, I see nothing else but heads and eyes. It is like an uncontrollable disease, except there is joy in painting them, not suffering. I have no control whatever, either of the colour or the form. I virtually don't know what I am doing. They are inventions which invent themselves. No one head is like another. Sometimes I wish that this

would stop and I could get on with other works but I cannot. I have to work with a speed I have never worked with before. No sooner do I begin one than I have an idea for another, which also wants to become an image. So it goes on for most of the day, most of the week. When utterly exhausted, I lie down in the ante-room, I think of other images I would like to do. I make notes, pencil drawings. Nothing comes of these, more little heads and more little heads. I do not know what all this labour amounts to. This does not matter. "Quality" has a way of taking care of itself. Some of these children of mine have better things than "quality". A few moments ago I spread out on the floor my morning's work. I was moved to tears. They have such unmistakable human identity. Perhaps I am deceiving myself. Perhaps they are autobiographic.[6] Mere self-expression. All I am aware of is that I hold nothing back. Nothing willed. Even when I chisel my way into form or light, I am following my feelings and not any deliberate notions. Perhaps in time, a year from now or so, I will know better what this all amounts to. In the meantime, let the waters flow.

10 March
Today a day of making "notes". These are more deliberate. They are very important to me. Some of them satisfy to the degree that I leave them as they are and do not think of them as preliminaries to something else.

30 March
On a deep, deep level the things true to me are the things I do and not the things I say.

8 April
When things are explained to me I lose interest in them. What is essentially art cannot be explained. What is called a "distant style" happens. It cannot be achieved at will. "Searching" is nothing else but following one's sense of rightness. As for technique: the main thing [is] not to use materials as they should be used.

10 April
Working against the "nature" of a material can prove just as good as working with the "nature" of the material. I like it when the paper gets tired and the watercolour loses its fresh look but I do not commit myself to this. In fact, I have never been less committed to anything a priori than I am at present. The less conclusive our means, the more unpredictable they are, the truer our "end results". (There are no end results –

[6] This is an important insight. Each is a self-portrait. They and "The Birds" which followed have still to be recognised as part of his most important work.

"results" flow from one work into another. There are only bouts of unconscious drives.)

27 April

Every painter, I dare say, who is working from the deeps of his feelings sooner or later finds himself in the dark of inarticulation. Even writers, like Kafka for instance, become suspicious of words. How little I can say with the belief in what I am saying. It is not a matter of being truthful, sincere etc, I wish I would know what it is! Certainly, it is a cage, consistency a trap. How am I to convey to myself the uncultivated stretches I travel from not knowing to the unexpected, yet real. "So many mousetraps for one poor little mouse" as a Polish peasant would say.

30 April

Coherence without system. I am now working on a group of paintings of subjectless subjects. Reality without realism. Last week I painted two pictures. One – a seagull, a boat with a fisherman and light: two – a man and a woman and figure passing. No sea, though it is on the sea front. No sky, yet I doubt if anyone could help feeling its presence. This morning I painted a small panel: a woman walking towards the doorway. All still, no floor, no walls. Hints of poetic awareness. I was deeply moved when the image gradually took on its own definiteness. The note I made previous to the little painting came to me as in a dream. A simple image a child could conceive. The only conscious striving I am aware of is for the image not to become a picture.

2 May

Yesterday I painted another of those subjectless images: three figures, very cool, very quiet – grey, black, brown and ochre. Now looking at it, I feel that I have to put in a blue bird on the right. Not certain what kind of blue nor of the shape of the bird. Must not disturb the quiet feelings.

7 May

Yesterday worked most of the day. Repainted an earlier work of a fisherman sitting on the edge of the boat with yellow nets. Though I improved on its earlier stage, it is still too much of a picture. Must stop rehashing things, must continue with my subjectless subjects. The little panel I did on Saturday of black figure against a blue figure had little definition but I feel is more real. No movement. All is still.

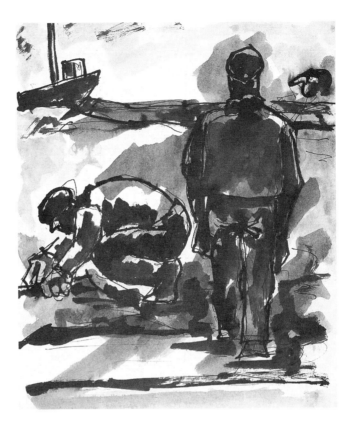

(top) **Landing the Catch**
Ink, wash and watercolour
25.2 x 19.7cm
(right) **Sorting the Catch**
Ink, wash and watercolour
25.2 x 19.7cm

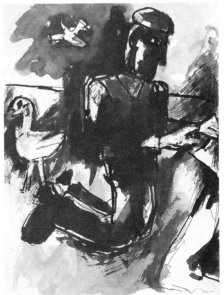

24 May

This morning I looked through things I did this week. The following occurred to me: an image should be quiet, strong and appeal to the heart at the first glance of the eye. I eliminated all sensuality of pigment and brushwork. Simplicity! Everything that brings this about is good technique. No preconceived ideas about content, style etc. Yesterday's image of a seagull with spread out wings against a sail and a mast, I painted after a note I made at Dunwich two years ago. I think I regained my first feelings by eliminating all descriptive details. When I looked at it this morning, I think I did not go far enough. The image is not yet as static as it should be. Put it away. When my feelings will be more composed I will return to it. Oh, how difficult it is to recognise the intelligence of the heart. So many side tricks. Yesterday I came across a gouache Becci did when she was about ten. I liked it very much. I called Becci and showed it to her. She laughed and said, "It's like your people. I like mine better." She left. How right she was! When the child in us dies, we are dead – I don't remember who said it but it corresponds with the way I feel. I wasted years trying to be a good runner without noticing that I am running in the wrong direction. Not until we free ourselves from the terror of the masterpiece, do we come near the reality of painting. The reality of art.

25 May

Became very fond of greys, pale yellows. Three figures: a dark grey, a pearl grey behind her, a pale brown at the left. This still image gave me a worrying night. This morning everything went right from the start. The watercolour I made of it was no use. Had to put it out of my mind and away from my eyes. It was then that things began to appear. Like a schoolboy I have to be reminded. I have to remind myself of basic things – *not to follow certainties*. When I look with the corner of my eye at this image still on the easel, it awakes in me a splendid mood of sadness.

29 May

Timothy [Hyman] in one of his postcards mentioned something that he calls *intentionality*. I see that this business of "intentionality" in painting most often is nothing more than a starting point. What makes of painting art is *unpredictable*. At this moment, the image is all intention and art stubbornly refuses to appear. The image is dead. At the moment I am helpless and cannot do anything about it. So it goes to the pack of canvases with its face against the wall.

17 August

This morning I did a few drawings. The subject: mother and child. The new freedom pleases me but must not let the form disappear. I worked on these drawings from 5 until 10 a.m. From 10 until late lunch I worked on the seagull, fisherman and sun. Good working hours. It is now I believe, a fine image. Little of nature, of memory, much of my feelings. While writing this I am from time to time peeping at it and each time get the same feeling of contentment that I sometimes get whenever momentary emotion gives way to more lasting feeling. Emotion is all very well but it is the deeps of human feeling that truly matter. Now I am exhausted and must lie down. I am lucky! Rachmaninov on the radio.

18 August

All religions promise peace of mind. Theologians with their pragmatic concerns make such attainment impossible.

19 August

The difference between a picture and an image: a picture is an artefact, an image is a raw feeling, an unknown process. I must trust my instincts and not my know-how. Now, when writing, I think that the old Titian also got fed up with picture making. In the Venetian exhibition these Titians brought tears to my eyes. Simple feelings do not come naturally. One has to dig for them. They are there. Painting is a way of linking up with them. To say that a work is well made is a way of condemning it, of putting it into irrelevance. At a level where art is art, the "making" is of absolute indifference. Painting should never be a mere performance. Not to follow, not even oneself. Not to make of anything a test. In particular of things we think got us somewhere. Even when I start on what scholars call an "intentional" painting I wait and hope for the unintentional to take over and guide my hands.

20 August

I am weary of all interpretations of works of art. The radio is on. Fine music. An "explainer" comes on and stops the flow of feeling. I want to switch off. Unable to interrupt the work at hand, I leave him prattling on. I am quite good at not hearing what I don't want to hear. The pleasure of interpreting is a thing of its own. An intellectual exercise. Little more, little else. It has no guiding lines into a work of art. There cannot be such guiding lines. It is all a matter of dancing nerves. When a work of art affects us this way, it is a work for us. If not, it is not. It has nothing to do with some "objective" quality. It is all a matter of dancing nerves. All connoisseurs run around like sniffing dogs each trusting that he has the right kind of nose for "quality".

21 August

Some street performers with bells. How fond I am of the sound of bells. When we lived in Hundon[7] our house was near a church. My studio overlooked the churchyard. The gravestones were grey and old. The local priest was a very old man. He was also the bell-ringer. Each time the bells chimed, I stopped working. I stood in the window, still, with closed eyes. The sound of the bells to begin with was very strong and gradually faded into silence. The echoes stayed on. I recall in Warsaw when the church bells rang, Orthodox Jewish boys covered their ears with the palms of their hands and stood in fear. I sat on some steps in a corner in a dream absorbed in the toll of the bells. Later, drums had the same effect on me.

There were four street performers. I was surprised that no one stopped to listen. Not even the children. The Morris Dancers usually attract quite a crowd. After a few minutes the bell-ringers packed up and left. They must have felt disheartened. I left the house and managed to catch up with them. I handed to one of them something for the performance. We talked for a few minutes. I learned that they rehearse every morning before "going into the streets".

"We want perfection."

I don't know why but I asked how they made out. "All right, quite all right. What we make, we divide into five."

"But you are only four," I said.

They laughed. "The fifth goes to a charity. A children's home and the like."

"It was disappointing for you here."

"Perhaps it was too hot. The English are funny this way, on grey days we always do better don't we?" They laughed. Now they asked me what I do for a living.

"I am a sort of painter."

"A decorator?"

"No, an artist of sorts,"

"Not a pavement artist?"

"Not yet, but you never can tell." We all laughed.

Back in the studio I felt quite cheerful as I always do after I meet with splendid men.

12 February 1987

No image is ever "realised". Abandoned, sold, realised – no. It always surprises me what dealers return: "like them but could not sell them". Reg[8] brought back five paintings. Was glad somehow to have them. I recognised the mood I was in when

[7] Our second home in Suffolk. The first was Holly Lodge in Little Cornard, near Sudbury.
[8] Reg Singh, a dealer.

painting each of them. The small man in a boat. The larger, a further man sitting on a heap of nets. Too bad they did not sell. Very good they did not sell. Today, before it went dark, spent an hour or so sitting and looking at the large "Homage".[9] Just looking.

15 February

Typed a note for Nini[10] to be read after my death: a strange experience absenting myself from myself. Never felt at such a distance from life and death – neither matter. Hope she will follow my last wishes – (traditional wordings make me laugh – use them whenever I want serious feelings not to sound all that solemn).

17 February

Not a good day. A. kept me waiting well over an hour. His excuse: traffic. He bought four drawings and a small painting. I am not a good shopkeeper, the sales did not change my mood. Was also irritated by A.'s expectations of a "good talk". After he left I sat down in the armchair, closed my eyes and with some effort rid myself of my irritation. All seemed so childish. To be so distracted by such trifling things. It is silly to see in every bit of human behaviour disrespect. Even if it is so, so what. Losing myself in drawing, all went well again.

19 February

In the "The Homage" I am trying to get away from any semblance of "actuality". This slows down the process. Have not worked on it for quite some time. I wait for the image to take over and make me do the first things that have to be done. I treasure spiritual impulses that the image alone can stimulate.

20 February

In the evening at Elaine Feinstein's, a little celebration – her biography on Tsvetayeva.[11] Afterwards dinner with N. Even these rare occasions of socialising tire me mentally. The hardest day's work does not fatigue me so much. Just had a phone call from Mr Gibson of the National Portrait Gallery. The trustees decided to buy the portrait of Arnold Wesker which I painted in 1962. Wrote to Imogen thanking her. It was her suggestion.

[9] "Homage to the Women of Greenham Common."
[10] No sign of it. [11] *A Captive Lion: The Life of Marina Tsvetayeva.*

23 February

The need to isolate still more from others – a need, not an attitude and to concentrate. Concentrate.

25 February

In a most pleasurable state all day. HOW I feel the person. WHAT I feel the artist. I felt strangely free and danced my way down the nine steps.

2 March

I cannot name a colour just as I cannot touch it with my finger. Colour acts not when it is named. Yellow is greenish, yellow is reddish, yellow is light, never yellow outside its function. A name restricts, its effectiveness always in nuance. What is any colour without its emotional implications. Colour is the connecting force between pigment and emotion. When I say the sky is red I exclude the otherness that makes this red particular. This otherness too negates all other reds which are also other than red. When a colour loses its name it is effectively born.

9 March

Only now the large portrait of three figures (fishermen) enters the dream grounds. It began as something much harder. Now feel more at home with it. Patience.

23 March

Douglas[12] and Matilda yesterday. Both look very well. Was worried about his health. Since he retired he looks even younger. I was delighted to see in what a good state Matilda was. She too seems happier than for a long time. Both had a rough time.

3 April

I create myself bit by bit each day. The day I don't create myself, I don't exist. Whenever my mind goes blank, my eyes feel it. Only when I work do I overcome my restlessness. I really enjoyed doing the designs for the book jackets. Peter Jay came yesterday to collect the design I did for their booklet of poems by the Yugoslav poet, Ivan Lalic.

11 April

Colours to which we can attach a name are without mystery. Nameless colours are the ones with life, a life of their own. Not enough words for this immense republic of

[12] Douglas Hall.

colours. The eyes make choices but the feelings dictate. I leave myself open to these dictates. Work is going quite well. Very much at peace with myself.

15 April

Back at work. Seldom hear dogs barking. See them walking the street quietly. Today was a horrific uproar. Stood in the door. Saw an Irish down-and-out, known by sight, chasing a large dog with a stick (I'm not good at recognising species). The Irishman gave up. Sat down on the bench muttering to himself. Saw me and shouted, "Kill, kill this bloody beast. Second time he's ran off with my sausages." I went over and asked whether a pound will do. "Sure, sure, thank you, thank you." He went off. This man once told me a tall tale but a very beautiful one and with much emotion.

17 April

Catriona[13] died. The news of her death affected me more than the usual death of friends. Only a fortnight ago she rang me, she was more coherent than usual, even laughed a good deal. *She was such a lovely person.* She suffered so much. After our divorce, some thirty years ago, we only met four times. Each meeting was a sad one. By now I could recognise the fatality of her mental states. Usually my attitude to death is "so what, we all die" but at this moment I am not so detached. *Her death seems the only death.*

4 May

I know suffering, nightmares, anxiety and other pains of the mind but I can boast that I don't know dullness, apathy, boredom.

5 May

I have no longer to refresh my spirits nor my creative energies by going to places. In fact the very thought of travelling makes me restless and I do things to get it out of my mind as quickly as I can – though I still look at landscapes of Westerns with pleasure. Travel would distract. Already the atmosphere of an airport makes me feel restless. Haste does not suit my temperament. When on the spot I manage to get back into my normal rhythm. Then the thought of getting back – the same panic. Once in the studio promise myself NEVER AGAIN. Continuity of feeling is even more important than continuity of thought. I can link up with the interrupted mode of thinking but feelings once gone, gone for good.

[13] Josef's first wife, Catriona MacLeod.

7 May

With *each work I declare myself.* I no longer want other forms of declaration. No *more interviews.* Anyway, whatever I have to say is of *no importance.* Got a short piece from Gabriel: sad but its depth escapes me.

10 May

Laziness, does not alas come naturally to me. Yesterday tried to get some pleasure from doing nothing. Sat for a while in the garden in the sun, reading. Almost succeeded. I sat in a quiet space, *absolutely* quiet and it was pleasant. Then I opened my eyes and that was that – by now a memory.

17 June

Meant yesterday to go to the opening of the Rothko exhibition. Was too tired. Also the thought of meeting with some people I know and the small talk on such occasions. Now glad that did not go but will go one early morning when few people. Feel deeply with some of his works. Even he is sometimes "explained" by the knowers with much emphasis on technique. How much technique does a present day painter need to have – not much more than a six-year-old child. Simplicity! In everything simplicity. At last back to work. Got a splendid little Eskimo mask, probably a fake. This would not worry me. It is good and this is what really matters. If it is a fake, the faker had too good sense *not* to improve it. It is too good to worry about its genuine- ness. It is *genuine* in its quality. Besides freeing oneself from the terror of the master- piece, I have also freed myself from the terror of the art industry with its connoisseurship and all in the service of this industry; in particular this so-called scholarship. A splendid little mask. Decided to keep it in the studio. Of course the whole business of faking is a social and commercial problem, not an artistic one. To clear my mind of these speculations had a cup of coffee, sat quietly for some time then I worked with calm intensity for the next few hours. Quite satisfactory results.

29 June

Painting in the morning. Watching Wimbledon in the afternoon. A leisurely time. At times quite lazy. Don't feel the worse for it.

2 July

The last few months worked happily with Diane.[14] She took on still poses and I followed her body, first with my eyes, then with my emotions, then with my pencil. At times I followed her with the passion of sight alone and did rapid notes of her

[14] His favourite model.

Nude
Mixed media
28 x 18.8cm

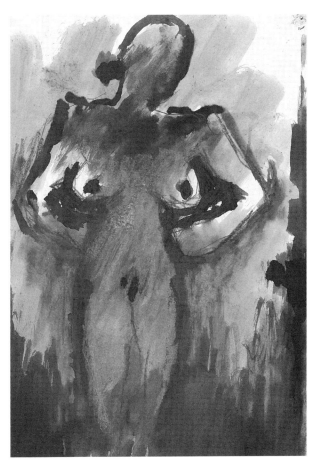

general attitude. At other times, I hardly looked at her, completely absorbed in what appeared on the page. I never posed her. She was so wonderfully inventive; she used her body as though it was a quiet instrument. It was even easy to dream in her presence. Some notes took longer to get into this state and must have been tiring for her but when I asked her, "Painful? Tired?" Her reply was, "No, I can hold on." These were a splendid few months but I am afraid my interest in her is now ending. A pity.

The nudes I am now doing, though from notes after her. I do without her and with no need of her presence. This too may change. She was the best model I ever worked with but when interest fades . . .

4 July

In the afternoon something quite moving happened. A young lecturer in English at Warwick University is leaving for the States. The English department collected £200 to buy him a farewell gift. He chose to buy a drawing of mine and wanted a work of my time in Ystradgynlais. Fortunately, I still have some good works of that time and what he selected gave me particular satisfaction. A miner, space, a tip: a working drawing for a painting I never did at the time. It often happened that when the drawing said everything I had to say I did not bother with the painting. A splendid young man.[15] The whole thing brought tears to my eyes. When he left, I could not even get involved in Connors in the Wimbledon semi-final. Late, late in the evening I regained some composure. For a department of a poor university – all universities today are poor – to collect money and for him to choose a drawing! Though a dealer this morning brought me a much bigger cheque for the sale of a recent drawing, this was a mere transaction. Emotionally it meant nothing, nothing at all. Today, I am still not quiet enough to start a normal day's work.

27 July

Yesterday at Becci's graduation. To avoid traffic we arrived hours too early. A fine walk in the forest. The little ceremony quite touching. Becci hugging her diploma. Her first positive assertion of her potential. Because of her difficulties in learning she thought herself doomed to "failure" in the dreadful terms of our dreadful society. The years at this course changed her self-image. She was always good at doing things. It was good to hear her being recognised for her own gifts. Perhaps one day she will no longer need this. Anyway, she was radiant and resolved to do her higher course.

28 July

Too many outside distractions. A letter from a young woman art historian who wants to write a monograph – the publishers, Lund Humphries are "very interested". A time ago I would have welcomed it, today I have mixed feelings – I may decide against the whole project. The lovely quiet of the nudes. The lovely quiet of the three women. Why on earth do I need to get a foothold on the "vanity industry" – the immortality industry?

29 July

The image is the meaning not a device for an ulterior meaning. The meaning is in the totality working towards its own end and through the whole process and it cannot be treated as a puzzle. The unconscious reasons. Images cannot be read as a sort of hidden

[15] Paul – son of Josef's friend – Moelwyn Merchant.

truth. Images should not be *read* at all. We discover them through the development of our whole being and not through the involvement of our intellectual faculty. Drawing is not a form of writing. Nor is it a way of codifying symbolic messages. Without a manifest truth – it is a truth. Not all I am doing at the moment is meaningful in this way but most of it is gratifying when done in this spirit.

30 July

I don't think I have ever been inspired long enough to claim an inspired work – a whole work. Those powers come in the process, lead my hand, my emotions, my perceptions and then fade. From what physical area does it come? Which are its physical sources and resources? I am not aware when I get gripped by it. When it is and as long as it is, it encompasses the whole of me, not any particular part. When it leaves me I am unchanged but contented with the thing I was an agent for and with myself.

This contentment sometimes lasts for days. From experience I can say that inspiration is completely independent of my reason and of my perceptions. If it affects my reason and perception, then this happens in a way that I am not aware of. It is relevant while it is. When it leaves me I cannot proceed in the way of its rightness. Inspiration is an occasional event. It is self-contained. It shows no future. It establishes no precedence. It fulfils its own functions and is not subject to any function.

Can I speak of its will? Only in as far as it is subject to my own will. It is not the prime mover of creativity though I am certain that it can be in certain instances. Can I point to the niches which owe everything to inspiration? It affects the totality but which section specifically I cannot say.

At the time, my satisfaction is so great that I don't care to look for explanations even if I could recognise them. If there is such a thing as fake inspiration, it must be like a delusion, not a lie.

1 August

The fear of saying the obvious – an unnecessary terror. Saying the obvious signifies that at a certain time it has become personal, no longer objectively distant. Always new, that *intensity* is important to expression. It verifies depth and sincerity: it is essential to the living quality of an image. Obvious. Yesterday, sitting in the armchair looking at the images I now have on the wall, I was struck by how much each of the works, their truth, depends on the degree of intensity I managed to get into them. Wherever it is not all prevalent, I know that I will have to go on working. To get towards the depth of spontaneous feeling can be a slow process. I also contemplated, among other things, on the distinction between individual truth and general truth. Individual truth cannot

be questioned. General truth is subject to arguments. Very often the two overlap. With different words and different associations we often speak of the same thing. Explanations are unsatisfactory. Artists and mystics often cover the same ground but the mystic's words are preconditioned by the nature of his theological background. The mystic often confuses the poetic colouring he gives to set beliefs. The artist reaches the poetry of his experiences in a poetic way free of predetermined intentionality. Spent hours in such a pleasant mood of reflections stimulated by my own images.

2 August

Doing something new. Redoing something old. Same thing. I follow obsessions which decide things for me. This morning got up early, dressed slowly, walked down quickly the nine steps, put on my overall. As often on days that start like this, the day's work went well. It was one of those days when aloneness had no trace of loneliness. I trust the spontaneity which takes its time to activate the whole of me. It may take a long time for spontaneity to come into its own.

3 August

A long day and nothing to say. Not even through silence. Walked in the little garden. Pleasant fragrances. All flowers out: the light of the daffodils [sic], dark clematis, the climbing roses and a fine variety of greens. Most of the time looked up to the grey sky. Also a few friendly phone calls make me feel less empty. Still no serious involvement in work.

9 August

N. left yesterday for a week in a cottage in Buckinghamshire.

10 August

Rang Becci in Norway. She sounded better. In the early evening rang N. All is well. About six months ago developed a pain in the right knee. It got to the stage where I could no longer walk up steps except one at a time. N. noticed this and asked what is the matter.

I: "At my age one can expect things to go wrong."
N: "Rubbish."

She at once made some phone calls and got a name of a woman, a Mrs Bunny. I have been going to her for an hour twice a week. The pain is practically gone. I can now walk upstairs without any discomfort.

When N. and I first met she was only 29, a general practitioner earning £6 a week. A splendid looking creature and splendid character: "I hate medicine. I like healing."

Still today she will try anything and judges things by results. Whenever I see her overworked and tired and in low spirits, now at sixty more often, it breaks my heart and though the house is not a home without her, I am glad she has taken this week to rest. On the phone she said, "I am more tired than I was aware of." I suggested she stay longer. She: "No, it will not be necessary. The few days will be enough."

11 August

At six yesterday I rang N. She sounded very tired and very sad. Fear that she may be heading for another breakdown. She went to see her brother one day and next day her mother. Meetings which at the best of times affect her badly. The next few days she will be for complete rest. May go down Saturday and travel back with her on Sunday. Would however prefer if she would decide to stay on another week. Now feel pleasantly tired. Will go into the kitchen and do a bit of imaginative cooking.

13 August

N. is much better – at least she sounded well. Decided not to go for the weekend. Agi[16] collected most things for the September exhibition. Will be glad when this is off my mind. At dusk, went for a walk in some of the little streets. Had a good conversation with the sky. Also thought what had happened to my childhood friends? Could only see a few faces. Then back in the studio.

15 August

What a dreadful botcher I am! How much on guard I have to be not to fall back on old habits. This morning, for no reason that I am aware of, I began on the brown around the blue lying figure. I put on some red ochre. To begin with I liked the warmth it gave. Then I awakened to the fact that what was an image had become a picture with my old atmospherics. It took quite some time to wash the ochre out, to get rid of any of its remains, to repaint the brown. While trying to get back to the brown, I had by chance put in a darker brown, and this gave an even greater strength to the image. So what started as a catastrophe ended with a good morning's work. Only strong images hint at my true feelings.

23 August

Not only am I a solitary, I practise solitude whenever needed at will. Solitude gives me more than relationship with others. I have no love of "culture", its manifestations in art. I have not been to a concert, to the theatre, to the cinema and whatnot for years and do not miss any of these. I read but I do not care for "literature". I seldom go to

[16] Agi Katz, Boundary Gallery, friend of over 50 years.

museums. What I go for usually is to see one or two works by someone I need to see that day. Having absorbed these I leave quickly! I am completely immersed in works I *have* to do. I have exhibitions – I would rather not have any but that is, in part, my livelihood. Exhibitions as part of the pattern of present day "culture"? NO! The so-called opening night is grotesque. Also painful. I came to dislike art theologians, knowers with missions. Perhaps, all this is self-protection but I also think it is something more. Behind all "cultures" the same barbarity. Socialising with intellectual "stars", a great nothing. I have nothing to say to them and there is nothing they say at social events that I want to hear. After I leave, there is such a dreadful dissatisfaction with all these acculturated moments of so-called exchanges of ideas/opinions that it takes me a day or two to recover. Oh, how I get lost in such encounters.

25 August

I cannot work. Went to the National Gallery. When I go to a museum to see the few images I want to see, I walk in the street for as long as it takes me to empty myself of my worries and other preoccupations. When free and ready, I go in. I walk quickly towards those images. I communicate with them in silence for as long as it may take to assimilate what I came for. Then I leave quickly so as not to be distracted by other images. It was raining. Only now more aware of the rain than before. Back home, back to myself. A bit less tense. Vermeer's girl pouring milk is more than an illustration of a daily event, it is an allegory of simplicity and quiet. De la Francesca's singing angels goes even deeper into radiance and silence. Contemplated on these two images: not on their outward subjects such as form and so on but mostly on the different levels of their deeps.

At times I had to fight off distractions when I fell into the trap of seeing the image in terms of concepts and meanings but these did not last long once I got into the more beneficial state of directly experiencing the image free of any intellectual and historical props. Then the images and I become one in a state of radiant daydream. This is also a way of "learning". I don't think I will have to go to the National Gallery for quite some time.

26 August

The notion that an image can be read and that puzzling things out lightens our perceptions, seems to me theological pretence that does not address itself directly to the things which make art and therefore cannot be taken seriously. Knowing why putting my finger on a place causes pain can be investigated. When I have put my finger there my immediate outcry will be AH! Our active perceptions work at a similar and instructive level. What is astonishing is how it persists on the same ground, behind

so many forms. No form makes art. Art finds its form. Whether a moody form or a still form, the primitive origins are the same. Whether the form is open, spilling all over the surface or closed and concentrated in quiet dignity, the primitive origins are the same. Whether the form is hazy or clear, the primitive origins are the same. The form is never a definition but a channel. A concentration, not a formula. Whether the form is like a Dervish dance or immobile, like a sitting Buddha, the primitive origins are the same.

28 August – Suffolk

Left London at 6 a.m. Not much traffic. After Ipswich hardly any. Arrived at Dunwich[17] soon after 9. Straight to the beach – we cannot get into the farmhouse until 10. N. lay on the pebbles. Sun. Sound of sea. I walked around. Then, sudden wind. A fisherman in the door of a black shed. "No fishing yesterday, no fishing today." Breakfast at the café. Just before 10 we drove over to our place where we would stay for three weeks. Much light on the terrace. Forgetting commitments, only drawing, jotting, reading. The sound of a passing tractor. The church bell. When these pass, the silence is still more deep. I am quite relaxed. I feel better and getting into a more relaxed mood. Thinking: what do I like about this place that I like to come back here every summer. There is nothing here to explore: a good place to sit back and absorb the little there is. Little is always enough for me. Sea, space, fishermen, seagulls – enough for my primitive perceptions to come alive.

29 August

Yesterday, after early supper, not yet dark, we walked down to the beach. Still sea. Hardly any waves. A few thin silhouettes walking, each alone. Walked midst the boats. Some of the old and familiar names are still around: "The Little Doer", "Two R's", "Fred's Last". Two new names: "Early and Late" and the more puzzling "No Name Yet". Made a few drawings. Reading. Slept well. It is now 5.30. Surprisingly bright for this hour.

30 August

Experienced a strange disappointment: no seagulls. Asked some fishermen. No one noticed. There must be a reason. Not one seagull. The large combine arrived in the yard. The man, still sitting high, mopping sweat off his face: "A very lonely job. Don't like it. No one to talk to the whole day long. Still the machine does the job for many. For me it is lonely work, up and down the fields the whole day long and no sound

[17] A fishing village on the Suffolk Heritage Coast where we rented an old farmhouse every summer.

around. No one to talk to. Still, must not complain. Much unemployment around. A lot of it here . . ."

On the road and on the beach, a few memorable encounters. One: a big tree of the pine family in a white sky. An astonishing symbol of serenity. Two: a man standing still for a long time, not changing position, looking into space beyond the sea. Three: the arrival of the boat; always a mythological quality to this scene. Four: the splendid voice of an old man from whom N. bought onions and beetroot. It reminded me of the rolling intonation in the Suffolk way of speaking. Not looking for impressions, memorable things happen.

31 August

On the way to the beach saw a man mowing a tiny lawn. Then he went down on his knees and with the palm of his hand went over the surface of the grass. Seeing me at the fence he said: "Not low enough. I cannot get it smooth and clean. This is the fourth lawnmower in two years, none good. You would think with all that going to the moon they could make a good lawnmower. 'Good,' they say. 'The best,' they say but I say 'Not good enough.'" Then he got up, kicked the lawnmower and said: "It will have to be as it is, cannot get it righter than this."

3 September

Yesterday in Aldeburgh. Many seagulls here. Stood still and listened. Stood still and followed their movements in the sky. The sky white, the sea dark, no wind, no waves. Went into a shop to buy warm pyjamas, was asked £57 – no warm pyjamas. Thank goodness weather changed. Today, quite warm though a small and distant sun. Recently became aware that in many of the books I am reading quotations at the opening of the chapters are more meaningful than the chapter. Often see no point in the comments, the arguments. What is strong in two lines loses its feeling fibre when enlarged. The poetic insight is diluted into prose reasoning. Active thinking knows no separatism.

4 September

Reminiscing. How was I when I was young? In a different mood, a different young I. Memory is very selective. Memory's selectivity is not unlike images in a dream; not what images are but what they mean to tell me. At present, all memories before me benign and they make me feel good. My reflections that followed were nothing like as vivid as the memories. So I gave up thinking about this or that.

17 September

Tomorrow, back to Edith Road. Brought with me all the material for the book *Notes from a Welsh Diary*.[18] For three weeks did not give it a thought. Today, I saw clearly the size, the jacket. The layout and order of illustrations. So unconsciously I did work on it. Good three weeks. Dunwich, a rare place. Missed the seagulls.

18 September

We left Dunwich at 8.15. No emotions. Nearer London, a strong wish to go back. At Edith Road and not yet home. The familiar not yet familiar. Know myself. In a few days I will feel as though I have never been away.

20 September – London

The book is going well.

25 October

Notes from a Welsh Diary has reached a satisfactory completeness. This week, first few days of painting flowers. The exhibition at Agi's ends next Thursday 27th. It went better than I expected.

26 October

Strongly divided feelings about the flower piece: too dramatic! Will wait and see. The great thing about an image – it produces no solutions and relies on no solutions.

27 October

Often surprised: picking up an abandoned work and cannot understand why? I set to work following its spiritual direction. It is never a matter of externals. The nude has not changed but it has become what it is meant to be. Glad not to have destroyed it. I work on an image until all literalness disappears.

28 October

For the moment I can go no further with the flower nor the nude; all my energies, mental, physical and spiritual are at present fixed not on performance, invention and the like but on this unknowable thing – the art totality. This does not depend on will. Solitariness did not come naturally to me. I had to make myself live within it. Only then am I truly with others and only then can I be of use to others. Today I would not have it any other way.

[18] Published in 1989 by Free Association Books.

30 October

Worked on the large blue kneeling figure. Took out all narrative elements. At last a degree of satisfaction with this image. Also worked on the flowers. The nude is not as good as I thought. Will see.

My creative sources are everywhere, in notes, in drawings, in places, above all in the studio. Always the same performance is near, art remote. Most of the time am concerned with the remote. Last night watched a fine programme about an Indian mathematician. Since years ago, when Hyman Levy sitting in my armchair talked about the aesthetics of mathematics, I have been fascinated with mathematicians – they are probably the truest artists. I did not understand a word of what was said but could have listened for the rest of the night. Like with all true art you are born this way and not conditioned into it. The moment the programme ended I fell asleep. When a mathematical pattern is not beautiful, it is not mathematics. You try a thing this way, you try that way, when it is beautiful you have the solution.

3 November

Whoever writes in the first person is open to the accusation of self-indulgence. So be it. What is often forgotten is that "reality" or issues in its name can also be a good hiding place. Whatever the case, more than in my ego, I am interested in the man – in me. I am not all that sure that I have ever drawn a sharp division like: here is the I and here the We. It is all a matter of departure rather than arrival.

Before I began work, I was very disturbed by a dream[19] from which I awoke wet with perspiration and very anxious. So much insecurity, so much pain hiding deeply most of the time. It takes a dream to bring things to the surface. Always touched how much my security depends on the involvement in work.

4 November

Worked the whole morning on the blue nude. Feeling! I am now getting somewhere. The main thing is the image took on a direction I recognise and can follow.

6 November

Because of builders cannot work. My eating habits have changed recently. Lost taste for meats. Prefer mixed vegetables. Chinese style with soy sauce. No vegetarian principles: change of taste. On the whole I give now little thought to food. Also came to dislike "eating times" – like to eat only when I am hungry. This presents some domestic problems. N. is very strict about "dinner time". Also some other new irritations with birthdays, anniversaries, holidays and all traditional jollifications. Nor do I care for

[19] These recurring nightmares were surely connected with the extermination of his entire family.

presents – to receive or to give. Very, very upset about these at the best of times. Always in a panic when having to choose. As for parties, this I gave up. Also attending "opening nights" of exhibitions, worst of all "social occasions". Content only when alone. The builders will end their work today. Now that Christmas approaches I am already nervous at the very thought. Once the builders have gone my mood may change.

14 November

Whenever I work on an older image it is not to "improve" it. Aware of certain things, changes etc, I missed earlier on. Nor do I draw to keep my hand going, mostly to get my spirit on some sort of track. On lucky days drawing is its own end. Skill often in the way. Drawing, painting, testing the spirit, testing itself.

21 November

In the storeroom yesterday I found a pastel from 1945, a landscape with a tip on the horizon. I don't know why it had to take forty-two years for me to notice its quality and potential. Worked on it from 6 in the morning until about 4 in the afternoon. I was back in the mood of my Ystradgynlais days. After ten hours work I was as fresh as when I was young.

16 December

Worked on the blue painting of fishermen in a café. Half tones, quarter tones, gentle contrasts – no rapid decisions. This is how I work now – towards a gradual building up of a mood that owes something to reality but more to my own spiritual needs.

3 January 1988[20]

Went as far as I can with "The Homage". As often, I leave this image with mixed feelings: dissatisfied one moment, hopeful the next. Mostly confused. Also irritated by having to use a palette[21] instead of my large marble. This is not it. Patience.

9 January

Gazing at "The Homage". In the past few days I put in certain things, then took them out. What is clear in the mind proves false in the painting. The nudes of the past two years have the serene atmosphere of a naked soul: in "The Homage", not quite. These eyes of mine see too much and dream too little. It is a long time since I had so little guidance from my sense of rightness. Everything comes from the eye and the head. In my case this is always a bad state.

[20] Josef's 77th birthday. [21] The huge canvas was hung on the wall too far from the easel and marble that served as a palette for easel painting.

29 January

I shun people who "have no time". How creative inactivity is! Which is not the same as being absorbed by passivity. I now have quite a bit of time for sitting and reflecting before I begin work. I see painting not as an expression of personality but as an extension of it. This must have been at the back of my mind when I stopped signing pictures years ago. As I see it, the artist is no longer an elevated performer. He finds himself in the same boat with the philosopher and the mystic but the artist is still freer than either. The philosopher is restricted by his drive towards constancy. The mystic by the theological norms of his religious background, his doctrinal tradition. Artistic experiences are the only ones beyond censorship of the conscious will. They may even summarise an intellectual totality without giving it a questing priority. I am not thinking now of historical categories only of man, the artist. Many things have to be peeled off before we get to the centre. Avoiding temperamental distinctions and cultural categories and other conditioning patterns, beginning with an absolute vacuity seems to me essential.

30 January

Diane is back. The thirty-odd drawings I did with her and after her. With her, I return to basics and feeling a beginner, testing the eye does me good. The watercolours I add after she leaves have a liberating effect on me. More of the unknown thing we call art enters my work when away from models. I sometimes like to exercise the eye for its own sake. She is totally without inhibitions, which is marvellous. There is more stiffness in her ways when dressed. When nude she is without any self-awareness: "it is all me". When she leaves I turn to the pages, work on them as though she has never been here. As for "the image", I still work on it with intense involvement. At this stage, mostly at inches here and there never losing sight of what they do to the whole.

For quite some time thought of going to Egypt to see that simplest of all form, the pyramids in their space. Without cultural prejudice in their simplicity, a greater emotional concentration than that of the tips. Cultural blinkers affect our responses. Now my yearnings are so strong I may go there at the beginning of March. My attitude to form changed after I saw the sitting scribe of the fifth dynasty in the Louvre.

1 February

Although I decided to ignore most of our culture industry, I have to make note of what S. told me. She arrived quite excited. Apparently Bonnard was addicted to the camera and took a lot of photographs, some of which he turned into paintings. The photographs have now been discovered. I really could not see any reason for the excitement. S. said, "I just came back from Paris. No one talks about anything else!"

I could not see any relevance: "Well my darling, I dare say the culture industry has to make itself now and again ridiculous."

S.: "In the last few years it has become increasingly more difficult, every year more so, to talk with you. People used to respect you, now all I hear about you is that you have become a bore." She was really upset, even the silence remained strained. The alone are never forgiven for being alone. She is the only person who tells me the most awful things about myself without causing me any pain.

13 March
Will now leave the "Homage" for a while.

27 March
The shape of colour, colour that suggests shapes. I am constantly aware that once I get away from the sensuality of colour there is little which differentiates colour from form. In fact they reinforce each other. Worked on the smaller version of the "Homage". It began as a study but now I think of it as another version. About the watercolour texture: I spent a lot of time to get away from the *watercolour cleanliness*. I even prefer a "tired" surface to a "clean one".

4 April
Not only the drawing, the page has to come to life. This was not my observation. S. was here this morning and while looking at some recent drawings and watercolours she said: "How well they belong to the page." She is right. Not that I give it much thought but I do take trouble to make it one with the space around it.

16 April
Much of the last two days work was really playing. It gave me much enjoyment but surprisingly, some outcomes were quite serious. So much pleasure through innocence. Indeed, the more the innocence surfaced, the more the pleasure intensified and became almost orgiastic. This morning I looked and said to myself, "Play more, old man. Play more."

19 April
I cannot deny my enjoyment in handling paint, though I seldom give it much thought. I feel so much gratification when lost in the moment of trying out this colour or that. When in low spirits I console myself with mixing colours for no purpose, or gazing at the traces of colour left on the scraped marble. Such lovely findings on a scraped palette! To look slowly. The eye is a slow thinker. It assimilates things from the

strangest sources in its slow way but the emotional compensations are tremendous and often of puzzling intensity.

20 April

What is called achievement in art is little more than a cultural affectation. I am no longer interested in achieving, no longer worried about a place for myself: free from ambition. Now that I need no longer to be loved and can live without loving,[22] my mind is often truly free. We are all strangers to each other. I am a stranger to myself, how can I expect to be less of a stranger to others? All my true concerns are in my work and there I do not expect laurels. It brings its own compensations *sometimes*. I settle for this. Nor do I live for the sake of those compensations. There is no good reason for living. I have invented many reasons, this when I needed beliefs. They all faded out of my life. I no longer build beliefs nor rely on beliefs.

21 April

Generally, I do not throw myself into work. I get into it slowly. To work slowly and feel every inch of the image "becoming" gives me a lot of joy. To feel the inspirational forces growing until they take over, bringing with them gifts which become the true meaning of the image without my having followed a reasoned beginning – this too is a source of joy. In science, it is misleading to ask the wrong questions. In art, it is misleading to ask any questions at all.

 After S. left, I sat down in my armchair for a few short minutes. I closed my eyes. When I opened them I was in my own environment, splendidly alone. Transcending my personality my feeling self emerges.

25 April

Titles belong to literature, not to paintings. They are *always* misleading, even as mere indications. Too often they condition the eye, the emotions. They indicate a poetic aura which may not be in the image – a state of feeling for which there may not be words. The image always goes further than the thoughts on it. Above all, even when related to the image one cannot simplify the inner complexities.

29 April

The less I have to say about my images the better I feel. Words are so off the mark! Rounded thinking always worried me. Pointing a direction tells nothing of the place. When in Wales I quite deliberately tried to give my images an atmosphere which would not fit comfortably on the walls of a middle-class drawing room. That they eventually land there made me laugh at my quixotic gesture. Still, I was right. What I

22 This was surely a delusion, although the idea of loving always posed the terror of loss.

am doing today has no gestures whatever. In work, as in life I treasure only the revealing moments. Other people's ways are not my concern. The main thing is not to question gifts of the imagination. As long as I am in control of what I am doing, painting is work. When the process takes overs and I follow, then it is no longer work. Even the title "A Homage to the Women of Greenham Common" is too restrictive. No title. No words.

2 May

Worried about the image.[23] Could hardly sleep. At two in the morning knocked myself out with a double dose of sleeping pills. Awoke at 5.30. Fresh with new energies. A strong cup of coffee and slowly down the nine steps. The forces of creativity are of course the most mysterious of all mysteries in the human psyche. Within half an hour of work the strength of the image that had so eluded me, now was there before my eyes. The most geometric image I ever attempted – this was already in the design of the drawing. What a splendid awaking. This guessing and testing the deeps and strength of emotion is quite painful but rewarding. Most rewarding. By psychological impact of geometry, I dare say I mean something relative, akin to the relativity of time in which experience of time is so significant.

6 May

I came to believe that jotting is an art form the least smothered by ambition and performance. Leonardo, Pascal, Montaigne, even without their example. I wish the word "sketch" would never have been invented. Thought of this for the first time years ago when I read Delacroix's division of drawing: first idea, sketch, drawing. Did not trust it then, still less today.

8 May

The drawings of Diane in my grey little book, are in terms of the emotions, a sort of diary. A diary of moods rather than self-conscious attitudes towards drawing. Each drawing involved me completely and kept me involved when I returned to work on it some days after the initial sitting. It is a truer diary than one I would write down with words. Some preserve a physical intimacy but most of them are more of an inner and spiritual kind. Not one, I feel, is a purely mechanical performance. This moves me most. I look through this diary every so often. Drawings become important when words, good, bad, are no longer of any relevance. Children achieve this more often. Drawing nudes, I came nearest to images where the subject is no longer the theme. Perhaps it transcends meaning.

[23] The "Homage".

9 May

Looking at some of these recent nudes, watercolours, drawings, I experience sensual stirrings that I am certain I did not have when drawing. Other nudes are quieter and do not disturb my own calm. They are the essence of light and in these I live better, more as if I was drawing with a smile. They become more intimate than anything of the senses. The less my nudes remind me of the woman, the better I like them.

A thousand drawings strive towards one image which alone is the emanation of a singular perception. The inward power of true perception is never without thought. In drawing things arise, become and eventually are what they are – not in meaning but in suggestion. At times this gives the impression that thoughts were not part of the process but I have never seen an unintelligent drawing free of thought.

I have to accept my limitations, my contradictions. Part of me is I, part of me is MAN. The identity of an image is a unity of the two, including also the dark, unknowable areas.

In these pages I have avoided, with rare exceptions, everything of my daily existence. This existence of mine consists of too many futile happenings and gestures and insignificances. My own clumsiness baffles me and often betrays me. I am often my own enemy. No one harms me more. Only with my work can I get out of my existence and begin to live.

I can never rise to anything as meaningful as when I am alone and at work. As I am not a good swimmer, I keep above the everyday waters as best I can, splashing in all directions which is enough to make competent swimmers laugh.

Favourable things happen to me now and again and this is how I survive. Because I survive more obviously than others at times – even "showing off" I was once told – people say that I am "shrewd" and capable of handling myself. I am glad that I am neither. I would have been more dissatisfied with my nature than I am.

10 May

MOOD brings all things together. The self is at its fullest, the mind at its dreamiest. A unity of marvellous feelings. The I in the centre of its own light. Strange that the MOOD should absorb and unify such a multicoloured variety. Time focussed on the moment and will have no other. The exalted cannot be denied. No fragments. A distinctive atmosphere encircling the reflective calm. Little of the world. ALL of the person. The mind concerned with meaning is as tenderly involved in living, a rare and dominant serenity, a radiance not brought about by outer light.[24] I believe that the same mood, the same reflective mood, is in my present work as it was in the works of

[24] Again and again, the struggle to put mystical experiences into words. As he grew older, he was constantly striving to achieve and define these states.

the past. This gives me heart. For me MOOD was always central to the positive of the unconscious.[25] The differences are not superficial but they do not belie the sameness of the mood. It is clear to me that I look at my work, as I used to look at the works of others. I very rarely look at the work of others now in terms of "development".

11 May

Sat this morning for quite a time gazing at the latest nude. I may have overdone the formal precision and perhaps overstated the logic of the design. I wish I could guess what dissatisfies me. The watercolour is less confirming. I find all the obvious formal confines disturbing. In any image strength alone is not enough. The watercolour records a truer growth of emotions. I started the oil because I felt I can go no further in depth. Now I am disappointed and look more lovingly at the watercolour. It is more revealing. Often time comes to my rescue. Patience. Patience.

15 May

Sometimes when a work turns out which cannot be compared with anything in reality or with the work of others, I tend to look at it with suspicion and fear. It takes me sometimes weeks to accept it for what it is. Fear is a positive test. Uncertainty too.

18 May

Am moving towards painting about which nothing can be said in words. Definitions in drawing are conclusive (unlike definitions in philosophy that are not the last word to be said about the defined). The drawing stands alone. It cannot be compared to anything in reality. The feelings I may have towards a model (the person) are different in kind and in depth from those which are in the drawing. Even the hidden has an unconscious history which the drawing takes in. *Understanding* exterior things gets me nowhere.

20 May

I came to dislike writing, painting, everything that is of a trend rather than a person. Categories have become repellent to me. "Good" writing and painting, in terms of performance means so little that it can be disregarded. Competence hinders expression. I am leading an uneventful life. Even so, too many things still happen. With people I get involved in conversations which I'd rather not concern myself with. I would rather not see a soul.

[25] Josef saw the unconscious as divided into positive and negative but not in the Freudian sense.

21 May

I like illiterate people. They say things in an original way. Short of words they make astonishing use of metaphors. People with a university education use too many quotations. Authorities use too many "rare" words. Afraid of simplicity, they mistake academic language for "culture". They get dozy with too much reading and knowing. They also "read" images. How dreadful "images" sound when packed into words!

24 May

When colour deprives an image of its elementary strength, of it sculptural wholeness, then it trivialises even the decorative element. An image should never lose the simplicity of its drawing, nor the design of the outline. None of these are a matter of decision but of priorities as they emerge from the process. An awareness of how things became as they are. With each painter, simplicity is different.

28 May

My present day attachment to some of my early works is little other than sentimentality. I like these distant works, not for what they are but for the nostalgia that they bring back. Within this nostalgia, old moods and feelings come back.

Whenever I feel "low", I go into the room where "Lear Destroyed"[26] hangs, that I bought back recently, sit in front of it, gaze and meditate. How great my identification with the Lear on the heath when I worked on the image twenty-five years ago and this has remained. Afterwards, when I come back to the studio, I have the feeling that I have been somewhere where it was good to be. How strange this refreshing power of images! In the saddest of them, there is a healing element. At least this is my experience. What is clear to me now is that there are few drastic breaks in the totality of my work. I have no past, no present and do not worry about what the future may bring; I speak of the feeling of continuity. Lear on the heath is me and always has been since the earliest years that I can remember.

31 May

I came to dislike reading which tries to explain and is not itself the explanation. All this attitudinising! All that judgmental pontificating! All those culturings! What for?

4 June

I am more interested in the evocative aspect of scale than in its physical aspect. Also, in the black and white drawings, I am trying to get away from contrast, from conflict, from light. I find this very difficult. I do not feel the way I see. This does not bother me

[26] It hung upstairs in a living room.

as long as in the process I begin to see the way I feel. At times, this is difficult to attain, at times it comes as easily as singing.

When S. was here the other day she remarked: "You have gone far away from illusion." Not far enough, whatever I mean by this. I like this little painting. I don't know how it came about but it has no tension whatever. To get into the essence of an image, one has to stand clear of the meaning. The meaning can be and often is, quite superficial – the essence never is. Each seed and each growth: different.

7 June

Quiet lines are fairly difficult to achieve. Quiet colours, more so. I am nervous about my colours. They tend to be too wordy. How difficult it is to free oneself from the habit of thinking with words and through words. It is not a matter of attitude. Attitudes are easy to change. It is a matter of inner reorientation, not unlike Teresa[27] learning to pray without words. When I read of her life,[28] I was struck by the common experiential roots of art and mysticism. Religions are too pragmatic and organisational to have anything in common with art. Freud's "there exists no religious feeling", is profound. The reality of mystical feelings seems to me, unquestionable. Whether these feelings affirm theological or doctrinal concepts, I really doubt. That atmospheric vagueness make them akin to the experiences of artists. Their links with moods and chance and states of mind, makes them akin to the innerness of the creative process, that of scientists and philosophers too. Wordless prayer. Wordless image. Neither is in any way dependent on logical conclusiveness.

11 June

The art industry is run on strange values. Let them. More important than the best performances are the ups and downs of the spirit on its single track. I see more of this in Leonardo's jottings than in his finished works. Sometimes, to reach our deeps, demands months and months of concentrated effort but this is not the same as "polishing" a performance.

23 June

Only the emotions in an image which are stronger than anything I felt, make all the effort worthwhile.

2 July

[27] The writings of St Teresa of Ávila (1515–82), a Spanish mystic, writer and the first woman doctor of the Church. He returned to these again and again.

[28] Her autobiography *The Way of Perfection*.

For the past few weeks, I awake each morning frighteningly depressed and plagued by an inexplicable anxiety. Being prone to this state for years, I am glad when for weeks and months I am free of it. I never know what makes them disappear or what brings them back. I am glad that I can manage somehow to do without antidepressants now.[29] This morning I had the strongest dose of it. Not wanting this state to get the better of me, I forced myself out of bed at about 4.30, made myself a cup of coffee, emptied the dishwasher (a routine thing I do each morning) and went quickly down to the studio. There, while looking at some of yesterday's drawings I began to feel the way I feel when free of depression and anxiety. Work is a healer.

Flat colours cease to be flat if their combination produces a radiance without a reference to naturalistic light, or any of the physical effects we find in museum art.

Worked on several kinds of blue and grey until I found the right kinds to help the yellow give an intense glow to the whole surface – all the time being guided by what I call my sense of rightness. Tomorrow I may find that it was all a vain chase, I hope not. Today I felt elated and this is compensation enough.

3 July

In drawing, only sincerity needs practice. The last few days, drawing more than painting lifted my spirits. In drawing, as in Haiku poetry, less means nearer the core of feeling.

11 July

This week's reading: Dorothy Wordsworth's *The Grasmere Journal*. Splendid simplicity. Much concentration on small events, all revealing. I loved it.

12 July

"Sometimes when I sit in the window and look at the moon, I feel so soft and lovely inside me that I think I will at any moment dissolve and not be here at all!" said the first girl I overheard in the little park.

Second girl: "Funny that you should say this, really funny 'cause it's so true."
First girl: "Yet people who walked there say it's only a bowl of dust."
Second girl: "Oh, what do they know."
I know the two girls are right.

[29] After his breakdown in 1966, he was on antidepressants for some years. They became an addiction from which he had to be weaned. This was accomplished over a period of many months – to his relief. Depression continued to be a problem, especially in the early morning.

18 July

Nothing could induce me to abandon the external world. Nothing could induce me to abandon my internal world. Living is one process. Living through one's labours is one process linking the two. I have no way of knowing whether life is worth living without putting myself into the box of values. What I am doing is my life. Death will choose my time of dying. To the accident of living and dying, to both I am indifferent. In between days of gladness, days of pain, I do not trust the principle of pleasure.

Martin arrived to collect the book.[30] Now it is all in the hands of the printers and the gods! If all goes well it should be a good book.

21 July

No desire whatever to limit myself to one way of working. The memory of the artist in me is good, better than ever. The memory of the person in me is dreadful and getting worse every day. I wanted to work on "The Homage" but I have not got the physical strength, this is the only thing I have lost to a greater extent at my age, otherwise I see nothing that would make me sing in praise of youth. Youth is physical strength, nothing more.

26 July

Physically I can no longer do with socialising. Yesterday we were eight for lunch! I somehow stood up to it. Had a phone call from a psychoanalyst, Arturo Varchevker, who organised a sale of drawings and paintings for Nicaragua. My watercolour was sold for £480. Altogether with the Pinter play he hopes to raise a few thousand pounds. Fine things do happen in these dreadful Thatcherite get-rich-quick times. I was glad that my watercolour got this price because I told Varchevker that since money goes to this cause I will not mind if he cannot get the normal price and to take whatever he can get. From bitter experience I have learned that no matter what the cause, people try to get from such sales bargains.

27 July

Some years ago I made an unexpected discovery. I had a bottle of French polish on my working table – and I can no longer remember exactly how it happened – I spilled some on a drawing. To begin with I was angry with myself, then I saw new possibilities of enhancing the texture, not unlike varnish on a painting. But surface effects do not hold my interest for long. When painters of our century did away with varnishes, they did so too dogmatically. Probably a reaction to picture making which

[30] Notes from a Welsh Diary.

made of varnish part of the "finished work". I have seen some works, Cubist and Fauves given a dreadful garishness by being varnished. Still, some of Sironi's splendid black landscapes gained in depth by his use of varnish. No, no, no dogma whatever way.

28 July

I still cannot make out the problem of old age. Beside a few minor physical things, I remain as I was. Nor do I believe in growing wisdom, supposedly one of the merits of old age. Nonsense. Even the awareness that death is now nearer has no effect and I seldom, if at all, think of it. Ignoring what I cannot affect came naturally without any reasoning or effort on my part. Nor has my isolation anything to do with old age. It is my temperament.

Even as a small boy of about three or four I liked spending long hours in lone corners. If I gave up travelling abroad, it is because hustle, discomfort and the unpredictability of our flights makes it not worth the effort. Blame it on "progress", not on my years. I never got much out of my travels but I did like finding myself in other places where I did not understand the language. To give this up is no great sacrifice. At the moment there is some fine music spoiled by some commentator. Just when some radiance comes through, some commentator pops in: "This was composed during his short journey to Italy." How dreadful! The cult of knowing has become a real menace.

29 July

Most of the things written, said or recorded about artists are seldom interesting. Only what artists say, no matter how poorly worded, is interesting. This is my experience of readings, past readings. I read now very little on art and artists. Like in their art, the merits of a single work, so their opinions matter less than the links they form in the chain of constant striving. No picture but the unseen roots of his talent in work as in words. Always stages, never an end. What death ends are the stages which did not end.

1 August

Saturday bought letters between Rilke, Tsvetayeva and Pasternak. My reading at the moment.

2 August

Definitely worked with too much excitement. Not in nature but in art there is a silent way of being born.

3 August

Little gains are also something to be grateful for. The sickness of European literature is the love of words. These letters are too wordy. One line less, a meaning better conveyed. All three are busying their minds with meanings. Many good things in between. The editor's comments we could do without. After a while began leaving them out. Each uses the word ''experience'' as though it was the most natural word. I guess that Tsvetayeva means the same as I: the subjective and objective brought together by a momentary flash of instinctive awareness. What makes art of a poem or a painting is not the performance but the sense of growth of awareness.

4 August

For too long artists borrowed their thinking from others. I, too, for far too long a time. Now there will never be ''thoughtless'' images. The main thing is to let the image work out its own thinking. I do not even try to understand the thought-direction of the images in front of my eyes. At work I do not direct but follow. I don't even know when to stop. Without an attitude I do not look for alternatives to attitudes of others. I am not interested in what others are doing or have done. The other day in Trafalgar Square I passed the National Gallery quickly, in case I was tempted to go in. What worries me about museums is peculiar to all museums; atmosphere in which ''styles'' figure as conclusive alternatives. I no longer get a thing from all the alternatives. Museums are still useful to those who like to speculate on ''theoretical possibilities''.

12 August – Dunwich

Left London at 5 a.m. Still dark. Surprised at so much traffic at this hour. Stopped at our little orchard: an egg, salmon sandwiches and coffee from a flask. Off the main road and away from the traffic, we discovered this little orchard two years ago. Arrived at Dunwich at 8. Grey sky. Slight drizzle. Unpacked and went down to the beach.

The old café burned down. The present one is a temporary one while a new one is being built. Bad news. The woman, a fisherman's wife, who ran this café, left after the fire. He went too and the daughters. I always expect things to remain as they were. Sad, sad, sad. The chats, the fish salads, the friendliness. The Ship Inn still seems as it was.

13 August

The sea was too rough. ''Not going out. Not tonight.'' Few seagulls. Two new boats on the pebbles ''Early and Late'' and ''Brenda Jean''.

I: ''Why 'Early and Late'?''

Fisherman: ''Why, it is clear. We go out early and come back late.''

I laughed: "Do you know why this one is called 'Brenda Jean'?"

Fisherman: "Ask him there. It is his boat. I know of course."

An old man, no longer fishing. I: "Excuse me, I am very curious about the names."

He: "It is a long story. Brenda Jean was my wife. She was sitting here on the stones while I was painting the boat. This was forty years ago, I remember. I said, 'I am going to give the boat your name.' She said, 'This is only right. I want to be with you everywhere.' She was. So she was, 'til she was no more. Because of the memory, I don't want to sell it and I have no sons to give it to."

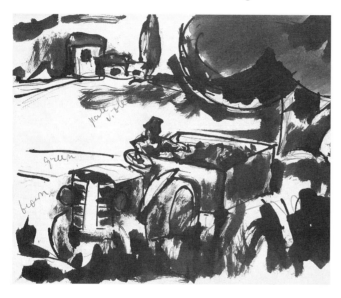

Suffolk Fields
Ink and wash
20 x 25.5 cm

14 August

Six days already and not a drop of rain. Now morning. Just after 6. Quiet and the church bells. A pity they chime so rarely and for a few minutes only. N. came down after seven, opened the door and let Sheba[31] out, then called me and pointed to a chain of birds' nests under the roof. We even had a gift of rare excitement, we saw a bird in the act of getting into one of them. Now N. went back to work on her manuscript. So much contentment and the day hardly begun.

This year, the return of the seagulls made us smile. N.: "I wonder what happened last year? There were plenty of seagulls at Aldeburgh."

I: "Without the seagulls, the place is not the same." Dusk. N. lay on the pebbles. I standing. Both watched the pattern of white wings in the sky.

[31] Our chihuahua.

16 August

When I speak of solitude, I do not mean the solitude of the "outsider". I mean the solitude in which I find new life for my creative energies. The positive condition of aloneness and indifference.

Ideals are offshoots of reason. I am more inclined towards great feelings. In their light, the best reasoned ideals fade in significance.

Only the alone have no need to hide. Only the alone know how to live with others without intruding on their space. Only the alone know the fullness of emotional self-sufficiency.

19 August

Each place I got to know was through the heart.

Not to be harsh with others, with myself, with life.

Of all nature, the human soul is the most unnatural. What has the soul to do with the "survival of the fittest"? I don't know what a star at dusk does to the body but the soul with its strange emotions begins a journey into the strangest regions of the human spirit. There is nothing like it. This is what makes it unnatural. How? Why? Why we?

The body and the soul live together with dependency on each other but they are not the same. Not a bit the same. Even the sickness of the soul is nothing like the sickness of an organ of the body. A dancer once told me, "It is the body that moves, my soul does the dancing."

After having so often followed others, I am now certain that what one learns from others is not worth knowing.

29 August

First, wood pigeons. Then the sounds of other birds but the quiet in between was most generous with its gifts. The early light, but still dark. Back from a stroll in the garden. The night retreats slowly. At this hour, it is easy to be alone, to be quiet, to feel whole.

It all started when I was sixteen. First I doubted God. Then I doubted his existence. Then becoming aware of the creative power of the unconscious, individual and collective, God died on me and has never since been resurrected. The dark, mystical sources of experience remained dark, relevant and life enhancing.

It is easier for me to withdraw than to be silent. Yet there is more of me in silence.

2 September – 5.30 morning

Will be leaving at 9.30 to avoid the morning rush hour in London. Went to the seashore. The sea, brown, in the most vicious temper. White waves hitting hard and spreading themselves all over the place. Fishermen placed the boats on higher ground. All boats were secured with thick ropes to poles. So Dunwich showed what this sea can be like.

Anxious. Sorry to leave. Could I have lived here? I could. We even looked at some places. High prices but nothing suitable. A strong desire to leave London.

10 September – London

After recurring anxieties got back to drawing and painting. The mixture of donkey work and creative work brought some relief and also got me back to my "normal routine". In days of depression, I find "decision making" impossible. To cancel the February exhibition took a load off my shoulders. The "attacks" no longer last for weeks or months as used to be the case. Now, only days, mostly because I make an effort to deal with them at once. Perhaps the depressions are no longer as oppressive and deep as they used to be. The first day is always the worst. Even on the first day, I no longer think of suicide. It is quite some years since I dismissed suicide as a way out. I view suicide in terms of a rational solution, not an escape. If I ever decide to go, it will be with a clear head. Just as no optimism keeps me alive, so no pessimism will force me out of it. Besides, I find both pessimism and optimism clouding my awareness to an equal degree. Living and dying is as much in my hands as it is out of my hands.

1 October

Too late to grumble. The book[32] is almost good, good to the degree that I am not ashamed of it. This is something to be grateful for. The exhibition[33] to go with the launching of it, done and out of my mind. The image of three women in the light of the moon is much better than at first I thought.

4 October

The large "Homage" goes well. Deeper. The scale has something to do with it. After five hours' work I got physically tired, irritated because mentally I could have carried on. Quite literally, I could not stand on my feet.

Things have to happen before I know what I am doing. The shapes of spaces between bodies and between things are almost satisfactory in the large "Homage". The energies of the intimate and the quiet only now begin to find their essence. The radiance too begins to find a kind of stability.

[32] *Notes from a Welsh Diary.* [33] At the Boundary Gallery.

5 October

Why do my satisfactions evaporate so quickly? Why does the feeling of not getting anywhere return and stay on longer and longer? Not that this clears a way for the next step. No, it darkens all in me. All I can do today is grind my teeth. I tried all the tricks in my repertoire to get into some sort of working state to no avail. It is now only midday.

7 October

Another splendid, uneventful day. A calm surface has its own intensity, its own calm rhythm, its own depth, its own intimacy. Because such surfaces convey no pain, no drama, even now I sometimes get suspicious of the degree of my involvement. The instinctive is the most difficult to categorise. The essentially primitive is the most difficult to recognise. Quiet revelations, quiet wonders and slowly attained goals. It is all a matter of human nature and perhaps also a matter of how long you live. The longer I live, ''achievement'' means less and less to me than ''communication''. Life has become significant very late. Very late.

8 October

Decided to sell most (almost all) of the art books. Their very presence on the shelves irritates me. Also most of the other books as well, with the sole exceptions of those which still mean something – very few. So-called expression of culture has become a nuisance. Too much of everything and too little I can relate to. I decided also to sell most of my collection of other artists' drawings and paintings – same reason. Not interested in ART, only in the things I am doing. Others distract. Most of them. The present day fashion for ''moderns'' to paint after ''some big name'' seems to me a ridiculous way of giving oneself ''museum prestige''. What use comparing oneself with anyone? Our human sources remain primitive, whether they be collective or individual.

9 October

Looking at the large ''Homage'' and my heart sank. After nearly two years' work, I found that I totally failed in setting the figures in a dream space. Without that dream space, so different from natural space, the figures are not dream figures. The whole image lacks the compulsive state of a dreaming mind. Perhaps, too many distinct fragments. Too great an accent on surface integration. Two years. So what? No relaxation in such effort. All should come and perhaps will come eventually when least expected, as it so often is with me.

10 October

The deepest areas of experience are difficult to reach, still more difficult to express. I know that most of the time I have to stop short, almost there, not quite. Hence, so often my sense of futility.

11 October

Everybody misses something in life. It is impossible not to. The problem for me, in daily life, was what I am willing to give up. I find that there are many, many things that I can do without and in human relationships I find that I do not mind being the loser and that it is emotionally too wearing to always be a winner and most of the time not even worthwhile. Now that my life is my own I think the decision, though a conscious one, to be self-contained and lean on my work only, was right. Outside work no rewards of real importance. "I want to get out of my life all I can." Well, do so my dear K.[34] I don't know what it means but whatever it is as long as it is not of one's own inner space, it is bound to disappoint. To make of greed a pattern of life usually impoverishes human emotions and deprives them of spiritual nourishment. Not what is essential to one's happiness but what is essential to one's being.

13 October

I am not much of a self improver nor a successful "adapter". Whenever I try to improve my relations with others I usually make them worse. All this aside, I am most fascinated by the unconscious that is most active when I work and give it no thought. In moments of silent reflection, it also rewards me with unrequested gifts: not always "rosy", sometimes stark and violent, nightmarish, though I am not asleep.

I call this "unconscious" which reveals a pattern in feelings, rather than in thought, distinct from anything I can associate with consciousness. Both are internal but consciousness takes in much of the external, while the unconscious, none at all. There is nothing theoretical intended here.

In the process of work, I cannot discriminate. I am too involved but in silent reflections I know better which is which. (Whether this makes psychoanalytic sense does not worry me. I am not my own patient. I use handy terms without much concern for their meaning in a stricter definition. I use what is useful to me just as none of my jottings are intended as a form of communication with others.) In my reflections I can contact more of "awareness" than in "peace of mind".

[34] Not known.

15 October

In spite of the restlessness – with the appearance of the book and the exhibition – restlessness was bound to creep in and take over much of me. Still, I manage to do some work each morning. Most of the day I have to make an effort to keep some sort of life in me. Not very successfully. When I look at the book I still worry why I have included this drawing and not another. Couldn't I have made this page better? Oh, how I wish I could be back in a mood of *indifference* to events, mostly events which affect me personally. Indifference to things is not the same as suppressing them. Be this as it may, at the moment I am in a maze of restlessness. Bob Young[35] told me that even if all 2,500 copies are sold, this will hardly cover the cost of production. This too worries me, though he added: "It is a lovely book and I am glad to have done it." He surely is not "the run-of-the-mill" publisher. Now another publisher approached me with the idea of publishing "all" my writings. I told him to make it a posthumous occasion when I won't be here to stop him. I do not mind to publish something as an occasion arises but it would be pretentious to present these as writings worth putting together in a volume.

17 October

Worked on "The Homage". I am still trying to remove the image from outer reality. To make of it something of inner contemplation. A mood in which we can experience the impediments of outer reality and not get immersed in visual trappings, nor in the transitoriness of a happening. As for the subject, I believe that I removed it from the "communicative" – speaking for itself. I am still far from the mood of a long lasting present – wars have been with us and have always been treated as a historic moment. Since 1945 there has not been a single day of peace. The old fears. Old, old, old . . . strong awareness of the old still alive, more so in moments of reverie than in argument. All those "because" and "it follows" get us nowhere. I came to mistrust the word "reading" when facing an image.

Now something else – work with the nude is going well. Work only in the mornings. The afternoon a lot of disturbances. The exhibition caused a lot of misunderstandings. I arranged it mainly to help raise the sale of the book not to be taken as something in itself. To some degree it helped: the gallery sold so far fifty-eight books but also eighteen drawings. All within three days. Even some people who should have known better make more of the exhibition instead of taking it as a background to the book. Though financially it helps, it also irritates. I hoped that the greater attention would be given to the book. The book alone should matter! I worked so hard on it! The whole of it, not only the text. Ah well, one should never expect too much. As for

[35] Publisher and friend.

myself, the book is a summation of those years in Wales. I will not have another exhibition of those works, nor will I permit another book of those years. My main concentration is on the works connected with the work of the last few years.

20 October

The horrors of nature are always with us. At this moment, the three whales[36] gasping for breath, their tragic heads surfacing now and again for air, are symbolic of stark and meaningless suffering – as though repeating the famines, hurricanes and all other "gifts" pretty nature brings to us. It does not bear thinking about. For a time I could not get out of my mind the image of a seagull devouring a fish.

21 October

What I enjoy most now are my jottings,[37] whether in watercolour or pencil. I don't know whether they are "drawings" or even "art", or leading towards something more "serious". This morning, looking through a number of those sketchbooks, it gave me a strong feeling of satisfaction, even exhilaration. I could tell myself that these months have not been wasted. Every oil done in the same spirit pleases me too. What I find so satisfying is that even those which start in preconceived notions find their own level of expressiveness.

23 October

Whenever I have to become part of the art industry I get disgusted with myself as with this exhibition.[38] Curiously, I am less affected by the shopkeeping part than by the present day exhibition cult. I feel better when withdrawn and alone. By now Agi has sold well over sixty copies. I doubt whether any bookshop will do half as well. I feel quite silly in that ceremony of signing copies. Ah, our high culture!

29 October

Every new work is preceded by days of depression and uncertainty. Once involved in the slow work process my anxieties are no longer of a depressive kind. It is only today after a dreaded week that I had a few ecstatic hours' work. Everything came with astonishing certainty and the blue, matted nude between black and yellow, gave me more than momentary satisfaction. The quiet of light! This which stabilises, even contrasts.

[36] Some whales were reported beached and unable to return to the open sea.
[37] He refers here to images. The other variety are written lines. The former he also called "Try Outs".
[38] To launch *Notes from a Welsh Diary*.

4 November

Last evening we were five for dinner. Anuschka,[39] Douglas, Matilda, N. and I. Age is often generous. It did a lot of good to Douglas's head. After dinner, Douglas and I went down to the studio. Looking at the "Homage" I was surprised to see him emerging slowly from his great shell. He also showed a good deal of involvement with the nudes on the wall and also with the ones in my notebook.

On the whole a busy day with some moments of gratification during the few moments alone with Douglas in the studio. Also Michel Duffett was sent by the Tate to photograph the self-portrait for the catalogue. Must build a stronger wall around 120 Edith Road.

8 November

Whatever is too precise is misleading. Works define themselves outside definitions. Setting out for a short route to India and discovering America goes on all the time. Still, no precise map for the next journey. Competence spells danger. "Truth to material" too. So many wisdoms to ignore! Fortunately, the image at hand absorbs the whole of me and there is no time left for choices. There is nothing left but blind obedience to the form itself.

It occurred to me that the only worthwhile exhibition I have seen this year was of the Tibetan Tiger rugs. It was my mistake to go to the Hockney; I am glad for him that he has popularity to sustain him. I cannot imagine that these works of his can make him feel alive. Perhaps for short moments. Perhaps. There were more people at the Hockney than at the Tiger rugs. It is quite extraordinary that slight sophistication is so much more gratifying to people than the real thing. This third visit to look at the rugs was even more gratifying. Such closeness I feel towards any kind of folk art and any not too tutored artist. How near those remote tigers are – each single one, no matter how little of the tiger remains in the overall image! In front of these rugs,[40] I feel so refreshed by humility.

9 November

Used to think *art* was a way of penetrating reality. Today's thinking! Art is *another reality*. What makes of images art is that other reality. The image is a shell.

10 November

Images and music. Difficult to take them both at the same time. Who, watching a film listens to the music? Or looks up the name of the composer. Yet when there is no music I am missing something. I am missing the sounds I hear but also do not

[39] Anuschka Menist, dealer in African art and close friend. [40] Josef bought one.

listen to. Images and music. Listening we often close our eyes. Looking we shut out sound.

13 November

Everything fulfils a need. No hierarchy here, only urgencies. Quiet and in shadow. In things done, my autobiography. Careful with things said.

3 December

A blue jar. Leaves mostly. The strongest design I attempted for a long time. Colour is god when in the right place, relating well to the shapes. The few hours work gave me great satisfaction having thought about it for the last few days. The blue is new to me. One never knows what happens with the drive for work. Believe that I am now in for times of work. Hope so.

10 December

I have everything I want and often a bonus: contentment in the studio. Why go anywhere? Now that we are coming near the date of going to Egypt, I wonder . . . Perhaps?

12 December

Since I stopped being intimidated by artificial light, life has become easier. Got up at 3.30 and saw at once what I have to do to the flower piece. Now I think I am free of it and can go on to something else. I put on the easel a large brown, underpainted board and am waiting for the image to appear on it. Not a bit nervous. Quite calm. Eduard [Roditi] has been staying for the past few days. Poor fellow, only two years older than I and very, very old. Lives on memories of the "great" he has known. A victim of good memory. Still has a great amount of good anecdotes. The most generous soul. He came to interview Kitaj for a new edition of his *Dialogues on Art*. People who give and are seldom given to are so appreciative of the slightest thing given them. Gave him a copy of the *Notes from a Welsh Diary*. Exaggerating its "historic" importance he made me feel uncomfortable.

23 December

Too many people come to buy: I felt a bit like a shopkeeper. I should not complain. It keeps out the money worries but it also made me restless. Whenever the phone rang, I jumped out of my seat.

2 January 1989

Whenever I force myself to be with others I make my life impossible. Alone, working, contemplating, reading, I find life not only bearable but also worthwhile, though I am never free of the anger about its impermanence. Get easily confused and upset often even when alone in dialogues with myself, let alone with others. The hurt opens the ground under my feet. Then I begin something and only a few hours of satisfactory work takes me out of the depression or melancholy. Surprisingly at the recovery I find myself totally undamaged and link up with the continuity and my more stable direction. Perhaps I am exaggerating the depth of my hurt or pain or whatever it is that I inflict on myself. Tomorrow off to Egypt. Very much looking forward to the week there. Worked on the jottings – one hundred, cutting each down to the shortest and simplest expression which surprisingly brings out the authentic intensity of feelings. This slows things down but also makes the commitment worthwhile. I mean of course the commitment to the jottings. Even ''The One Hundred Dawns'' as a general title came to me out of the blue and ''dawn'' after weeks of thinking of other possibilities.

Susie[41] gave me Forster's short book on Alexandria, David gave me Flaubert's accounts of his Middle East travels. Forster's short essay on Cavafy is by far the best I have read about him, far and above the introduction to the edition. I can only read poets I can identify with. No bookish language. Some friends say that I write the way I write because I don't know English. It is perfectly true that my English is hardly English but the simplicity I am after has nothing to do with it. Even if I would have had a greater mastery of the language, I would still have preferred to write in the language of the street. In art, primitivity is an attainment. Never too far from the real, never too much involved in it. The mystery and the force of it. Mountain peaks look at each other. The dream is the thing. The truly dreaming my dream.

13 January

Back after seven days gazing at the pyramids of Giza. Their impact is difficult to imagine without the experience on the spot. What one has to do is empty one's mind of its functional and historical association and just see them as the simplest of all architectural inventions.

I am still short of breath.[42] I have made some notes on which I hope now to work. Also the drawings – I only made about fifty. Maybe I will leave them as they are but on some I will work. I am incapable of learning in any other way than by absorbing.

[41] Our daughter-in-law.　　[42] From excitement.

17 January

I have read somewhere that a seventeenth-century Japanese poet walked for miles to see his favourite tree. When he arrived the tree had been cut down. He wept. I feel like weeping every morning when the dozens of advertising leaflets and other paper items are pushed through my letter box. This morning: six leaflets urging me to buy a house or country property, four leaflets and a brochure urging me to buy this or that, to invest in this or that. Barclays bank explaining to me at length what opportunities I miss by not borrowing on their wonderful terms and six invitations to exhibitions – two from abroad. Poor trees. Wouldn't we be better off with less paper and more trees?

30 January

One day I like what I have done and hate it the next day. In the last few years I found a more balanced emotional attitude towards a work. This week extreme reaction came back. I took a day off from work and spent most of the time reading: Cavafy, Paz, Basho. I also for the first time in recent weeks succeeded in sitting still and letting the mind be naked. This happened on Tuesday. On Wednesday I was back at work in the right spirit. An astonishing January. Mild as an English summer day. Did quite a bit of walking in the nearby little streets. How few of them have trees. Yesterday, spent the whole day typing my Egyptian jottings. They are falling into some shape: seven days gazing at some pyramids in Giza. First part: the pyramid. Second part: the sphinx. Third part: extracts from the diary. On all these I have a lot of work before me. At the moment lines seem to matter more than structural continuity. I am open to whatever comes out.

6 February

An image which dreams my dreaming also knows my thoughts.

10 February

The exhibition of the dancers[43] at Covent Garden will be quite good. I have underrated many of the drawings.

13 February

"One Hundred Dawns" – tentative title? Now think it right and will probably stick to it. Reworking old pictures is like revising older manuscripts: something of the old remains and something new comes in. With some works it may take me a longer time

[43] Josef had spent some weeks drawing at rehearsals. In February 1989, some were exhibited at Covent Garden Opera House.

Dancers Resting
Watercolour, 1962
20 x 25.5cm

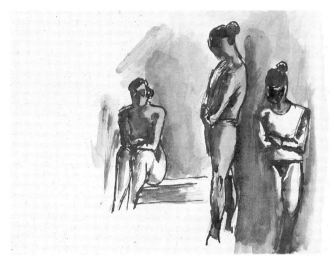

to get some feeling towards it. I prefer to put them aside rather than to destroy them, though I do destroy them every so often. The last two works I reworked are very fresh (I don't think freshness by itself is anything to go by. What strikes me here is that time brought me nearer my true feelings.) I need time. If things come through at once, good and well. If it takes time, nothing to worry about.

Three things worth putting down here:

1. I always tried to keep my distance from people who tried to promote me, sometimes clumsily so that I lost their goodwill altogether.

2. When a painting has something good, it is a good painting. The bad in it can be ignored.

3. I like works of others for different reasons than I would like a work of my own. The art in a work makes the performance as such fairly unimportant. There is more art in a child's painting than in most "perfected" works by "masters". The only thing that makes me restless is long hours of socialising.

22 February

I have often to remind myself not to "correct" expressive clumsiness. Folk art owes much to the "untutored" hand and eye. From Becci I learned a lot. She never did any painting again. I still have a charcoal drawing by her of a cockerel which is truly magnificent in every aspect. She is twenty now. Sometimes she asks that deadly question, "Daddy, how do you do it?" Always a mark of an imagination that is no longer alive with a belief in THE technique! When she was ten, she was proud of her work. She would throw a work of hers on the floor and with obvious glee exclaim, "I did it," and dance her way out of the studio. It was from her presence in the studio that

I became aware that art owes everything to the inner creative SENSE OF RIGHTNESS and not to museum examples!

25 February

As it often happens: my decision some years ago to live and work in isolation is not entirely MINE. Stepmother nature also had a hand in it. I get terribly upset, mentally restless whenever with people and it takes me at least two or three days to regain my inner resources and get back to my own rhythm of living. Yesterday Tutte[44] rang and told me that the Moscow Jewish Theatre is in London and that yesterday evening was the opening. He will have a ticket for me. I wanted to see them. I went. A terrible mistake. A noisy shamble. At times, embarrassing. I got so restless that I wanted to run. Restrained myself. Chatted with some people. Then left before the reception.

Nervous. Tense. For no predictable reason. Everyone I was introduced to was "pleasant" in a party sort of way. "Culture" makers affect me in this way. Fortunately, I realised that this world of "instant wit" can be left and no one is missed when he leaves. Now I am still a bit of a wreck. I let myself too often be placed into a situation in which I do not fit. Though here my interest was quite real. I wanted to hear Yiddish from the lips of a Yiddish actor; there regrettably was little of this. Most was Russian badly sung. Yiddish popular songs, one or two folk songs, the rest was noisy dancing. Poor echoes of a greater theatre past.

26 February

I find everything that comes out of my orifices detestable and embarrassing. In particular now in my old age. There are days I would rather not think of. Yesterday S. was here and we were talking quite leisurely. Suddenly I could not control the thunderous motion of my bowels. I let out quite a noisy fart. It could have happened when with others. Thank goodness it happened in the presence of the understanding S. To cover my embarrassment I laughed almost hysterically. S. merely smiled: "Yes, darling. The spirits lift us high but the bowels keep us down a bit. When I come out of the lavatory, I always let down my head as though I had committed something I shouldn't have."

Clumsily I uttered something quite apologetic: "This could never have happened when I was younger. I have little to complain about in my old age but there are a few damnable things." We let it go at this. Then S. gave me a hand in selecting drawings for the forthcoming exhibition at Angela Flowers. We had lunch in the pub.

[44] Tutte Lemkov, dancer, actor and director.

**Children of the
North End Road**
Watercolour
each 25 x 20cm

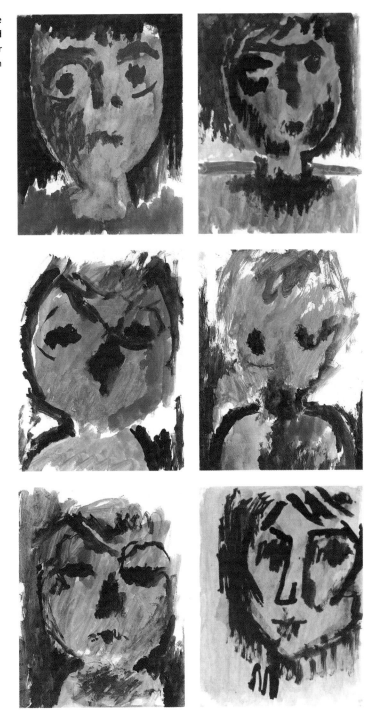

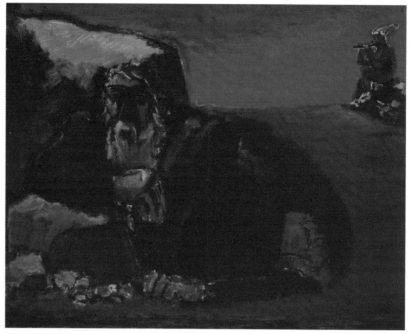

Lear Destroyed
Oil on canvas, 1961
71 x 91.5cm

28 February

Every work with me is what professionals would call "a work in progress". I don't know what it means a "finished work". Am not quite certain when a work begins. A lot of work goes on long before the canvas goes to the easel.

To be and not to belong. The despair of belonging and the despair of freedom. A stranger even in nature. Particularly in nature. No territory. No race. No history. Don't mind staying in the dark. The striving towards expression is consuming enough.

The more self-contained an image, the more I like it. All geometric signs, the triangle, the circle, the square or oblong, all self-contained. Even in the "Homage" I tried to make an effort for the overall image to be self-contained. The expressive totality even now, quite of a dream nature. In the process of work I do not think: colour, form, design etc. Fragmented thinking is destructive. I do not think of the personality of an object or of a person. In fact, I hardly think at all. I follow vague notions or feelings. Every nerve in me wants expression.

10 March

Quite pleased with the exhibition. Both Angela and Matthew [Flowers] will take care, of this I am sure. So now back to my shell. Last night took a pill and slept till 5. Work is going well considering the restlessness of the past few days. Feel a bit more detached than usually after an opening.

19 March

Still difficulties with work because of the two exhibitions hanging round my neck.[45] It was silly to have them. Make great effort to do something. N.'s arrangements of flowers keep me mildly going. The last one began with violent contrasts but after two days' work it became restrained and quiet. Have often to get rid of the restlessness to get to the desired stillness.

20 March

I like silence around me. When involved in a thing called "exhibition" there is little of it left. By all standards of the art industry this "exhibition" is a great flop: few sales, poor attendance, no reviews. Yet I don't regret having it. Looking at this group of paintings in the more detached surroundings of a gallery, I begin to see the links between the works. I am even sorry that one of them has been sold. I will miss it. It is all about positive emotions which no sad events, no amount of discouragement I meet could or did destroy. I gained new heart to carry on. No result calculated. No direction followed, yet some wholeness in sight. I may not live to experience the greater satisfaction but if I am not deluding myself, the last few years were not wasted.

[45] The other being at the Boundary Gallery.

21 March

The flower piece has also now some contemplative quality. Little of the physical. More of the spirit. The body is there for the soul to have its say.

29 March

I never think of "solutions" nor am I presented by surface with "choice". Nothing as mechanical as all that. Colours define themselves and so do forms and I have patiently to follow their ways. It is all quite fascinating even when nerve-racking. The assurance comes very late. Of course, I miss out on many things.

30 March

Each theory closes a few doors and succeeds only in opening a little one at the utmost. Even the little it opens is of dubious value. The assurance which works often is never fool proof. Contradictions are important. What we deny one day and assert the next are all part of the driving force to which we have to submit and be guided by.

31 March

Late afternoon. It feels good to nod one's head with approval at this latest stage of the three-quarters nude. The blue on the right is good and the red shape around the figures (left side) is good. An image with no place in history, a figure which does not belong to any person. A reality all the same of feeling more than transient emotion or even moodiness. I did not feel so good for quite some time. The half light in the studio is the right vague atmosphere in which to contemplate this image.

2 April

What I like most about geometry is that all its symbols are self-contained without anything besides the frame. The triangle, the square etc does not frame a philosophy; a belief. Not even a mood. Nothing joyful or sad. It is what it is without any emotion attached to it. I don't think I would like the same in art. This is beside the point. This is what I found so attractive in the Giza pyramids, fighting off the intention, the religious intention, above all others. I could contemplate the geometry as applied to architecture. One can admire certain things without necessarily drawing them into your own sphere of interests. I am really not one to draw conclusions. Something is what it is and let it be so. No use looking everywhere for personal values.

3 April

With some pictures I find myself working towards the beginning. This may sometimes take weeks, even months but I always recognise when I get there. Working towards an

end is simpler. In such instances I am not personally concerned with colour or form but anything that will get me to that dormant but present (I know in my bones) feeling-territory. Such awareness rewards a little especially when you retrace the process of some more complex works like the last three-quarters nude. I find reflecting on some works quite rewarding and never think such hours of contemplation a waste of time. The world of feeling is immensely rich in nuances, in fact inexhaustible in intensity and variation, sensation and emotion. Feelings are all different, easy to mistake one for the other: feeling is the least physical experience and nearest to the soul. What I am jotting here is not speculative, it is in the nature of my experience. With feelings I am lost for words, literally so. Colour registers emotion but often distracts from feeling.

31 March 1990 – Tunisia

Hammamet is quite a beautiful old town. The ancient part of the city is everything one can expect from such places. How quickly the charm of the exotic wears off! A taxi back to the hotel: Les Orangères. It is very warm. I should guess in the eighties. I am still amazed at the thought of how we got here and why.

The three-week-long 'flu left me stupefied, without energy, without a will to do anything. N. with her intuition said, "You need sun. I need a rest. Becci can do with a change." Within an hour she came back: "We are going to Tunisia. At this time of year this is the most likely place to have the sun you need."

I could have gone anywhere. I had as much initiative as a corpse. So here we are, indeed in the sun. In a fine place. Yesterday, at dusk, we walked to the sea. We lay on the sand and listened to the waves. The sky was darkening. The sea almost black, loud in spite of the absence of any wind. About twenty camels were lying as still as if of stone, also a few Arabs who make their living by taking tourists around on a camel. At this hour there were no tourists. The drivers were as still as the camels. It was getting cold but we did not care to leave or move. Back in the hotel, an early supper and by 9 o'clock we were in our beds. This was the first sound sleep without a drug I had for weeks. N. may well have been right. The sun is a healer.

The prevalent colours here are dark green and ochre. A strange combination but it works very well! Mostly on the woodwork.

Feel refreshed and for the first time filled with longing. Splendid low palm trees. Also a rare tree with foot-long large leaves the shape of oak leaves, dark, almost black. Faint voices far away. I am glad of this feeling of longing. It is a mark that I am coming back to life. I found nourishment in the sun.

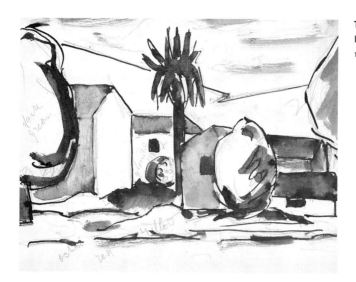

Tunisia
Ink and wash
17 x 22.5cm

1 April

A pity that the little spouting fountain is placed in the busiest part where cars come and go the whole day long. I look at the little fountain but cannot hear it. The tall, old Arab in a carmine fez, he looks after the fountains, read my disappointment and told me that there is another fountain near the bungalows, hidden midst cacti and low palm trees! "You can sit there and listen to the fountain." What a sensitive and amiable old man.

It is on a stone near this fountain that I am now sitting. I have a book with me but I don't want to read. Not yet. It is quiet as at day break. The softly falling waters of the fountain confirm the overall silence. How refreshing for my tired mind. When something is true, it cannot be truer. What else can it be what I feel now? Being, as I have not been before, I came to this spot and I will not be like this after I leave it. Something will remain. Everything which makes any sense to my being lies with the memory of such rare moments. Obviously, to others the beginning of the day is different.

An Arab in a brown shirt helps tourists on to a camel. Then he leads the camel in a slow trot along the white sand. I got some pleasure from this impressionistic scene but like all movement, it also awakes restless emotions. I was glad when they passed. Only things static, stable and quiet are durable. Simple presences.

Sitting in this pleasant place, I opened my sketchbook and began to draw, nothing I could see before me. Nudes. I drew for about an hour and then went to find N. and Becci.

Last night read, though for no longer than an hour. Brought with me three books:

Paz's prose poems, the letters between Sand and Flaubert and Camus' note books. Familiar with all three. In the state of mind I was in I thought these would do to dip into some passages.

On the way back from the little fountain, I took a different route and found myself in a grove of the most splendid cypresses. A cluster of the same trees has a peculiar power. Nothing fleeting about them. So much certainty in just being what they are. Tall, stark, strong. What I dislike about these hasty jottings is that I do not manage to record the exceptional and the rare. Anyway, I always respond to shapes free of trivial details. When it was time for me to move on I was quite exhilarated.

2 April

While I am grateful to the god sun for all it did for me, I cannot say that I care much for the African light. Each dusk I walk to the beach in the hope of seeing the kind of twilight I like but so far, not one. A cool blaze, then darkness, nor did I ever care much for the Mediterranean light. "The nationalism of the sun" is not a catchphrase I can easily accept, nor do I have much heart for "Mediterranean culture". I spend most of the time in shaded corners where I can see little of the permanent midday light. My only indulgence in sybaritic living is having breakfast brought on to the terrace.

My great joy each morning is walking through the huge grounds. Now I am back at the little fountain where I spent a few memorable hours yesterday. The delicate shimmer of the water. The purity of being alone. All around me is fresh, perhaps a bit too clean, in particular the blue of the sky. Still there is the quiet, there is the fountain and no one else around. All very well but not quite. I am anxious and worried. I have no will to work. No active feelings which would drive me on. Four days! Perhaps this is too much relaxing! I decided to go to the fishing harbour in Hammamet.

In Hammamet on the terrace of a café. Waiting for my lemon tea. No place is beautiful or not beautiful. It all depends on what the memory will do with the impressions. What the memory rejects and what it retains. Distance from the objects makes the objects. I know what I am missing in this harbour: no seagulls. The few fishermen do exactly the same as fishermen everywhere else: some work on the nets, some put paint on the boats, some repair the sails, some lie in the shadow of a bigger boat. There are some women all in white and a child.

4–18 June – Corfu

Albanian hills. Dark waters. Dark and still. No motion whatever. The first fishing boats and reality at once inflicts itself. The day raises its head. Since they came in sight the two little boats glide slowly leaving no trace on the surface. They took a long time to arrive and half on the sand the two fishermen emerged quickly. No one

was waiting for them. They went on with their task trying to get most of the yellow nets on to the sand. They moved mostly their arms, the rest of their bodies still and flat as shadows.

Very few cacti and no palm trees. Cypresses though, tall, stark and unforgettable. Shaggy hills, round hills, all grey. The circular bay and an open sea. Nothing impressive. All serene. An inexplicable unfortunate glare from dawn to night. No aggressive sun. Secret ties, stronger each day between my feeling and this place. It feels quite natural to sit, half awake, or to walk at night without sleep. A crescent moon in the sky and the water. Nothing advances at you. All sits back. Nothing lavish. All fits together. A masterpiece of a place. In the distance the barking of a dog. The only cockerel, behind the Villa Santa Maria, announces dawn.

The Villa Maria – a slightly exaggerated name for our small, two-room cottage with kitchenette and bathroom but its location pleases me immensely. A narrow little street with Greek neighbours. A Greek family: grandmother, grandfather and a young couple with a girl aged three or so. Our verandas almost meet. On their wall, as on all other walls, a narrow border of geraniums, roses of a crimson colour, flowers I have never seen before. Everybody waters these borders twice a day. First thing in the morning and late afternoon. The best thing in the Villa Maria is the veranda. We hired a sun bed and each afternoon after work I lie on it, read and regularly doze off for half an hour or so.

I come here to the same stone every day as though I had nowhere else to go. I come here because nobody else does. In silence things come together. From here I see the cypress trees I became so fond of, trees of great splendour and austerity. Besides this, all other things awake the same feeling of wonder – not one thing more than another. It all depends whatever strikes first. Each light lives in a different way. The light of a silver day has the light of a metallic shine. The light of dusk, a fiery crimson that has nevertheless a tenderness along which the tide-waves of the wind float on as in dreams. The moonlight is all heart. That the light of a dead galaxy should awake such stirring of the soul which through the ages became the life of love songs in all places and all languages. Now it is the fierce midday light from which I want to escape. No ethereal afterglow in it whatever.

In some places you read a familiar poem better than in another. In London reading Cavafy's poem ''Ithaca'' I could resist the passion of investigating the roots of its originality and comparing it with other poems of his Helenistic dream. I was outside and the poem was in front of me. The link between us was intellectual. Reading ''Ithaca'' here it was different. It at once became more than literary attraction. The quiet sensuality of his words set off my spiritual longing far above the externals of the subject. His voice, more than the conveyed meaning, guided me on. It was like

following echoes and resonances of my own spirit. In this way I found myself on that strange journey to Ithaca all morning. It was living more than reading.

I like the calm of this bay. Enclosed on both sides by leafy trees. From these hills come an infinite variety of scents mixed with the strong aromas of the deeps of the sea. Above all I like the air of a dreamy uneventfulness. When empty and indolent, solitude becomes loneliness with all its pains. True solitude generates its own content, its own stimulations, its own open-heartedness – to me at least more commanding than the purely emotional "zest" for life. Solitariness and birth are the same.

Distances which lead into the infinity of space awake in me the most mysterious feelings. The nothing beyond it. The nothing without it. Does everything, everything come from an eternal darkness? A wide yellow round the bay.

Timelessness is an experience in no way linked to the invention of time. More than in any setting there is nothing in it to hold on to. I never think of it as something archaic or of now and around me. I am absorbed by it and strangely live in it for as long as it keeps me. All I know of it is that I lived in its name, cherishing the radiance of every single letter.

Walking in the hills. Thin woodlands. Bare fields below. The sparkling sky wide and formless. The landscape as though out of obscurity, trees which glow. Soundless white homes on grass. Light, like sound, is easy to follow. It is like catching sound. It fills the eyes with a reverence for colour and shapes which are as they are and are not meant to be anything else. Scarlet geraniums. Vermilion poppies. Low violets. I also love the round hills standing together. Slender poplars and a chorus of singing light-green. Still walking when a moon like a soaked face emerges from watery clouds. It was not yet night. Back on the coast, a dark wind played with the waves tossing one over the other. A strong aroma of water everywhere.

My memory for names of places, plants and people is faint. The memory of my eyes is intact. This memory I can trust. I can live without criticism but I cannot imagine my life without the critics rooted in my eyes. They do my thinking. They store my experience and are my judges. They need not always be open.

Let's forget what St Stefano really is – a small resort with tavernas and souvenir shops. For me, it is a bay that is quite extraordinary at 5 o'clock in the morning, circular in shape with hills and leafy trees on both sides – on the horizon the first mountains of Albania. In fourteen days I have not missed a single of these unfolding spectacular dawns. No soul around. The twilights with many people around are not the same.

One dawn I had a strange experience. From the moment I came down to the bay a dog followed me and when I sat down on my usual stone, the dog chose to lay at my feet. When the sky began to dazzle with its sharp and spreading light I would get up

and sit on leaves in the shadow of a eucalyptus tree. The dog followed me. Even later, when the place became more alive, this place remained deserted and I and my friend remained gloriously alone. Whether my quiet ecstasy communicated itself to the dog I don't know. I thought it did, the dog lay without motion, silent as though it had stopped breathing. Every morning I ordered for him/her a pizza. The dogs here are unjustly neglected.

Quiet lines are the result of reflection not of inspirations. They follow the gradual rise of emotions. Their lack of rhetoric, their humility, their drive towards form and decisive form in no way contradicts the uncertainties with which they make it possible for emotion to get together. The closed eye plays as much part in this process as the open eye.

Grey sky. Azure patches. Yellow outlines of trees.

A passion for books can go two ways; it can follow the passion for the writer and it can follow the passion for the printer. In a second-hand bookshop in Corfu I found an old book, in the Greek I cannot read, of such beautiful print that I had to buy it.

The sourness of some faces when the sky gets thick and grey. As for myself, I am slightly tired of the relentless brightness from dawn to night. It brings about a certain emotional impoverishment. It is strange how even epic trees cannot withstand constantly grinning skies. I sometimes miss the northern sky without brilliance.

Each day a new sea. Two white boats come to the fore. The surface of the water is slightly trembling. I gaze at the short waves.

In every European heart lives a bit of Greece. Perhaps not the Greece of history. More the Greece of myth. Whatever is significant in the structure of that myth we cherish! The Olympian heights destined for man's spirit, the inert marvels of things real, the world of Gods projecting the world of man. As for the tragic, we have not to look for it – its patterns change but we will never be free of it. I hear lamenting choruses.

These dawns, with no one in the bay, have an idyllic serenity. I came to love those slightly yellow dawns. Everywhere reality becomes marvellous by its air of unreality.

At first it was a morning mist which gradually grew and swelled into a thick fog. No space. No horizon. A bed of thick grey. Sitting alone at the table in a not quite peaceful quiet. Within this fog, how do the energies of nature preserve themselves? Would continuous death have such a final austerity? Where I placed my eyes was like looking into a lump of cotton wool. A soft surface. Impenetrable. I never felt so isolated. Yet I did not move from my chair. Suddenly, the fog burst open and there was sky and sea and a yellow horizon. The passions of a new day showed themselves on all sides. It was only six o'clock. I recognised Dimitri's little boat returning from the night's fishing.

Each little house in the street where our Villa Maria is has a border of flowers. Strong scents and colours. In my diary I named this little street "The Street of Flowers". At one end a dark olive grove, at the other the blue sea and a yellow sky. Also a single tree between two houses. Gradually, I developed a strong affection for this little street. Each day the same dog follows me.

I walk here like an explorer with eyes fixed on things; this is about all there is of the explorer in me. I have not his sense of curiosity, his enquiring will nor his will to know. The way I feel about real things bears no relationship to what the things are in themselves.

A row of tavernas, each with its blackboard and white chalked list of foods. Each taverna has its own coloured chairs and tables under a canopy alongside the edge of the bay. Ugly souvenir shops. All quite monotonous. The bay is the secret and the beauty of St Stefano, though the waters are no longer musicians. Each morning the fishermen spread out yellow nets with very few reddish, small, meatless fish. Cold skies and a rainy day make even the children look old.

St Stefano could have been a small world but it isn't. Too many boats all day with noisy people in a quest for immediate "enjoyment". When they leave you think it is all over. No, other boats with similar men and women ready to laugh as loud as they can.

Lying in tall grasses and looking up at the fine cypresses, I relax perfectly.

Dimitri was once a sailor. He knew Southampton and "Soho, London". He speaks English with much gusto. Today, while we were drinking cold Greek beer, he told me something I never heard before: "When I come home after a month at sea with only men around me, I first run to the nearest brothel. It is not nice to come home and want to rape your wife. After one, two, three in the brothel I come home relaxed, give my wife presents and at night I am ready for one, two, three with her and she is lovely. When my wife was pregnant I liked caressing her big belly. With the child into the world, her belly collapsed. I never touched her belly again.

"There is nothing night and day about sex. For weeks I don't think about it. Then boom, one, two, three and I cannot think of anything else. I wish I could be a deserter. But no. As we all do, I obey. One, two, three, how urgent it all seems. No time for anything but the thought at the time."

Little Leonara, age three, is taught every morning by her grandmother how to sweep the steps. She is handed a big brush which from now on for the rest of her life will be part of her.

The old man, our neighbour wanted to say something. Not understanding his words I understood his will. He wanted me to follow him. I followed him. We stopped in a little orange grove. I stayed at his side. The grove was dark but the oranges

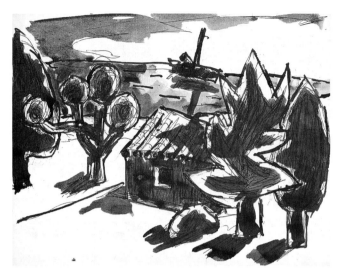

Corfu
Ink and wash
19.5 x 25.5 cm

were alight. The old man pointed this way and that way and talked with great excitement. Then stopped, bent down, lifted some earth and let it fall through his fingers. Then he put his hand on his heart and pointed at the oranges. I read this that this little orange grove grew out of nothing but his labour and love. He smiled. Then turned and we left.

Not being all that anxious about feeding on new impressions, new subjects, I found here, too, things I know, which I drew many times, and like drawing them again. There is no lasting stability in novelties. Sometimes luck is on my side and I see old themes as though for the first time; this way even the new finds its way to a more permanent sphere.

20 July – London

I am aware of the chaos within myself but I am not attracted to it. The rarer moments of tranquillity do more for me. We feel unconsciously how the great quiet brings out the more creative motions and energies. Unlike others, once involved in work, nothing, no amount of noise around me can disturb me. I am *completely* withdrawn, I am virtually deaf. The other day I thought quite a bit about tribal art and the tribal artist – one cannot think about one without the other – though the tribal artist hides his presence, his work is part of the mysticism of the tribe. The artist does not invent. He conceives. His work is not entirely his whatever is manifested in the style. The illogical, the unreason, follows a collective spirituality though his observation, or the visual memory contributes to the significant character of the style. The physicality of

the tribal type; the outward specificities are brought together with the unconscious echoes of the tribal myths. The art is secondary to the spiritual expression; of the conscious *directed* towards the unconscious. With this their art differs from that of religious art which is objective in its conscious aims: illustration of the life of a saint, his martyrdom etc. Instead of religious guidance, the tribal artist produces objects of magic. The single figure does not tell a story but summarises sensations which the tribesman will recognise even if not aware of this recognition in any literal sense. Like in religious art, unconscious sublimation affects physical impressions retaining only basics of things visible: a figure, no matter how stylised, is a recognisable figure with at least some specificities of a tribe. Generally, these characteristics are subjugated to the needs of the psyche. All cultures are formed this way. Styles define psychic needs, not of the individual though.

21 July

The black mother and child seems better now or maybe my eyes got used to it. Certainly, the mood is true though far from that I began with. I began with something quite realistic, with a horizon and a sky, but it became more real in terms of feeling when I moved away from the horizon and sky, figure, memory. I am so glad of the quiet through colour correspondences – echoes rather than definitions.

 Last night watched the splendid Claire Bloom in her rendering of Emily Dickinson. I tried several times to read her but always found her work too soft, lacking a harder centre. Still, I prefer her to all that stuff written to illustrate some theory of linguistic obsession. However, she is not my all time choice. I am speaking here of myself, no criticism of her. No poet can help the nature of their talent. When I say lacks a harder centre, this is what I expect of a work if I have to take it as part of me. This is how a dependency establishes itself between myself and any work by others; painting, music, poetry, prose, philosophy etc.

26 July

Slow lines and quiet feelings go together. Unhurried images in a sense have always been one of the specificities of my work. I recall that as a youngster I was repelled by all this commotion and gesturings before the "composition of the Old Masters". At the time these made me laugh. Today I am independent: at a cool distance. The *experience* through a work of art is also its meaning. The experience is wordless as is the meaning. Reducing "meaning" to the mere literal and intentional also gives that meaning to the food we eat.

16 August

I am quite indifferent to masterpieces. There is really *nothing* to learn. Every single work has to be done without the slightest thought of whether it is as good or an improvement on whatever was done in the same spirit. Ambition – a crippling emotion. Every painter should think as children do without any models in his mind. Whom did the cave painters follow or "rebel" against? No reading of books on art, except for relaxation as one would read thrillers or anything else. Definitely not with the object to emulate examples. Being what one is, doing what one *has* to do, guided solely by one's emotions. Most important, avoid discussions. All I have to say I have said a thousand times. Impossible to be original on elementary things.

20 September

I rarely make an effort to understand anything, even things easy to understand. With mystery I feel intimate. Last evening listening to Beethoven's Ninth, I could not help feeling how strong emotions take me away from the rational, possibly as far as to madness. At this depth of experience we literally don't know what is happening to us. In the process of work whenever we reach this level, the notion of the perfect form or harmony or whatever does not even occur to us. Expression, like a cry in the night, is all that matters. This cannot be perfected. In all these matters explainers lose ground: they always make it sound as though the painter follows some blueprint. Images are never in themselves but beyond themselves, like dreams, an existence in the interpretation even beyond this too. We don't learn to dream. What we learn from others is always superficial. *This is why followers always limp.* We shrink in the dream and expand in the interpretation. The interpretation is no longer the dream and the expansion works towards its *own limits,* a neutral *intellectual zone* which a dream never is.

21 September

Being part of nature does not make my attitude to nature any easier. Nature and I are not friends. Its blind energy frightens me. The more we know of nature, the less reason to love her. Everything in it is astonishing and frightening. Everything. It is meaningless to offer yourself to nature. Nature is not there to listen. We owe to nature a short existence. Why and what for? Why would we be the only creatures to understand its whole bloody mess which some may think of as a privilege. I see it as so many other things, a stupefying chance. Evolution? Perhaps. An end in itself? All observation serves limited ends. Where to beyond this? From the fragments we guess the greater pattern and a horrible pattern it is.

Whenever I hear the glib "it is a law of nature", I can only respond with a bitter

smile. Suicide? Just as ridiculous as the, "ah, I am part of the great scheme of the great nature". Escape into our talents and die not in the battlefield but in our bed without any great goodbye. "I will weep no more . . . I will endure." (Lear) As much as I dislike quoting, I could not resist those words because they came to me as though they were my own.

22 September

I was certain that my indifference to death has freed me from the pain of the death of someone dear to me. Not at all. The death yesterday of little Sheba, though her longevity of life is 14/15 years and she was already 16, shook me as profoundly as the death of a close human being. I know and of this I am certain, that I could not care how my body will be disposed of yet I wanted somehow to preserve, perhaps through embalming, this little body. Of course I will do nothing about it but I wished this. Whenever I enter the sitting room I look into the corner where she was sleeping in her basket. I tried very hard to lose myself in work with little sketches. The pain is still with me.

This death, now in my head for the first time in years, scared me of my own death. The pain recedes and comes back. Such a painful solitude. About 9 o'clock, still quite dejected, went down to the studio and in a spirit of pure escapism I began working. Worked non-stop until midday and got back my bearings. To get to know an artist, one has to know his biography.

23 September – Suffolk

We left early at five o'clock. Traffic did not start until around six. A red sun between trees. Later, high in the sky, the sun was white, cold, its contours vague in a mist. We reached Dunwich about eight o'clock. The heather we were looking out for was not red and violet but brown – because of the drought N. explained.

Before going out to the farmhouse, we first went to the sea. New on the sand, two enormous anchors. They were not there last year. Also the seagulls are back. Made my first drawings of the anchors. Then we unpacked at the farmhouse. How quiet.

25 September

First day. Splendid. Mind at peace. Drawing. Many changes. The beach café which burned down last year has been rebuilt, it's much larger with more tables and benches outside. On the beach, more sand, fewer pebbles. The old boats with splendid names have gone. Larger boats with no names! Luckily, I wrote down some names last year. Two old, big anchors.

I spoke with a fisherman, "They were not here last year."

He: "No, we fished them out not so long ago."

I liked the wording "fished them out". Seeing that it is a bank holiday, there will be crowds until Tuesday but no transistors and no noise except for a few bouncing children. All the crowds gather in a small area. A two minute walk and half a mile down the beach, it is empty. Lunch at the Ship Inn. Dinner at home.

My routine is the same as in London, got up at 4 a.m. It is now 5.30, the sky just brightening. The cockerels next door are already awake. Waiting for the church bells to toll. I must buy a better bulb for the bedside lamp – impossible to read.

Cockerels
Ink, wash and watercolour
20 x 25.5cm

26 September

I like the pigeon calls at dawn. Deeply moved by the quiet and the vague light. I sit in the conservatory, looking, listening, pleasantly relaxed. I am very fond of the trees here. Yesterday was grey with rain. When we passed the field with the heather, the heather was almost red. I pointed this out to N. N. said: "Because the sky is grey." This was perfectly true. Because I do not look around much in London, I make up for it here. The work is still an inward affair. The symbolic and decorative aspect of the landscape interests me more than its realism. Painting is not an aspect of seeing but of feeling.

27 September

Old Sam said that the splendidly named boats I had been looking for yesterday had been sold. Today N. drew my attention to at least four of last year's names that are still here: "Fred's Last", "The Two Sheilas", "Little but Safe" and "Early and Late".

Last year, having made notes how each name came about, these boats took a lasting place in my mind. I was as glad seeing them as I was of an old friend. I am always glad to come here and it needs no "good reason". As always, I find my soul in the rediscovery of things. My real life is my dream life. The huge old anchors at once transported me to these dream grounds. At the moment I am still "experimenting" with them, not in any scientific sense of the word. I am definitely not out for guessing the reality of real things, I don't know what I am after. I like simplicity because too many nuances confuse me.

2 July 1991 – London

Only one visitor this week. Keep it this way. Need to get myself together. Need all the time. Work is going better. The dreadful feeling of "what's the use" has gone. Now rather eager to work. Wasted too much time "socialising" and reading what I did not need to read. Now back into my shell. Also decided no longer to give works to dealers on sale or return. Must simplify the last few years.

A moon in the skylight. When it left it left a quiet difficult to endure. Its face *everywhere*.

4 July

I need to work more on the hardness of the line, with the firmness of the form. I too often fall back on the less satisfactory softer lines. Watchfulness in this respect, at least for a time is essential. With firm forms I also achieve a greater degree of calmness. Watchfulness or being one's own guinea pig pays off.

6 July

The spoken word leaves no time for controlling words. In a way a painter is lucky. By watching himself in the process of work he can find a model for thinking: not to be afraid of incoherence, inconsistencies, repetition. Not get easily carried away by niceties, by *mots justes* and other outward effects. My God, what trash "great" conversationalists and orators get away with! To follow only one's spirit. Unfortunately, in this I gain more ground when alone than with others. The thinking I have in mind is nearer Teresa of Ávila's "Prayer without Words". Started Peter Matthiesen's *The Snow Leopard*.

Always our feelings precede observation even if observation comes first. It is our

outward experience that will transform things into artistic values. Some of the watercolours, including the two today, have a mystical feel to them. This I find satisfactory. I don't know what makes them so. I only sense it. I do not work from a "point of view", this is perhaps why, looking at some works, I am short of words.

8 July

Thought of Bob's[46] readiness to publish a second volume of *Related Twilights*. The problem is that I have lost confidence in autobiography as a worthwhile literary genre. It strikes me that even when good it is little more than elevated gossip. This holds me back. It is human to feel the need to justify one's existence in one's own eyes. Don't we do this with our creative labours?

12 July

Thunder last night. N, who is terrified of thunder as much as of lightning, was surprised by my matter of factness and asked, "Aren't you afraid?"

I: "No, but I don't like it either. I find it all too exciting for my peace of mind. I prefer the normality of steady weather. Dull nature is better for a dreaming mind like mine."

She must have found this quite reassuring. She fell asleep in my arms. At 2 a.m. the electricity came back. N. was quiet now. I went back to my room, read for about thirty or so minutes and fell asleep.

30 September

N. is away for a week. The house is quiet. A good morning's work on the blue fisherman. Months ago someone wanted to buy it. I said: "Sorry, I have still to work on it."

He: "You will spoil it, painters don't know when to stop."

I: "They don't know when to begin either, nor how!"

Today I was glad the painting was still with me. Worked each hour with greater involvement. To follow one's unconscious is better than to follow "nature". The best way to find a foothold within the mysteries of reality.

Late afternoon. N. has left a hamburger mixture. Boiled potatoes and hamburger for late tea. No supper. At about 7 decided to rest in the ante-room. Gradually went into a state of meditation which lasted about three hours. Then fell asleep. Awoke about midnight. Jotted down these few words. Undressed.

[46] Robert Young.

1 October

Art does not serve an end – it is an end. It has perpetuated a process through which it became what it is. Many styles, one art.

2 October

The morning began well enough. Some writing, then painting flowers. Gustave [Delbanco] arrived at 12.30 and stayed on until 4! The day was lost. I was worn out. I am not that interested whether Rilke was the greatest German poet of the twentieth century. I am not all that interested in great and greatest. Vollard heard about Cézanne so he went to Aix and bought 400 paintings. Drivel, drivel, drivel. I really have lost all interest in conversation.

9 October

Music can make me weep. It cannot make me laugh. Not in the way words can. Even the most amusing parts in Mozart make me smile, not laugh. I do not believe that any composer ever succeeded in humour. Art can contribute to the sphere of ideas only when the artist does not impose ideas already in existence. Ideas in art are not propositions; rather self-contained representations as realised in the process of work – arousing thinking in the unconscious stage and when it reaches its conscious rational level.

14 October

Yesterday, I made a rapid note of a nude woman with a nude child. This morning I underpainted, covered with white an old painting I no longer cared for. How nervous, waiting to see what the canvas will tell me to do next. What I have in mind and what the canvas will say may not be the same. As usual, I trust the canvas more than my intentions. Waiting. Used a quick drying paint. Still, have to wait.

15 October

Worked six hours on the mother and child. Don't know. This image may take longer. Everything clear in my mind when started this morning: wanted a pale image, yellow-grey. Exactly as I wanted it, yet . . . too tired to think. Much too tired. Telephone: Eli[47] – will come here tomorrow week at noon. Always glad to see him. By then things may resolve themselves.

[47] Eli Rozik, one time Israeli Cultural Attaché, with whom Josef struck up a friendship as he had with his predecessor Benjamin Tammuz.

17 October

After many months work, the man sitting on a rock in red light is now getting the right intensity and the right simplicity without losing anything of the mood which was there from the start. Simplicity of mood is more difficult to sustain than simplicity of form. I am gradually discovering the spontaneity with which I began.

20 October

A big inner jam. Glad when N. suggested we go to Holland Park: "A good Sunday sun. Nobody will be in the park." We went. We walked. N: "Plenty of red berries. It means a cold winter. Worse, it may even mean a long winter." We met a few grey squirrels madly running up the tree and down the tree nibbling something they found on the ground. Few birds, they too had their economic problems. Autumn. Quiet. Brown, yellow, remnants of green. Warm blots of the sky coming through leaves high up. Back home. Felt better than when I went. Cannot say that nothing exists for me but painting and drawing. Never could. Cannot say that I could do anything else but draw and paint, good or bad. It does not matter. It does not come into it. I am just more complete when I do the two. When I felt this way the first time, long ago, so long ago when I was barely eighteen, I told myself never do anything else. Why do I jot this down when I am so old? I have no certainty: because . . . guess, the last four days disrupted my rhythm and I don't know how to regain it. Maybe. Another *maybe*: the last two paintings, I could knock them out of my life and feel the better for it but have no courage to do so. This may be a truer *maybe*. Must always – how pathetic – remind myself that painting is my way of feeling, not an "accomplished" performance. Not even a reward of transitory emotion. I was too impatient maybe. The humanness of being human and this is always in the deeps of feeling.

21 October

N. came in handing me the *Observer* supplement. "Here is something about Gerald."

 I: "Gerald?"

 N: "Brennan."

 A sensitive reporter. Humane reporting. Memories: his amiable voice. His cultivated kind of modesty. Recalled when Jimmy[48] first brought him to our little house in Torremolinos.[49] A sunny face in a sunny landscape.

[48] James Burns Singer (1928–64), poet. [49] A six-month stay in 1958.

29 October

Memories invent themselves. The trouble is they make you feel old. The good thing, they don't go into everything. Today, sitting in the armchair, I am sure the memories meant to cheer me up – all were light hearted, some roaringly funny and I laughed for well over an hour. The hours of depression have gone. I cannot write down a single one, not in the same spontaneous way. Memories have their own style.

31 October

The only thing which really shook me, shook me deeply, was Walti's[50] sudden death – not so sudden, yet sudden.

Moran rang yesterday, "Walti died! I was out shopping. When I returned I found him lying dead in the courtyard."

A strong fear of coming loneliness. Thus lost the last of friends. Now there are only acquaintances, a few unreliable allies but no friends. No more friends.

Walti was the last. He was always there even when he wasn't. I thought I was free from being shaken by death. I am not. Lay for some hours on the bed in the ante-room unable to move, just choking stifling tears. I'm going to see Moran Sunday afternoon.

Moran also said: "Doctor said that Walti did not suffer. It was an internal haemorrhage which makes one sleep into death. No suffering." We must be thankful for this. He suffered enough the last few years.

Oh, Jodie.[51] It is now 5.30 in the morning. Dark. Sounds of early chirping birds. Will I be able to bury myself in work today? If not, what will I do? The long coming hours. Think of this. Think of that. Think of nothing – even the something is nothing.

1 November

Because of the intense depression, whatever I attempted yesterday was so morbid that I dismissed one drawing after another. Somehow, though, these restless hours of non-doing quietened me immensely. I began working.

2 November

When the surface loses its evocative strength or the spontaneous feeling, the best thing is to start from scratch. This is what I did this morning. Over the surface I put on thin white and within a couple of hours the image became new.

Must do now without my pipe. It weakens my upper teeth. First day, missing it terribly. It was part of the left corner of my mouth for fifty years.

[50] Walter Segal, architect. [51] Jodie – pet name for Josef.

8 November

Some twenty odd years ago I wrote something that I provocatively called "Art and Mysticism". I recall that the gist of it was that on the level of experience there is no distinguishable difference between the two. The preconceptions of theology link mystics with a particular religion: Christianity, Hinduism etc. Art is true to the experience per se. The mystical experience should be brought up to our times, cleansed of the religious preconceptions which were little more than the pragmatic quest for power of priests, rabbis and so on. The Old Testament and the government of religious institutions gives ample evidence. So-called rationalists denied the nature of mystical experience on the mere evidence of the misdeeds of religious institutions. Freud's "there is no such thing as religious feeling" also shows the chaos of rationalistic thinking; Jung knew better. The undefinable, the inspirational, the motivational without preconceived motive – this is mystical without being religious. In a conversation with Bronowski, he said this is also true for creative science. When I got up this morning at 4.30 without my usual coffee I went down to the studio as if something was waiting for me. A small panel: a standing nude. As always, glad when I do something after a drawing and the painting makes of it something else than the drawing. Found an old drawing coloured thinly brown, the two figures black and ultramarine. Recall – thought of it at the time as a sort of unity of sexes. Young man and young woman close to each other. Liked it. At once underpainted a large panel which is still drying. Hope to free it of all narrative content. Patience. Perhaps will be lucky and the painting will become something other than the drawing. Must wait; want to see the image on the panel before beginning work. It is already 9 and I cannot think of anything else I would like to do. Panel will take a few hours to dry. Not bored, impatient.

9 November

N. accuses me that I don't spend enough time with her. That we don't go out. That as far as she is concerned she might as well not exist. That she is lonely. Heard this so often. Much of it may be true. Took her in my arms and this passed: "I am my own greatest nuisance." This appeased her only for a moment.

At 9.40 the minicab arrived. N: "I don't like going alone." She went into the cab as into an unpredictable cave. At 4 she rang from the Tibetan Centre.[52] The train was twenty minutes late.

[52] Tibetan Buddhist Centre in Scotland.

12 November

Received catalogue from Düsseldorf – Adler's retrospective. Many early paintings I did not know, though with the type of his works I am familiar. Not enough drawings though. With historians, not speaking of the art industry, drawing is still the shabby relative you acknowledge with a nod of the head and go on to the "more important painting". From the point of view of image making, this is of course rubbish.

13 November

Yesterday evening Roditi arrived. Will stay with us until the 16th. We chatted until about 11. Sickness after sickness. Poor fellow. First volume of his autobiography already completed. How he manages with all this globe trotting and lecturing. Brought me a catalogue of L'École Juif. They are making of a small hill an Everest. All very important. Really? Art industry. Catalogues are now as heavy as rocks.

14 November

Why does the canvas take such a long time to tell me what to do next? Why do my feelings take such a long time to surface from the deeps? This morning covered miles walking away from the easel and back to it and to no avail.

This image continues to worry me. When dreaming I see it still as a death mask. When I look at it, it has too much "life". To deaden it: too impatient with myself.

Benjamin[53] arrived yesterday to say goodbye! Going back to Israel until June. Much bitterness about present life there. Likes better to live here. Eduard is leaving today for New York. Poor Roditi. He can hardly walk. N. bought some years ago a chair which reclines. There he sits, legs up, chain smoking and talks away on Arabic writings, on the Jewish "contribution" to Arabic thought and literature. Then on literature of the Turks, Middle Eastern architecture, Islamic decorative arts. Things which moved me: his dreadful childhood, the psychoanalysis which made him live without guilt about his homosexuality. Believe he built this intellectual strong wall to hide behind it his load of pain. Later, drinking wine, his voice slow and quiet, his words no longer splashing about – no quotations, no erudition, no names, we truly talk when we find it difficult to find words.

17 November

Yesterday afternoon Gerber[54] came. Bought four early watercolours. Did not stay long.

[53] Benjamin Tammuz. [54] Cyril Gerber of Gerber Fine Art, Glasgow.

Flower
Mixed media
29 x 19.5cm

18 November

This was a good week. No complaints. Now feel exalted. Ready to fill with a new image. My living is not central to my painting. Painting is central to my living.

21 November

Did not think of it yesterday. Knowing now I added the black cat because I was frightened of too much austerity. The cat added an element of intimacy. My feeling now: this intimacy should not be there. Not in this image. Uncertain. Worried. Guessing my intention is always a bad sign. Like reading from tea leaves.

25 November

Too many things happened. Too many. Far too many. All over now, getting back my bearings. Wonderful dull days ahead. I do treasure them. Tunisia: one image – event. Endless expanse of sand, sea and sky and light. Amazing. Amazing that such bare stretches can awake such tender feelings of belonging. That day I discovered the beauty of emptiness. The light did not change for a long time. Nothing happened. Nothing.

The absence of things and of shadows. I never felt so content of being alone. Even my body did not feel like a body. Weightless. Neither concerned nor unconcerned with myself. Forgetful even of being. I recall this merely as an event. An important event. If it has any meaning I don't know it. Don't care to know. I remember through the memory of what it felt like. It is not a recall of things of the past. It is now of the present, the everlasting present. This I like to think is the metaphor: incarnation. The dance of events renewing themselves. When I lose track of memory my fantasies bring them back. N. just came in and said Mrs Schrimplin's[55] husband died.

28 November

Last evening at Milaine's [Cosman]. Four others as well. Hans [Keller] is already corpse-like. Some muscular sickness. Head hangs on his chest, he can only keep it up when supported by armchair. Hand thin without much grip. Cannot digest food. Prognosis: very soon bedridden. Goes on working. Mind still alert.

3 December

All anguish comes from my uncertainties. It was so much easier when all I wanted was to "paint well". Today things are different, very much different. The achievements of others, the mistakes and struggles of others all is of no avail. Even the thinking which awakes an emotion has to be rejected otherwise I am back in the trap of intentional illustrativity.

Mysticism as a discipline is not all that different from other disciplines. Mystic experiences are a different matter – they "are" – but they point to no conclusions.

Ramakrishna[56] described his first vision to his disciples thus: "House, walls, doors, the temple, all disappeared into nothingness. There I saw an ocean of light – limitless, living, blissful. From all sides, waves of light with a roaring sound rushed towards me and engulfed and drowned me as I lost all awareness of outward things."

Many Christian mystics describe similar experiences, in similar words. I too have such experiences without yoga, without links to any religion. Experience is a stranger to principles. Oh, all those system builders. Nor is mysticism any form of "enlightenment". It is one of our psycho-physical properties that makes us human. Its specificity is not in the devised techniques of meditation but in the splendid otherness of our experience. An otherness without which there is no creative moment, creative time. Art, science, philosophy, without a contemplative perspective are pure mechanical application and useless drudgery. In my own case, I can always feel myself entering the contemplative state. Sometimes, on rare occasions, this is followed by inspiration, that is when I no longer have any awareness even of contemplation.

[55] Mrs Schrimplin, our dear cleaning lady for 25 years. [56] Indian sage and mystic.

Lyricism and severity can contain bits of each other without one becoming too soft and the other too hard.

I recall when I was about seventeen and in love, Dora[57] and I went one warm day to take part in a demonstration for some cause or another in which we desperately believed. I recall that on that day we did not walk arm in arm as usual but joined our hands. When we merged with thousands of others, we still held on, joined together with our clasped hands. When the mounted police with batons attacked the crowd and each ran for his life, we two somehow emerged unhurt, still holding on to each other.

5 December

Cannot account for what happened to me yesterday evening. At 9.30 suddenly found myself in the darkest of anxieties akin to the one in Suffolk before my breakdown. Never had anything like it since. Why? Then fell into a deep sleep. Awoke about 3 depressed, thinking of suicide. Took a temazepam, fell asleep. Woke at 5.30, fresh, full of energy, aware of what had happened and brushed it out of my mind. Work went well.

10 December

Last evening went to the opening of the German Art. Good. Most impressive. Klee, Modersohn-Becker. To whomever I had mentioned these names they lifted eyes in surprise. Beckman, Kirchner, Nolde and so on. Change in the crowd. Not one evening suit. Not one long dress. "Casual" is the word. Good! Still a "culture"-loving crowd. Glad to have left. At 6.30 went down to the studio not knowing what to expect. Worked on the sun and moon nudes. My mood changed.

11 December

In the evening to Bernice.[58] Had met once before Howard Hodgkin. This time managed to chat with him for a while. At 9 N. got restless: the noise, the crowd . . . so we left. Stopped at an Indian restaurant. Had supper. Was rather glad to have left so early. The new nude is on my mind . . .

12 December

Got up at 5. Fresh. Put on lights. Guided by the small watercolour started on nude. Worked for five hours then stopped. Nothing more to do . . . for the time . . . Now in the armchair reflecting. The hours of painting, nor the nude as it is now from the

[57] Josef's first love. She died very young of tuberculosis. [58] Bernice Reubens, author and friend.

corner of my eye, gave me the desired quiet: not as the other nudes. Why? Don't know why. Must take it off the easel, put it face to the wall, look at it in a few days. Tired. Am very tired.

Roger[59] brought the letters. Is having lunch with N. At 7 with the Barons[60] – Dinner. The Abses,[61] Jacobsons.[62]

At home, "Do you want me to come down?" "Yes, it would be nice." Cuddled together as when we were young. Young love, old love, there is no love without the habit of loving . . .

13 December

Left N.'s bed at 3. Did some reading. Took a pill. Before falling asleep things became clear to me: something of the Far Eastern decoration had crept into the nude. All decorative art has a hardness which is strange to my way of feeling. All became clear. With this awareness fell sound asleep. Awoke at 7 and no longer hurried. Had coffee, slowly went down to the easel and with clear purpose did what I had to do. Now the nude is still and serene. Still strong, but soft and for lack of a better word – dreamlike. No longer worried. Have now an image to think of. Small panel or larger? How we tend to overrate spontaneity. Sometimes it works. Sometimes it doesn't. A contented feeling. Why should others concern themselves with my concerns? Hope N. will stick to what she said: "I am most content when alone." The solitary life may have its drawbacks: living like a snail in its shell, when I crawl out the outside looks like a room full of strangers. I adjust clumsily to all those strangers: am nearer to man when alone. Definitely.

15 December

The simplest route from the heart to the canvas. The simplest means. Nothing else. Images without strain, without conflict, tension, torment, without disquiet, without agitation but not passive: a way of asserting the humane through positives. The sheer uselessness of things which bring disquiet and restlessness.

16 December

For the past ten days worked on the family group[63] – began it when still in Suffolk! Probably should have left it. Portraiture is far from my present-day mood.

[59] Roger Thornton, a student of Josef's. [60] Alec Baron, author. [61] Danny and Joan Abse, writers.
[62] Howard Jacobson, writer. [63] Later cut up into three portraits. Nini, David and Josef at the easel.

17 December[64]

Still on the "Homage". Things in it emerge gradually. Every inch has to drag out from some inner darkness of mine. At 7 went up for morning coffee. On the news, the last colliery in the Rhondda has closed down.

Art is what reveals itself through experience. The rest is cultural camouflage. The camouflage is very much the product of a time.

20 December

There can never be an absolutely uncontrolled work. This does not bother me. The main thing is to get an image before which words have to abdicate. What interests me in the image is not *what* it says nor *how* it says it but how it makes itself real.

22 December

An artist's "homeland" is no longer within the boundaries of his birthplace. The spiritual homeland has expanded and has *traces* of culture he may not even have full knowledge of. Perhaps a slight awareness. Perhaps not even this. Perhaps it was always like this only now we are more open about our sources. The strange attraction of other cultures.

I am now convinced that what can be taught is not worth learning. What I have learned from others I forgot. I don't go to the easel until I am empty of any preconceived notions. Sometimes, some basics I work out on a scrap of paper. Even this is only a board to jump from and has no effect on the swimming. The destination sets its own posts in the process.

28 December

My recent images estrange me from others. A pity. They are meant to bring us closer. They do not. I can see this from the faces of those who come to the studio and look at them. I cannot do otherwise than follow my own ways. I find it difficult at times to build up enough confidence.

Slowly, slowly, the "Homage"[65] begins to work. It dictates its own pace. Yesterday I added a child with outstretched arms. There was a space and it felt right to be there. Not in terms of "composition" or narrative. A symbolic presence.

[64] From this time on, Journal dates are uncertain. The editor has made an educated guess.
[65] Exhibited in a RA Summer Show. Josef later destroyed "Homage to the Women of Greenham Common". He painted it over with black and said that it lacked a dreamlike aura he kept looking for. He intended to start work on it again but time and strength ran out.

The Old Barn
Ink, wash and watercolour
22.5 x 17cm
(overleaf) **Old Couple in Sunset**
Ink and wash
19 x 25cm

5 January 1992 – London

Thursday. Very happy with work today. Also with the few one-lines for the "symbolic musings". Very intelligent interview on TV with Steve Davis[1] and his perceptive assessment of some of the greater players. No false modesty either. He is the most articulate of the snooker players. I find it difficult to get to the facts but we will never again see Higgins at the green table!

7 January

Friday. In my work there is too little humour.

Phillip[2]: "Why is it that a thing I bring you looks better in your place than it was before you bought it?"

I: "It is quite simple; mine is a specific environment and I never buy a thing if by its very nature it does not belong to me. What you see is not the thing you sold me but the thing as it reflects me. It is so with most of my objects. You give things a spirit. Prior to this, spirit impressions of objects are deceptive."

8 January

The postman at the door. A few letters. All good news. Also a letter from Lady Graham. She included a catalogue from the Cecil Higgins Gallery. I enjoyed her visit and hope she will keep her word and call again. The two drawings she has in the gallery are indeed very old. They were bought from RBD in the fifties. The little nude, a small oil, quite satisfactory. A good day, a very good day. Even now at my age there is nothing better than a good working day.

22 January

Details worry me. I cannot completely ignore them; too many of them weaken a drawing. Within them are hidden the few essential ones. Few mean the heart knows better than the eye – following the need of expression rather than putting down

[1] Josef had a passion for snooker on television. He was fascinated by Higgins whom he considered a genius but who was struck off for some misconduct much to Josef's grief. He painted a snooker player which is now in the Edinburgh Museum of Modern Art.

[2] Phillip Murphy who visited most Fridays when Josef and he lunched together. Phillip usually brought along an African piece hoping that Josef would buy it. At times he did.

impressions. I am often in the situation where words fail me. A few right words put everything in a nutshell. Both the language of the street and the dictionary help one another.[3] Not the aesthetically rare but the heartfelt. Originality is a matter of character not of performance.

Many have often tried but even they had eventually to face the fact that no one can be more than a man. Of course I repeat myself. When aware I will start, ''as I said before''. I used to be certain of my more personal ideas. Not so now. Too many doctrines about. I wish people would think of ideas and of art as food. With books and drawings: splendid feasts.

My interest in nature is twofold: as a poet and as a critic of its foibles. Even looking back at one's life depends on the mood of the day. What fills one's life at the present, one finds in one's past.

Do I understand my work? Poor explainers.[4]

Sometimes while writing, quotations come to my mind. I regret them and continue to stumble on my own way.

Thinking of money makes me nervous. I cannot account to myself how I survived and at times even well.

Haiku is a form of a short poem. I would like to go further: one fully comprehensive line.

23 January

In our days we admire and submit to everything that is spiritually deadening. Is it possible to be objective to one's subjectivity, to look at it from a distance? I can sneer at my foibles but this is not as good as to look at things objectively.

Several times awoke in fear of falling out of bed. I moved as near the wall as possible. Very strange.

All cultures have something of their own which together add to all human culture.

Ménage à trois, ménage à quatre, I could not care less. I find the ménage of one difficult.

24 January

Tuesday. Yesterday I worked most of the day on the jacket for Jean's new book[5] of poetry. It was worth all the effort. Simplicity does not come easily. One has to work for it, particularly when there is a combination of drawing, lettering and graphic layout. Thank goodness it was not a waste! I am rather pleased with the delicacy. Today her

[3] He listened with real passion to conversations in the North End Road, jotted down odd comments and retold them to me over lunch with great joy.

[4] His rather contemptuous word for critics. [5] Jean MacVean. An old, close friend and poet.

publisher, a modest little man, a Mr Rety is coming with his daughter who is a painter and advises him. "Do you mind if my daughter comes?"

Generally, I do not mind working for someone though I do not like publishers who know what they want; they do not leave much room. All this no longer matters. I have done a jacket I like. What worries me is whether Mr Rety has a good printer who can bring out the more subtle nuances. I will insist on a proof. Publishers have a way to think that this can be ignored. Besides, I have a difficulty of a character nature: I am not a good listener and not good at compromises. So far I was lucky. The couple of jackets I did were accepted with some enthusiasm. It is not a matter of vanity, I simply don't like "discussions". I am strongly at peace and hope that this state will continue.

I renamed the "symbolic musings" "Autobiographical Musings". I want a more factual sound. Perhaps one dawn I will think of something more evocative, whether factual or not. I am now working on another book: *Women of Taos.*[6] Very much in the character of "Autobiographical Musings".

As for drawing for the first time in a month I am pleased with line drawing and feel no need to add washes.

25 January
The Spanish and the Moors had different beliefs but the same weapons for killing.

Thinking of moral pleasures.

At last an effort is made to preserve the elephant; one of the great shapes.

12 February
Too many misleaders.

Moral issues are NOT, by their nature, religious issues.

When you say, "only a Frenchman, a German, an Englishman" could do this, you express an emotion not a well-considered opinion. ALL men are capable of doing all things.

In painting rarely, more often in writing, the title can tell much of the story. *The Loneliness of the Long Distance Runner* is one of the best titles for years.

I am not a sun worshipper. The whole day at work I don't give any thought to the weather. I know when it rains, the drops run on the glass of the skylight.

I sometimes watch Van der Valk on TV because of my nostalgia for Amsterdam. Streets near the dykes, though not enough of these.

[6] There is no trace of it.

13 February

Thursday. Whenever I feel pain in that left side near the heart, I say to myself: "Is that it? Is it now?"

No panic. Just aware death is imminent.

The conception of linking a drawing with a one line text came to me quite recently.[7]

Busy answering a quite unpleasant letter to one who belongs to the literary industry and speaks in its manner. I made a mistake seeking his advice. I could kick myself! The best thing is to get the whole incident out of my mind. Stupid, stupid. To me, mysticism is a category of experiences which do not fit into a rational pattern and do not lend themselves to a logical explanation but are real all the same. Perhaps it is more a quality than a category. It may also be an aura around a theme rather than a theme in itself. Perhaps we can get its sense through interpretation, like when dealing with dreams. In fact, mystical experiences are very much like dreams.

14 February

Performers have to aim at perfection, artists at expression of feelings.

For once the patient knew better. Dr: "You are getting better."

Ibsen: "To the contrary," and died.

A phone call from Cardiff [about] the BBC interview during my visit on the 25th June. This by itself would not be of much interest but the woman who would interview me is John Ormond's daughter. She told me of John's illness when he died of a heart attack. He retired from the BBC and was working on his collection of poems. Some years ago we saw each other whenever he came to London. Not a close friend, nevertheless someone to whom I owe some gratitude.

Drawing is action, less so when in the service of action.

To be of one's time, we have to know what is representative and what to ignore. Still better to forget that such a problem exists.

I don't trust people with missions. Still less nations with missions.

When I lived in Ystradgynlais I worked on a lot of images of miners. This is not precise, I worked on social types. Not that I abandoned my interest in social types but I needed to experience in more directions. Subjects and means are one. Supporting each other, they become indivisible.

A complete form. Nothing artificial. Not even the drive after perfection! A tranquil space. White.

Living? A nice pastime while it lasts. So many things to be curious about. And now? Bah . . .

[7] It was then that the "Autobiographical Musings" (his Jotters) began and the *Song of the Migrant Bird* was conceived. Curwen Press (1998).

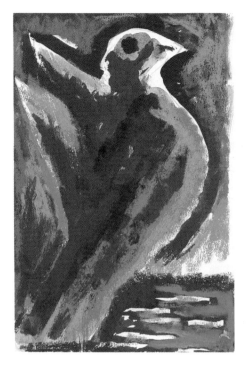

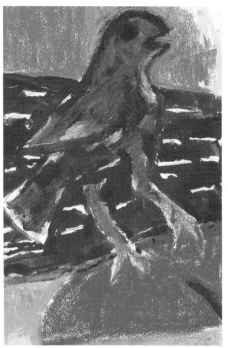

(top left) **Bird**
Mixed media
21 x 14 cm
(top right) **Bird**
Mixed media
28.5 x 19 cm
(bottom) **Bird**
Mixed media
21 x 13.5 cm

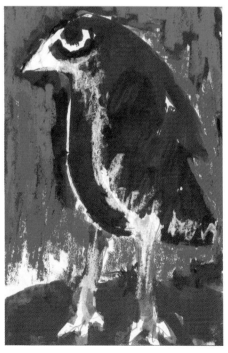

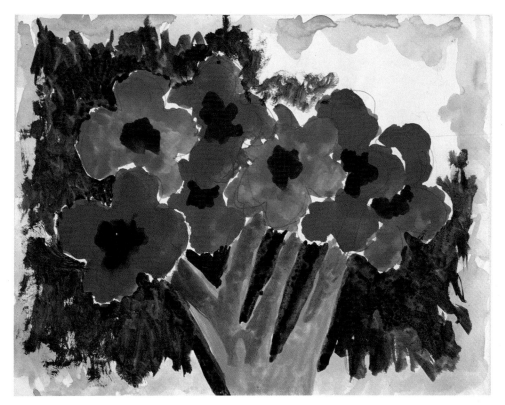

Poppies
Oil on canvas
60 x 48cm

The experience of the eleven years in Wales was so strong that wherever I went Ystradgynlais came with me.

Whatever comes to my mind in one way or another had to come. Most I forget. Then I decided to jot things down, important or not. Let time decide. Then I took a liking to jotting. I preferred them to be sparse and when possible without people. In this way they go on: not fact or fiction. As words make their way from memory or imagination to the page. What was left out had to be left out. Not that they were secrets; they were out of place.

15 February

With the dark winter days and the severe weather, the street as I see it through the window is empty and sad. There are the cars; I saw no one leaving them but they don't look abandoned – just left, no one knows for how long. Whenever there is something on at Olympia, all nearby streets, the whole of their length, shine with the wet, black cars.

Of all the houses, only No 120[8] has a red door and therefore stands out. I did not mean our door to be conspicuous; the door needed a coat of paint and I had in the studio a tin of high gloss red. So to use the tin, the door became shining red.

We have now added two black balustrades which are a help in walking up the steps from the street to the door. At 81 my legs are not as firm as they were even two years ago. One of my neighbours thought they made the scene "beautiful". She said, "Of course you being an artist would know of such things."

To make the way down to the studio easier – nine steps[9] – we bought thick white ropes in a shop which sells things for boats. Together with the brass fittings, they indeed look quite good, decorative. To make the steps less slippery, we covered them with dark green felt – I would have preferred light brown but no such colour was available.

N. misses trees, I miss church bells. No Catholic church within a short distance. Edith Road is clean and the rows of Victorian houses pleasant. Sometimes I walk to the end of the street just to look at it from a distance and I can find nothing offensive. To the contrary, I find something quite serene in the Victorian solidity. I cannot think of any area where I would rather live. The mixed ethnic groups with the black women colourfully dressed, add a new physical dimension to the pleasures of the eye.

In some places you work better than others. Not only the studio but the whole

[8] The number of our house.
[9] The steps were extremely steep. Eventually, I had a Stannah lift installed. Huge protest. Later Josef enjoyed it, as did the grandchildren.

neighbourhood suits me.[10] I have planted myself here and though I may soon die, I still grow.

16 February

Autumn is a messy season, dead leaves, sniffing dogs and papers in the air drifting in the outraged wind.[11] Each autumn, the same feeling of some unreality. A few feet from the buildings, battered pavements on which bent people walk fast, flat as shadows. In the autumn, streets look undefined as though raw in the making, confused. Funerals have disappeared. Are people no longer dying? Or more accurately, as a friend, a minister, pointed out to me: "In an age of efficiency many things disappear out of sight." Things go on but are blurred. Nothing happens in public view so the feeling is that nothing happens at all. "The dead are beyond caring," says my neighbour[12] – "funerals are the style of the living." I nod my head. I feel something is not right. I miss the professional weepers; old women I recall from childhood, used to yell and tear their hair and make a good job of it too. "Do not go gentle into that good night." Though I am all for simplicity, funerals too are subject to fashion. The old type funerals have disappeared. Old Jahveh threatened his followers by saying that if they didn't obey, their dead bodies would be thrown to the dogs – I hope he meant the dogs in Spain who are poorly fed and walk about with their heads down, always sniffing for food. Seriously, I hope that someone will have enough sense and let them feast on my body instead of burning it and letting it go up in smoke.

What has brought all this up? A conversation with N. I suggested that I would like to give my body to some hospital in case they can use some parts. N.: "Whatever you decide, I won't let it happen. I cannot bear the thought of parts of you floating in jars."

I know that what I want I will not attain; perhaps what I want is not attainable. Also, I don't even know what it is. When a thing is right you don't care how much of it is due to outer reality and how much it reflects the inner reality of its creator.

I have always been fascinated by the bent figure. Today I was asked why. I began guessing. Because it represents strain I think. A friend has been to the National Museum of Wales. He liked my bent figure of a man pruning the vine and bought the postcard they have made. It is on sale there as a reproduction, well done.

If the image is convincing, there is little difference between a drawing and a painting in spite of the hierarchy established by the art industry: painting at the top, drawing at the bottom. Lucky the cave men who did not fuss about the difference! The image!

[10] Josef always referred to "posh" areas as "dead places".
[11] Street sweepers were few and far between. People threw every kind of rubbish away – including condoms!
[12] The house next door belonged to a Housing Association. There were four flats with the nicest tenants, if a little alcoholic.

I have no eye for details. When they are pointed out to me I am glad that I missed them.

Re: garden. There is a big difference between N. and I. She loves working with plants and seeds. I love sitting in the garden or walking. I admire what she does but am not inclined to help. Besides, we would not agree on aesthetics. Not doing a thing, I appreciate what she does. Like with hanging pictures. No two people would arrange paintings on the wall in the same way. In the thirty odd years I did not once take part in hanging an exhibition of mine! Maybe because I pick out single works I care for and do not worry about how they relate to others. I remember years ago in Grenoble my friend said to me, "This curator does not know how to relate paintings." I could not care less. Not the walls I took away with me but a few paintings; some early works by Gromaire,[13] a splendid Soutine and an early Chagall. I hope that whoever is now curator there does not follow the present day method of hanging: more wall, fewer paintings.

My washes I once wrote, are like smudges on the page space. For drawing, only the page space is important – the drawing has its own "rules". If rules they are. Often a drawing is more a sign than a representation. The naturalistic "laws" do not help the drawing in its suggestive power as a sign. It became an academic trade mark, that is all.

In drawing, we gather strength, lose it, regain it and again lose it and so it goes on; no certainty at the beginning, no certainty at the end.

17th February

Today, something quite astonishing. On the bench opposite No 120, the whole day long, sat a group of people N. calls "meths drinkers". Whether they are or not, we don't know. Today, I went over with some sandwiches and gave them a few pounds.

One said, "We need wine to keep us warm." I went back home and took a bottle of wine over to them. I asked one of them his name, he answered, "Does it matter?" I did not insist. When I handed him the bottle of wine, he handed me back the money and said, "I have no more use for this."

I said, "Don't you want to get some food?"

He said, "The wine will do."

I really dislike the draughtsmanship of strip cartoons!

Western European literature has become too wordy. What is usually called development is usually a way of spoiling a good beginning.

19 February

This morning I got a letter from Heinz.[14] He had a heart attack and was in hospital for

[13] Marcel Gromaire (1892–1971), French painter. [14] Heinz Roland.

five weeks. He sold Woking and lives now in Monaco. Most probably we will no longer see each other. We had our ups and downs but I cannot deny that in our association of thirty-six years, I had much to be grateful for and should he die before me I will miss him.

I had a good morning's work, writing, dreaming, painting. Got up at four. It is now midday. Slightly tired, now resting in the ante-room. Reading Hemingway's *Moveable Feast* which along with *Old Man and the Sea* I like best. On television, some woman messed up the wonderful song "Stormy Weather". Probably, somebody told her to be original. I love this song so much that I could not bring myself to switch off.

Today not as grey as yesterday. Winter light can be beautiful, cold but bright all the same. There are other winter pleasures. In the evening sitting around the open fireplace, talking, sipping coffee and looking at the flames. N. collects logs for those occasions. Once reconciled to the two climates, the warm indoors and the freezing outdoors, the different life of both give equal satisfaction. As I am allergic to alcohol, even some does little else than mess up my head, my main source of pleasure is work and sitting in the armchair meditating at dusk. I never put away the drawings that I did that day; they lie spread out on the floor. It is wonderful to open the eyes and catch the one I am pleased with. All drawings depend on luck; it is easy to recognise when luck worked for you, then you may whistle something cheerful for joy. Of course there are drawings which cannot get going for days, try as you may. Then walking around in the hope that when getting back to the page, the right line will suddenly take you by the hand and lead you on. You cannot will expression. Expression has its own will, the best your eye can do is to recognise it and let the hand follow without imposing any preconceived ideas.

20 February

Some letters, invitations etc. Pleased to have heard from Eli.[15] His book *The Language of Theatre* will come out this autumn and he wants to use for the jacket one of my drawings. He has several and if I remember rightly any of them could be used. He has one in mind and I have no objections.

Being a great fan of bell-ringing and Morris dancers, I was delighted with today's "Pebble Mill" on TV. What splendid accordion melodies! A pity they did not perform in the open.

A drawing begins with the first good line but one can go through quite an elaborate muddle until one comes to it. Once it appears, the drive of the unconscious is easy to follow. The real obstacles are previous drawings. I have to forget them, forget completely. To forget what you can't articulate and if others come out of my memory,

[15] Eli Rozik.

they too must be forgotten. This is fairly easy after some discipline. The process loosens the arm. The eyes were already moving freely. It is very important not to be aware of anything else, not even of the silence. It is also important to follow what the drawing wants you to see. Drawing makes me happy, often more than the drawing itself. What gives no happiness is to have to sell drawings I particularly like. Only rich painters can afford to keep what they don't want to sell.

I am not as careful with lines as I am with words when I want to write something (not literature, I am not ambitious in this way). Fortunately, lines take care of themselves, they always know their direction better than I and what they are after. I may work hard at the form but the line will still lead me with care and ease. Drawing cures me of anything, even of hardships which resist the doctor's tranquillisers. I do not exaggerate: I can well understand the ancient Chinese artist who left a note to a friend, "If not in the garden, you will find me happy in the ink!"

22nd February

I like my exercises in the one line text. It is a good discipline in using as few as possible words. I prefer a Haiku poem to the whole of the *Aeneid*! Words pale.

Yesterday I walked alongside the Thames. A heavy sky, stormy waves and a hard hitting wind. I liked my walk and did not mind the weather. While walking strange memories came to me. When I lived at 85 Fellows Road.[16] I found one day a fine tribal piece. When Miss Coe[17] met me in the passage she said: "This means I will have to wait for the rent."

I said, "You are an angel," and tried to kiss her cheek. Like all spinsters she hated affection.

When I bought Edith Road and had to move she said, "Now the studio will be empty. I cannot bear the thought of someone else living in it. I too can get used to people, you know." She quickly turned from me so as not to show her emotions. She did not mind all the women who came to see me but when all this stopped and N. was the only regular, she was deeply upset. One day when N. lay on the grass in the garden Miss Coe was quite unpleasant to her. She said, "The garden is mine and does not belong to the studio."

Another thing showed her displeasure with N. Every now and again I found my shoes waxed and polished. As I never indulge in this ceremony I said to Miss Coe, "You need not do this, but thank you."

She blushed, "I don't know what you are talking about."

With N. on the scene this shoe business automatically stopped. Some years later we

[16] Josef's rented studio in Swiss Cottage (1954–6). He then bought Edith Road.
[17] Josef's landlady. She had a really sad crush on him.

passed No 85 in the car and the house was no longer there. Pulled down to make place for one of those monstrous high-rise buildings.

N. said with much affection, "I wonder what happened to Miss Coe?"

I knew she had gone to live with her sister in Eastbourne. "She sent me a card," I replied. I have never heard from her since.

I think of not thinking. Thinking makes me sad. Perhaps this is in the nature of thinking. Not in the dialectic way; in the Socratic dialectical way, thinking is a game.

23 February

In the last few days cold winds, dark skies and sad streets. Changes in weather do not affect my moods. The sun does not make me happy. Rain does not depress me. Now that I see so few people I cannot say that they spoil my days. Work is always a good escaping road. If I feel contented it is not because it is spring. The studio has two skylights but no windows. The skylights give the same cool light even on the warmest days. The sun quickly dries the glass. Most of the time, no sound whatsoever. Visitors often remark, "you must be very happy in such quiet". I am. On warm days when I leave the door open to my little courtyard, I sometimes hear neighbours' doors opening and shutting. The big plant, which N. put there, always has the same dark green which covers most of the opposite wall.[18] Cats sometimes come on to the roof and from my little garden, I hear the twitter of birds, which often makes me forget that I live in that busiest of all cities, London. This is not a rich quarter or a poor one. People on the whole are well dressed. Particularly colourful are the black women. They do have a sense of colour and know how to look beautiful! With one such woman, I made a friend in a distant way.

One day she saw me in my painting overall, she slowed down and said, "You are an artist. I thought you might be." One sunny morning, I chanced to see her and asked whether she would pose for me. She stopped, looked into my face with her big eyes and asked, "In the raw?"

I said, "Yes."

She laughing, "Honey, I would have loved to but *he* wouldn't." She pointed to her wedding ring. We still smile at each other.

All big cities are unhappy places. I breathe its pulse out as the million others. I had to use all my ingenuity to survive as there was no one to give a helping hand. If you fell, you had to rise on your own. This is the law in this ten million jungle. All were outsiders. Except those in uniforms blue or green. Yet after the day's work, I found it quite refreshing to walk alongside others, one of the crowd. I tried not to think of that,

[18] The plant was an oleander that had a profusion of pink flowers in high summer. Josef seems not to have noticed. Plants were as he saw them at that moment.

walking on, just walking. Walking back seemed like having a purpose. When you have little money, you wonder how much you have in your pocket. I could have seemed severe with myself. I wasn't. There were books I wanted to buy, there was tobacco for my pipe, there was wine I needed – at that time, wine was a necessity with me. So not having money meant thinking of these things and others and not getting them. Shop windows were strong citadels. Being poor bothered me. I thought how wonderful it would be to have a room with a shower. Mine was an attic in which standing you touched with your elbows the opposing wall.[19] Still, there was a window through which you could get on to the roof. From there the panorama of roofs seemed a joyful view. Some of my friends congratulated me on having this view. The trouble was the winding stairs with the shopping. They seemed unending. The toilets, two of them, smelled evil. The flush always spilled over the floor.

Once a week I went to the local bath house. I never stayed long there. I did not like the odour of steaming bodies, but I liked going there. The building stood between trees, up a hill, not too steep, easy to walk up and also quite pleasant at the end of the street.

Not one of the women[20] who stayed a while ever complained. They did their best to give the place some basic cosiness. I never did as much as sweep the floor. Maria could never stay for long. After a couple of weeks she would disappear, leaving a sweet note. She was the only one who went down on her knees, "This floor could do with a wash." Splendid Maria, I wish I could have loved her. The only time I came near to a strong feeling for her was always the first day after she had gone.

One day I asked her where she went after she left my place. She answered with a lot of tenderness in her voice, "None of your business." The smile meant to stop further enquiry. Not loving had its compensations; there are other bonds between men and women less painful than love, equally basic and instinctive. When Maria undressed and before getting under the blankets, she would lift her head slightly, smile and say, "I smell of woman." It was through these words that I became aware that I cannot do for long without the aroma of a woman's body. The stronger, the better. No perfume.

I spoke of Maria but there were others for whom I had a similar affection – with whom I would share a short time of happiness. Money was always a problem. I cannot give a reliable account of the ways I managed. Occasionally I would sell a drawing or two, or a painting. No regular or even foreseeable income. It was all part of the pattern of being poor. I hardly ever spent a penny on clothing. Two shirts, two vests, one pullover, a corduroy jacket and trousers, an overcoat which seemed to last, brown

[19] I have no idea where or when this was. Josef never spoke of this. Was it a state of mind? Was it Warsaw, Glasgow or London when he settled there?

[20] Some were strangers. Maria was a deeper relationship.

shoes with laces; I liked to be able to slip into them. I cannot do without materials for drawing or painting but clothes are hardly on my mind.[21] In winter, the same overcoat. In summer, it is easier. Being poor did not make me think poor. It was a way of living with little, or less than little and some days with nothing in the pockets.[22] It never became a state of mind. It never seemed strange to wear things until they could no longer be warm. My terms with the old ones were always friendly. You learned the cheap way and became familiar with the warmth of the accessible. How wonderful it can be like this. What formerly seemed sad and to be avoided now looked like welcomed dress.

All the walls were whitewashed and the light on them fresh. The glass on the windows had a liquid look similar to reflections on water. On the round trees, the leaves looked new. I looked around with watchful eyes – the light leading all the way. When for a long time you had no money, then you have some, all money seems big money. You walk differently. All you want is to share it with someone. I knocked at Maria's door. She had just washed her hair and her body was wrapped in a towel

"Stop talking, you're out of breath. Have a drink. I have only white wine. Give me a chance to dress." She threw off her towel.

I never stopped marvelling at the secrets in the texture of her skin. As she threw off her towel, what surprised me was that although I had quite often seen her naked, her body always looked new and the texture of her skin, fresh. Each body has its own specificity – hers suggested intimate secrets. There it was for you and your eyes. It conveyed, "That space between us gives me a life of my own. Do not transgress it. My form is strong. My sensuality fragile. I am a feast only for your eyes." These were the terms of our relationship and on these terms, we were important to each other. She was as much mature in her mind as in body, well read. Talking with her was fun. Her words never sounded like questions as with other well-read people. That day I was not drawing. I remember it better than other days with her.

She said, "When you are working you look as though you are and I know that I am included." She spoke in such a light-hearted manner that we both laughed.

You knew that I thought wine was an overrated drink in spite of its age-old reputation, so you poured a bottle of wine over your body and made me lick it. Indeed, it tasted better this way but when you tried it another time it had lost its magic. I still love the space between us.

One day we went to the country and lay on the grass near a lake you liked, referring to it as "nature's blue eye". The lake was not blue at all but I would not spoil your fantasy so it remained nature's blue eye.

[21] If I had not bought Josef's clothes, he would not have noticed that he was in rags.
[22] To Josef, money in the pocket was the only reality. Banks meant nothing.

You said, "At certain places you like to live every moment. This is what nature's blue eye means to me." Looking into the water became part of the pleasant things that day. We could not afford more than lettuce and tomatoes for the sandwiches but they too belonged to the splendours of rare desires. Near that water, we lived every minute. There was so much to see in the dark. You said, "Because we are privileged."

I come now to the last days of your life. In the days of hunger we saw so much. From the cheapest things in the market, I tried to make a feast. You could not cook but you agreed to walk around naked while I pottered around the gas cooker. Whenever I took my eyes off the pot you were there, fresh as new fruit. This was exciting. We were hungry and ate off paper plates. I ate fast but you were a delicate eater. You ate slowly, little bits on the fork. Your smooth, dark hair in its simple way hung on both sides of your face. I could not believe my luck and looked more often at you than the plate. You laughed a good deal while talking of the day when you were a little girl and you would stand naked in a basin while your mother splashed water on your body and rubbed you with a big sponge. Already then you rejoiced in the mystery of your sensuality. You could not name it in this way but the references to the tingling flesh made it clear. This remained with you, of course. It was wonderful to hear you this way.

You said, "I could not stand still. My mother's fingers were delicate and moved smoothly on my skin. I knew that the touch of another's hand is more pleasurable than that of my own hands. It was also like this when at the age of thirteen I went for the first time with a boy. The intercourses were disappointing but not what is called the foreplay. Hands are wonderful; whenever on my body in the dark, they seem the essence of love. I could hardly sleep. The final act never lived up to the foreplay. I lay awake even when he was asleep."

On such nights the attic seemed an open, immeasurable space. I did not think yet my mind was not still. Yes, the great rewards of life are simple and strangely subtle. You are here to lie still and let the waves of the gentle night take you wherever. You are definitely miles from the dingy poverty of the attic. The better things are always at some distance from reality. I looked into the dark window and imagined mountains and a moon. My true passions started with things I knew and fantasies took me to territories material and esoteric at the same time. I liked it there because I was far from reality that could put demands on me. I got so mixed up with these fantasies that they mattered more than anything in my life. Even when in bed with Maria, I slept with the eternal – a generous abstraction. Being involved I was also an onlooker to my fate.

Besides Maria, *there were others, all depersonalised*, subjects of exaggerated beings. Each embrace, each kiss, each dream was for real and false. It was not hard to believe what the make-believes stimulated. The end was beautiful beyond words. The affection was

real, even honest, though not wholly involved. There was no great hardship when a relationship broke up. Some partings were violent. No woman in love can grasp that in *a creative man's life she comes second*.

I cannot recall which one it was who cried out, "This is cruel. You tell me to go *because you want to work*, or still worse *you want to be alone*. What am I to do, vanish when with all my heart I want to be with you? And you hypocrite, you mumble that you are with me but work comes first! You are sick. You cannot get completely involved. I hate you, I hate you . . . don't smile, I mean it."

I smiled because I knew that good and bad interrelate, that I as an object cannot complain. It is the same with me but to appease Maria was not easy. To the contrary, I may have made things worse.

24 January 1993

Eighty-one and no worry about age. Only from my knees down are there symptoms of age.[23] They tell me when to get away from the easel and relax in the armchair. From the knees upward to the top of my head, no great difference from the time I was eighteen or so.

My worry sometimes is whether I have already gone as far as I can – I don't think so. Besides, I hardly ever think about it. Each of my decades had *its memorable ups; the downs are of no importance*. In my life, chance leads me on and I follow. I was never out to prove myself. Thank goodness. Without ambition life is fairly simple.

Several good drawings – good that is, *in contrasts*. No nuances whatever.

I watch all major sporting events. *The Loneliness of the Long Distance Runner* always comes to my mind. When I look at the participants before the challenge begins, I see all loners. Loneliness is the inevitable emotion in all creative endeavours in sport as much as in other performing situations. I asked Alan [Sillitoe] once whether this splendid title was the inevitable outcome of the story.

He said, "No, I was sitting alone in the room facing the blank page in the typewriter. I only knew that I wanted to write a story about a sporting event which would also be autobiographical. I did not know how to begin. Then I thought first of a competitive event which would also be autobiographic. I did not know how to begin. Then of the loneliness of a man who wants to impose his presence. When the title came into my head, the story wrote itself." It is not like this with all stories but it was with this one!

25 February

I always watch sportsmen before they start. How they concentrate and separate themselves from the environment. At this moment none of them is a performer or a

[23] He was actually 82.

competitor. Each nurses his own loneliness. I find much of myself in others. As for things called "subjects", not in my line of working. I know only moments of life.

The one line text – a full text in one line.

All big cities are grim, more so on sunny days. All cities have a visible past and an undetermined future. No city is an environment. The environmental specifics are left to the street or to areas each with different schemes of sadness which resist any rational or even fictitious frame. No street is basic for a tradition. The mystery is behind the windows but the nylon curtains do not let in my eye. Besides they are often too high even for an uplifted head. Subjectively you can be sentimental about a city. Those who indulge in mental cities fare better than those who try to elevate its stature. The truth is that most cities are creepy. Not every city has an Eiffel Tower – a monstrous structure but preferable to all those abominations that are monuments to famous generals, presidents and kings. Thank goodness no one has been mad enough yet to work on a monument to Elizabeth II. It may come. Dreadful habits on their own track go on.

3 March

It is a long time since I was hungry. Really hungry. Starving as when I was a child and there was nothing to eat at home and I cried and my mother cried and hugged me. This was real hunger. Not like today, the hunger between meals when N. says "Don't eat now, I have lovely salmon for supper. Do you want it grilled or fried?" So I have to stay hungry but that hunger causes no pain.

My two names have often been spelled wrongly: Joseph for Josef, Hermann for Herman. Not once have I written to an editor. It is laughable to take umbrage for such things! I was told that there is in Australia another Herman. Let him worry. Of course I know that some works I do are little more than curiosities; when done they make place for more relevant ones to come. I don't know whether there is any link between a failed work and a good one! Whatever the case, I do not worry about uncertainties as I used to. I used to tell myself "don't feel so bad" and I would go out for a walk. On such a day I wish I had a taste for alcohol. A long walk and talking myself hoarse without raising my voice did what alcohol is supposed to do. Back I would start again. The main thing is to make oneself feel beyond understanding. Words are often enemies. You learn nothing from casualties and you learn nothing from what is called good work. I still don't understand what is meant by discipline – perhaps not much, perhaps regular work. Now that I have lost the taste for chatting I don't know what others think.

With me, improvisation is a means of getting my mind to work and of reaching imagination.

Advertisements with Maureen Lipman are by far superior to all others employing actors. I myself have *never* bought anything advertised but Becci does. Obviously there are others too.

I have great difficulty in using words like love, friendship, home.

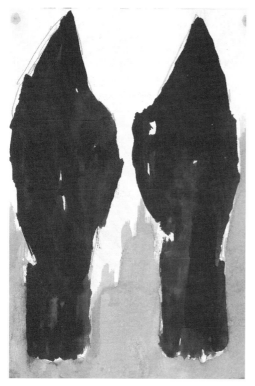

Confidence in the Form
Ink and wash
21 x 14 cm

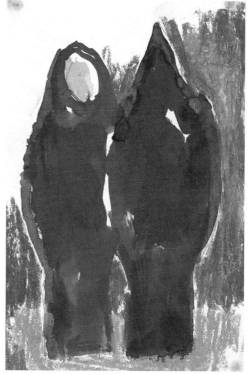

The Secret of Belonging
Ink, wash and mixed media
21 x 14 cm

1 June

Today, I made a few more drawings of those conical-shaped women, all in black, whom I first saw in the square in Taos.[24] Damn it, how I would love to be there but these women are as real in my daydreams now as they were in the sharp light in the square. How they stood out! I could ignore the shop windows, the passing cars and everyone else passing and keep my eyes only on these women. Women more familiarly dressed did not interest me. It was a lucky chance that I did not want to miss a second of their presence. They were new to me and irresistible. I filled page after page. All

[24] New Mexico.

with the same shapes of monumental silence. Impressions are important when they suggest a beginning. What is irresistible is the stable nudity of a splendid outline. Then I and the object were quiet and close like all good companions. When the lights came on there were only holidaymakers left still shopping. The conical women I loved were no longer there.

The spring evening still had some rose light. I saw through the window some people passing. Some hurrying, some unexpectedly meeting friends and stopping and talking. In this light everyone and everything seemed an event. None gave the feeling of being lost. I felt good being a witness to pleasant moments. Such moments are never recorded in newspapers. Only hates and whatnot, as long as it is bizarre. Nothing original the way I felt. My hand felt some change in my pocket. I ordered another coffee. Black this time which is cheaper.

Ambitious people make me nervous. Best to leave them to their ambitions and say nothing of what you think of ambition in general. When it is a lovely day, better to walk alone the little streets than to argue. Ambitious people seem to feed on arguments. It is winter and there are no children in the streets. When I went out I met little Malcolm aged eight so he told me. He also said he is going to be a doctor "then you help people and get paid". I gave little crusts and we both fed the pigeons. Ambitious people have all the time new friends. Where on earth do they get them? Then I still went on with little Malcolm and the pigeons until some big vans filled the streets. Somebody in fact, two families were moving. I did not know any of the two so I did not know where they were moving to.

When I stop caring it shows in my work. You cannot choose what you have to care about. Things you could care about have to hit you – even then you can get things wrong.

I sometimes miss white mountains and heavy snow. In London, winters are grey and wet while the snow when it does come doesn't last long. It is impossible to give London winters a definite quality. You can do this with other cities. You can do it with Edinburgh, with Vienna, with Paris but not with London. There is too much of the city, too many streets, too much of everything and nothing put together.

Those who like London better than any other city make many claims for it but not one have I heard calling London "intimate", "lovely" or "endearing". London is too big for such small affections. Yet London had a strange effect on me when I first arrived. I could say as a French poet said *ma belle ville*. Even on the first day, London did not look new. London has the endearing beauty of old age. You have to bring with you your own stimulation, this city won't give it to you. Some parts do, of course, the East End, the Thames. If it destroys you, it is because you brought with you self-destruction. London has the lonely mentality like other monster cities. When I like my

area, I could be in another city. I don't live in London, I live in a small, very small part of it and seldom venture into the heart of the big London. London and I are hardly acquaintances. So it has been with me for the last thirty odd years. I don't want it to be different.

My real life is behind a red door and it would be like this wherever I would live. Now that we can get into outer space, perhaps I will change, though I don't think so. The London which is for me an outer space phenomenon, does not tempt me. I am not curious enough. You live as you live, day by day. If it would not have been London, it would be any other place. It is all the same to me. My heart is my danger place, not London. My magic begins when I am alone. No matter all the change London has gone and is going through, London remains London. I keep too much aside to be an intruder.

Happy chance, eager of the unpredictable. The suppressed comes back. The gleam of the unforeseeable. Awareness changes perception. In the midday light things are bare.

Through things we do, we say what we cannot say in words.

All religions proclaim the right to dominate. Shapes not to forget.

No thoughts as revealing as the things the spirit holds back. Shapes are gifts.

A sleepless night. Read Rousseau's *Confessions*. His within a tradition I don't much care for. Having never had to sacrifice for the sake of good performance I may be a bit too impatient with men who accept ''believers'' and set about another way of saying things already said. ''A Christian Tragedy'' too easy, too easy. Got up at 4. Worked 'til 7 on a miner's head, a kind of nostalgia. I am sorry that I started my secluded life so late, only about 5–8 years ago. Under one recent drawing I wrote: many compensations in working alone. Not entirely a recluse – the nearest my temperament lets me be. My interest in people does not permit me towards *the extreme* I often desire.

Each tradition sets its own formal limits, though at the outset its imagination may have come from an alien tradition.

From the Dunwich jottings: the sun going down. The sea and the quiet walls of a local village.

2 June

I do not think of work – what I am doing at present. Rather a sort of playing about, although now and again something acceptable, even good, comes out of it. No direction. Whatever happens, happens and it does not worry me if nothing comes out. Out of twenty odd drawings only two or three maximum and these because they hit on something new.

Harmony in nature, natural harmony? In nature enemies all! The earth cannot take

Old Man on the Road
Ink and wash
22.5 x 17.5 cm

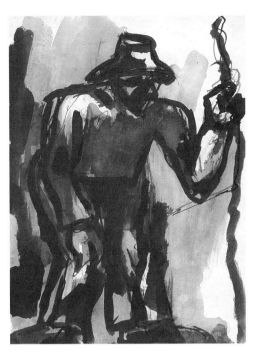

care of itself, nor can the waters, nor can the forests. Only mountains resist, also not very successfully, only where they serve no purpose. Progress often means taking from nature more than it can give. The "Greens" want to change all this that "progress" did not consider good. New voices of tribes who need forests and rivulets. We listen to them for the first time. Ecology has acquired a new importance. Some have seen this for a long time – the new importance is the world-wide concern. Got a heart-rending letter asking for support. Today one has to live in many places at the same time and support those who make single concerns the main thing in their lives. No one can do everything so the second best is also useful. Support what you cannot do yourself. Art is a moment in life I keep reminding myself. The sound of birds in our little garden, whether they sing or not.

3 June
All religions have inspired or were inspired by splendid metaphors most of which are from the treasure house of the unconscious. Not only angels and their counterpart, devils, but all the attributes of God. All dream images. The sets of values, ethical and moral, are of social roots. Whenever religions tried to bring the two together they too changed into codes of governing trends. When governing, they were not much worse but in no way better than other systems. They also knew of no better means of asserting

their power than tortures and wars. Their history has nothing to boast about and their spirituality has nothing to offer to the spiritual needs of modern man bred on modern science, philosophy and art. After a few hours work resting in my armchair I remembered certain places of our recent travels. Open places, dark trees, no historic sites – these I avoid – faced with some ruins I look the other way. Tall rocks are more interesting. I am not for ruins and look at the sea or at mountains or at the vast and deep space. Ruins have too many historical references, most of them dreadful. At the moment I am concentrating on three separate groups: trees, anchors and the conical shaped women. Every now and again I'm doing one or several drawings and additions to one of these groups. Only in the last few days I did some nudes (without a woman posing). Some coloured. In drawing nudes the concentration is on outline and mass, colour is secondary.

14 July

The news of the disaster in a Turkish mine broke my heart; another of those "not enough safety precautions". At 5 o'clock, Sir Michael Culme-Seymour and a friend came to tea. She told us that he recently had a heart attack. Anyway, he looked so weak that I did not want to take him down the nine steps to the studio. Politely I said I had nothing new there. So we had tea and a chat. I was glad to hear that he was keeping the paintings of mine and one in particular, "The White House" and the figure I liked of a man in a beret. He is selling quite a number of his collection though. He lives in Dorset and only rarely comes to London. It was a pleasant visit. He told me that he is on the purchasing committee of The Arts Council. He really looked tired as though he has little time to go and he is only one year older than I.

He: "You look in good health." With polite people I never know their true feelings. Still a good man.

David has something to do with "The Late Show".[25] Will try and keep awake. His friend [Michael] Ignatieff will present the programme.

Genoa v. Liverpool. Too much pushing. The Italians moved livelier. The first half Genoa 1 Liverpool 0. Not interested enough to watch the second half.

If spirituality does not come through my work, then and only then, I failed. I am not a mere performer and do not want to be judged on performance.

The silence of the sea. Things better when they do not move.

My washes like smudges in space.

The same medium, new ways. Always new ways.

The main thing is to explore a medium to the utmost of its possibilities.

[25] Our son was the producer at the time.

An uneventful day is a good day.

I have better things to do than worry about originality. Random jottings? Why not.

Our behaviour is closely related to well thought-out attitudes. These are different in quality from spontaneous reactions.

? July

Consciously and deliberately, I have given up all thought about people's attitude towards my work. They have their headaches and I have mine. I have written on the left of the "Homage" painting: HALF VISION, HALF NEWSPAPER. Once I have seen things I have to do the image.

A drawing is a physical record and a psychological event. Not one without the other.

I now treat ink as though it was a colour. It is a colour. The attachment to a medium is very much like the attachment to objects or subjects – a sort of infatuation.

Every drawing says something I did not know. "Do not wake a sleeping tiger," says a Chinese proverb.

You cannot talk to a believer. You can only listen to him if or when he is interesting. Ever since I was a boy, the pain of others hurt me more than my own pain. My pains pass quickly, the pain of others is always with me.

Tell me of an art centre and I will go the other way. Not art, the moment of life matters. Life is the centre, not art.

I thought it sad that Esperanto never took on. Above national language, we need one of all human kind.

Now we are back to national flags, I am sad that the red flag will no longer be what it was meant to be.

The best in all religions, the architecture. Mosques, the cathedrals or old synagogues. There will always be a need for half dark interiors where men can sit with their heads down.

No dogma has ever stopped murder, often encouraged it. Gods were born of frightened emotions.

No emptiness in nature. A great tangle of emotions. The sun is going down. The sea a new black.

What is stirring will pass – perhaps will be forgotten. Each mood might be the last. No fear as long as the mind does not die first. No yearning now. In the still I sit still. I take the pleasure of this atmosphere and of the light which will not last long.

14 ?

Must think twice before I let words go. The second thought is calmer and more reasonable but also more reliable. I can trust and follow them. Also must not answer letters after first reacting. My reactions usually aggravate others but to the same degree if not more, they aggravate me. Each line in the "Autobiographical Musings" has been written and rewritten and yet they suggest a spontaneity which the more spontaneous writings have not got because of the muddle which has been purged.

16 October

I get up now at random hours. I awoke at 2 eager to work. Went down the nine steps. Worked some more drawings for the book *Women of Taos*. Also some shapes of birds, one good in shape and contrasts. After about three hours work got back to bed. My mind was too active though the eyes were tired. Did not sleep, quite useful day dreaming.

When people speak of pleasure they think usually of physical pleasure. Few think of moral pleasures. Maybe because these are most intimate pleasures.

Taste owes more to culture than to an individual.

No religion has stopped killing but it gives it a more directed reason.

Each image says something I did not know.

Pure thought is philosophic myth.

Mystical doctrines are more boring than scientific or religious doctrines.

The things we do reflect what we are.

Those who have no private life think nothing of depriving others of their lives.

Revelation, not invention.

Violence is built in nature. Peace can find no model in nature. Human culture asserts itself in the striving towards peace.

Serving the unconscious, craft becomes art.

I don't like factual accounts. Things of the imagination have more colour. I like the hours of dusk. They are almost sad. The earth on which I sat was dry and cool. Pleasant grass. You expect the earth to be silent but not sordid like a black play. No holes, smooth, flat. How revealing a long stretch can be. On the horizon, a red sky. Not aggressive, quiet, like part of a noble design in an icon. More than other images I thought of Greek icons. The unmatured in nature is its best. The dusk closes slowly. I detest the bed. Dozing on earth is better.

4 December

Believe it will be a very creative day. My head is full of courage. Much of so-called public life is a game. It is dawn and the sky is still night-black. Too lazy to get dressed. The red pyjamas are light. I hardly feel them on my body. According to the morning news – the papers are full of drivel and of the Princess[26] who makes it public that she want to be private. I am indifferent and relaxed.

I do not envy people who have many exhibitions, I don't like the exhibition cult. I have had enough of it. No matter how little sells from my studio, I prefer it this way than selling through dealers. If I don't like someone, I will show a few things and say that they're not for sale. There are no queues for my work; this does not worry me. I like to work long on a painting and as long as it is with me, I go on. I don't know what it means to "finish" a work. When I sell a painting and no longer have access to it then it can be said that it is finished. As long as it is with me, I can go on and on. I always find an inch here and an inch there that could do with a greater freshness.

I love this process of reviving parts which died on me. An overworked surface does not bother me as long as the emotion is deep and true. To express true feeling is not a simple matter. Styles make me laugh, I only respect emotion but also radiant thought. I have never seen a good work which is not as elaborate as any philosophy. I know that I am alone by the quality of my thinking. I follow a narrow track: I hope to combine the simplicity and intimacy of a lullaby.

What the mind often works out is direction, emotions confuse.

The Degas–Pissarro, a typical television concoction. Lack of simplicity and too much wordiness. A lot of silliness. Traditions not explored.

2 March 1994

Have a good deal of work. Mostly editing of others. At six o'clock, opening of the exhibition. Christopher[27] said he would have the catalogue booklet this morning. If its printing is as good as the invitation then all is well. Farr was once a painter hence his concern with good presentation of what he exhibits.

A splendid woman folk singer spoke about folk song with great affection and enthusiasm – Barbara Dickson.

3 March

Christopher hung the rugs very well, they really look impressive. The catalogue deserves to be kept. He is very pleased with the exhibition which reflects in the sales.

[26] Princess Diana.
[27] Exhibition organised by Christopher Farr showing Josef's rugs, made in Turkey from photos of his abstract designs.

For me, the satisfaction came with the good quality of the execution of the images; some of the large ones make the wall quite as alive as any good mural could.

N. chose a good Chinese restaurant for supper. Tired, was glad to rest on the bed in the ante-room. Back to my everyday routine. Hungry for a good book.

Things as they come. Not to get stuck in a narrow dogma. I am not exploring an intellectual ideal. I merely follow the variety of my moods. Ideas happen.

No century is without its specific horrors. Nor is our century. It is even difficult to catalogue the worst. The rise of Nazism, the Ku-Klux-Klan, the Moscow trials, the onslaught on the aboriginals and the most recent events which go under the name of "ethnic cleansing" – the killing of six million Jews.

Dealing with the moment is a way of understanding the epoch.

What pleased me in my rugs is the sophistication of the design in spite of my striving after simplicity. The two are not exclusive of one another.

I trust myself when humble. My arrogance gives me no pleasure.

I don't like myself to have works, emotions or the mind of others. I like my state as simple as a lullaby.

The Catholics' insistence on the celibacy of priests makes sense. Artists are often celibate, even when married.

Found a splendid woman who now comes to the studio to pose. A proud body. She is about thirty years old. A lovely maturity. My involvement with her body is complete but not erotic. Work and no distracting problems. She is also warm-hearted. Never used professional models. Every woman proud of her body will undress without fuss. With most, I remained friends even when we no longer work.

14 March

I do not mind whatever people think of me. I will never fight back, never did. But I did fight for my bread. I hated my hungry days, I hated being homeless and having to worry about money for materials I needed for my work. This was in the distant past and if things go as they go now, I am satisfied with little without envying the much of others.

21 March

I cannot expect much from Nicholas Serota, not from his position as director of the Tate nor as publisher. Matthew Flowers bought some months ago from me what I think was a good painting of a miner. He told me the other day that he offered it to Serota who refused to buy it for the Tate. When I learned that he is involved in publishing I sent him a polite note asking whether he would consider publishing my

"Autobiographical Musings". Not even a reply. Ah, well. I even considered him as a possible friend. I will leave him in peace. I cannot stop dealers submitting any of my works but if any of them tells me of their intention I will discourage them.

Our scientists are looking for other civilisations. Let's hope that when we do find them, they have a better history than ours.

No men around. An empty fishing village. On small stones a few boats lie upside down.

Against a grey wall a girl clearly shivers. Her feet are bare.

No amount of words can say more than what we express in "Oh" or "Ah".

The alone, whether with others or alone, are alone. In the darkening sky seven stars I counted. How can one forget things which absorbed us in the long day. So much purpose, so little of it in the echoes.

A boy amuses himself shaping his piss into a rainbow.

I will be leaving first thing in the morning.

Things have no inner nature only layers of matter.

Once, sitting in a yard in Toledo, completely absorbed by sounds of the fountain, I closed my eyes – seeing seemed disturbing to the mind. I sat like this for a long time. When I opened my eyes and looked around, everything appeared unique as though seen for the first time.

How can I deny the invisible power of the spirit. I heard it sing. I follow distant tones and hummed what I thought I heard. Singing, the world becomes simple.

Dawn. A yellow horizon and a long line of camels against the sky. Lying still in the shadow of a leafy tree I rejoiced in passions I have not experienced before. All things of nature seemed far away. I forgot the routine hours of the day.

I moved my eyes. The summer day gone. Small white clouds in the night sky.

Strong contrasts unfolded of real heather, another of yellow daffodils. Beautiful contrasts.

Removed from daily passions, in silence watching the red horizon of the setting sun. In the dark sky the few stars were uniquely bright. Removed from things and from human affections, being alone, made me more aware of the passions of my mind. Soon will be night. I welcomed the growing darkness. This will be a night for dreaming in which time does not move at all. Discovering one's own darkness can be as rewarding as discovering one's own light.

Sitting on sand at the foot of a chain of low mountains, we talked of the grave visionaries and their idea: how to make the world young again. All of which is false. In history only the bridges of metaphysics survive. Trust your instincts not the teachers. Awareness never fails to upset myth. Our cries are like all calls of fate.

On the white river flat fish floating. Their dead eyes open.

A heavy bird in the sky. It passes leaving no trace.

Some days I draw quiet lines. Today all lines I drew were noisy. Even if I knew the mystery of drawing, their changes, I still would have to follow the dark course of my emotions.

Things physical are quite simple. Not so simple the things of the spirit.

My brain followed all other laws of evolution. So did my toes. Whatever happens in my brain worries me. The movement of my toes make me laugh.

Like a white wall the thick mist.

The eye shapes things. Feelings repeat themselves. Awareness runs along with its own animation.

I look at many things. When the one thing which matters comes along I don't look at any other.

No winners. No losers. In nature only mysterious happenings. Some more remote than others.

How refreshing the green light, more even than spring water.

The reason why something is written is to get to know my single ways.

I hate violence. More than any violence I abhor the violence of nature.

Physical passions disappoint. Spiritual passions are more satisfying. They come from many directions with gifts which never fail to astonish.

I cannot do without the gold of twilight.

I follow the radiance on each colour.

Even when I tried to imitate others I looked for my own expression. Each work was nothing else but a shadow of my soul, satisfying even, little else. Memory often holds me back, never imagination.

Expression as it happens and is – is.

Sometimes a new involvement revives my creative drives.

I was never interested in the "mechanics" of art. Only in their power to make me dream.

Art, probably better than philosophy reveals the requirements of the human spirit. It serves by not serving.

The day I found the whereabouts of my heart, that day I was born.

The classical line is hard, the romantic soft, the realistic line is that of the subject: sometimes delicate, sometimes powerful.

After hours of work I am now pleasantly tired. I open the book. I read. I close it. I open my eyes and read for a while then I close them. I get away from myself and return to myself. Not a good way of getting into someone else's world which is what reading is. I am reading The Wanderer by Knut Hamsun for the second time.

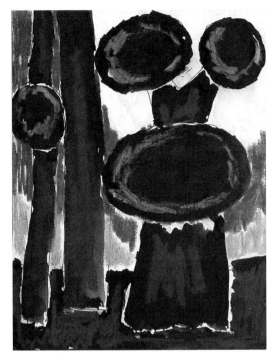

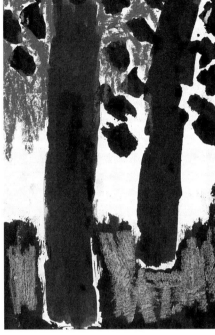

Trees in Holland Park
Mixed media, 25 x 20cm

Autumn in Holland Park
Mixed media, 21 x 14cm

The tree on my page is not this tree or that. It is the treeness of which all trees are made. I have filled several books with my notion of "treeness": visual notions. Each tree on the page makes me wonder.

I like the dawn for its quiet.

4 June 1998

The exhibition of my work is good. Also because of Matthew's splendid display of the works.[28] No catalogue but something *better* – a book with a splendid text by Heller.[29] I am satisfied; I am also pleased with the smaller exhibition at the Boundary. The Boundary is well visited – had many phone calls, "Mrs Katz[30] did a fine job with your works", "I saw the exhibition twice. Very impressive" and the like. "Moral Imperative" – Andrew Lambirth.[31]

[28] The large, almost retrospective, exhibition at Flowers East, June 1998 coincided with one at the Boundary Gallery. Early Saturday mornings, before the Flowers opened, we used to drive over and sit quietly enjoying the splendour of the gallery's space and the fine hangings.
[29] Robert Heller, *Josef Herman. The Work Is The Life*, Momentum (1998).
[30] Agi Katz. [31] Article in *London Magazine* Aug/Sept 1998.

16 June

Today, I worked well, drawing. From midday 'til dusk. I still feel happy with ink and washes. When a drawing defeats me, I feel miserable. Not so when I am defeated by a painting. I just put it with the front to the wall with the idea that I will return to it and save it. A bad drawing, I crumple into a ball and throw it on the floor. On a bad day, the floor of the studio is hardly visible. Even when defeated I don't despair. I take another page and another. Drawing is more like a game. Not so, painting. Painting is more complicated. With a good painting I feel a winner. I sometimes whistle a cheerful tune.

N.: "I'll deal with the phone. I'll deal with the front door. You have a good rest and if you can, a sleep." The growth of love. From passion to caring. Love is not what lovers in hot mood profess. Like other mysteries of life love is of the physical territory, demanding and aggressive like hunger and thirst.

The last few weeks there have been quite a few enquiries for prints of my work, some quite impressive reproductions. Considering that I hardly socialise, I am surprised that people bother. They do. I know that they often come for a signature which I write on the back. "Sorry to bother you, just in case we have to sell the drawing. You know how Sotheby's and Christie's are particular about provenance." I tell them that the signature is in the style. "This may be so but I need a signature."

The other day I fell on the pavement.[32] I lay bleeding. A woman ran to get an ambulance. I then spent hours waiting in casualty at Charing Cross Hospital. N. lost patience and took me home. On the way out a Sister saw us leaving and said, "Too few doctors. You might have stayed here the whole night." So home to Nini's care.

19 July

I was advised to cut down on smoking. So far, so good! Have not smoked the whole morning. No pain in my right side but I still cannot lift my right arm high.[33] I hope in a fortnight I'll be back to normal. Memory is not affected.[34]

A man coming out of a lavatory says to his sister: "Where were we when nature so rudely interrupted our conversation?" She: "You don't expect politeness from nature."

[32] Falling became a regular occurrence. In December 1998 he fell in the street and broke his right shoulder. In June 1999, he fell in the kitchen and broke his left hip. This initiated a slow decline to his death eight months later.

[33] Though his shoulder healed, he could never again lift the arm high enough for easel painting. This he took philosophically.

[34] His main worry remained loss of memory and a fear of failing mental faculties. There had been a brief experience of this following a course of ECT in 1966.

Some weeks ago, when in Cardiff,[35] I went to the National Museum. They were showing my frieze of miners (borrowed from the Glynn Vivian in Swansea).[36] I was pleased that the paint is as fresh after all these years as when newly painted. The second thought was sad: I have not painted anything as good for a long time. The image also made me think of two other aspects. My involvement in human reality is much greater than my interest.

I am at the moment very much concerned with relating the shape of an object to the page.

Every so often we go to the Columbia Road flower market.[37] I like the flower sellers, rough looking chaps. "Begonias, three for a pound, you can't get them cheaper." Biggish full blooded girls pull passers-by to their stalls and usually make a sale. At George's Café, salt beef sandwiches and a big jar of tea! George, a chap still speaking with a strong Polish accent: "Make no mistake I was born here."

In another café, an elderly Jewish lady: "We sell genuine smoked salmon, not like bits of herring dyed red."

"Four little blighters are quite enough. Most of the nights I spend now at my mother's."

A middle-aged woman to a younger one: "Turn your back to him and let him get on with it. It's quicker that way and you can have your sleep."

Of the drawings made, a few may be of some use. The hand makes better decisions than the eye.

When back home I busy myself in the studio. I made out of the casual jottings drawings; some of the writing not even related to the drawings.

My memory is getting so bad that the names I know I often mistake. For instance, this morning I said August Moreau, meaning of course *Gustave* Moreau. I spoke of my visit to the Moreau Museum in Paris where there are many bleached Prussian-blue watercolours which remind me of R.[38] who was Moreau's pupil.

About my failing memory. I used to be able to quote whole pages from a book without any mistakes. Now I often cannot mention a title, or even a writer with certainty. I may even mix them up with other works by other writers. I had to develop a technique for introducing people. I say, "Please introduce yourselves." When N. is about, she helps me out.

[35] The occasion, in 1992, was to receive the Silver Medal.

[36] The one commissioned for The Royal Festival of Britain for which Josef received the Gold Medal 1962 for Services to Welsh Art.

[37] Every Sunday morning in the East End where nursery men from Eastern counties bring their flowers and plants by old tradition.

[38] Rouault.

No preconceptions. Trust in the leads of the imagination. I still trust the unconscious and its certainties. When I read aesthetic opinions or hard beliefs I know that I have been dished out something not altogether complete.

Sickness, death – nature's violence against the life it has given in such abundant variety.

My dialogues with myself sometimes succeed in evoking a slightly mad but inspired monologue.

In the azure sky, almost Italian, loose clouds. The midday light hurts. Dark is my favourite time. I hum or sing not interested in anything else. Who can wish for a better life. I sit in this half-real life as though resting. I don't rest. I pick up the jotter and write with speed words which only come once. I was never good at socialising. I breathe freedom when alone. I meditate physically. I became intimate with my instincts. "In nature, no victors, no losers only passers by." I write this down not knowing why.

Often when drawing from a model, I forget she is naked. If the woman is very beautiful, I freeze. It takes me quite a while to treat her as I would treat a mountain or tree.

Whatever the intention, the image has the final say.

In wash drawings, nuances matter. Hard fact in the line. Life in the nuance.

I stopped going to the theatre and concerts because the slightest movement of people around me disturbs me with a force as though I was hit with a hammer.

20 July

I have made a short list of over twenty works which have impressed me most.

1. Urs Graf: "Dancing Couple".
2. Michelangelo: "The Meeting of the Infant St John with the Holy Family".
3. Sebastiano del Piombo: "Head of St James".
4. Lope de Vega: "Figure Studies". (Splendid washes).
5. Veronese: "Sheet of Studies".
6. Bassano: "Driving the Money Lenders from the Temple".
7. Pordenone: "Martyrdom of St Peter".
8. Parmigianino: "Study".
9. Guercino: "Study of a Young Man".
10. Callot: "An Army leaving a Castle".
11. Poussin: "Apollo and the Muses on Mount Parnassus".
12. [?] Lorrain: "Landscape with Farm Buildings".

13. Rembrandt: "Nude Woman with a Snake".

14. Cuyp: "A Milkmaid".

15. Chardin: "Seated Man".

16. Adolf von Menzel: "Studies".

17. Millet: "Shepherdess with her Flock".

18. Tiepolo: "The Flight into Egypt and View of a Villa".

19. Fragonard: "Oh, If Only He were as Faithful to Me".

20. Raphael: "A Pencil Study of a Figure".

A candid thought needs no rhetorical ornaments.

Emotion is the essence. No polemics. What I feel cannot be contradicted.

The season of miserable weather. Grey days. Unpleasant and wet. Worse, no desire to work. Not working. Two long days. My way of living never depended on my relations with others. Only on active working days, on long hours painting or drawing. N. now more than ever, is of great support.

"A good wife, a good library, good work".

Every word could be mine. How I long for a long, good day.

Travels are no longer on my mind. In my ante-room I am everywhere, like the ancient philosopher in his garden.

The unkindness of man to man is today as it has always been.

I am still messing up things for myself. My talent for this is as it has always been.

Quakers, charity.

I have no time to be interesting. I said it to Anne and I meant it. Nor am I interested to be in the thick of things.

Neither optimism or pessimism. Down from Mount Olympus an old man looking around bewildered.

I don't need encouragement. Life's energies bewilder and encourage me.

England is full of smiling people, meaninglessly nice.

A runner, I did not run against the others. I ran against the clock.

No ambition. No competition. Slightly scared. Carrying on.

Apparently the triptych "The Moment of Living" made some impression on quite a number of people including some reviewers. For reason of space I had to take it apart when it came back to the studio but whenever I show it to people I show the three

canvases together. I was really pleased the way the hanging placed it in the exhibition.[39]

A grey dawn. It is time to begin. The pages of my jotter are blank and tell me nothing. My eyes are still tired. I think of the white seagull and the still sea. Think of the grey sand and the millions of white pebbles. Small fishing boats smelling of fresh paint. Each has on it in clumsy letters short names. I read them once again. What does this one mean? "We were two" or that one painted with a soft brush "Your voice is with me". I have noted down in my jotter what I read on each boat. The quiet movement of the waves rising when hitting the sand. I lay stretched out hearing the silence.

I listened, not passively. I corrected without writing down a word. Splendid, splendid. Hours of exploring the invisible.

Daffodil: Stencl used to bring N. a daffodil on each visit – "Roses are common."

Amber is a quiet colour.

Yellow can hurt the eye like too much light.

Red cannot be taken lightly.

With black, I perceive some threat and the fears of the night.

Only in the colours of the rainbow, do I find some peace.

Each day I try to make time for reflecting. Beginning with no direction, sooner or later I follow some purpose. Some I manage to put on the pages of one of my jotters. Amazing how many worthwhile ideas I forget if I don't write them down.

I am always at my best on awaking until midday. Then my mind becomes dull, even confused. Only drawing and painting activates my mind and may even become creative. Even this does not stop me to talk nonsense in an excitable way, only later to regret the things I said.

Outside rain and grey light – if you can call it light. Few people, the streets almost empty. No traffic on the road. Holidays affect me miserably. The only solution is to busy oneself in work and forget, forget the misery of holidays. On good days I don't mind insomnia but on those wretched holiday nights, it is torture. No amount of temazepam helps.

When I was a boy I liked to press my face against the windows of the bakery. There were only two men working. One at a long table with his arms in dough, with him work seemed a continuous beginning. The other at the open oven pulled out the fresh baked bread with a long flat spade, one after another. The smell was delicious. For hungry children, this smell was almost food.

[39] At the big Flowers East exhibition May 1998.

The day was my enemy. How I feared hunger! There were other enemies and other hungry children. The only refuge to find a corner and there forget in an intimacy with Karl May's *Old Shatterhand*[40] and still better with *Winnetou*. With them I learned to forget food.

There is no place on this earth without some corner which one could not love. I remember darkness and I love it as I love the colour black. Nor can I forget blue, a colour I dream with. And there is yellow, sharp as light, for many hours until it pales into dusk. The trees are dark and thin like shadows and the grey is grey. People bring pain. How clumsy they are trying to fit into time. Strong women select vegetables for food. A woman volunteered to caress the belly of a fat man. He lay on a heap of hay and groaned when each caress gave him pleasure. "You are a good woman. Cover yourself with the shawl and go on licking my belly and lower. I could not wish for a better woman."

There is something of the Adonis in me. Sometimes I look at my reflection and like what I see. In another state of mind I loathe myself. When a work of mine turns out well, my eyes smile. No other approval gives me satisfaction of this intensity.

My admiration for norms of other cultures does not make me want to imitate them. About their way of affecting my unconscious. Ah, this is something I am not clear about. Nor am I particularly interested. I like best my drawings which are as free as singing in the bath. Contradictions, coherence, is all the same to me, just as doing the same thing over and over again.

Bright surfaces or dark surfaces, expression matters.

The need to change to a new medium is preceded by a spiritual crisis. A new medium, new design, new forms. With oil pastels I got involved with shapes and textures quite new to me. Not only am I concerned with a new surface but also with explorations of new intensities. As always, feeling first; I arrive at feeling, I do not start with it. Otherwise, small victories, big defeats. It is not my intelligence that serves me but the instinct, of which we know little, that saves me. A blind force but I have to rely on it. I have often to water down my attitude or harden it but it is all improvised. A time ago I decided "no footnotes, no quotations". I was at the time irritated by culture's preoccupations. I still am. My moods are my own and so should my words be. What is a mystery to me had better remain a mystery. Besides, I have no time for the past. History is a parade of customs. What was beastly or uplifting has not changed.

Looking for the static, thinking of the still.

In each object, my self-portrait.

Nature is a blind energy. Where to? What for?

Gods are forgotten. Who remembers the mighty Zeus?

[40] Greatly loved "Western" novels that children read at the time. I recall them from the thirties in Germany.

The best in all religions has always been the architecture. Splendid temples, splendid cathedrals. I like best small churches in which people sit with their heads down.

This tree is van Gogh. This tree is Cézanne. Each tree a self-portrait.

No one is ever loved enough.

Before you knock, make sure it is the right door.

My life? Nothing wild. No adventures. Ordinariness suits my temperament. No passion for what is new but things do happen which break the settled routine. Not that I deliberately make a distance between myself and others. Nor do I nurture a cult of privacy. Me, a recluse? No, but I like my days when alone. Some of my "Try Outs"[41] turned out to be more complete than I thought. At least a dozen are interesting enough to show when an occasion comes my way.

A woman singer. A plain face and straw colour hair. With each note she became more beautiful!

Midst all the irrelevancies, "Will he or won't he be King?" The terrible floods in Italy with so many people losing life is a heart-rending situation. Especially as the government declined to act before things got beyond control. Nature is still energy number one. I am in nature and outside it.

I will continue working on the works I call "Try Outs". I became fond of mixing media, watercolour, ink, oil pastels.

Glad to see that the accordion becomes more popular in England. In France it has always been popular. It is a fine popular instrument. In Scotland, too, in dances it is often used.

Experiments on "Try Outs", whatever the results, are very important to me at the moment. I will carry on.

Journalists make me nervous, particularly on the phone. They fire questions at you and expect instant wisdom. I decided if they want an opinion they will have to come and leisurely exchange views – do the interview in the studio.[42]

In the present situation, art is for enthusiasts. Cold connoisseurship does not exist.

I learned it from many young and not so young women: "Now that my mother is dead, I am a new person." N. speaks now of her mother with greater tenderness than when her mother was alive.

"'Til you sleep with me you won't know what a legend in bed is . . ."

"Are you sure you know the difference between legend and myth."

As a rule, I do not go out to places which require a kind of suit, tie, etc. Whenever I get an invitation for dinner or another occasion and I see "black tie" mentioned, I

[41] Towards the end of Josef's life, he filled some sketchbooks with mixed media works, almost scribbling – following instinct blindly. He called these "Try Outs".

[42] Some took this up. From others he never heard again.

Young Couple: Try Out
Mixed media
25.5 × 20cm

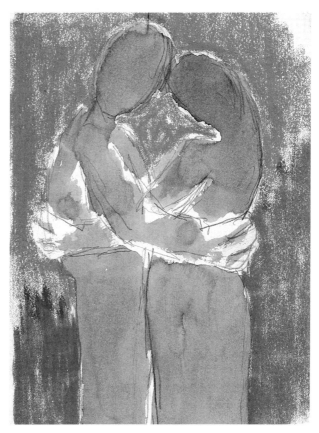

throw it into the waste basket.[43] ''Well-dressed'' men look ready for the coffin. Fashion designers make women look as though they were brainless.

Tribal art still excites me. With no effort it finds its way to the deeps of my imagination. I often forget that they were the soil for many of my images.

K. was here yesterday. He liked my single line writing under my images. I am not very responsive to flattery. When I recognise in it words as I would have expressed them then I am pleased and no longer think them flattery.

Ezra Pound was right in losing patience when asked to comment on a poem: ''I am not an explainer!'' Yet his comments on Eliot are as creative and absorbing and as free from any expression of the imagination and instructive. Much of his self-conscious attitudinising stinks. He was a pathological liar. He called Roosevelt a Jew. Also his apologia for fascism embarrassed even Mussolini. He was as obnoxious as any servile creature, yet I keep his book of the many advices to Eliot. For fresh air open wide the

[43] One secretary of the Royal Academy persisted – ''Josef come – as long as you do not mind the others wearing theirs.'' He went in his old brown corduroys, threadbare by then.

window and remember Whitman. Walt Whitman was the great voice. It was new. It was America and Europe that needed it: a primitivity of grandeur.

A vermilion sky. Half of the sea dark, half on fire. Seagulls on gravel. All so real and like all things real, disturbing.

Yesterday David arrived with loads of food and then cooked a huge supper. A fine company for the evening! Becci rang: had I got enough food?[44]

Just watched a sad film about Benjamin Britten.

"A Tribute to Goya's Black Pictures" – although when I painted this work neither Goya or his black pictures were on my mind. A good afterthought I believe, as titles should be.[45]

A strange contentment. It may have something to do with the good work I did this morning.

Nini was right. I must reframe the lithograph of the mother and child. David will collect it on Sunday morning and has promised to do the frame within the week.[46]

Let's hide from the terror of light. The inward gleams in Rembrandt's mind are more revealing. Once seen, you will never forget them.

Decided not to have the two exhibitions I committed myself to. Wrote to the two galleries giving my reason in the most polite way.

Though I promised myself not to buy more tribal pieces, I cannot resist when a dealer offers me a good piece.

No engagements and no visitors for the next few days. Peace and work.

Art has its own reality. N. gave me the collected poems of Mandelstam.

Also liked his Armenian journey.

A fine edition of Cavafy. Zen poets. I like work by others in which I find much which I can relate to myself.

I developed an aversion to museums.

Fine, very fine: on television a young girl who just won gold for the high jump, when asked by an interviewing journalist how she acquired such a technique answered boldly, "I know nothing of technique, I throw my heart across the pole and jump after it."

The first day in weeks some good drawings. What a relief.

Reality is the great mystery

The Pyramids. The last few weeks a strong longing to go back to Giza.

[44] Dates of these jottings are near impossible to locate. I must have been away.

[45] This tragic work, a woman with her arms raised in despair, was at times also called "In Memory of the Holocaust Survivors".

[46] Over the decades David Winter did all the framing, collecting and returning work always on a Sunday morning.

I awake at three o'clock. Still black in the window. Dressed myself quickly and driven by a strange urgency went down the nine steps to the studio. My day's work began.

About the nude: not how real the body but how much of the human spirit went into the process of making it an image. Art has its own reality. Here it is all a matter of feeling, not of objective seeing. Feeling shapes. I never knew "problems". The process of work sorts things out. States of mind quietly creep in. The right becomes right and makes the face smile. I make objects of silence, no noise of words needed.

Watched the programme on Pasternak. Too many flashbacks whether on Olga's life or on others. Instead of clarity it brought about more confusion. Nothing as simple as *My Sister, Life*.

Nature? Universe? Only man. Good work keeps me sane. My weakness I can diagnose easily: the fear of death, even of sickness, above all fear of insanity – this fear was with me since my early adolescence.

After the day's work, I found my way back to the inspired beginning. I arrived at the spontaneous beginning.

It gives me some satisfaction when I manage to cut down two or so thousand words to a couple of hundred.

A letter from Roditi. It must be terrible for him to suffer from epileptic fits particularly now at eighty when he thought he was cured. Still he manages to get on with his work: two books this year.

Over my ears in work! Drawing and painting. Work does not tire me! Today I put in ten hours and stopped when Nini called me for dinner. Ink is still my favourite medium. Not pencils. Pleased with my washes. Pleased with the notes on the nudes. Sometimes I refer to them as "naked bodies". Writing helps to clarify one's direction. I am not a bit interested in thinking as a writer writing. What I like is the style of Delacroix's journals, of van Gogh's letters. They typify the *genre* of artists' writings.

We must care for each other. The world is not worth caring for. The Universe does not need our caring.

Travels confuse. Glad to be home. Decided to stop travelling for a while, a longer while.

Silence. No arguments. Reading Camus' *American Journals*. Restless notes. Perhaps he needs them for some future novel. Henry Miller's notes are better.

Lunch in an Italian restaurant with the splendid woman who works on translating from Yiddish. It was tactless of me to mention how difficult it is to translate Yiddish vernacular. She: "I know." I could kick myself.

On my jottings! Even these have to be practised to serve some future purpose.

Haiku journals: what a joy to read.

Today worked the whole day on some watercolour. Stopped when the light faded.

December

I like uneventful days. I go now out only to buy things.[47] Otherwise I spend the whole day in the studio. I am alive in a quiet way – some of the quiet found its way into my work. A mild rain hitting the skylight.

My economic security I owe to chance. I have no talent for business. I have a small following of people who come from time to time and buy, "May I come again?"

The most profitable way of being with others is reflected in one's work. Outward questions mean little. Not a leader or a follower, a worker alive in his work, most of which is little more than "Try Outs". My experiments taught me quite a bit – experimental work rather than masterpieces. One can only come to some awareness of one's experiences of life through one's work. Chance plays a great part in my work, as in my life.

A wide openness I sometimes call space. Radiance and no shadows. Smaller space

Josef Herman in his studio, 1995

[47] Turps or white spirit, from the little hardware shop down the road.

defined by relationships between things is more common. Everything which has contours confines. The vast space experience frightens me. Tires first my eyes, then my mind.

A young moon. Pale stars. Blue dusk.

Competence is never good enough. In fact it is a killer. Workless days wear me out. Labour heals.

Turner? Which Turner? The Turner of the last six to eight works is the Turner for me.

Imagination goes its own way, its course unpredictable.

I collect things or works by other artists in which I recognise something of my own heart.

Of all "landmarks" I like the pyramids best. I am also very impressed by the opera complex in the Sydney harbour. I don't like the Statue of Liberty.

When I was in New Mexico an old woman told me of a saying popular there: "Wolf, wolf, eat that child that does not stop crying. I have no more lullabies in my heart."

For no reason that I can think of, my visit to old Pasternak[48] in Oxford[49] came back to me very vividly. He spoke a little about his son, Boris[50] but spoke with a lot of venom about Mayakovsky.[51] "Is he still alive?"

I: "No. He committed suicide ages ago."

Pasternak: "Good. Very good. He was a student of mine but he had no talent for painting. None whatever. He had only talent for hell-raising."

I: "And for poetry."

Pasternak: "No. For shouting. Boris was a poet. Still is and will always be. Mayakovsky has a voice but no sense of the Russian language. Boris, ah Boris, my Boris . . ."

In the doorway I turned my head, I had another look at the large painting of Leonid's at a table in the passage. The daughter came with me to the door, "You must forgive me, I am not being inhospitable but my father is old now, he must rest."

The row of terraced houses was bleak at dusk. Another atmosphere or mood of Oxford. Bits of the conversation lingered on in my mind. And the tones: Russian.

Marching feet, chests out, heads high, banners. How I detest national celebrations!

One woman to another on North End Road, "She had principles. You could see it in her hard and unforgiving eyes."

[48] Leonid Pasternak (1862–1945), Russian painter and graphic artist. Josef visited him in the early 1940s.
[49] House in north Oxford. Strangely, as a child I also visited there. Our paths kept crossing in this way . . . in absence.
[50] Boris Pasternak (1890–1960), Russian lyric poet, novelist and translator.
[51] Vladimir Mayakovsky (1894–1930), Russian poet and playwright. Friend of Boris Pasternak.

It is the object of every painter to follow the needs of his talent and stay away from the art industry. What the art industry does with a work of mine has nothing to do with me. What I get helps me to survive and get on with my work. I paint but I don't control the weather. My inner weather needs a steady climate of quiet and peace. Everything outside my studio feeds not only my body but also inspires my sense of humour. How else could I survive and get on with my work?

My more intimate ideas are more important to me than the economics around my work. At the moment my paintings are doing better than my drawings. There is a greater demand for my paintings. A peaceful dawn. A good working day, a dreary dusk. No more economic nightmares. My most worrying days when my imagination becomes dry as a desert and my emotions find no words to express its reality.

August 1999

London is a monster. I feel no attachment to the city. I respond to the atmosphere of some small streets. I feel alive once I am near the steps leading to my red door. Behind this door my life begins. I don't like café life nor the noisy pubs. How can one speak of the "atmosphere" of a city with 12 million or so inhabitants?

London is a compilation of many atmospheres, not one of them has a particular emotional significance for me. On good days I like walking and making my way in some areas which seem new to me. A well-known dealer once said to me, "You don't draw things of London's rich life." I smiled but said nothing. The rich life of London? What a ridiculous presumption. The city does not make me particularly happy. Nor does it make me suffer. I am not a great communicator with walls! I like only the few walls which became architecture. No city has many of these. London had more humanity during the war; now it is a city of opportunists and money grubbers. Those with a talent for private life can find their corners providing they don't give it an aura of some philosophy. You can dream in London! Whatever I experience makes my life. I have few dull days. In forty-five years of marriage, I believe I have gone through all the relevant stages, from passion to caring. I need no artifices to enhance artificial experiences. I still experience intensely what I respond to, in physical as well as in spiritual spheres. What has fascinated me for years still fascinates me; the man within me more than my ego! Even in the years of poverty I was the same man as I am today in relative security. I have learned to live with few pleasures. A very pleasant state. Of course while the horrors of life, whether of nature or man made, still affect me they are at some distance. I am more an onlooker than an activist. I cannot commit myself to everything but I can and do commit myself to what my hands can do.

The coward in me has taught me how to hide from storms. More than anything it

has taught me that no storm lasts for long and the dubious leavings are not worth saving at the cost of one's life.

Expect nothing much today. Looked through some sketchbooks. Works set too much in reality. Only the trees are not of nature, their strong shapes on the page witness to my moods and not at all studies of natural structures.

I have no friends – I find friendship difficult to bear: it demands compromises and hypocrisy.

There is little hatred left in me. A pity. I learned more from my enemies than from any well-wishers. It takes me some time to discover how harmful praises are, often being rejected hurts. Like most human beings I too am complicated. No man is as simple as animals. They devour without hatred.

Many writers suggest to look behind the surface. I trust surfaces. I saw the other day a group of drawings by Victor Hugo. Their surfaces say all: contrasts become conflicts. In accidental blobs, deep mysteries. His is true draughtsmanship. Why must everything be understood at once? When puzzled, I know that I am on the right track.

I know that one tree is not what another tree is. But in my drawings I was not interested in categories but in the "treeness". That is to say what makes a tree other from a mountain and even when seen against a mountain, is a thing in itself. This makes for individuality in nature. Nature is a totality not a summary of individual things. Nothing defines Nature.

The mystery is in the seed, the beauty in the tree. Green is beautiful. So is the flushing of the dawn. So is the red of the dusk. I like a white moon. In the mind my defeats last longer than any of my successes. It still comes back to me with intense pain a chance which I lost and knew that I should have won. I was then seven years old. I never thought myself a unique being – seven was enough and still is.

Designers for fashion are a sick breed. Women's fashions make them look idiots. The over concern with exercises to get strong bodies empties their brains. I have not switched on the television for weeks. Nonsense aside, back to work.

Poor Baudelaire, great Baudelaire! Reading now his intimate journals. The title is best and rare entries, also the restrained voice is talking with honesty.

At six o'clock before going down to work I read some of Rivera's[52] entries in Roditi's *Dialogues on Art*. He is too serious for gossip and too gossipy when serious. A loveable fellow. A time ago he gave me his first book of surrealist poetry. I mislaid it and spent more than an hour and still could not find it. Got irritated. Read his interview with Chagall. Not as good as Chagall's on writings. When painters take the trouble to write they are better than the writers who attempt to write about them. No polish, direct force and often the charm of clumsiness.

[52] Diego de Rivera (1886–1957).

After a visit to Altamira and the Lascaux caves,[53] the drawings in the Louvre seemed slick performances. The only drawing which never stopped fascinating me was Leonardo's self-portrait: pencil done in his old age. Less psychological than Rembrandt's but the richest surface I have ever seen. Age which inevitably affects the paper and the pencil add to the mystery the fresh paper could not have had.

A reader who has no editorial gifts will never understand the writer. What the writer does not say is as important as what is said. Writer-explainers are bores and worse, misleading quacks and self-deluding opportunists. Almost stupid but not quite. Never trust the knowers. The best museum is the street. The things which strike you will train your eye. The trained eye will train your arm. The trained arm brings out the best of the mind and of the cherished emotions.

Thinking, not always thinking things through. I am not writing this with the idea of having these things published but it will not worry me if some of these will be made public. I will definitely not make an effort in this direction. Mine is not a dream world though some days I will spend hours, lazy hours, in indulging in day dreams. They give me pleasure, little else. Composition does not come into my head. The result, fragmentary explosion sequels in my "Try Outs". I live now in London but I did not embrace the city. I could, I believe live somewhere else. My little ante-room and my studio mean to me much.[54] Whenever N. and I speak of moving my forehead sweats.[55] Being with others gives me no pleasure though talkative as I am I may have given a different impression. I would gladly escape from myself if I could. On days when I am overcome by shyness of one kind or another I am overcome by boredom and am a bore to others. I invent contentments so vividly that I begin believing in them myself. Not that I am fascinated with myself but I do watch myself: who am I now? At different times in different situations, I too am different.

The last week I reread Dante, Voltaire and Montaigne. All with equal pleasure but *Candide* I found most absorbing. Some passages in Dante are beyond me even after rereading them several times.

Deliberate is the opposite to the inspired but it cannot and should not be despised. Who knows where it might lead? The main enemy is stagnation. Unpredictable and full of mystery is the creative process. A work has its merits in the stages of becoming. Objectivity, no matter how well expressed is not the goal as the way of the heart is.

Designs without subject are more spiritual than the best designs towards the

[53] Increasingly memory weaves into the day-to-day.
[54] He was still able at times to go down to the studio in the stair lift that had been installed.
[55] As years went by I wanted to move to a smaller house while I still had the energy. Ours was a huge house with sixteen rooms and a studio. I moved to north London to be near our children and grandchildren after Josef's death.

realisation of a subject. Subjects, no matter how idealised, are too near to materialistic attitudes.

Sadness and my concept of beauty.

There is something in what Balzac called "creative laziness". After some lazy days, work finds its rhythm in an unexpected way and things surface often with a rare and candid energy. New things. So I learned not to fear days of sterility. I still go about with my sketchbook but my inner drives matter most.

Reading some translations of Mallarmé's poems. Very good ones.

A rose day. I contemplate the light: mild like a whispering voice. What is heaven but an intimate sky!

Many things can motivate. Fear as much as enthusiasm, dread as much as vision. Ali[56] said that he was "the greatest". People laughed but he *was* the greatest. The greatest have the right to say that they are the greatest. So has Linford Christie. When I watched his splendid face I did not laugh. No modesty, no conceit.

In these jottings, no place for "family affairs" though at times they present themselves with great urgency. Good or bad, no family affairs. David Winter framed the Japanese (or Indonesian) work and hung it on the wall. It looks splendid. All the work he does for me is faultless. In all the years I never had reason to complain. All people, at the moment, who work for me do good work. In the past I was less lucky. Frame-makers behaved like prima donnas! David does as good work as any, on time and no fuss! A good craftsman and a pleasant man.

There is a hypnotic element to all good work, whether music, painting or drawing.

On days when I cannot work, some terror comes over me. An hour of introspection earlier put me down. All morning I could not think of anything good. I would not mind if there was some philosophical content.

In comparison with the elephant, human life is short. It could have been shorter than that of an ant. The ants achieve what they are meant to achieve, man remains dissatisfied.

I can no longer bear the company of achievers. Ridiculous creatures at best, monsters at worst.

Deeply moved. Becci came into the ante-room and sellotaped a piece of paper on the right of the bed. "Now," she said, "you ring me at any time, no matter how late at night or how early in the morning and tell me whatever you need from the shops or chemist. Do so, I am here to look after you."[57] I was moved to tears. I could not hope

[56] Muhammad Ali, the boxer.
[57] He always forgot Becci's phone number. He kept a book of addresses and phone numbers but it was not in alphabetical order and he would spend hours looking for the right number or address.

for anything better than this and my children's caring in these last years of my life. Nothing can match this.

What do my trees mean? I don't work with meanings. Meaning unobtrusively creeps in and has to be discovered.

I remember once I was close to death.[58] When I opened my eyes, I looked around. How pleasant it was for a short time not to be alive.

You have to learn to get away from the aristocrats and middle-class ugliness.

Workers are beautiful.

We owe much to our brains but not as much as we owe to our hands.

I like ink. I don't get on so well with pencil, soft or hard. I like mixing media, charcoal washed with watercolours. With pencils I often jot down an impression or some ideas. With washes I go a step further.

The news: instant wisdom, tradition. Yesterday a young lady rang me, "I am from *The Times*. I would like to ask you about the coming exhibition of African Art."

I: "On the phone? You must be joking. Come and see me in my studio and leisurely in the quiet we can talk about it."

She: "I will ring you back." She did not. Good.

September

As always, a splendid occasion. The last night of the Proms. The "masses" singing. Deeply moving. I found myself involved as though I have been there – one of the many.

By "Try Outs" I mean things not completely resolved in form and style but suggestive enough of a direction expression is taking in the process of work. Not being willed, their freshness is, I hope, a quality in itself. Some of them are starters which I did not continue for fear of losing what was already there on the page. Some of these went into the black book I called "Autobiographical Musings". Some friends objected to the word "musings" saying that the works are more than the word musing suggests. Be that as it may I thought that the word musing should be taken not in its static sense but like words coming from the deeps to the surface – more in one place than in another. I thought of it as an image of delight. The azure of the cloudless sky, they were also a source of emotional comfort. With the lightest of my instincts I felt myself rising. My eyes were delighted.

Simplicity has its own dynamics.

Each image a gift to whoever it may concern.

Images are good to me. Each image in its own way. No words.

Mohammed was a general. Christ was a victim. The imagination is stretched with

[58] This may relate to a week in the Intensive Care Unit after a long anaesthetic for the hip surgery.

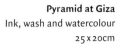

Pyramid at Giza
Ink, wash and watercolour
25 x 20cm

stories about them. No amount of talent can compensate for lack of character. Now and again my mind like in a cloud, dark: where to, what for, why? Is it worthwhile?

Simplicity easier said than done. After the pyramids, nothing is simple. The pyramid mystifies and is the epitome of the best in all architecture. It is reductive in form, rich in abstract inferences. For my figure drawings I took the pyramid as a model.

I never thought of my commitment to work as a career. I do what my natural energies make me do. On days when I do nothing I am sick. Work is a healer.

From Passion to Caring[59] – today tore up the fifty pages I have written. No good. No good whatever. Will begin again.

A splendid short film of barefooted people treading on grapes and making wine. Dynamic dancing of young women and middle-aged men. Putting the grapes into barrels and not waiting for fermentation – drank from the barrel. Sun. Red earth. All very refreshing. A joyfulness not to forget. A fine image of a golden daybreak. Old women sitting in the shadow looking at the young dancing in the sunlight. The ritual of kissing bread handed from mouth to mouth.

At four in the morning the cab arrived to take Becci to Gatwick, she is off to Greece

[59] His philosophy on marriage.

for a fortnight. We hugged in the doorway. "Daddy, don't worry, I will be all right. You know me, I make friends quickly." When the car moved off she wiped tears from her eyes. I too wanted to cry. How much I love this child!

In the evening Becci rang. She sounded very contented. She has a room overlooking rocks and the sea. "The nightfall was lovely, a red sky. I stood in the window until the sky was dark." To think that until the age of ten, Becci could neither read nor write. Now she expresses herself in quite a personal way. Nini should get much of the credit. She worked with Becci some days for hours and hours.

Dear Mr B, thank you for your letter. Let me make it clear. I am only interested in the human side of industry. I draw workers because they are beautiful. In their Sunday best they are as ugly as the members of the middle classes. On this basis I do not mind to be included in your project. In human labour I see the heroic aspect of our existence.

Of recent time, the guitar came back into fashion. After Segovia all those young people seem as though they set out to modernise that great instrument. They hammer at it hard with ferocious anger. The delicacy this instrument is capable of, the privacy is ignored. Ah, Segovia, Segovia, you left few good followers.

To copy things of nature is too complicated and not all that useful. Even smaller triumphs of the imagination are better.

Longer paragraphs are easier to compose.

I do not suffer from the fears I used to suffer of the whole canvas nor of the empty page.

There is a good reason why I often turn to xerographic reproductions of my work; I often like the printed texture better than that of the originals. There is a great myth and worship of the "original". After all, the xerographic print has been as much controlled as the "original". The machine is a tool.

I like working for things commissioned; a plate, a rug, a mural. Being commissioned makes me feel needed. Commissioned or not commissioned, my commitment to the work is the same.

I said last night to Nini, "We all die, I am already eighty-eight. Every morning I awake I laugh 'still here?'" All rather silly to be born to die. How? When? What for?

Lillian[60] got into the Honours list, deservedly so. Late, she is 93, she giggled with satisfaction like a young girl. It gave me much pleasure to look into her glowing eyes. Her autobiography[61] will soon come out.

N. often shows remarkable common sense which often helps me in decisions. A German dealer was eager to buy our several Menzel drawings. He offered, I thought, a generous price. I was tempted. Over lunch I talked about it with N. She said, "What

[60] Lillian Browse of Roland, Browse and Delbanco. [61] *The Duchess of Cork Street.*

would you rather have, money in the bank or the drawings around you?" The answer was obvious. We both laughed. No sale. If I don't sell some works of mine for a while, I feel desperate.

My knees are weak. I drag my legs along. Not pleasant. No more steady walk.[62] England's grey suits me. Yesterday, with friends lying on the grass of Hyde Park, they missed the Mediterranean light. I didn't.

The street was open and bright like an ocean. Buildings, things and people all swam in light.

Some of my drawings of nudes are soft and atmospheric. Some I place in hard contours, these belong to my more intellectual contemplations. Classic is hard, romantic is soft.

I know how to do with very little but I don't like it. I know how to survive on next to nothing but it is not amusing. I like to surround myself with things I love. My pieces of tribal art, besides giving me great pleasure, are a source of learning about *what the nature of primitivity is*. The primitives of any culture are my teachers. Simplicity is an overused word. We have to train our eye and mind to find it, to absorb it and to make of it part of nature. We need a great refinement of spirit to learn to differentiate between the academic and the rough sphere of the heart. We draw with the heart and the instinct. The pencil follows the eye. The self comes out of hiding. The world is new. I am a beginner. With each work, a new beginning. Like looking for a thing hidden I see the image before I have put down the first line.

I never draw the object, only what it suggests.

The world is not normal. Has never been. When it changes it changes into another abnormality. The more cultured, the more odd.

How beautiful are the Yiddish folk songs! Today, I heard one I had not heard before. It brought tears to my eyes.

Images without stories. I am in my works. In life I am shadow.

Alone but free! I find my freedom in work. Also in meditation.

Would I and my work be to everyone's liking, I would have worried.

The shape of light. Form is already a content.

In nature, light and shadow. In drawing, black and white.

I often draw because the arm wants me to get somewhere.

We pick fragments of a culture to make them fit concepts of the day.

In a dark mood I often see my way.

I have to work for a simplicity. It does not come to me naturally. Does it to anyone?

I often talk myself into a state of confusion.

Style is an academic invention. I know only expression.

[62] Josef could still take a few steps if supported.

Forces of the earth. Of the sea. The most mysterious the forces hidden in the sky. Heaven is a promise, not a place.

A work which shows no primitive tensions, no matter how good the performance, defeats its own sincerity.

Poets, artists, scientists, philosophers all go through mystical experiences in the states of their most creative moments. Mysticism stimulated by a faith is a different matter. Here preconceptions condition – a different kind of mysticism no longer pure in itself, of itself. Mysticism has its own reality but not its own life. Its reality is without the deeps of human emotion and not of religious stimulation. It has its own feeling emphasis and this makes its impact on the mind.

The sad sound of the saxophone.

Dawn and I have not yet been born. Each dawn has the same feeling.

Back to myself. Blackened with black paint the "Homage to the Women of Greenham Common". Will start again. I have some on my hands. What I did was no good.

I abhor all fame seekers. Poor devils! The love of work makes life worthwhile. All natural drives are neither here nor there. Ideologies, beliefs and attitudes people consider serious, I cannot take seriously. Intellectual affectations, because they are shared by many knowers, are packaged and handed to "posterity" as the culture of a time.

I do not like travels nor do I care much for new places but once I am there, I do manage to steal something of the place which I feel is my own. Oh yes, artists are thieves.

Sometimes a drawing is a thought. More often it is the search for a thought.

Art is one thing which cannot be judged in terms of right or wrong. With each painter a new right. When D.H. Lawrence said, "and who are you to say that I am wrong", he said something universally true for all involved in creation. "The creative energies," to paraphrase Nietzsche, "revalue all values." I can obey only my instinctive drives.

Very few people I see have grandeur. Grandeur is an artistic concept. This is true for a tree, for a mountain. Not in every appearance can we find it. In one mood we may bypass something or someone, in another discover elements which make for an imposing solidity and an unforgettable expression of its very matter. All matter is sculptural.

Sculptural means also simple and primitive. Never floating and transient like all things of the senses. Movement is its basic enemy. In stillness is strength. There is no political thinking per se. Politics defined in terms of quest for power does not answer what power has to realise. In the pattern of this realisation the true meaning of politics.

I like a drawing which suggests the unexpected in the ordinary. I like a drawing which has the simplicity of the pyramids and the intimacy of a lullaby. I like a drawing free of the echoes of the great of the past. I like a drawing which suggests colour no colour can attain. I like the power of black and white.

Patience. The main thing: to understand one's place in a given situation – when to retreat into one's own corner. When to get out of one's shell. Patience . . . talent does not always help. Talent for a reason.

Certain worries keep coming back. On my eightieth birthday Nicholas Serota gave me a lunch at the Tate. His few words were friendly. My answer was long and incoherent. It is only now that I know why. For months I suffered from an anxiety I could not get to grips with. In my little speech I said nothing worthwhile. Worse, it was that I still don't know what I was driving at. I was at the time given some pills to calm me down but they had no effect. Fortunately my work was not affected but my social relationship with people was. I have lost quite a number of people who were willing to stay by me, worse still I have also lost the few friends I had.[63] After two years I now see clearly how deplorable my state of mind was. Perhaps it is not too late to stretch out my hands towards the few people I care for and explain myself. In what form? This question bothers me and I have not yet done a thing to improve matters. I really hate misunderstandings, particularly when they were brought about by my own clumsiness or sickness.

I am still struggling for a style; as few words as possible. It is easier to write a paragraph than one solid line. It is all a matter of clearing one's mind of the cultural clutter and of the books one trusted. It is also a matter of finding models as Klee did when he decided to look closely at children's drawings.

In human relationships, one should never assume that things will go the way we would like them to go. Winner, loser, no great tragedy. Sometimes things work for me without myself lifting a finger. At other times I am my own worst enemy. Everything I do is wrong. One does this or that obeying the secret laws of one's temperament – always stronger than the mind. Sometimes when things go badly, whatever I do I tend to make a mess of things.

The best symbol of all political parties is the abstracted flying bird of the Liberal party. A splendid symbol, a free design. Freedom and open space – readable at a glance. The Labour party's red rose says something but not enough. I don't trust roses.

Good thinking, like good work cannot be rushed.

To get on with people is a gift. Often a very dangerous gift.

[63] There was no outward sign of all this. Probably this was an interlude of depression.

9 October

My isolated existence gives me much pleasure. 120 Edith Road is not part of London. It is part of my world, my own world, the only world which is any world. Even this world I hardly know.

Chris Eubank: "The boxer and the person are not the same."

11 October

Becci worked today 'til eight in the evening, yet came home all smiles. It is a joy whenever she comes into my little ante-room. We chat for a few minutes then she goes up to her room and cooks for herself something neither N. or I would care to eat. She calls it "Jamaican food". How I love this child.

12 October

I trust the certainties of the unconscious.

The eye first, the mind follows.

IN PRAISE OF THE HANDS.

In drawing, the object is the shape. The art is in revealing the shape to the page.

No matter how short, life is a gift.

Art mysterious and dark abyss. Sensual perception often misleads and social lies behind the surface.

In a dark mood I often see my way with great clarity.

My fear of mind blindness.

Sickness and death, nature's conflict with life.

In slightly mad states I often find my best images and ideas.

My mind is eager. My emotions, anxious. My senses of knowing are in my hands.

Heaven is a promise, not a place.

Images stay on in the mind and images have a long life.

I trust the quiet of loving hearts.

Detached. More detached.

Harmony another word for excellence. Mind and emotion; the mysterious journey of line toward shape.

All crowns are ugly and all kings and queens look ridiculous with those dreadful things on their heads.

All which moves the heart and not merely the tickling of the senses. This is probably why I respond strongly to Chinese art and not so much to the Japanese who stole a lot from the Mongols but did not manage to give new strength; only decorative and pleasing arrangements, whether of the elements of a figure or of a composition.

December

Japanese art reminds me of European rococo. Where is sadness and pain? No serious art can be without it. Much European concern with aesthetics bores me to tears. What did the cave artists know about aesthetics? What does our childrens' art know about aesthetics? Our instincts know best.

Ideas, metaphysical or materialist yes, but humanity first and last. I am not attracted to artists. I pity them. Genius is a burden. Michelangelo paints himself in hell. If Leonardo has poise it is because he was many things and his coloured drawing of himself has calm and awareness of his importance as a man; nothing confessional. A statement of prestige, a master of his emotion. He busied himself with many things, none trivial. Part of the everyday and at some distance from it. What makes a bird fly? Water has a tangled softness of hair. What epitomises things? Their qualities open to interpretation but first the understanding of them. Humble even when asking for work without ever compromising the work itself. Observing birds he thinks of a machine which could make men fly. Not a romantic dream; a romantic involvement. A mind sound as that of Socrates and as elevated as that of Goethe, yet with hands which could do what the hands of others could not. Observation and a warm factual style. Drawing and phrasing. Notes of the constant renewal of the mind. Feeling, yes but mind's confidence. Accordingly clarity even when the mood is subtle, even vague.

I was asked the purpose of my work. I was not prepared. Then I lowered my head and said: "First personal, then moral and social." Now thinking again: this was true.

My solitude (almost) made me free of expecting sympathy. Psychologically I am much freer than in my social needs. In my social needs there is much convention, or how conventions moulded me. No I am not free of these, not altogether.

I am not a saint. My life has no design. Some of the contradictions irritate me. I don't dare think of their effect on others.

Friendless and the better for it. Loveless and the better for it. All I fear is mind blindness.

Books, and time passes slowly. I sit in the wheelchair. Cavafy's splendid poem "Ithaca" makes me nervous. All those men waiting, waiting for the enemy who will possibly strike them down.

Van Gogh's letters to Theo. Much passion and pain. Not half as interesting as Delacroix's Journals. Troubled minds seldom reach supreme thinking. The characteristics of his style: spontaneity. Too few correctives; no second thought – truth. Aspects of theory, slight. Never developed. The last weeks of mental breakdown truly tragic. Chaos at its bleakest.

Images and words.

Thinking first. Ideas follow. Ideologies and fame often overvalued.

Conviction's a different kettle of fish.

Drawing absorbs me completely.

The beauty of churches when half dark, with a few people sitting with their heads down.

Painters are thinkers. I have never seen a great work done by an idiot. For the painter, nature is a source though not the only one – not a figment for admiration or like. Nature is not a kitten.

The poverty of my childhood and the bareness of the street which in effect took the place of my home will always remain with me. The only trees were behind the white wall of the hospital for children. Two rows of bare walls – this was the street. And a cobbled stone road.

I can now say from experience that old at heart has something in its favour which young at heart has not. The cult of youth, of which the Greeks were the first to fuss, is not all that serious. It is more a gesture of an exploitative nature, especially in time when we want the young to die for this or another cause. I am now over eighty and still care with the same intensity I cared with when young. Emotions have their own continuity.

While on the subject of places, only Ystradgynlais changed my life and my work. Not Paris, or Provence, not Italy nor the Middle East. Ystradgynlais mattered. When I left I took it with me. The telegraph poles were crucial, the road with the mother and child in a Welsh shawl but above all, the miners.

I never loved the poor, nor did I hate the rich – I wanted a society without either. I still want such a society. The only inequality we *have* to accept is the inequality of talent and intelligence – natural privilege in contrast to social privilege.

I only live for rare days. A quiet day – a good day. The luxury of the right word.

3 January 2000 – 89th Birthday

Enjoyed my lunch: herring on bread and butter, coffee and a feast of strawberries. Now resting on bed, Nini reading me some German classic. This I call a good rest.

Awoke at 5.30. A restful night. Four hours' solid sleep which has not happened for some time. Looked through some work in a scrap book. More useful stories than I thought. Enjoy the quiet. Matthew told me that he had sold a good few of my flying friends. Nini came in, glad to hear that she had had a good night. So all is well in the kingdom. Whenever Nini comes in with a cup of coffee, her cheerful face makes the morning shine though the weather is grey. Nini's mother left me some shoes.[64] Nini makes better coffee than I. I am comfortable with my life in a small corner.

[64] I had found a pair of soft leather boots in Mother's flat after she died. Josef loved them. David thought them awful. I rejoiced as they were comfortable.

I think of sad birds.

The more I close my eyes, I hear better.

Black is my favourite colour.

I still think of my book of birds.[65]

Who are we?[66]

I can hardly walk without my frame. Even with the frame, the right leg drags along.

Mid January

Money is not everything except when you need it. An hour later: as I said money is not everything.

Wolfgang was here. He paid me a compliment: "To be in London and not to visit Herman's studio, I will be asked? With some German friends you are as popular as ever. I am always asked what about an exhibition of recent Hermans."

I: "What can I do?" For me painting leaves me no time to worry about exhibitions. I am now 89. Each day must be given to work. At least this is how I see it.

One day a flower, one day a tree, one day a man.

Years ago I bought a splendid Carrière. The reason why I bought more drawings than paintings was a small matter of money. There are so many things, drawings, paintings I would like to have were it not beyond my means. For me buying and producing is one and the same. I often buy what I wish I could have produced myself. What I buy is for my family.[67]

I have framed the drawing of two trees. Good Mister Herman. A graphic study of black and white which cannot be improved. The two silhouette trees . . . must work on them. Good, clear masses.

Roditi's drawing – got it for next to nothing. All the same, good. Very good.

Some days I tire suddenly and have to stop working. After only one hour I had to stop. The eyes got heavy. Whatever I drew seemed in a fog.[68]

Head of Manger. Bill Fagg, self-portrait, style not premeditated. Manger died in 1943.[69] A good work does not age. It remains as good as it was on the day I did it.

When I say a "good day", I mean of the drawings taking me by the hand and one leads to the next in improved forms.

These jottings I often find difficult to read where the content often puzzles me. What could I have meant?

[65] *Song of the Migrant Bird.* [66] Much of this is totally illegible.
[67] There were, after his death over a hundred such acquisitions.
[68] His strength was failing badly. He maintained that he "worked" in his wheelchair. It made me want to cry.
[69] Isaac Manger died in 1969; perhaps 1943 is the date of Josef's portrait.

30 January

The tree in the window has lost all its leaves, the remaining ones are pale yellow.

Dvorak's cello concerto.[70] Little Joe, four and a half, Nini, big granny. The sky white and shining. In the distance, a moon like a sick face.

Young man, help me. I want to get to the other side where the lamp gives me some hope.[71]

From where does this dissatisfaction suddenly rap on my door?

Defeated by the absence of the sensory . . . After all it was not worth the effort.

Nini recently received a gift, a pleasant shape, a candle placed on our mantelpiece. A pleasure to look at.[72]

A few interesting letters, postcards. A phone call from Mary Yapp.

Refreshed imagination. Good work. Some sales! Not much to show for it, still something is better than being forgotten. When I don't work for a while, I have a strong feeling of being forgotten.

Fishermen of the shore . . .

This is all quite futile
Things which had to be said
Have been already said
It is quite futile[73]

[70] David had rigged up a CD player by his bed. [71] He was bed-bound, confused.
[72] Beautiful candle, red and gold. Christmas present 1999 from Ruthie.
[73] The last words Josef wrote. From 1st February he drifted in and out of consciousness. He died at 3 am on the 19th February 2000.

(top) **Seagulls**
Mixed media
25 x 20cm
(right) **Seagulls**
Mixed media
21 x 14.5cm
(overleaf) **The End of the Day**
Ink and wash
17 x 25cm

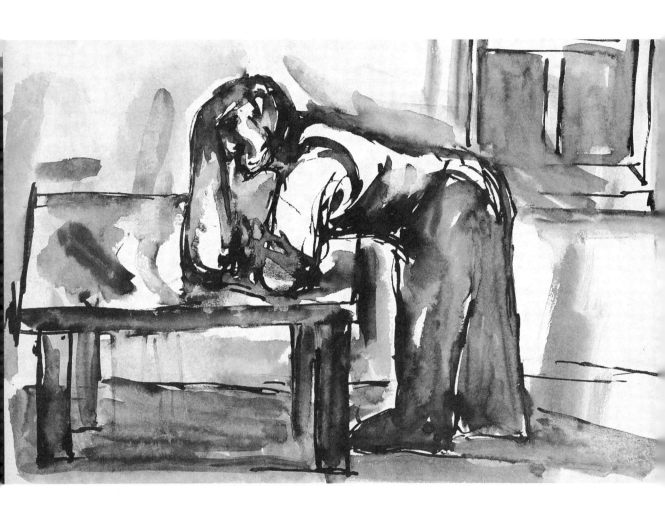

Jotters

Not the first, not the last, an old man looking around. The thinking eye leads him on.

The best in all religions is their architecture, the great cathedrals, the slim towers of Islam. They make you forget the killings in the name of belief.

For lines a pencil, for contrasts ink. In drawing the power transforms objects into subjects. The sense of rightness, expressing the thoughts that invisibly creep in.

This tree is van Gogh. This tree is Cézanne. Each tree a self-portrait.

Out of the shambles we call reality, our instincts help us to find what is strictly ours.

Colours are categories, that is when they are used straight from the tube. Vermilion is vermilion, ultramarine is ultramarine, carmine is carmine; on the palette and under the brush they become vague and mysterious. They lose the hardness the chemist imposed on them; each now has an individual existence. Each vermilion is one of a hundred colour bodies, each vermilion, and each different. The lessons of the eye become one with the needs of our emotions.

Inspiration is a rare visitor. One has always to keep the door open, one has always to be ready for such a visitor.

N. first; now also my children and my grandchildren are a great comfort to me. It used to be only and exclusively my work, no longer so. There is a distinct difference between the two kinds of comfort – one keeps me away from people, the other keeps me with people. To be friendless would not worry me as much as not being able even in a neutral way to be with others; I am a social animal.

I may not be loveable, most probably I am not but in spite of its terrible history, I love man. I would find nothing endearing in a universe without men.

Like love we also use the word friendship too casually. I do not think that I could apply this word to more than two or three people who in a special way are dear to me. Montaigne is right when he writes that it is a great fortune to know two people you can call friends. I often feel more close to a mountain or a tree than to a person. With people it takes me a longer time to make closer links. I have never been lucky with first impressions.

First, I learned from my feelings and later I learned to use my mind. Even now emotions make me aware of experiences before I can put them into words. In my daydreams I find my reality. The reality of pure sensations.

With people I seldom, as the saying goes, "open up". I even say things that later I regret, or even find them humiliating.

Sensitivity is one thing, theory another. I can never bring the two together. Imagination is the great educator.

You can grow old with only one woman. The many are forgotten. Death makes a mockery of our best intentions. No life is worth imitating. Followers limp.

On days when many people call I get confused. Inevitable of course by my situation of being a painter and forced to sell my own works. I do not mind working with dealers but most of the time I do my own dealing – this I find most of the time exhausting, but on some occasions there are compensations such as getting to know some pleasant and worthwhile people.

But art serves a greater purpose. Without false modesty the object of art is to enrich human life. This may be above the camaraderie between artists for there is more at stake.

Art is a nurse.

Other people's rages I can forget, not my own. They torment me for days.

In each experience an element of madness.

How often I am liberated by my ignorance. My illiterate heart knows its way towards the atmosphere where the unpredictable happens and reveals what you could not foresee: the real in its own reality.

In my losses my gains. It is now six o'clock and I have been up since four. The light in the window has changed from grey to yellow. I will soon be eighty-four. "How are you, Mr Jenkins?" "A day nearer to the grave but otherwise all right." Thank you, for these wise words. I feel so too.

When a work makes me feel a better man I know it is good art. The flower piece I completed yesterday makes me feel this way.

When the eye is ignorant it sees best. The eye is its own teacher.

Seeing is a liberating energy . . . do not follow what you know, always ignore intentions, you want to be free. No preconceptions. Your enemy is in you when you are trying to succeed.

We see the tree not the seed. It is the seed that matters most. My seed whispered

gently: "Do not give in to your will, you cannot be anything else that does not come from me."

I like red moons more than the white or the yellow ones.

A friend wrote to me about the "losses in his personal life" – not much difference from mine but with an anger of which I am free. He wrote: "What is the use to wave a fist towards an empty heaven." I pitied him, he obviously still hoped that there may be someone mightier than man.

A memory I will not forget: Becci, then aged six, on a pouring day holding an umbrella over the head of a horse. The man, an "any old iron" man, covered with a sack, looked on and said, "Oh child, angels are made of girls like you."

I cannot get out of my mind the victims of our century of terror. Nor can I forget Auschwitz, nor the Moscow trials. My painting "In Memory of the Victims of Terror of Our Times" began as a tribute to the fighters in the Warsaw Ghetto but the longer I worked on it I put in more emotions which wanted to cry out for all the victims of our times: the two million gypsies, the six million Jews, etc. The list too long for a small page.

As for surfaces, I often get better textures on poor paper than on academically recommended Ingres or other such like. Academies are also influenced by industrial snobbery.

In our society a painter is made to live a kind of schizophrenic existence: a creator one moment, a shopkeeper the next. I have accepted my situation and am quite calm about it.

These jottings are to me like the people I see talking to themselves.

Whenever I achieve some quality in my work it takes me a long time to see it. My failures hit me with greater immediacy.

"Racial cleansing", "human engineering", "eugenic improvement": each form of terror finds new words to make things sound better than they are.

Civilisation has not begun yet and barbarism is not a thing of the past.

The past few years have been the calmest in my life. In such calmness I have no need of the art of others. I hardly go to exhibitions not even to museums: I feel more complete in myself.

. . . I know of no drawings that come from a stupid head.

Colours leave echoes, not unlike music. I get much pleasure from listening to colours as though in a trance. Monet's lily ponds are the works of a great musician.

I make myself draw, draw or paint: to save myself. Work is a healer.

In my first passport, under profession, I wrote artist. This passport expired none too soon. In the later one I wrote: painter. This pleased me. Mine is the modest quest of a man who is lucky to love a medium which helps him to know his nature.

Whitman: "Forget me. Read my poems. The man is not the masterpiece." The artist and the person sharing the same body may not even live in harmony with each other. Words take over, the person fades.

Preconceptions mislead. Look between the shadows of the mind. No trust in the pronouncements of knowers. Trust only in the primitive in our emotions. Emotions have their own energy, like suns in space.

Drawing is more therapeutic than painting. Black is my favourite colour. Ink is my favourite medium. A drawing is good when to paraphrase the Negro spiritual, "It causes me to tremble, to tremble."

My hands have set me free. I came from an invisible seed. Because I am aware of other lives I have no illusion about my own end. I still don't know in my eighty-fourth year, whether it was all worthwhile. Still, at times, I am contented with the small thing I am. Nature has given me enough talent to do things; in the process of doing I forget the eventual futility of it all. Besides dreams and illusions there are also refreshing quests and the pleasures of achievement that, like with the first love, you believe that living is a rare gift.

Flowers, trees, landscapes, figures, as long as it is true painting.

With every new work I am still a toddler. More alone when with others than when alone.

I was brought up on a pennyworth of Judaism. When I understood its underlying seriousness I found it wanting morally and ethically. Mean and restrictive, though not more so than other creeds. I became an atheist mistrusting even atheism when it did not meet my emotional needs. My spiritual striving always coincided with the energies of all primitive ways of looking at things. I never trusted explainers nor the things easy to understand. I loved the mind's hard labour. I trusted my instincts.

One reviewer who strongly dislikes my subject of labour began his attack on me: "Slog, slog and slog again." I smiled. He missed so much of my real concerns. One day I discovered he is a painter of a kind. I withhold my reactions, he has a small family to support.

The best performers were always in the circus. Why has the circus died? With the death of the circus, much of our innocence died too. Besides the circus, I miss comedians.

Love can make you feel very lonely.

The language of the street is not as limited as is often thought. Ordinary people use language more imaginatively than those with a university education; they are not afraid to invent words that are not yet in the dictionary, nor do they strain their imagination. My difficulty is that I think with images and not with words.

Because of the "fabulous" collections of the very rich, collecting got itself a bad name. In fact collecting is an inner need and the most ardent collectors are children.

Yesterday, Mr. Gorbachov was taken to Covent Garden. He got an ovation and graciously sat through the first act. When he left he got another ovation. Why did he bother to go at all? Well, politicians are in for culture aren't they? One act of culture is enough.

I would rather listen to church bells than operas. Why has simplicity such a rough time? Can one really get into the intimacy of a performance when dressed up and sitting stiff in an audience?

When drawing or painting, I don't think with words. The intelligence of the eye does all the thinking.

There is more of me in my washes than in my lines.

What I have accomplished with some effort will someday be scattered. I will not be here to be sad. The thought of it makes me so sad.

I am a poor follower. Even when driven to work by the impression of a work by another painter, I quickly get involved with my own emotions and lose track of what this work was about. Altogether, it doesn't matter much what one sets out with . . .

Like life evolving from a sperm, each drawing begins with a dot.

When colour becomes articulate, words have nothing more to say.

How much of reality to retain in an image – this is the problem.

I never think of teaching others . . . my voice is of a man talking to himself.[1]

The true masterpiece is not a single work; it is the nature of a single talent.

Like a mother appeasing its child, the blank page tells me, "Put down the first line and everything will be all right." It usually is.

No amount of skill can set us free from our dependency on chance.

Noise outrages the senses. Silence appeases them.

[1] In fact for many years Josef, by invitation, made a round of the country's art schools. Students of the time still speak of the inspiration he gave by chatting. Also many RA students came to the studio in groups. Our friend, Norman Adams, keeper of the RA brought them every year.

The man who wrote the psalm that he feared the terror of the night had no experience of the greater terror of the day.

All my landscapes are memories.

When still a child, a moonbeam reminded me of a smear of butter on black bread. When I said this everybody laughed and for a long time afterwards I avoided metaphors.

Whatever we have learned has to be forgotten. Each dawn has a new beginning.

Hatreds I forget. Love lasts with me longer.

What a great pleasure to have my head lying between your breasts. You caressed my hair. I waste too much time on ideas. Pleasure above ideas.

Yesterday N. took me to Sudbury. I got blotting paper. It helps.[2] N. too is working each morning on her essay on Walter Rathenau,[3] her great uncle. I had to laugh when she told friends in London that all we do here is lay on deck chairs admiring the view. In fact, I spend most of the time indoors, N. in the study at the typewriter.

When I don't work I live like everybody else, inadequately most of the time.

With tribal art, I did not go in for a variety of subjects as much as the variety of styles. All have a reality of their own without striving to establish a realistic tradition, in their singularity and their strength. I like their austere attitudes to the female form and the avoidance of sentimentality even to such subjects as mother and child.

Today was a good day. My knees did not bend and my legs were not shaking. My body is well balanced when my spirit is. It's internal smiles gives me confidence.

I sat in my studio on a rock looking at the sea. I completed image after image in my mind. It would take years to put them all on canvas. I did not move from the rock. I continued my work, completing images in my mind.

Drawing, drawing, what a joy! Thank goodness I have no longer to battle for my bread! People who assume such battles are an incentive are wrong. They are exhausting! The urge to work comes from a more important and primitive source: the inner creative energies.

The person and the artist in the same skin hardly know each other.

More people are attached to the artist than to me. I cannot blame them. The artist stretches the hand out to one and all. As for my devotion to work, when I was still young I became aware that I am not a witch, I cannot blow and make things happen.

I know some dealers who are decent men. But I know no dealer with a vision.

[2] It was our yearly summer stay at Cox Farm, near Sudbury.
[3] Part of a book *Letters to the Living and the Dead*, Bellew Publishing (1994).

I have not yet read of a single experience that a mystic might link to his creed, which I, as an artist, did not experience.

"Do not forsake me
Oh, my darling,
On this our wedding day"

The tune is even more haunting.

True, you cannot do much with the misery of life but without the sense of it, whatever is done is shallow.

I have often to cope with emotions of psychotic intensity . . . these crises affect me profoundly, especially in my relations with others. No blame on them. What would I not give to be what is called mellow.

N. has a presence which fills the house. When she is out only for a short time, the house feels empty. When she comes back, I know that I am not alone even when alone in the studio.

In a good drawing so much is hidden that no matter how penetrating the analysis of the surface, the meaning is still playing a hide-and-seek game.

The most difficult of all creations is friendship

Henry Moore: "I like to work with old, almost worn-out tools . . ."

I: "Isn't it a matter of being used to the weight of the tool, one that is familiar?'

Moore: "This too. With an old tool you know where you are, it has become part of the hand."

I: "I keep brushes until they are worn down to the metal and can no longer be used. This may seem funny but it is not ridiculous."

When I put drawings together they somehow complete each other. In fact a hundred drawings are one drawing. Perhaps a lifetime's work is in effect one image.

How could one forget this little fellow who stood, on a grey day in June, against a wall with a clumsy doll made out of rags calling in a low voice, "A penny for the guy, please mister." When I handed him some money and asked, "Is this not rather late?" he said, "I have been ill, I have been in hospital." Back in the studio I made a watercolour of him. It still hangs on the wall in the passage.[4] He died some time later I was told by other boys. Whenever I look at this watercolour it brings tears to my eyes. I framed it as a sort of homage to little Toby. When I learned of his death, he was not yet

[4] It now hangs by the stairs in my new home in a place of honour.

six. How I miss his little figure in the doorway saying , "mister, again" meaning that he needed some pennies for a lollipop or some other urgent thing.

"I want you baby, to rock me slow," and the crooner in the dark repeated more gently, as though in pain, "Rock me slow." That night I came to love New Orleans Blues. It is good to have one's heart broken once in a while.

In the process of work the spirit gets to know itself.

Open window. A green moon. Not yet tired of living.

On the 3rd I was eighty-five. Whatever I did or did not achieve no longer worries me. The few years left to me I will isolate myself still more; draw, paint, edit things from my jotters, do things which give me pleasure, which includes reading. And so death, here I come.

I am always content when a drawing is as simple as singing in the bath.

Zen drawing, like Zen writing, is economic and precise. The beauty of unforgettable truth. Truth is beautiful, never more so than on the page. I seldom want to scratch out a word. The soul not being an organ is its own real thing. Real things don't seek honour. They come to be and are what they are, naked, not dressed for competition.

In an auction: a poor Rembrandt oil, crazy bidding. Some very fine drawings of his had low prices. I wish I could afford them (not at present, not much selling of my works).

A child is not a man, nor is a man without the child in him a man.

Ambition makes me nervous. I trust quiet works, undertakings so serious that the clumsiness of the arms is quite obvious. I never laugh at clumsiness. I am not all that easy when faced with a virtuoso performance.

Nini's book, *Josef Herman: A Working Life*[5] is shaping well – tender, no hurrah, hurrah! Restrained style, even I can read it without blushing.

The time when painters had to work to impress others has gone. I, for one, work to impress my eyes; this helps me to know when I fail. What pains me even today is when I fail in my own eyes. I cannot endure my failures and they are many. I don't learn from my failures, I don't believe anyone does.

Always alone. It needed courage. Not now. Not for the last goodness knows how many years.

Spoke today with a journalist who in most moving words spoke of the time when

[5] Quartet Books (1995).

Fleet Street died: "Fleet Street may not be what it was but it will live on as a metaphor, even a concept."

"I agree," I said. The taxi-driver stopped chatting. We moved on in silence.

I can think of nothing more repulsive than people having "a good time".

I am mad about drawing. Drawing is a service. Whatever others may think of them, they are as much for others as for myself. At times I am a shopkeeper; I get worried when no one shares my enthusiasm so that selling is a kind of test to what degree I can involve others, dealers or clients. Drawing makes me feel fresh – like after a bath.

Whatever we have done that we can be proud of does not compare with the horrors we have inflicted on each other throughout our history.

Earth colours, sombre and strong. Glazes more spiritual like bright dreams.

Causes are overrated. I can imagine giving my life for someone I cared for. Not for any cause. Causes took over the authority of gods. Both feed on followers.

I have to be committed to what I see in a subject. With this commitment I begin and as long as it lasts I can go on. When it leaves me I use my skill but now it is labour in the hope that creative energies will return. They usually do. Work on. Never stop. Truth is what serves us. No other absolute has such certainty, bright as fire in the dark. Truth, like the erotic energy retains its primitivity, its own splendour.

The Nolde exhibition. Remarkable: good in oil, good in watercolour. Nothing quiet. What remained in my mind is his immense decorative sense. More compelling than that of other expressionists.

My inward gifts cannot be seen through the eyes of others. Thus began my liberation.

My philosophy of indifference gives me much peace. My studio protects me. Outside is madness.

Whenever I see some performer, dancer, pianist or violin player standing on the stage in front of many people to be at his best, I thank my lucky stars that as a painter, my performance at the easel is in an empty studio. There a blush or smile means something only to myself and myself alone.

The first evening of an exhibition makes me nervous. Some people believe that buying a work of mine gives them a special right to a bit of my living self. I never got used to the loneliness flattery awakes in me.

A dreadful sight: dying birds, victims of oil pollution. Helpless, completely helpless. Humans, women, trying to wash them back to normal.

Cold, hungry seagulls in the air, on the pavements, all over Edith Road. A few old women with baskets of scraps. A lovely sight.

Considering my retiring way of living I am surprised when some visitors, especially younger painters come and show me affection. Not like some pundits: "Herman? Oh, he belongs to the fifties!"

I owe Nini a debt of immense gratitude. In her book[6] about me she reprints quite a few pages of my recent jottings. Now reading them in her book, they seem to me better than when I wrote them.

Today another fellow from a museum looked at some of my sketchbooks and ended up with: "At our place, we cannot do a thing with works on paper, we need all the space for important oils." What splendid works Zen artists did with brush and ink!

When I was younger, I was under the illusion that selling a work to a public gallery is a mark of achievement. Today I know better. Your eyes are the only judge you can trust.

My way of working has not changed for years. I sit at something resembling a table. On one side, an open sketchbook for drawing. On the other side of my arm, a jotter. I draw and write things down at the same time. In each case I am not concerned with performance, only with expression.

The main thing, my passion for work, has not decreased. Without this passion I would have been a lonely creature, even within marriage. My contentment is my life behind my red door, dedicated to work and my love for N. and the children. I sometimes fear N.'s death. Not very likely, she is only seventy-one. Without her, what would happen to my life? Would I even want to carry on?

No local colour in the street but some colour inside, all due to N.'s way of arranging things; without her even this would go.

My day's work ends by lunchtime. Whenever N. decides. I go back to the studio until dinner. A good life. Work, love, and books by good minds. Whoever expects more from life will die a bitter man.

Some days, my suffering from anxiety is hard to bear. But my passion for drawing is a good healer; a few hours of good work and I can go into the street and whistle cheerily.

Scholarship makes me nervous. Looking at a picture, I empty my head of the artist's history; the eye cannot cope with too much information. The eye wants to be its own Christopher Columbus.

[6] See p. 258.

Each time I see little Josef[7] he is more splendid. A tough body, an angelic face. A splendid evening with the Hermans. David holding Josef in his arms in the light of the doorway, seeing us off. While we move on in the car this image stays with me. Six o'clock in the morning. N. went off for her swim.

Life is not meant to be orderly. It began from nothing and goes towards nothing. I trust only fragments.

Wishing for a sun in the night. Wishing for your head sharing the pillow with mine. Even love is only a beginning. The long way from passion to caring.

For the past few years my name has disappeared from the writing of our "culture makers". Even good works of mine in exhibitions are ignored. Still, I did not change. Work is going well. Sales from the studio go on their usual slow way.

It is now clear to me: all my years were preparations for something I never realised. The word failure would not be right. I did not fail. I avoided a deeper dialogue with the nature of my talent. I was too impatient. I did not, in the fullest sense, follow my conscience. I followed the haphazard ways of my moods. I saw things in the raw; this was good but I did not see them flower, become bread!

Comments around about the death of Marxism. Well yes, and no. Marxism as a quality of the mind and imagination will live on of course. What some have made of it, this is a different matter.

Genius is a quality which disarms all reason.

I refuse and often have to force myself not to paint or draw images of suffering, my own or others. *In Memory of the Fighters of the Warsaw Ghetto*[8] is my only painting of suffering and protest but my main concern is to make images of silence and dignity of the ordinary and the everyday which transcend that reality.

A year of quite a number of distressing happenings. The eviction of people who cannot continue to pay their mortgages or loans! The lot of the low paid and unemployed. It is heartbreaking to see some poor young family dragging their few belongings and children to some place provided for a short time by the council! What kind of a society is ours: homelessness and hundreds and hundreds of empty houses!

Truth to material has never been my main concern. In watercolour, even more than in another medium, there are beautiful accidents that enhance the texture of a work.

I have good reason to complain: my last two exhibitions have not sold a thing[9] but I do not like to get myself in a mood of self-pity. Work is going well and this

[7] Our youngest grandchild.

[8] Also called "In Memory of the Holocaust Victims" and "Tribute to Goya's Black Pictures".

[9] 1991 – a recession year.

compensates. At the moment there is hardly any interest in my work. Maybe my works have become too elemental without any compromise to the sensual and "beautiful".

As far as my feelings are concerned, they are not elemental enough – in this I am not all that pleased with myself.

Time is passing. Not much done. No regrets. I am often back where I started.

All these jottings, not to feed my ego but to know the man inside.

The writing I like best; where the writer gives me the feeling that he never read a book, that he is ignorant of the literary industry, that he is not professional. I prefer clumsiness to the drunkenness with words.

I listen to a book. If I hear a sigh, I stay with the writer.

My memory goes back to the age of three – a little boy in the sun.

At the moment, I have cut myself off completely from that little slum we call the "art world". Working with much peace of mind. Quiet images. Stable emotions. What believers get from their religion I get from my inner self. A successful work the evidence.

I listen to a work in the hope that I will hear my inner voice.

You say, "There is much sadness in what you write."

"Of course there is. Don't you know that the permanent smile on a clown's face is a mask?'

Art is inevitably of its own time but forcing it to be of its time makes its limitations even greater.

If I go back to my childhood, I remember that I often found myself alone and happy in this aloneness. Playing with other children? Sometimes. More often in a corner alone.

On a day like today I could do with a letter or a phone call that would give me courage to carry on.

I don't think of any place as a retreat; each place another door into life.

Nothing is more misleading than information.

If I could make my living and keep my work a secret, I would.

I am at a station without a timetable. Time no longer matters.

I am used to sadness; in pain I often find new energies.

Of course I am fully aware that I am not all that celebrated. Still, I get more than I deserve. This I believe. No false modesty.

So much to do, so little time left. At eighty-four one can expect death any day. I do.

I owe all comforts to N. She comes into the studio and finds something wrong with the central heating, rings Mr Smith. He and his son come at once and all is well again. N. smiles, "You are hopeless! You would not notice if the ceiling fell on your head." She may be right.

When at seventeen I made up my mind to make my living from art I expected only bread thickly buttered and sweet tea. If to get this I may have to gain public recognition, then so be it. Fame without bread frightened me.

Ystradgynlais was the last place where I identified the place with ideals and the miner with the great human presence . . . the eye saw what the mind wanted it to.

In my head I have a special place for the organ grinders I heard as a child and who I followed from street to street. A great moment of elation came when the organ grinder put the parrot on my shoulder and I did not dare to move; I stood still and proud and the parrot for a short time was part of me.

Heavy is the human heart – this discovery I made when I was twelve or so.

The talent for friendship is even rarer than the talent for any of the arts.

The joy of labour makes us forget the process of ageing and dying. An inch of good painting makes me forget the impermanence of life.

I like iced lemon tea. Prefer it to champagne, a highly overrated drink.

At eighty-six it would be silly to ask, "Am I wasting my life?" Most of it was wasted. I doubt whether if I would live again I would have wasted less of it.

Paradises are small places. At the moment, mine is an armchair near an open fire.

On the 3rd of January I became an old man of eighty-seven. How do I know that I am old? My knees shake. My mind and my emotions are as they have always been.

Today after hours of what seemed pointless "slogging" the "art moment" arrived. A few drawings made themselves by themselves as though I did not have a hand. This is how one knows of the visit of the "art moment". When still in Wales, Llew Morgan[10] took me one day to a place where we could watch a legion of salmon fighting their way upstream. The "art moment" completely free of self-doubt.

When my sexual energies decreased, I felt rather relieved; my capacity for loving increased. In the relationship between the sexes, it has to be only "because it is you". My last few years with N. were of this kind. A greater caring than ever before. When N. rang yesterday and said, "Am coming back Saturday. Am missing you," it brought the

[10] The photographer Llew Morgan. See *Full Circle: the Life of Llew Morgan* by Carole Morgan Hopkin, Gomer Press (1997).

proverbial lump into my throat. All I could mumble was, "Am missing you too." When thinking of death, a slight worry: how will she cope when alone? Of course I know she is resourceful, still the worry is there.

Old age? Except for a few minor irritations I don't know what it is. All that made me feel alive is still there as it has always been with the same intensities. Perhaps when old one becomes a better viewer of one's life. It takes an age to see the ridiculous side of ambition and achievement. Nothing of it will remain in the ashes.

The more I say "I" the less I speak of myself. I am observing the strange man within my deeps. I have now a greater respect for him and less of the self-love of half a century ago.

There was always my work to help me to avoid the small, devastating details of the everyday and there was N. Whenever I had to cross the road, she stretched out her hand and held on to it.

Asked Becci whether she needs some money, knowing what she spends on presents this time of year. She: "Daddy, I have to learn to live on what I earn. You and Mummy have spoiled me too much." From where this realism?

An old woman wrapped in bits of rag rings the bell. "A few coins for a cup of tea."

I: "Do come in. You can have your cup of tea and some food."

She: "No. If I go inside it will remind me of what I have given up. Just give me a coin. Thank you sir, thank you. I don't need much."

I went back to work. The bell rang. The old woman again. "Forgive me sir, I don't mean to be a nuisance. Can I use your loo?"

I: "First landing, door to the right."

When she came down she said, "Sometimes I have to hold back for days. Not everybody lets you in. Thank you sir, I will not bother you again."

In the afternoon I saw her with an old man. She shouted, "Sir, can you spare another coin. This old man is helpless, I have to look after him."

The great excitement, the appearance of an old-fashioned cart with two horses. How much I miss horses! I stood in the door for quite a while. The driver smiled, "You look as though you were watching some ceremony."

I: "Ceremonies are dull. You, this cart, these two horses . . . much better. Much." He drove off but looked back several times. I waved to him. My days are made of simple accidents – the simpler, the more moving and memorable.

There will always be someone who will say that you are finished when you have not yet begun. Fortunately, those who have the strength to be beginners are hard of hearing.

To continue work on "The Homage" I decided to take it off the wall and place it on two easels. This represented a problem too difficult for us to handle. The painting is quite large and heavy. N. went out into the street and returned with some young but tough Yugoslavian. A splendid fellow.[11] A lot of common sense. Within fifteen minutes, all was done.

Could I have survived fifty years to make my living only from the sale of my work if some critics who voiced their opinions against me would have succeeded? Of course not. The art industry needs art critics and other kinds of hullabaloo. Painters need solitude and peace. On my eightieth birthday I was surprised with the many who wished me well.

I trust little in the human capacity for affection.

It turns out that I did over 300 drawings this month that I thought worth keeping. I also tore up a similar amount.

Missed Bill.[12] Apparently he has deteriorated both physically and mentally. How dreadful our stepmother nature can be even to her most splendid children. He was never very articulate but the effort of listening to him was always worthwhile. Kind, even angelic, always helping others, especially young Africans. He helped to train them to run their museums.

Out of the storm safety first. I found a cave not all dark. I heard the wind and saw the water of noisy rain. Sitting hunched up on a stone, I thought of early primitive times.

I settled for the less and left the more to those who want it.

Several tractors turning over the earth. Seagulls following. All has the look of a celebration.

In our age I still think with tenderness of the warm glow of candlelight. Nothing similar in electricity.

In our very deeps is the intensity of poetry that is often mistaken for religion. All religions are outer frames. There is no such thing as religious experience. All gods were poetic revelations given a pragmatic shell.

I am a sound sleeper so I cannot say what angels do at night. At dawn, they fly out of the window.

A memory. When I had my first exhibition, some journalist who wanted to know

[11] Bypassers thought I was soliciting. What it is to be an artist's wife. Josef seemed so desperate to get on with the work.
[12] William Fagg. The occasion was a lunch at Christie's.

about my background went to talk to my father. My father could not grasp any of the questions – they were in a language far above him. Eventually he said, "He is my son." The journalist began to praise me. This confused my father even more. "I wanted him to be a tailor. My wife wanted him to be a doctor. Nothing was good enough for him. He wanted the moon." The journalist reported this.

Some time later, some weeks before I left for Belgium, I saw a thing I never imagined could happen. My father hung a watercolour of mine, a group of workers against a yellow sky, on the wall over his working bench. How can one not be moved by such a gesture of love?

What almost destroyed my will to live in our age was what a Polish friend, an eye witness, told me: with dozens of others my father was dragged into a gas van. Too late, much too late, I found in the deep of my heart my closer ties with this man, my love for him. My sorrows remained with me. I always write with pride: "Josef, the son of a cobbler." This is my homage to him.

With N. we no longer plan our future. After forty years we have had enough futures. We have both settled for a working day and a walk in Holland Park[13] to look at the trees and flowers.

Oh, Warsaw, my Warsaw. I will never forget your green winter skies. Your white walls, your restless pavements. The men and women poorly clad, serene at dusk when taking air before sleep. The first star quietened your voices.

It breaks my heart to see young men put in uniforms, made to march and sing at the top of their voices, while in reality they are made into killers.

An anthropologist once asked a tribal carver how he knew when to stop. The carver looked embarrassed, scratched his head and said, "I don't – the wood knows."

There is no reason to speak of old masters unless you mean the cave painters.

We have still one week here.[14] Mixed feelings: don't like to leave. Got used to vast spaces, dark mountains and loud rivers. Got to like the adobe buildings, low, oblong and the colour of pink terracotta. How splendidly they are placed alongside a street in the light against tall trees.

Each drawing I start like a child learning to walk.

I thought of my life in obscurity and concluded that life in obscurity has its rewards. I also thought of complete aloneness. I considered my inner resources.

At the seaside I saw the strain in a gull rising to fly and of its freedom when in full flight high in the sky. My intimate essentials go through the same two stages.

[13] Our nearest park and our greatest pleasure. [14] Three weeks in Taos, New Mexico.

Like water, emotions spill over without shape, song or no song. I listen to emotions, song or no song.

Often, after I have made love, I turn away from the woman into a pleasant tiredness. The woman feels hurt. I turn not from her but from her nakedness. It took three weeks to become the closest of friends. We worshipped the summer sky. July became an important month. The wine season we spent in Burgundy. A woman's loveliness shows itself in her contentment.

When Nini dies, I will die too though I may still go on breathing. Ours was the mysterious way from passion to caring.

The object of art is to remind reality of its poetic roots.

The best I could say about my life was it had its moments.

I thought of Poland, of Flanders and Spain. Of all the places where I was young and hungry and of the dirty walls, tall and bleak.

I thought of the men lean like bones, with mad eyes, dark like worms, crawling left, right, not looking, not seeing. The world hurts too much.

Doing nothing makes me sick, irritable. Creative times make me so absorbed in myself that I become insufferable in a different way. In whichever mood, living with me can be no picnic. If I could get away from myself I would. I cannot blame anyone, women, men, who leave me. When I find myself abandoned I do not and cannot blame the other person.

The only works I look at with envy are those of the cave artists and childrens' art.

I listen to the whispers of the soul. I call this meditation.

When I was four or five, I met giants. In my early youth I lost sight of giants. I saw many men standing on their toes, pretending to be big.

Remember Auschwitz. Recalling Auschwitz. Their cry was their last freedom.

The studio is my retreat, no more so than for the last six months. Here is my absolute freedom and the best imagination and feelings I have to offer. I hear voices within me. Oh Joan, I believe in the call of your voices. You heard them because of your creative talents. Oh Joan, my sister, my sister in art.[15]

It is clear to me now: I fled from much I hold dear. I needed a space from my daily life.

I have been "discovered" many times and forgotten. I have been discarded for

[15] Joan of Arc.

reasons I will never know. I forgot the hurts. Each dawn is mine to receive gifts. There is nothing that was more than a beginning.

I miss painting for an occasion; the other day in the National Gallery in Cardiff I saw the frieze of miners I was commissioned to do for the Festival of Britain. I looked and wished I had more commissions.

My wife is a special person. She was not always like this. Each year, in forty years, she became more and more special. In passion and in caring, she is equally special. My independence and her independence make our dependence on one another. Beautiful in body and in mind also are her spontaneous emotions. Oh my love. Here is my birthday gift: the simplicity of the pyramids and the softness of a lullaby. The space between us hurts. I cannot bear it . My arms are not long enough to reach you. Come back, come back, let's feed on our madness.

Put a larger canvas on the easel, all white. I know what I want to do based on a good drawing. This frightens me a bit. Bad drawings make better paintings while good drawings present problems. The painting may not live up to the drawing. Be this as it may, I am waiting until I see the image on the canvas without relying too much on the drawing.

I discovered no fixative as good as the spray women use to harden the fashionable hair on their heads.

N. went to Oxford. Ellen[16] no longer leaves the bed. She hardly eats or drinks. Most of the time she just dozes. N. has told the nurses who look after her not to torture her with dressing or walking around the room.

The owner of the Taos Inn had a large number of D.H. Lawrence's paintings which he does not want to sell to the many pilgrims who follow Lawrence wherever he has been. I did not like any. He had no sense of pigment, though some were well composed and were quite imaginative. They are the least loveable objects I have ever known. They do not convey the sensuality he was after nor the joy we find in nudity. The bigger the better seemed for him to be the tremendous thing.

Very often in the early morning we go to the Kyoto garden in Holland Park – probably the best designed small garden in London. Japanese, yes but with universal flavour. We sit on the bench looking but mostly listening to the gentle sounds of the waterfall. Splendid mornings. Subtle feeling and dreaming moments.

I am deeply moved by poverty and the poor. I am indifferent to the elegant things of the rich. I see beauty in the working clothes of a worker but don't look twice at "well dressed' women and the tidy figures of middle-class men.

[16] My mother was ninety-two years old.

Ellen died aged ninety-three. At this moment I am incapable of going into details of my emotions. I am alone on the bed, not thinking.

I never knew but when I heard of it I liked the symbolism – peasants to make the earth fertile, sleep with their wives in the furrows of the land.

After so many years, each time I begin a new work I suffer what actors call "stage fright".

My faith? Only in things I ask of myself.

The first image that moved me deeply and brought the first of many changes in the course of my life, was not a museum work. It was a poster by Käthe Kollwitz: "Deutschlands Kinder Hungern".[17]

Art and morality have close roots. Here was a beginning and remained my objective.

Picasso was nearer to the cave artists. I trust his scribbles more than his attempts at a finished work.

It takes some time for a finished landscape to enter my mind. Usually weeks after I left the place and it is then that it comes to live in me. Only by that time I no longer know whether it is the spirit of the place or a place formed by my own spirit. By then it may even be a dream.

I have time for little else besides work, my life with N. and my small family that is now richer with grandchildren. I know of no better occasion than the Sundays when N. and the rest of the family sit at the table and share a meal which N. prepares with so much care and love.

[17] "Germany's Children go Hungry".

3032